Rethinking Japan's Modernity

Harvard East Asian Monographs 473

Rethinking Japan's Modernity

Stories and Translations

M. William Steele

Published by the Harvard University Asia Center
Distributed by Harvard University Press
Cambridge (Massachusetts) and London 2024

© 2024 by the President and Fellows of Harvard College
All rights reserved. No part of this publication may be reproduced, translated, stored in a retrieval system, or transmitted in any form or by any means, electronic, mechanical, photo-copying, recording or otherwise, without prior written permission from the publisher.

Published by the Harvard University Asia Center, Cambridge, MA 02138

The Harvard University Asia Center publishes a monograph series and, in coordination with the Fairbank Center for Chinese Studies, the Korea Institute, the Reischauer Institute of Japanese Studies, and other facilities and institutes, administers research projects designed to further scholarly understanding of China, Japan, Korea, Vietnam, and other Asian countries. The Center also sponsors projects addressing multidisciplinary, transnational, and regional issues in Asia.

Library of Congress Cataloging-in-Publication Data

Names: Steele, M. William, 1947– author.
Title: Rethinking Japan's modernity : stories and translations / M. William Steele.
Description: Cambridge, MA : Harvard University Asia Center, 2024. | Series: Harvard East Asian monographs ; 473 | Includes material previously published in English or Japanese. | Includes bibliographical references and index. | English, with some text in Japanese.
Identifiers: LCCN 2024001363 | ISBN 9780674297562 (hardback)
Subjects: LCSH: Fukuzawa, Yukichi, 1835–1901—Political and social views. | Japanese literature—Translations into English. | Civilization, Modern—20th century. | Japan—History—Restoration, 1853–1870. | Japan—History—Restoration, 1853–1870—Sources. | Japan—History—Meiji period, 1868–1912. | Japan—History—Meiji period, 1868–1912—Sources. | Japan—History—1912–1945. | Japan—History—1912–1945—Sources.
Classification: LCC DS881.4 .S84 2024 | DDC 952.03—dc23/eng/20240325
LC record available at https://lccn.loc.gov/2024001363

Index by David Prout

♾ Printed on acid-free paper
Printed in the United States of America

*To Katherine, Matthew, Julia, and Andrew
and to their spouses and children.
The future is yours!*

Contents

List of Figures		ix
Acknowledgments		xv
Note to the Reader		xvii
	Introduction	1
1.	Pacific Vistas: California and the Opening of Japan	7
2.	Apocalypse Now: A Bottom-Up View of the Years 1853 to 1868	29
3.	Fukuzawa Yukichi: A Petition on the Subjugation of Chōshū	57
4.	That Terrible Year 1868: Satirical Cartoons and the End of an Era	74
5.	Negotiating Modernity: Sada Kaiseki and the Movement against Imported Goods	103
6.	Mantei Ōga: Sparrows at the Gates of Learning	126
7.	Katsu Kaishū: Looking Back at the Restoration	148
8.	Fukuzawa Yukichi: On Fighting to the Bitter End	171
9.	When East and West Meet: Japan's *Mingei* Movement	198
10.	Nationalisms and the Anglo-Japanese Alliance	219

11. "To Help Our Stricken Brothers": The Great Tōhoku
 Famine of 1905–1906 235

12. Postcards from Hell: Glimpses of the Great
 Kantō Earthquake 263

13. Looking Back on the Enlightenment: Kume Kunitake
 and World War I 282

Epilogue: Ambiguous Pasts and Unknowable Futures 304

 Bibliography 311

 Index 345

Figures

1.1	Yerba Buena Cove, San Francisco, around 1851	12
1.2	View of the vessels composing the Japan squadron, 1852	18
2.1	*Kaei nenkan yori bei sōba nedan narabi ni nendaiki kakinuki daishinpan* (A new publication of rice market prices and chronicle of selected events beginning with the Kaei era), ca. mid-1868	32
2.2	Kaei chronicle: Foreign ships arrive in Uraga inside Edo Bay for the first time, 1853	34
2.3	Kaei chronicle: Battle at the Sakurada Gate on the 3rd day of the third month, 1860	34
2.4	Kaei chronicle: Outbreak of fighting by ronin insurgents in Shimotsuke Province, 1861	35
2.5	Kaei chronicle: Shogun Iemochi travels to Kyoto in the second month, 1863	35
2.6	Kaei chronicle: Great fire in Kyoto on the 15th day to the 20th day of the seventh month; many people die, 1864	37
2.7	Kaei chronicle: Police patrol the streets of the city of Edo, 1867	38
2.8	Kaei chronicle: On the 15th day of the fifth month, the battle at Ueno Hill, 1868	39
2.9	Rice price and purchasing power of 100 *mon*, 1853–1868	41

2.10	Kaei chronicle: In Edo, poor camps established to alleviate poverty and hunger, 1866	43
2.11	Kaei chronicle: *Kaichō* of Shibayama Niō held at Ekōin temple at Ryōgoku, 1857	46
2.12	Kaei chronicle: *Kaichō* of Kinkazan Benzaiten held at Eikōin temple, 1865	47
2.13	Kaei chronicle: Tidal wave hits Osaka at the mouth of the Kizu River, 1854	49
2.14	Kaei chronicle: Great earthquake strikes Edo on the 2nd day of the tenth month, 1855	49
2.15	Kaei chronicle: Great storm hits the Fukagawa area in Edo on the 25th day of the eighth month, 1856	50
2.16	Kaei chronicle: [Cholera] epidemic spreads widely, 1858	51
2.17	Kaei chronicle: Large-scale outbreak of measles in Edo and throughout Japan, 1862	52
2.18	Kaei chronicle: In the tenth month, the main keep of Edo Castle goes up in flames, 1859	52
3.1	The young Fukuzawa Yukichi in 1862	60
3.2	The first page of the manuscript copy of Fukuzawa's 1866 petition on the subjugation of Chōshū	65
4.1	Utagawa Hiroshige III, *Osana asobi ko o toro ko o toro* (Children playing a game of chain tag), second month, 1868	79
4.2	*Banmin odoroki* (The people **wood** be shocked), n.d.	81
4.3	Utagawa Yoshimori, *Ryūkō shokan uketorisho* (Townsmen offering up petitions), tenth month, 1868	83
4.4	*Toba emaki mono no uchi he gassen* (The Toba war of farts), n.d.	84
4.5	*Kodomo asobi mizu gassen* (Children at play: A water war), n.d.	85
4.6	*Kodomo asobi takeuma zukushi* (Children at play: A battle on stilts), n.d.	86

4.7	*Tōsei mitsuji no tanoshimi* (Enjoying the shamisen), n.d.	87
4.8	*Shinsaku ukiyo dōchū* (On the road to the floating world: A reissue), n.d.	88
4.9	*Sangoku yōko den* (The romance of three countries and the magic fox), n.d.	90
4.10	*Yama no taishō hanabi no nigiwai* (Children playing king of the mountain with firecrackers), n.d.	92
4.11	*Ichinagashi ukiyo yokuaka* (Rinsing away greed and grime in the bathhouse of the floating world), n.d.	93
4.12	*Tomo kenka* (A fight among friends), n.d.	95
4.13	Utagawa Hiroshige III, *Tōsei nagatchiri na kyakujin* (Guests who have overstayed their welcome), n.d.	96
4.14	Utagawa Hiroshige III, *Mutsu no hana kodomo no asobi* (The flowers of Mutsu: Children having fun), tenth month, 1868	97
4.15	Utagawa Kuniteru, *Tōkyō Edo Shinagawa Takanawa no fūkei* (A scene of Shinagawa and Takanawa in Tokyo-Edo), tenth month, 1868	99
4.16	*Shinkei hōseiki* (Chronicle of the world of divine grace), n.d.	101
5.1	Utagawa Yoshifuji, *Honchō hakurai nigiwai dōgu kurabe* (A contest between things foreign and native), 1873	105
5.2	Mantei Ōga, *Kinsei akire gaeru* (A toad fed up with modernity), 1874	108
5.3	Sada Kaiseki, *Fukoku ayumi no hajime* (First steps toward a wealthy country), 1880	114
5.4	Sada Kaiseki, *Baka no banzuke* (A ranking of fools), n.d. but around 1878	119
6.1	Mantei Ōga, *Gakumon suzume* (Sparrows at the gates of learning), section 1, part 1, centerfold: "The battle between the eastern and the western sparrow," 1875	134

6.2	Mantei Ōga, *Gakumon suzume* (Sparrows at the gates of learning), section 1, part 2, centerfold: "The Great Way and the side roads," 1875	143
7.1	Katsu Kaishū in his later years, 1880s or 1890s	157
8.1	Fukuzawa Yukichi in 1901, shortly before his death	174
8.2	*Kanrin Maru* memorial stone, Seikenji temple, 1887	177
9.1	Bernard Leach and Yanagi Sōetsu in Tokyo, 1935	201
9.2	Edward Sylvester Morse in Boston, around 1930	206
9.3	Matsuura Takeshirō in Tokyo, 1885	209
9.4	Okakura Kakuzō and Ernest Fenollosa in Tokyo, 1882	211
9.5	Langdon Warner in Izura, 1906	214
10.1	Torchlight procession organized by students at Keiō Gijuku, 1902	224
10.2	"The Alliance Flag," postcard commemorating the Anglo-Japanese Alliance, 1902	227
10.3	The imperial portraits of King Edward VII and Emperor Meiji, 1902	231
10.4	The Anglo-Japanese Alliance: Britannia and Princess Yamato, 1902	233
11.1	The Foreign Committee of Relief for the Famine in North Japan, 1906	241
11.2	A scene in northern Japan: Cover of the *Christian Herald*, April 4, 1906	245
11.3	Cover of a special issue on the Tōhoku famine, *Kinji gahō*, February 1, 1906	250
11.4	"In the Famine-Stricken Districts: A soldier returns from Manchuria," *Kinji gahō*, February 6, 1906	251
11.5	"In the Famine-Stricken Districts: At death's bed," *Kinji gahō*, February 6, 1906	252
11.6	"Money which might be contributed to the famine relief fund for the people of North Japan," *Tōkyō Puck*, February 1906	254

FIGURES

12.1	Fissures in front of the imperial palace, postcard, 1923	264
12.2	Yūrakuchō before and after the quake, postcard, 1923	265
12.3	Yokohama street scene, postcard, 1905	268
12.4	The Battle of 203 Meter Hill, one of the bloodiest episodes of the Russo-Japanese War, postcard, 1904 or 1905	269
12.5	The Great Tokyo Flood of 1910, postcard, 1910	269
12.6	Open-air picture postcard sales in front of Tokyo Station, newspaper photograph, 1923	271
12.7	Packet cover of a set of earthquake postcards, Kikukadō printing house, 1923	272
12.8	Map of the burned area, postcard, 1923	274
12.9	Yūrakuchō in flames, postcard, 1923	275
12.10	Ryōunkaku (Asakusa Twelve Stories), postcard, 1923	276
12.11	Asakusa before and after the earthquake, postcard, 1923	277
12.12	Ginza in ruins, postcard, 1923	278
12.13	Maruzen Bookstore in ruins, postcard, 1923	279
12.14	Headless Great Buddha in Ueno Park, postcard, 1923	279
13.1	Kume Kunitake at the time of the Iwakura Mission, around 1872	284
13.2	Kume Kunitake in 1927 at the age of eighty-eight	285
E.1	The meeting between Saigō and Katsu, 14th day of the third month (April 6), 1868, *Meiji Taishō Shōwa dai-emaki*, 1931	306
E.2	Great Peace Commemorative Exposition, March 10, 1922, *Meiji Taishō Shōwa dai-emaki*, 1931	307
E.3	Ambassador Wakatsuki's broadcast speech, February 9, 1930, *Meiji Taishō Shōwa dai-emaki*, 1931	308

Acknowledgments

Many people have helped and guided me over many years of exploring the highways and byways of history. Patricia Sippel has always been my greatest support. Feeling ourselves to be graduate students again, we went over every chapter word by word. I cherish the time we spent revising the book for publication. Thanks to Trish, the text is much improved, both in grammar and in clarity of argument. I also pay homage to the teachers who first showed me the way: Akira Iriye, who taught me to see broadly, and Albert Craig, who taught me to think critically. Now retired from teaching, I remain in close contact with friends and colleagues in the Department of History at ICU: Kojima Yasunori, Takazawa Norie, Nasu Kei, Kikuchi Hideaki, Olah Csaba, and Rob Eskildsen. All have offered support and intellectual challenge as we worked together on our teaching, research, and administrative duties. I also acknowledge my debt to former senior colleagues: Takeda Kiyoko, Minamoto Ryōen, Joe McDermott, and Kasai Minoru. My students have also been the source of constant stimulation: the contents of these chapters received their first airing and critique in lectures at ICU. Over many years, friends including Jim Baxter, Martin Collcutt, Steven Ericson, Sally Hastings, James Huffman, Kate Nakai, and Anne Walthall have inspired me by their commitment to scholarship, friendship, and good humor.

Regarding specific chapters in this book, I thank the curators at Hachiro Yuasa Memorial Museum, Fukuno Akiko, Hara Reiko, and Gushima Megumi, as well as my former student Shinohara Masanari, for helping me squeeze out meaning from the late Tokugawa political images introduced in chapters 2 and 4. Yoshioka Shirō, anime specialist, helped me with chapter 5 on Sada Kaiseki. Tanaka Yusuke spent

hours helping me to decipher Mantei Ōga's parody of Fukuzawa's *Gakumon no susume*, which forms chapter 6. Okamoto Yoshiko assisted with chapter 9, deepening my understanding of Okakura Kakuzō and the *mingei* movement. I drew also on the friendship and advice of Kumakura Isao, specialist on the tea ceremony and on Yanagi Sōetsu and the *mingei* movement. Kawanishi Hidemichi, friend and leading historian of Japan's Tōhoku region, gave me valuable feedback on the famine of 1905–1906 discussed in chapter 11. Gōdo Natsuko and Kishi Yū came to my rescue in chapter 13, when Kume Kunitake's texts proved too dense. Several of these chapters were superbly translated into Japanese by Robert Ono for a book on new views of the Meiji years, *Meiji ishin to kindai Nihon no atarashii mikata* (2019). I thank Andy Gordon and Akira Iriye for their encouragement to publish my work in English. And thanks, too, to the anonymous readers whose comments and criticisms made me rethink and revise once again the essays and translations that make up the book. Finally, I am much indebted to a team of professionals headed by the editorial staff of the Harvard Asia Center. My sincere thanks to Bob Graham who guided me in the beginning stages and to Kristen Wanner and Daniel Lee whose insights and expertise (and gentle nudges) were all-important in bringing this book into existence. I am also grateful for the meticulous work of copyeditor, Akiko Yamagata, the creative cover design realized by Regina Starace, the innovate layout and composition skills of Suzanne Harris, and the careful services of indexer, David Prout. Thank you all!

Note to the Reader

All Japanese names follow the Japanese custom, surname first followed by personal name. The dating system used in the text is more complex. Beginning on January 1, 1873, the Japanese government, as part of its westernizing reform agenda, officially ended use of the traditional lunisolar calendar and adopted the purely solar Gregorian system used in Europe and the United States. In keeping with the attempt to understand how people of the past understood their world at a particular time and place, dates relating to people and events in Japan before January 1, 1873, are given in accordance with the Japanese lunisolar calendar. Era names (*nengō*) will nonetheless be avoided, converted instead to Gregorian years. Hence Ansei 2 will be rendered as 1855. The format used is day (in numerals), month (spelled out), and year (numerals). For example, the date of the Battle of Ueno Hill is the 15th day of the fifth month, 1868. This use of the Japanese lunisolar calendar applies especially to dates in chapters 2, 3, and 4. Occasionally, the text provides the Gregorian conversion for the day and month—in the case of the Ueno battle, July 4, 1868. Specifically, in chapter 1, given its focus on American, especially Californian, views of the Perry expeditions of 1853 and 1854, dates follow the Gregorian system in the format of month, day, and year. Hence, Californians first learned that Perry had been successful in negotiating a treaty with Japan, with headlines proclaiming (erroneously) that "Ports of Japan to be open to American commerce," on June 8, 1854.

Introduction

This book aims to take a new look at people, places, and events associated with Japan's engagement with modernity, starting with the arrival of Commodore Matthew C. Perry (1794–1858) in 1853. In many cases, this new look means taking advantage of visual sources, such as popular broadsheets, satirical cartoons, ukiyo-e and other woodblock prints, postcards, and photographs. It illustrates the diverse, and sometimes conflicting, perceptions of people who experienced the unfolding of modern Japan. History is not one story, but many, and some of these stories make up the thirteen chapters in this book.

Let me first trace the origins of the way I have come to see history and of my particular focus on modern Japan. As a sophomore at the newly established Santa Cruz campus of the University of California, I took classes on Japan and on Japanese American relations taught by a youthful Akira Iriye. I had intended to major in the history of ancient Greece and Rome, but Iriye's teaching style, his warm personality, and the content of his classes inspired me to switch to East Asian studies. On Iriye's advice, I applied to the University of California international exchange program at the International Christian University (ICU) in Tokyo—the same school where I would later return as a faculty member to teach modern Japanese history. I arrived at ICU in the fall of 1967. Despite, or perhaps because of, the student unrest in Japan, my mind was stretched in various directions.

Toward the end of my year in Japan, I asked some friends for help in buying a hanging scroll to take home. One friend relayed my request to his mother, who contacted her brother, a sake merchant in the city of Ōgaki in Gifu Prefecture. Taking the romantic yearnings of an unknown foreign student interested in Japanese history and art seriously, my friend's uncle sent a letter that outlined three conditions for my receiving a hanging scroll. First, I had to go fishing for sweetfish in the Nagara River at Ōgaki; second, I had to eat the sweetfish and drink a cup of sake at his house; and third, I had to study about Katsu Kaishū (1823–1899). The first two conditions presented no problem: I liked travel, enjoyed fishing, and had become practiced in the art of sake drinking. The third condition, however, was not so easy. Although I had never heard of Katsu Kaishū, I found in the ICU library a biography published in 1904 by E. Warren Clark with the title *Katz Awa, The Bismarck of Japan*. I also bought the recently published *Katsu Kaishū* by Matsuura Rei and, with dictionary in hand, read it page by page. I learned about Katsu's growing up in Edo, his eccentric father Kokichi, his determination to learn Dutch, his study under Sakuma Shōzan (1811–1865), his memorial advocating an open-the-country policy to the shogunate following Perry's arrival in 1853, his role in establishing the Nagasaki Naval Training Center, and his success in sailing the *Kanrin Maru* across the Pacific in 1860. I was especially impressed with the role Katsu played in the 1868 Meiji Restoration as commander in chief of the Tokugawa shogunate's military forces. Instead of all-out war, he chose to negotiate with Saigō Takamori (1827–1877), his counterpart in the imperial army, thereby making possible the peaceful surrender of Edo Castle in the spring of 1868.

Armed with this knowledge, I traveled to Ogaki, went net fishing in the Nagara, ate sweetfish sashimi, and drank delicious sake. I was also able to display a rudimentary knowledge of Katsu Kaishū in conversation with my friend's uncle. At the end of the day, I was rewarded with a scroll. Unrolling it, I discovered Katsu's bold calligraphy: 雪中松柏有余情 *setchū shōhaku yojō ari*, which translates roughly as "In the snow stands a lone pine tree, deep are my feelings." I later learned that Katsu was drawing on a poem by the Chinese scholar and official Xie Fangde (1226–1289), in which he expressed undying loyalty to the Song dynasty (960–1279) after the Mongol takeover. Katsu's one-line

calligraphy reflected his own conflict between loyalty to the Tokugawa family and service to the new Meiji state (1868–1912).

I have been a student of Katsu Kaishū ever since. Returning to the University of California, I wrote a senior thesis on Katsu's response to the opening of Japan under the supervision of Harry Harootunian. As a graduate student in Harvard's History and East Asian Languages program, I wrote a PhD thesis titled "Katsu Kaishū and the Collapse of the Tokugawa Bakufu." Unlike my adviser Albert Craig, who had examined the role of Chōshū domain in bringing about the Meiji Restoration, I focused on Katsu and the losing side of the Restoration drama.

Through my study of Katsu, I developed a general interest in underdogs and losers and more generally in the lives and experiences of ordinary people. As a concerned historian, I came to include the quest for equality and social and environmental justice in my scholarship. This has led me to approach history from the bottom up rather than the top down and from the peripheries rather than the center. In a study of "alternative narratives," I explored the freedom and people's rights movement (*jiyū minken undo*) of the early Meiji era by focusing on Yoshino Taizō (1841–1896), a political activist in what is now the city of Mitaka, the location of ICU and my home in the western suburbs of Tokyo.[1] Challenging a political rhetoric that demanded service to the state, Yoshino, in the 1880s, argued that priority should be placed on local welfare and economic development. Yoshino's story complicates narratives of modern Japanese history that stress the dominance of national over local interests. History demands the appreciation of multiple, even contradictory narratives. Some of these form the chapters of this book, which aims to rethink Japan's Meiji Restoration and its embrace of modernity.

Of the thirteen chapters of the book, all but one have been previously published in English or in Japanese, though substantially revised for this volume. I have arranged them somewhat chronologically, both in terms of when they were written and of the history they attempt to interpret. They represent my attempt to turn, however slightly, what H. Stuart Hughes termed "the conventional prism of historical vision"

1. Steele, *Alternative Narratives in Modern Japan*, 141–56.

and explore different perspectives on modern Japanese history.[2] Chapter 1, "Pacific Vistas: California and the Opening of Japan," retells the story of the Commodore Perry expedition to Japan in 1853–1854 from the viewpoint of California, rather than from Japan on the other side of the Pacific. Chapter 2, "Apocalypse Now: A Bottom-Up View of the Years 1853 to 1868," examines a woodblock print issued in 1868 that illustrates the extraordinary variety of events that occurred between Perry's arrival in 1853 and the collapse of the shogunate in 1868. Paying more attention to natural disasters than to the machinations of imperial loyalists, the print challenges established narratives that trace the course of events almost inexorably to the Meiji Restoration. Chapter 3, "Fukuzawa Yukichi: A Petition on the Subjugation of Chōshū" is a translation of an 1866 proposal by Fukuzawa Yukichi (1835–1901) urging the Tokugawa shogunate to crush its opponents and set up a centralized government with the shogun as monarch. The proposal not only complicates usual understandings of Fukuzawa but suggests other possible outcomes to the struggles of the late Tokugawa years. Chapter 4, "That Terrible Year 1868: Satirical Cartoons and the End of an Era," draws on contemporary political cartoons to illuminate the experience of Edo commoners in 1868; to them, the year that came to be celebrated as the birth of modern Japan was one of bloodshed, suffering, destruction, dislocation, and impoverishment.

The westernizing reforms undertaken by the Meiji imperial government did not go uncontested. Chapter 5, "Negotiating Modernity: Sada Kaiseki and the Movement against Imported Goods," describes the array of campaigns that opposed the invasion of things Western in the 1870s and early 1880s. The arguments advanced by Sada Kaiseki (1818–1882) against foreign goods, including gas lamps, throw light on Japan's ambivalent and sometimes contradictory experience with modernity. Chapter 6, "Mantei Ōga: Sparrows at the Gates of Learning" complements the critique of Western things with arguments against Western ideas and values. In the early 1870s, Mantei Ōga (1818–1890), a popular writer of nonsense fiction, turned his wit against the "civilization and enlightenment" (*bunmei kaika*) movement led by Fukuzawa and other advocates of westernization. The

2. Hughes, *History as Art and as Science*, 20.

chapter is a translation of section 1 of Ōga's 1875 incisive parody of *Gakumon no susume* (An encouragement of learning), Fukuzawa's primer on the importance of Western learning.

Recollections also offer valuable insights into how Japan's modern transformation can be understood. Chapter 7, "Katsu Kaishū: Looking Back at the Restoration," analyzes Katsu's memoirs and historical writings from the 1880s and 1890s as his effort to counter an emerging emperor-centered historiography of the Meiji Restoration. Fukuzawa Yukichi, in his silver years, also had memories of the events of 1868. Chapter 8, "Fukuzawa Yukichi: On Fighting to the Bitter End" is a translation of Fukuzawa's condemnation, written in 1891, of former Tokugawa retainers such as Katsu and Enomoto Takeaki (1836–1908) who, he claimed, had failed to "fight to the bitter end" in defending the shogunate.

Although Japan experienced an outburst of "national mindedness"[3] from the late 1880s, modernity was also a negotiated process of cultural hybridity. Chapter 9, "When East and West Meet: Japan's *Mingei* Movement," argues that the *mingei*, or folk craft, movement pioneered by Yanagi Sōetsu (also known as Yanagi Muneyoshi) 1889–1961) and Bernard Leach (1887–1979) in the early 1900s, owed much to contemporary arts and crafts movements in England and the United States; these were, in turn, influenced by early exhibitions of Japanese design and craftsmanship. Similarly, Chapter 10, "Nationalisms and the Anglo-Japanese Alliance," illustrates the multidimensional nature of modern Japanese nationalism by focusing on the 1902 Anglo-Japanese Alliance as the product of peaceful diplomatic achievement rather than victory in war.

Although Japan had thus achieved great power status in the early twentieth century, for some, the belief in progress began to fade. Chapter 11, "'To Help Our Stricken Brothers': The Great Tōhoku Famine of 1905–1906," illustrates contrasting realities of Japan during these years. Victory over Russia in the summer of 1905 produced nationwide celebrations and outpourings of patriotism, but crop failures in three northeastern prefectures later that year produced suffering and deprivation that attracted worldwide attention. Internationally, the famine

3. Gluck, *Japan's Modern Myths*, 23.

created an image of Japan as poverty-stricken and in need of humanitarian aid. At home, it confirmed long-standing perceptions of Japan's northeast as an undeveloped and backwards region. Chapter 12, "Postcards from Hell: Glimpses of the Great Kantō Earthquake," demonstrates that a natural disaster, striking the very center of the nation in 1923, exposed the fissures of modernity. Picture postcards, a relatively new media, illustrate both the hell experienced and the doubts some people held about Japan's future.

Chapter 13, "Looking Back on the Enlightenment: Kume Kunitake and World War I," reflects on the course and consequences of Japan's pursuit of civilization and enlightenment through the recollections of Kume Kunitake (1839–1931). The young Kume had accompanied the Iwakura Mission (1871–1873) to the United States and Europe and compiled its official account as a blueprint for modernizing reform. However, looking back during and after World War I on what he and his fellow advocates of civilization and enlightenment had brought to pass, the older Kume did not like all that he saw. Kume died in 1931, worried that peace might not endure.

Do these chapters offer a new and improved view of the course of modern Japanese history? That is not the aim of this book. As the epilogue notes, history is multifaceted, filled with ambiguity and having no fixed trajectory. My aim is, rather, to add to the matrix of stories that both inform and challenge our understanding of change and the links between past, present, and future.

CHAPTER ONE

Pacific Vistas: California and the Opening of Japan

This chapter offers an alternative view of the opening of Japan in 1853–1854. Instead of looking at diplomatic overtures from Washington, DC, and Commodore Matthew Perry's interactions with the Tokugawa shogunate in Edo Bay, it focuses on the expectations of American merchants and ordinary people in San Francisco on the other side of the Pacific. The chapter takes advantage of the extraordinary attention that the Daily Alta California, *San Francisco's first daily newspaper from 1848, devoted to Japan and its arguments in favor of American westward expansion across the Pacific. In 1852, learning that Commodore Perry would be sent to Japan, the newspaper's headline proclaimed, "Hurrah for the Universal Yankee Nation, Com. Perry, and the new prospective State of Japan!"*

As a fourth-generation Californian whose great-great-grandmother walked across the Isthmus of Panama in 1849 to take up work as a cook in the California gold fields, I can find a personal connection to the opening of Japan and the events leading to the Meiji Restoration. I grew up in a small town close to Santa Cruz, California, about two kilometers from the ocean, and looking west, I could imagine Japan on the other side of the horizon. My father was a Marine, who fought in the war against Japan and survived the horrific Battle of Iwo Jima. He spoke often of his war experiences, and the stories rest uncomfortably in my memory. In 1951, when I was four, my father took me to Moffett Field in San Francisco to witness the return of his hero, General Douglas MacArthur, from service in Japan and Korea. My mother, too, had war memories. As a teenager, she was assigned watch tower duty, looking out for Japanese balloon bombs that might float in across the ocean; she had Japanese American neighbors who were sent to internment camps.

Perhaps because I grew up with stories of Japan across the Pacific, I was somewhat disappointed to learn that Perry had departed from Norfolk, Virginia, and sailed east by way of Africa, India, and Hong Kong for his journey to Japan. However, I returned to the Pacific connection in the 1980s, when preparing for a workshop on the opening of Japan. During a summer visit to California, I read microfilms of San Francisco newspapers that expressed a dynamic and ongoing enthusiasm for engagement with Japan. That was the origin of this chapter, revised several times over the years, and again for this book.[1]

The "opening of Japan" by the United States in 1853 is often considered the baseline of Japan's modernization. The specter of a squadron of mammoth "black ships" contributed to a growing Japanese nationalism that in turn led to the Meiji Restoration of 1868 and the creation of a centralized nation-state devoted to the goals of wealth and power. This chapter adopts a different platform from which to view the origins of Japan's modern transformation. Instead of American foreign military, diplomatic, and economic pushes (centered in New York and Washington, DC) or Japanese nationalism and its pushbacks (centered in Kyoto and Edo), the focus here is on San Francisco. What did Californians think of Japan, the Japan squadron, and events taking place on the other side of the Pacific? What role did California play in the construction of the new special relationship between the United States and Japan? In the end, who opened Japan?

A series of articles relating to Japan that appeared in the *Daily Alta California* (1849–1891) and other California newspapers helps to document the response of Californians to and their participation in the opening of Japan.[2] The *Daily Alta* traces its origins to the *Californian* (1846–1848), California's first English-language newspaper,

1. Steele, "California's Pacific Destiny."
2. The full contents of the *Daily Alta California* and other early California newspapers may be found in California Digital Newspaper Collection, a website maintained by the Center for Bibliographical Studies and Research, University of California, Riverside: https://cdnc.ucr.edu.

and the *California Star* (1847–1848). Both early newspapers followed the course of the war between the United States and Mexico (1846–1848), including the July 1846 liberation of Yerba Buena, the settlement that would soon be renamed San Francisco, and the March 1847 siege of Vera Cruz, in which Commodore Matthew Perry played a leading role. From its earliest issues, the *Daily Alta* reported extensively on California's gold rush, the explosive growth of San Francisco, and the admission of California as the thirty-first state of the union in 1850.

However, dramatic as these domestic affairs were, Californians were also looking outward—across the Pacific, to China and Japan. The *Daily Alta* and its immediate predecessors focused on the importance of future commercial relations with Japan. In November 1846, the *Californian* reported an attempt by Commodore James Biddle (1783–1848) to "open intercourse with the emperor of Japan." The newspaper informed Californians that the Japanese were "a fine, athletic race, inquisitive and intelligent" but also "determined to preserve their exclusive policy." It concluded: "How long Japan will be enabled to maintain herself as a *terra incognito* is a problem of great interest to us lovers of something new."[3] In 1847, the *California Star,* commenting on the progress of the war with Mexico, noted that the "annexation of California" would present special advantages to the people of San Francisco. They could expect a great influx of people who would "engage with vigor in commercial pursuits; no people in the world have greater natural advantages. The trade of China, and of the Japanese Archipelago, will crowd their ports with vessels."[4] Later that year, the *Star* declared that, more than the simple acquisition of territory, victory in war would lead "to an almost boundless enlargement of our commerce to new channels and spheres of trade, and to great markets for our produce and manufactures." Specifically, it presented a "golden opportunity" to realize the construction of a canal or railway across the Isthmus of Tehuantepec that would "provide quick and easy access to China, the groups of the south sea archipelago, the Sandwich Islands, Russian settlements, and even before long . . . the tempting and

3. "News from the *Polynesian*."
4. "The Progress of Annexation."

untouched treasures of magnificent Japan."[5] On February 19, 1848, several months before news of the discovery of gold inaugurated the great California gold rush, the *Star* saw California's future intertwined with Japan: "We begin now to feel ourselves as near neighbors to Japan. The frequent arrival of vessels that have touched in, and attempted intercourse, keeps up an interest in the public mind towards that country, which yearly creates a more ardent desire for commercial intercourse."[6]

Statehood confirmed what Californians had come to believe: gold was not only in the Sierra Nevada hills but also across the Pacific. On October 29, 1849, massive celebrations were held in San Francisco to commemorate California's new status—and its new future. In his oration, state senator Nathaniel Bennett (1818–1886) focused on California's role in the Pacific. It would break down the wall of Chinese exclusiveness; it would introduce "the children of the sun" to the splendors of civilization; and more gloriously, it would assist in the creation of a new world economic order:

> It needs not the gift of prophecy to predict that the course of the world's trade is destined soon to be changed. But a few years can elapse before the commerce of Asia and the Islands of the Pacific . . . will enter the Golden Gate of California, and deposit its riches in the lap of our own city. Hence on bars of iron, and propelled by steam, it will ascend the mountains and traverse the desert, and having again reached the confines of civilization, will be distributed through a thousand channels to every portion of the Union and of Europe. New York will then become what London now is, the great central point of exchange—the heart of trade . . . and San Francisco will then stand [as] the second city of America.[7]

This chapter examines the enthusiasm of Californians for trade and communication with Japan as reflected in San Francisco newspaper

5. "The Movement of the Age."
6. "Japan," February 19, 1848.
7. "The Celebrations."

reports in the middle of the nineteenth century. The first section introduces home-grown initiatives taken in 1851, before news of the Perry expedition reached the West Coast. The next section examines in detail California news, editorial advice, and actions relating to the expedition and the signing of Japan's first international treaty in 1854. The conclusion suggests that the opening of Japan should be understood within a framework of engagement with the Pacific world and beyond.

Before Perry

On May 9, 1851, President Millard Fillmore (1800–1874) placed Commodore John H. Aulick (1790–1873) in command of a naval expedition to Japan to "secure friendship, commerce, a supply of coal and provisions, and protection for our shipwrecked people."[8] On June 10, Secretary of State Daniel Webster (1782–1852) gave Aulick his sailing orders: he was to negotiate a shipwreck convention, secure the right of American ships to enter Japanese ports, and procure a coal depot. Webster foresaw a revolution in world commerce resulting from the mission to Japan: "The moment is now when the last link in the chain of oceanic steam navigation is to be formed." He looked forward to the time when, from the "Pacific Coast, north and southwards, as far as civilization has spread, the steamers of other nationals and our own carry intelligence, the wealth of the world, and thousands of travelers."[9] The *Susquehanna* with Aulick in command departed from Norfolk, Virginia, in June, but its mission quickly proved to be a fiasco. Quarrels broke out between the commodore and his crew, and allegations of fraud led to his recall in November 1851. After arriving in China in February 1852, Aulick was forced to wait for more than a year until the arrival of his replacement, Commodore Matthew C. Perry. Perry left Norfolk, with additional ships in November 1852,

8. Hawks, *Narrative of the Expedition*, 257.
9. Webster, *The Writings and Speeches*, 14:427–28.

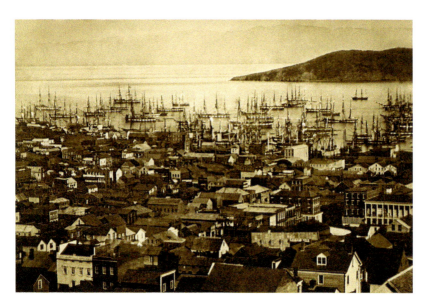

1.1. Yerba Buena Cove, San Francisco around 1851. Public domain, via Wikimedia Commons.

rounded the Cape of Good Hope in early February 1853, and arrived in Hong Kong on April 6.[10]

Even before the actions of Fillmore and Webster, however, Californians were looking west. On March 13, 1851, the *Daily Alta* predicted the future of San Francisco as the "Mistress of the Pacific" (fig. 1.1): "The commerce of the whole world is directed to these golden gates and we can now see ships of almost every nation riding in our harbor, and bringing us the product of every clime." San Francisco was a boomtown, and its citizens had no doubt about its future: "The whole Pacific seas are before us and invite us to occupy them with our trade. We cannot escape our destiny if we would."[11]

In order to realize this destiny, it was important to open communications with Japan, "the invisible empire of islands," and

10. Hawks, *Narrative of the Expedition*, 153. It is interesting to note that the official *Narrative* made no mention of Aulick in China waiting for Perry.
11. "Commercial Supremacy of the Pacific Coast."

Californians were eager to take the lead.[12] An opportunity had presented itself on March 4, 1851, when seventeen Japanese castaways were transported to San Francisco on the American whaler *Auckland*. They included Hamada Hikozō (1837–1897), later known as Joseph Heco, who went on to work as an interpreter, businessman, and journalist and was one of the first Japanese nationals naturalized as an American citizen.[13] Others rescued were Sentarō (1832–1874), known as Sam Patch, who was to accompany Perry to Japan, and Denkichi (?–1860), also known as Iwakichi, who later worked as interpreter for the British Legation in Edo and was assassinated in 1860 by antiforeign activists.[14] On March 5, the *Daily Alta* reported: "They were fifty days on the wreck, and were in great distress, having exhausted their provisions. . . . They appear exceedingly grateful for the assistance and kind treatment received from the Captain."[15] On the next day, the newspaper suggested taking advantage of the situation: "Would it not be wise and probably profitable for some of our merchants to fit out a pioneer expedition from this port to Japan?" It proposed sending a ship loaded with "cargo suited for the market" to return the "poor Japanese" to their homes. "They would carry back a favorable report of us 'outside barbarians,' and might prove the opening wedge for a free commerce between the world and Japan."[16] On March 17, the *Daily Alta* suggested again that the castaways' return to Japan might be the "means of opening a communication with that country." It noted that, after staying on board the *Auckland*, they had come on shore on March 16 for the first time and "appeared to be highly delighted with all they saw. We believe these men are the first Japanese who have ever set foot on the American continent."[17]

12. "Intercourse with Japan," March 26, 1851.
13. Heco described the shipwreck and rescue and his experiences in San Francisco in his autobiography. Heco, *The Narrative of a Japanese*, 55–99.
14. Parker, *Japan's Sam Patch*; Miyanaga, "Eikoku kōshikan tsūben Denkichi." For a general account of the Japanese castaways, see Plummer, *The Shogun's Reluctant Ambassadors*.
15. "China and Japan."
16. "Intercourse with Japan," March 6, 1851.
17. "An Hour with the Japanese."

The appearance of the Japanese on the streets of San Francisco seems to have caused a sensation. On March 18, the *Daily Alta* reported that they had been invited to the Grand Fancy Dress and Masquerade Ball scheduled for the next day: "They will appear in costume and will perform some of their favorite dances in the Japanese style. . . . It will certainly be very amusing, independent of their own dancing, to see them engaged in dancing with the ladies of a civilized country."[18] In "The Japanese at the Ball," the newspaper declared the event to have been a great success: "They appeared to be much pleased with the music and dancing of the 'outside barbarians,' and remained till a very late hour, being feasted and talked to by almost everybody."[19]

On March 26, the editors of the *Daily Alta* repeated their proposal for using the Japanese castaways as a wedge for entering Japan and set out the first in a series of arguments in favor of opening commercial relations with Japan.[20] They appealed to an emerging international sentiment in criticizing Japan's government and its "boorish, distrustful touch-me-not system":

> It is impossible that the world of nations, around which commerce and mutual dependence, untrammeled thought and practical freedom of action and enterprise are so fast and certainly weaving the golden web of brotherhood and international communication, can or will much longer endure or allow the maintenance by Japan of her most obnoxious and ungracious system, her universal embargo law, shutting herself up from the rest of mankind—in the world, but not of it. It is seriously doubted if any nation has any such right inherent. Japan is a problem—it must and will be solved. . . . The truth is the world's curiosity will not let things rest as they are.[21]

18. "Something New."
19. See Heco, *The Narrative of a Japanese*, 92–97, for another version of this episode.
20. For details on the Japanese castaways and their fate, see Humeston, "Origins of America's Japan Policy," 212–13.
21. "Intercourse with Japan," March 26, 1851.

The editors argued that ordinary Japanese people were anxious to trade with the Americans and they looked forward to the day when "the bigoted representatives of power there could be tumbled down from their self-exaltation." A later editorial concluded: "No country has the right to be exclusive and hold its productions from all others; none have the right to close their ports to the call of traffic; most certainly not to the calls of distress.... The earth is a common heritage of all mankind, and its productions are meant to be shared by all its inhabitants."[22]

Other *Daily Alta* articles stressed the inevitable westward movement of civilization. Americans had moved across the continent, and having reached the Pacific Ocean, they would not stop: "The spirit of enterprise and adventure has for centuries been pursuing its course westward, and now in that direction when American progress on our continent has been stayed by the waves of the Pacific which dash against our rocky coast, the eye of the adventurer is looking far off into the ocean."[23] With Californians in the lead, Americans would carry "civilization, commerce and liberal institutions" across the Pacific in order to "modify and change the superannuated habits of the Asiatics" and lead them to rejuvenation.[24] On July 10, the newspaper declared this to be a matter of destiny:

> It has long been known that the tendency of civilization is to progress toward the realms of the settling sun, and that from the Occident the Yankee nation are fast merging into the gorgeous clime of the Orient.... It has been our destiny to push on, precipitately regardless of the result to other nations and recess of the future, for ourselves; propitiating fate by the banner which we have borne aloft, whose folds have flung Freedom to the world, and dispensed the favors of the free and enlightened wherever it has been carried.[25]

22. "Intercourse with Japan," July 29, 1851.
23. "The Spirit of Conquest."
24. "The Island of Formosa."
25. "West Moving West."

Even more important than Japan as an object of American enlightenment, however, was the image of Japan as a market for American industry. As the *Daily Alta* put it on July 8, 1851, America, and the golden state of California, occupied an important place in world history:

> Of all the countries in the Eastern seas, important in the line of commercial relations to the great civilizing center of the globe, the United States of America, not one occupies a more favored position, or presents in greater abundance advantages for an enlightened trade than the vast and wealthy region of Japan. In the great chain of a connecting commerce which now girds the earth and by every added link secures strength and wealth for the majesty of the great Republic, the importance of uniting Japan is becoming every day more and more perceived. . . . A golden link to the chain of commerce was added in the acquisition of California and in the opening of intercourse with Japan there will be another link united, precious as the gems of an oriental bride."[26]

The plan to use castaways as a wedge for gaining entry to Japan was later picked up by Aulick and approved by Secretary of State Webster. In March of the following year, 1852, under orders from Washington, some sixteen Japanese nationals, including Heco and Sam Patch, were transported from San Francisco to Hong Kong on the USS *St. Mary's*, a sloop-of-war in the Pacific Squadron. From this point, they were expected to accompany the Japan expedition to Edo under Perry's command. Although the castaways reached Hong Kong in May, only Sam Patch took the final leg of the voyage to Japan. Amid delays in Perry's arrival, Heco and two others accepted a private offer by Thomas Troy, master-at-arms on the *St. Mary's*, for passage back to San Francisco, arriving in December.[27] By this time, however, the *Daily Alta* had lost interest in the castaways' story; it did not report Heco's return. Instead, interest had shifted to the fate of Perry and the Japan expedition.

26. "Commercial Intercourse with Japan."
27. Heco, *The Narrative of a Japanese*, 114–24.

California and the Opening of Japan

Before the first transcontinental telegraph line went into operation in 1861, news from the East Coast of the United States often took more than three months to reach California. The first mention of an expedition under Aulick to Japan appeared on March 7, 1852, in a *Daily Alta* report on a survey of the shipping route between California and China. The article expressed hope for securing an open port for trade with "unsociable" Japan and a "depot for our whaling fleet and coaling place for our steamers, and a refuge for the distressed."[28] In fact, this was old news. Following Aulick's recall, Perry was already in charge and preparing an expanded Japan expedition; Perry's connection with the expedition was first reported in California on March 16.[29] On May 1, the *Daily Alta* printed details of the Japan squadron, complete with a list of the ships, commenting that "a more efficient fleet has not been dispatched from the shores of the U.S. for many a day" (fig. 1.2).[30] On June 21, 1852, it exclaimed: "Hurrah for the Universal Yankee Nation, Com. Perry, and the new *prospective* State of Japan!"[31]

Following this initial excitement, various California newspapers published Japan-related items gleaned from the American East Coast, Europe, and China. However, details about the Perry mission were scarce. On August 9, correspondence from Canton dated June 3 appeared in the *Daily Alta*. It reported that ships belonging to the Japan expedition had been in the area for over a year and "no one here has any idea what is the occasion of it."[32] On December 2, 1852, reflecting the continuing anxiety and unaware that Perry had sailed from Norfolk less than two weeks earlier, the *Daily Alta* published a lengthy editorial on the importance of the Perry expedition for prying open the "Hermit of Nations." As before, its argument centered on the special destiny of California: "The geographical position of California

28. "Survey of the Route."
29. "Naval Expedition to Japan."
30. "The Japan Squadron."
31. "The Japan Expedition," June 21, 1852.
32. "China Correspondence."

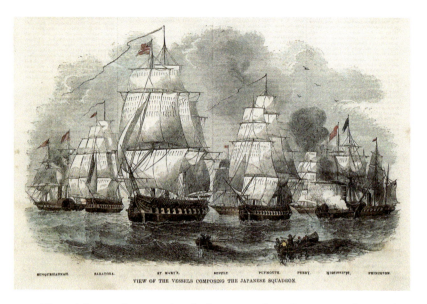

1.2. View of the vessels composing the Japan squadron. Perry is standing on the long boat in the lower right corner. *Gleason's Pictorial Drawing-Room*, Boston, May 15, 1852. Author's collection.

and its occupancy by the most powerful and active of human races, clearly destine it to share largely the profit of the commerce of the East. . . . Hence it is difficult to exaggerate the interest of our State in all that tends to develop and promote civilized intercourse with the populous and wealthy regions of the East."

The *Daily Alta* had learned that the Perry mission was preparing a slate of gifts, including a miniature locomotive and other instruments of advanced technology and design, in the hope that "the promptings of an advanced civilization" would encourage the Japanese to open their country:

> To stimulate the curiosity and excite the desire of this Eremitic people, the expedition will be supplied with apparatus intended to display some of the most surprising manifestations of modern discovery. The steam engine, the electric telegraphy, and the daguerreotype will be exhibited in operation. An interesting miscellany of presents for the court, the fabrication of American skill and ingenuity, will be carried out. Every

effort of a peaceful character will be employed to effect the desired result of friendly intercourse.[33]

It warned, however, that the use of force in opening Japan should not be ruled out: "It is obviously the duty as it is the avowed intention of government to employ primarily peaceful and persuasive means. Should these fail, we hold *limited coercion* to be necessary and proper."[34]

A commentary on the Japan expedition published the following day was even more militant in tone. The editors criticized the Atlantic press for focusing on the "presents and toys" to be offered Japan, arguing that such an approach added to their fears that the expedition would not meet with success: "A government like the Japanese are not to be bought or coaxed, and in whatever spirit the gifts are presented, it is to be feared that they will be viewed in this light and become a hindrance instead of assistance to negotiation. To be successful, an immediate and prompt demand must be made and carried with such a show of force that it cannot be refused." They declared that the Japanese, and other Asiatic people, would not act unless the American side took "prompt and decisive measures":

> Our seamen have been abused, imprisoned, murdered, and perhaps even now may be held captive; our merchants ships in want of water, have been fired into on their coast and in their dependencies, and death or captivity is the certain fate of any unfortunate enough to be wrecked within their dominions. These are reasons enough for a demand of a port and resident consulate, and to enforce which is but a duty our Government owes our rapidly increasing commerce.[35]

The December 6 issue continued this argument:

> If the expedition is going out with temporizing, child's play instructions, it might as well stay at home. If, as it has been reported, the ships are

33. "Japan," December 2, 1852.
34. "Japan," December 2, 1852.
35. "The Japan Expedition," December 3, 1852.

loaded with trinkets and trumpery, with which to coax the Japanese into a treaty of commerce and amity, there will be no treaty made. But if the Commander of the expedition has instructions and power to enforce our demands, why then we may expect it to result in something more than a mere visit of form.[36]

On January 11, 1853, the *Daily Alta* could finally report that Perry had departed from Norfolk on the *Mississippi* for Edo. Details of the "long-delayed" expedition countered fears that it would be one in form only. Including the vessels waiting in China, it would consist of thirteen vessels (including store ships), 236 cannon, and 3,125 men, making it unprecedented in the number of men and munitions mustered in peacetime for the purposes of US diplomacy.[37]

Although the opening of Japan was clearly a national enterprise, the *Daily Alta* saw California at the forefront. A February 1, 1853 editorial likened San Francisco to Venice of the Middle Ages, arguing it was destined to become "a dispensing mercantile medium for the world." At the close of the nineteenth century, however, the stage of world commerce would be the Pacific Ocean: "Asia is at our gates.... The period which shall witness a continuous chain of steam communication from the crowded marts of China to the port of San Francisco, and thence across the continent to the Atlantic, is at hand." San Francisco would be at the center of an "enlarged intercourse" between East and West that would "expand apace with the progress of civilization."[38] Fillmore's letter to the emperor of Japan, published in the *Sacramento Union* in May 1852, acknowledged the importance of California in the future commercial relations between Japan and the United States:

36. "The Japan Expedition," December 6, 1852.
37. "The Japan Expedition," January 11, 1853. Although these numbers were widely publicized (see, for example, "Commodore Perry's Squadron"), they were aspirational. Perry arrived in 1853 with only four ships; he returned in 1854 with nine (or ten) ships, some 1,600 men, and around 150 mounted cannon.
38. "Editorial," February 1, 1853.

You know that the United States of America now extend from sea to sea; that the great countries of Oregon and California are parts of the United States; and that from these countries, which are rich in gold and silver and precious stones, our steamers can reach the shore of your happy land in less than twenty days.[39]

Californians waited anxiously for news of Perry's progress. On March 5, 1853, the *Daily Alta* complained of the lack of news reaching its readers on the shores of the Pacific:

Our contiguity is such that we might also expect, on the breath of the wind that bears away our clippers, some tidings of the startling events that are now actually transpiring on the western shores of the waters that lave our coast.... We must await that day—and glorious will be the dawn!—that will bring to us steam communication with the shores of the Eastern Old World.[40]

More alarmingly, rumors circulated in May that the Perry mission, like the Aulick mission before it, had been recalled. The *Daily Alta* lamented:

Japan is still to remain a sealed book, after all. The squadron is to be recalled, Commodore Perry is to be taken out of his element, and hauled up on the dry dock. We are to have no port in Japan, no further knowledge of its people, no treaties for peace or good will, no protections for our wrecked seaman, no harbors for our Arctic whalers, nothing but mystery and non-intercourse, nothing but stripes and prisons, and death by starvation, bastinado and poison.... All our boasting about opening Japan is to prove only boast and gas, our ships are to return to rot, and the nation is to become the sneer-target of all civilization.

39. "American and Japanese Intercourse." This is an excerpt of the original letter to the emperor of Japan prepared in 1851 for Aulick. The letter was rewritten for the Perry expedition. The Aulick document is included in "Secretary of State to Commodore Aulick" correspondence dated June 10, 1851.

40. "Interesting Political Occurrences."

It issued a vehement attack on the apparent failure of the Washington government, led by newly elected Franklin Pierce (1804–1869), to grasp the importance of the Pacific:

> President Pierce could scarcely do a more unpopular thing than to recall the Japan Expedition. . . . The recall of this Expedition is against all our ideas of progress, is against the character of our people, is against the spirit of the age. . . . Japan spits in our face, and we are about to act like Sir Walter Raleigh, but with a far different result undoubtedly. Our great nation, having armed itself, put on helmet and shield, girded its sword and cocked its rifle, turns meekly round, takes out its bandana, wipes the spittle from its face, and the warlike General Jonathan becomes merely a militia corporal held up as the target for the scorn-balls of creation.[41]

The rumors of cancellation were denied later in the month, and more hopeful, though terse, information on the Japan expedition arrived. On June 10, a letter from Hong Kong dated April 24, 1853 reported that "Commodore Perry is now here with the *Mississippi* and *Saratoga* and intends to proceed *at once* to Shanghae [Shanghai] and Japan."[42] On July 11, Californians learned that Perry had arrived in Shanghai (on May 7) and was about to leave for Japan.[43] In September the *Daily Alta* reprinted dispatches from Washington indicating that Perry could expect a friendly reception due to the good offices of the Dutch.[44] At last, on October 18, the *Daily Alta* could inform its readers that Perry had arrived in Edo Bay, an event that had taken place on July 8. The editors were suddenly enthusiastic about the success of the mission:

41. "Editorial," May 9, 1853. For background information on the rumors, see "The Expedition to Japan," published in the *New York Times*, and its follow-up, "Naval Expedition to Japan." General Jonathan, or more commonly Brother Jonathan, was a common personification of America, often used in editorial cartoons and humor magazines to satirize boasts of American wealth and power.
42. "News from China."
43. "Late and Important from China."
44. "Editorial," September 20, 1853.

The favorable reception of Commodore Perry by the Imperial government of Japan is the most interesting event of the age, as indicative of an early abandonment of the exclusive policy so long and so tenaciously adhered to by that rich beautiful and remarkable country. There is no reasonable doubt of the speedy completion of a treaty of amity and commerce between the United States and Japan, which will constitute one of the of the important events of modern times—an event, the effects of which are almost incalculable. It will be the virtual creation of a new and mighty empire, whose influence among the nations of the earth will be felt in all after times.[45]

The newspaper expressed excitement at the prospect of a new and rich trade in the Pacific and satisfaction at the Washington government's policy: "It is probable that Commodore Perry is now in Japan prosecuting his important duties, and that the next intelligence from that quarter will be of his entire success. The spirit of the age is truly progressive, and it is progressing in the right direction, when it seeks its triumphs by the genial power of commerce and peace, instead of by fire and sword."[46]

Perry completed his first round of negotiations in Japan and left Edo Bay on July 17, 1853, intending to spend the winter months in Hong Kong. Informed, however, that the Russians intended to annex Japan and replace America as the maritime power of the world, he decided to return early.[47] He entered Edo Bay on February 13 with an enlarged American fleet. Negotiations began on March 8 and continued through the month; on March 31, the Treaty of Kanagawa was signed. Although it was not the commercial treaty that Perry had wanted, it opened two ports, Shimoda and Hakodate, to American ships in need of stores and repairs, allowed for the stationing of an American consul at Shimoda, and proclaimed the "lasting and sincere friendship" between Japan and the United States.

It took more than two months for news of the treaty to reach San Francisco. On June 8, 1854, the *Daily Alta* editorial claimed that

45. "Editorial," October 18, 1853.
46. "Editorial," October 18, 1853.
47. Hawks, *Narrative of the Expedition*, 78–79.

"through the skill and successful diplomacy of Commodore Perry," Japan had signed its first international treaty: "We may consider our treaty with her as a matter of the greatest, the most vital importance to our country, and to the commercial world at large. It is the entering wedge that will, ere long, open to us the interior wealth of these unknown lands, which shall pour their riches in our lap. As it is, a new field is opened to our commerce, and one in which California is especially interested."[48] Headlines for a news article on the same day read:[49]

NEWS FROM JAPAN.
ARRIVAL OF THE SLOOP OF WAR SARATOGA
AMERICAN TREATY WITH JAPAN!
COM. PERRY'S MISSION SUCCESSFUL.
PORTS OF JAPAN TO BE OPEN TO AMERICAN COMMERCE.

Although the article clarified that Perry had signed a treaty of amity and friendship rather than of commerce, Californians could dream of a bright future: "A Treaty has been made with Japan! The wedge has been entered, which will not fail to open that empire to the ultimate free residence, egress and ingress of Americans, and probably of all other commercial nations."[50] Already, an enterprising merchant, Silas E. Burrows (1794–1870), had set sail from San Francisco aboard the clipper *Lady Pierce* with a cargo of goods in anticipation of a favorable conclusion to the Japan expedition.[51] He arrived in Edo Bay fifteen days after Perry had left, thus earning the distinction of being the first private foreign merchant to operate in Japan.

The *Daily Alta* and other California newspapers followed Burrows's progress carefully and noted the warm speech of welcome he received from Japanese officials: "The high Japanese officers said the

48. "Editorial," June 8, 1854.
49. "News from Japan."
50. "News from Japan."
51. Born in Old Mystic, Connecticut, Burrows was a wealthy merchant and philanthropist who operated out of New York, San Francisco, and Hong Kong. His self-published account of his voyage to Japan is titled *The Lady Pierce at Japan* (n.d.).

visit was much more pleasing to them than that of Commodore Perry, who had with him 'too many big guns and fighting men.'"[52] The *San Joaquin Republican* published a lengthy transcription of the speech in which Japanese officials expressed their satisfaction with the visit:

> We understand what ships of war are, also what whaling ships and merchant ships are, but we never before heard, till you came here, of such a ship as yours—a private gentleman's pleasure ship—coming so far as you have, without any money-making business of trade, and only to see Japan—to become acquainted with us and bring home one of our shipwrecked people, the first that has returned to his country from America or foreign lands.[53]

The shipwrecked person referred to in the speech was a fisherman named Yūnosuke (1832–1900), known in English as Dee-yee-no-skee, who had been rescued at sea in 1853 and taken to San Francisco.[54] Burrows offered to return him to Japan aboard the *Lady Pierce,* predicting that he, more than Perry and his "big guns," would be able to open Japan: "He will be able to tell them, from his personal knowledge, what kind of people we are in California and coming from such a source, they will believe it. I . . . look to Dee-yee-no-skee as one who will do more to remove the former prejudices and seclusion adopted by the Japanese than all the Ministers and navies we can send to Japan."[55] Burrows also played his part: while in Edo Bay, he opened the *Lady Pierce* to crowds of visitors, who were "profusely regaled"

52. "The Lady Pierce's Visit to Japan." Other *Daily Alta* articles on the "peace expedition" by Burrows appeared on October 6 and October 30, 1854. See also Hildreth, *Japan as It Was and Is,* 534–36.

53. "Interesting from Japan."

54. Yūnosuke, who came from a fishing village north of the port of Niigata, was rescued by an American ship after drifting at sea for nearly seven months. The only survivor of a crew of thirteen, he was taken to San Francisco, where he met earlier Japanese castaways, including Heco and Denkichi. See Kawamoto, "Yūnosuke no koto."

55. "Interesting from Japan." A variation can be found in "Letter from China," October 30, 1854.

with refreshments, including fresh oysters and peaches followed by copious amounts of champagne.[56]

Conclusion: Learning from California

The gold rush years of the late 1840s into the 1850s often define the framework within which historians view California and its history. It is a framework that focuses on the place and people of California: a special place, with gold in the hills, drawing in people from outside, and rewarding hard work and good luck. But as Thomas J. Osborne argues, this inward-looking view of Californian history needs to be augmented with attention to the world beyond the state's borders.[57] Osborne quotes Walt Whitman's "Song of the Redwood Tree" (1874) to illustrate what he means by California's relationship with the Pacific world: "Ships coming in from the whole round world, and going out to the whole world, / To India and China and Australia and the thousand island paradises of the Pacific." To this we must add Japan as a destination of economic, political, and cultural interest, as vividly reported in the pages of the *Daily Alta* and other California newspapers.

What can we learn from the extraordinary interest Californians, and especially San Franciscans, had in the opening of Japan to international commerce in the nineteenth century? We learn, first, that action in the historic drama that played out in the 1850s was not confined to the political, economic, and intellectual elites of Japan and the United States. Nor were American participants confined to Washington, DC. Ordinary people, on both sides of the continental United States and on both sides of the Pacific, were important mediators between East and West. In addition to the well-known Nakahama Manjirō (1827–1898), who advised and interpreted for Tokugawa officials during their negotiations with Perry, castaways such as Heco, Sam Patch, Denkichi, and Dee-yee-no-skee, who appeared in California

56. "Letter from China," November 4, 1854.
57. Osborne, *Pacific Eldorado*, 20.

news sources, were early participants in the creation of new bonds of "peace and amity" between Japan and the United States.[58]

Similarly, in the opening of commercial relations, the efforts of Burrows, who sailed from San Francisco aboard the *Lady Pierce*, were closely reported in the local press. They preceded by as many as three years those of Townsend Harris (1804–1878), the first American consul to Japan and official trade negotiator. In securing his appointment, Harris benefited from his familiarity with China and Southeast Asia, gained as owner and captain of a clipper ship based in San Francisco. Arriving in that city in 1848, he, like Burrows, was a merchant looking west.[59] Their initiatives to engage in trans-Pacific commerce were mirrored in Japan. When Yokohama was opened in 1859, Shinohara Chūemon (1809–1891) and other merchants in the silk and tea trade set up shop in Japan's boomtown, where they mingled with Westerners and proved themselves equally eager to participate in the new global economic community.[60] A report in the *Daily Alta* described Yokohama on the day it opened: "We were all greatly surprised to find a new city spread before us—in fact, resembling a California town in early days."[61]

More broadly, the interest of Californians offers a view of the opening of Japan that goes beyond the standard story, of foreign threat from Perry's warships and Japan's response in opening the country to commerce, industrialization, and military buildup. The accounts of Japan in newspapers such as the *Daily Alta* show the opening of Japan as a pivotal event in world history, integrating local, national, and international histories. No one person (neither Perry nor Dee-yee-no-skee) and no one country (America, Russia, England, or the Netherlands) opened Japan. Nor was the opening a single dramatic event confined

58. See Manjiro, *Drifting toward the Southeast*; and Bernard, *The Life and Times of John Manjiro*.

59. See Griffis, *Townsend Harris*, 12, for Harris's decision to begin his life anew as a Pacific-based merchant: "Settling up his commercial affairs, he left New York, resolved to see Golden California and the Mysterious East."

60. On early Japanese merchants in Yokohama, see Partner, *The Merchant's Tale*; on early foreign merchants in Yokohama, see Notehelfer, *Japan through American Eyes*, and De Coningh, *A Pioneer in Yokohama*.

61. "Our Japanese Correspondence."

to one time and one place and of significance only to one country. Borrowing from Osborne's concept of a "Greater California" and his concern to identify links beyond borders, we can see the emergence of a "Greater Japan"; and we can attempt to construct a more coherent historical narrative of the interactions, including periods of endearment and estrangement, between Japan and its Pacific neighbors in the modern era.

CHAPTER TWO

Apocalypse Now: A Bottom-Up View of the Years 1853 to 1868

Soon after taking up a teaching position in Japan in 1981, I began to collect late Tokugawa satirical cartoons and other woodblock prints as historical documents. One of the first prints I obtained was Kaei nenkan yori kome sōba nedan narabi ni nendaiki kakinuki daishinpan *(A new publication of rice market prices and chronicle of selected events beginning with the Kaei era). In addition to political and military upheaval, it portrays economic and social stresses and the destructive power of natural disasters. Published in the middle of 1868, before it was clear that any semblance of stability would be restored, the print reflects the fears of ordinary people that the world as they knew it was about to end. It gives no evidence that the Meiji Restoration was the inevitable outcome of the international and domestic challenges confronted by government and people in the years after the arrival of Perry's expedition.*

Over the years, I used this print in my classes on modern Japanese history to offer another view of the events that led to the end of the shogunate and the establishment of Japan's new imperial government. This chapter is a revised version of a visual essay I prepared for the University of British Columbia's Meiji 150 website.[1] *In offering a glimpse into the way contemporaries understood the flow of events taking place in the years before what historians today call the Meiji Restoration, it attempts to recover a sense of the lived history of the late Tokugawa years.*

1. Steele, "Apocalypse Now"; Steele, "Bakumatsu mokushi roku."

CHAPTER TWO

In the middle of 1868, the Kintakudō publishing house in Osaka issued a woodblock print, consisting of illustrations and text, that chronicles the years leading to the collapse of the Tokugawa shogunate (fig. 2.1). Neither the artist nor the compiler is known, though the text reveals close familiarity with the life of Edo townspeople. The print is entitled *Kaei nenkan yori kome sōba nedan narabi ni nendaiki kakinuki daishinpan*, hereafter Kaei chronicle.[2] Visually, the print is reminiscent of a *sugoroku* board game. It is divided into sixteen panels, with the arrival of Commodore Matthew Perry in 1853 as the starting point and the defeat of the pro-Tokugawa Shōgitai forces at the Battle of Ueno Hill in 1868 as the goal.[3] Each panel includes a list of major happenings and rice price data for the year, with a pictorial depiction of one representative event.

The events depicted in the Kaei chronicle do not necessarily mirror those in modern historical accounts of the 1850s and 1860s. While some well-known incidents, such as the 1860 assassination of Ii Naosuke (1815–1860), a key shogunal advisor, and the 1863 procession of Shogun Iemochi (1846–1866) to Kyoto, are featured, equally prominent are less familiar military skirmishes, religious festivals, and a legion of natural and human disasters, including earthquakes, epidemics, floods, and fires. As in many other accounts of its time, one event follows another with no apparent rhyme or reason, no distinction between human and natural affairs, and no indication of cause or effect. The seemingly incoherent chronology recorded in both text and visual narrative suggests the difficulty for people at that time to make sense of an era disrupted by events beyond their control. At the same time, it reflects a somewhat ominous view of history—an apocalyptic confluence of natural, political, economic, and social disasters.

2. My copy of the Kaei chronicle is stored in the Hachiro Yuasa Memorial Museum, ICU. Other copies are in the William Sturgis Bigelow Collection, Museum of Fine Arts, Boston, and the Ishimoto Collection, University of Tokyo. The print measures 33 centimeters by 47.5 centimeters. The date of publication is assumed; it was probably issued before the change in era name from Keiō to Meiji at the end of the ninth month, 1868. On its contents, see Osatake, "Mikaeshi-e kaidai."

3. On *sugoroku* board games, see Salter, *Japanese Popular Prints*, 164–82; and Kanaya, "Reading Edo Urban Space."

As a cartography of time, the Kaei chronicle thus offers a glimpse into the way contemporary people understood and remembered the flow of events that led to what historians today call the Meiji Restoration.[4] It is especially interesting because it was compiled before the imperial side had succeeded in its attempt to create a new national government. The testimony of images adds depth to our understanding of these dramatic years. As Peter Burke notes, the printing of images made it possible to illustrate current events while the memory of those events was still fresh.[5]

This chapter examines the events in the Kaei chronicle organized by category—politics, economics, religious festivities, and disasters. Special attention is given to the representative illustration that appears in each panel and to descriptions of the same event that appear in other contemporary texts. The conclusion discusses the Kaei chronicle as a visual narrative that portrays the challenges confronting ordinary Japanese people in the closing years of the Tokugawa shogunate and suggests new perspectives on its collapse.

A Different Political Narrative

The starting point of the Kaei chronicle is the arrival of Perry and his black ships in Uraga in the sixth month of 1853. At full force, the expedition consisted of nine vessels, some sixteen hundred men and around 150 mounted cannon (chapter 1). The foreign paddle-wheel steamship illustrated in the upper right-hand corner of the print does not appear menacing (fig. 2.2). There is no billowing black smoke, no visible cannon, and no indication of national origin. Very likely it was drawn in imitation of the many black ship broadsheets that appeared for sale on the streets of Edo shortly after Perry's arrival. Edo commoners were naturally curious to learn about these foreigners who had suddenly appeared within sight of their city. Over five hundred monochrome woodblock prints known as *kawaraban* appeared on the

4. On chronologies and graphic representations of time, see D. Rosenberg and Grafton, *Cartographies of Time*.

5. Burke, *Eyewitnessing*, 141.

2.1. Anonymous, *Kaei nenkan yori kome sōba nedan narabi ni nendaiki kakinuki daishinpan* (A new publication of rice market prices and chronicle of selected events beginning with the Kaei era), n.d., but perhaps mid-1868. Author's collection.

嘉永年間より米相場直段

嘉永六癸丑年より
・米捌場
・御蔵米石代金
百文五匁

嘉永六癸丑年
・一升
・七斗一升
・尼十九匁
・米捌場

安政元甲寅年
小田原大地しん
家っぶれ
めつ浦海へ
きへる

同二乙卯年
・一升
・七斗八升
・一升二合
十月二日
江戸中大

同二乙卯年
・八斗八升
・大阪本漆川に
つなみ三人家に
つるぎ
一俵五匁

同六己未年
・百八十俵
・二升三舛
・一合七夕
十月八日より
えんえん
横浜まで
ゑどぎさき

元治元甲子年
・百八十俵
・二升三舛
・一合二夕
七月
十九日
京都大火
人家多く焼

万延元庚申年
さくらの木

文久元辛酉年
・百六十俵
・三升五舛
・二合二夕
これより
せん人山
上のたひ

慶應元乙丑年
・金花山不
・一升七合
・二合二夕
金花山

同三丁卯年
・百二十俵
・八升三合
・一合一夕
市中老人ら
立たぬ
子供らをつれて
大坂千人

同四戊辰年
・三百六十俵
・一升
・一合二夕
春天ちらちら
大さきあれて
ありがれ
大川まで
そりける人家多く

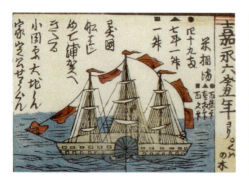
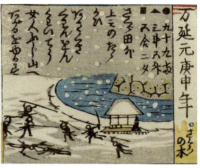

2.2. Illustration for 1853 (Kaei 6 Kichō): Foreign ships arrive in Uraga (inside Edo Bay) for the first time.

2.3. Illustration for 1860 (Man'en 1 Kōshin): Sakura no ki: Battle at the Sakurada Gate on the 3rd day of the third month (depicting the assassination of Ii Naosuke).

streets of Edo for sale during this time. Although filled with inaccurate information, these crude broadsheets gave commoners their first detailed view of the world outside Japan. They also served as a stimulus for popular national consciousness.[6]

Although Perry's visit was thus a national event befitting the beginning of a new era, it does not form the central narrative of the Kaei chronicle. The death of Shogun Iesada (1824–1858) is listed among the events for 1858, but it is the cholera epidemic that swept through Japan in the same year that is illustrated. Similarly, no reference is made to the messy succession dispute that followed Iesada's death in 1858 or to the reign of terror, the so-called Ansei purge, conducted by the new shogun's chief senior councilor Ii Naosuke in 1859. But Ii's dramatic assassination, on the 3rd day of the third month, is depicted as the representative event of 1860. Snow falls on the banks of the moat surrounding Edo Castle near the Sakurada Gate as a group of seventeen men from Mito domain and one from Satsuma cut down the chief councilor, labeled by his enemies as a tyrant (fig. 2.3).

6. Steele, "Goemon's New World View"; Dower, "Black Ships & Samurai." See also Ono Hideo, *Kawaraban monogatari*; Nakayama, *Edo-Meiji kawaraban senshū*; Kinoshita and Yoshimi, *Nyūsu no tanjō*; Linhart, "Kawaraban." Digital versions of late Tokugawa *kawaraban* can be accessed in the Ono Hideo Collection.

APOCALYPSE NOW 35

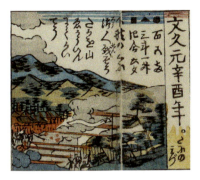 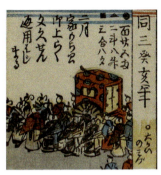

2.4. Illustration for 1861 (Bunkyū 1 *Shin'yū*): Outbreak of fighting by ronin insurgents in Shimotsuke Province.

2.5. Illustration for 1863 (Bunkyū 3 *Kigai*): Shogun Iemochi travels to Kyoto in the second month.

Another major event of 1860, the Tokugawa mission to the United States to sign the Treaty of Amity and Friendship, is not included in the Kaei chronicle. On the other hand, an outbreak of hostilities in Shimotsuke (present-day Tochigi Prefecture) in the spring of 1861 is depicted as the major event for that year (fig. 2.4). In this incident, absent from most present-day historical accounts but reported by contemporaries, a group of pro-imperial anti-foreign ronin from Mito domain demanded money from wealthy merchants and farmers to support their cause.[7] The illustration shows the hard-fought and bloody skirmish that took place at the foot of Mt. Tsukuba.

The next political event highlighted in the print is the great procession that delivered Shogun Iemochi to Kyoto in the spring of 1863 (fig. 2.5). The representative image shows the shogun being pulled in a wheeled carriage reserved for the nobility. Intended to awe the court, this first shogunal visit to Kyoto in 229 years instead weakened Tokugawa prestige. The shogun was forced to promise the impossible: to expel the barbarians. The center of political power had moved to Kyoto.

Kyoto is the stage for the next political event illustrated in the Kaei chronicle, the Forbidden Gate Incident of 1864. Despite the shogun's presence, Kyoto had become a hotbed of pro-imperial, anti-foreign

7. Contemporaneous accounts include the *Kinsei shiraku*, which was translated into English in 1873. See K. Yamaguchi, *Kinsé Shiriaku*, 17.

activists. Although Tokugawa forces managed to expel them, a group of pro-imperial radicals from the southwestern domain of Chōshū attempted to retake the city, pushing Japan one step further in the direction of civil war. The *Genji yume monogatari*, compiled that same year, gives an eyewitness account of the battle and resulting fire:

> [Soldiers were] brandishing swords and spears, rushed hither and thither and showers of bullets flew overhead. . . . Some of the townspeople had fled, throwing down their things in the street. Lying prostrate here and there were men who had fallen down wounded, and the roads were full of headless corpses. . . . The sky was lit up by the flames as if it were broad daylight, and the roar of the cannon never ceased. . . . Palaces of the great and dwellings of the common people came tumbling down with a sound of general ruin, like the falling of hundreds and thousands of thunderbolts. Heaven and earth trembled and quaked, until the end of the world of seemed to be at hand.[8]

The illustration in the Kaei chronicle seems to depict this very scene. Kyoto, with Mt. Daimonji in the background, is engulfed in the flames of war, which barely spared the imperial palace (fig. 2.6).

The Kaei chronicle makes no mention of the deepening civil war between Tokugawa supporters and its enemies, led by Chōshū domain. The first Tokugawa campaign against Chōshū was launched in late summer 1864, soon after the Forbidden Gate Incident; a second expedition began in the spring of the next year. The death of Shogun Iemochi in the seventh month of 1866 is not recorded, nor is the installation of his successor, Hitotsubashi (Tokugawa) Yoshinobu (1837–1913), destined to be the last Tokugawa shogun. Also unremarked is the passing of Emperor Kōmei (1831–1867); he was replaced in early 1867 by the young prince Mutsuhito, the future Emperor Meiji (1852–1912). Instead, the Kaei chronicle focuses on the breakdown of law and order in Edo and on social and economic dislocations. The list of events for 1865, for example, notes that ronin insurgents had taken up residence in a vacant daimyo mansion in Honjo, on the east bank of the Sumida

8. Baba, *Japan 1853–1864*, 172, 187, 239. The original text was compiled in 1864 and has been reprinted as Baba, *Genji yume monogatari*.

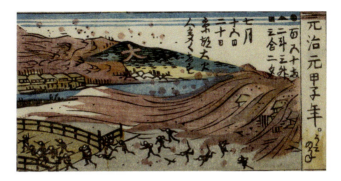

2.6. Illustration for 1864 (Ganji 1 *Kasshi*): Great fire in Kyoto between the 15th day and the 20th day of the seventh month; many people die.

River, just north of Ryōgoku Bridge. There, two areas were reserved for the public display of severed heads—primarily those of captured pro-imperial provocateurs.[9] The illustration for 1867 shows a squad of armed police patrolling the streets of Edo (fig. 2.7). These peacekeeping forces may not have been effective: one inflammatory poster criticized them as inept: "None of the rioters were arrested, only the spectators were caught."[10]

Two major events of late 1867 that define what we now call the Meiji Restoration are not included in the Kaei chronicle: the decision of the last shogun, Yoshinobu, in the ninth month to return governing authority to the emperor (*taisei hōkan*) and the coup d'état in the twelfth, in which anti-Tokugawa troops seized control of the palace in Kyoto, abolished the office of shogun, and declared the restoration of imperial rule (*ōsei fukkō*). Instead, the final panel, for 1868, presents a bottom-up view of the collapse of Tokugawa rule. It opens with the report that nearly all the daimyo in Edo, suddenly freed of any obligation to remain in the city, returned to their domains, taking with

9. According to Botsman, *Punishment and Power*, 20, there were 123 severed heads put on display in Edo between 1862 and 1865.

10. Minami, *Ishin zen'ya*, 155–57.

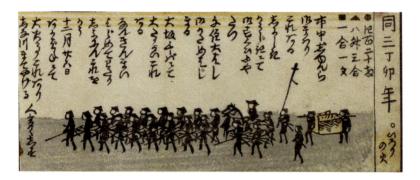

2.7. Illustration for 1867 (Keiō 3 *Teibō*): Police patrol the streets of Edo.

them their family members and retainers.[11] The next entry suggests the sense of mounting crisis that confronted Edo commoners as the imperial army advanced on their city: "In the third month, people riot and Edo in great confusion (see chapter 4)." It echoes the sentiment of Katsu Kaishū, the Tokugawa official charged with maintaining order in Edo, who wrote in his diary: "Edo is in great confusion. There are many rumors. The truth of the morning is false by night. Will the imperial army halt at Kuwana? Will it advance on Sunpu? Will it come through the Hakone Pass? As a result, the people are angry and upset. They run about blindly; the situation is like a boiling cauldron."[12]

In the fourth month of 1868, representatives of the Tokugawa family handed over Edo Castle as a result of negotiations conducted between Katsu and Saigō Takamori, commander of the imperial army. The Kaei chronicle does not mention this event. It does, however, report news of fighting in nearby areas to the east of Edo. Rather than accept surrender, many Tokugawa troops disobeyed orders and fled the city, and engaged the imperial army in battle. According to a contemporary observer, the Tokugawa men "formed themselves into bodies of guerrillas and harassed the troops of the Mikado throughout the country around Yedo."[13]

11. According to Smith, "The Edo-Tokyo Transition," 347, Edo's population declined by some three hundred thousand in 1868.
12. *Katsu Kaishū zenshū*, 19:25.
13. Dispatch from Harry S. Parkes, June 13, 1863, no. 139.

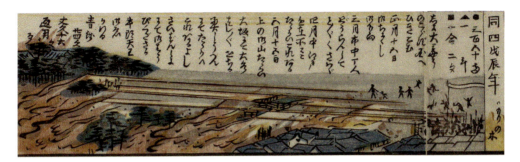

2.8. Illustration for 1868 (Keiō 4 *Boshin*): On the 15th day of the fifth month, the battle of Ueno Hill.

Even after the surrender of Edo Castle, a separate group of Tokugawa loyalists, the Shōgitai, remained in the city, with their headquarters at Kan'eiji temple in Ueno, determined to fight to the bitter end. They were defeated in a bloody battle that took place on the 15th day of the fifth month.[14] This battle and the resulting fire are, for the visual chronology, the defining image for 1868 and its largest panel (fig. 2.8). Contemporary viewers of the print could easily imagine the power of the cannon and rifles, fired across Shinobazu Pond at targets on Ueno Hill, reducing the Shōgitai's stronghold to ashes and setting the northeastern section of Edo ablaze. A newspaper account of the day mirrors this scene of destruction: "Ah! How sad and deplorable is this day! The most sacred spot in all Kantō has been, in an instant, reduced to flames. Fleeing from the disaster, the aged, the young, and the womenfolk of the city wander aimlessly on the roads, filling them with cries of pity. The working of heaven seems to know no right or wrong."[15]

A new city government, the Saibansho, was set up after the battle; imperial troops patrolled the streets to restore law and order. The Kaei chronicle states that rewards were offered for virtuous behavior. Controlling Edo did not, however, guarantee control over Japan. Just before the battle on Ueno Hill, some twenty-five northeastern domains joined an alliance opposing the new government. The ongoing civil

14. Steele, "The Rise and Fall of the Shōgitai."
15. *Soyofuku kaze*, no. 7, 408.

war is noted with this entry: "Reports of fighting in northern Japan." The viewers of the Kaei chronicle are offered no hope for the future.

In the Shadow of the Great Inflation

Although the years following Perry's arrival saw an expansion in trade and overall economic growth, they were marked by dislocations in Tokugawa and domain government finances and violent upheaval in the Japanese economy.[16] Military measures to counter the foreign threat added to fiscal burdens; even more devastatingly, the 1859 opening of foreign trade under Western rules led to a substantial outflow of gold coins, in what has been termed the Yokohama Gold Rush, at unfavorable exchange rates.[17] To address its monetary problems, the Tokugawa government resorted to issuing new currency and devaluing existing currency, strategies it had traditionally employed to increase its revenue.[18] In 1860, it conducted a major debasement of gold currency. The result was a sharp acceleration of the inflation that had been under way since around 1820, especially in food grains, led by rice, but also including daily necessities such as salt, miso, soy sauce, and sake.[19] Exacerbated by poor harvests and the enormously expensive shogunal expeditions to subdue Chōshū in 1865 and 1866 (chapter 3), inflation reached a crisis point in 1866, the single most inflationary year.[20] By the end of 1867, general impoverishment and widespread social and economic unrest intensified resentment against the Tokugawa shogunate and contributed to its demise.

This narrative of money, prices, and hardship forms the background for the events recorded in the Kaei chronicle. Heading the text in each panel are rice price data, with a key to the data displayed in the first panel (fig. 2.2):

16. Saitō, *The Economic History*, 1–8.
17. Bytheway and Chaiklin, "Reconsidering the Yokohama 'Gold Rush.'"
18. Ohkura and Shimbo, "The Tokugawa Monetary Policy," 241–64.
19. Minami, *Ishin zen'ya*, 91.
20. Metzler, "Japan and the World Conjuncture," 26–34.

- Price of 100 *hyō* (bales) of rice in *ryō* (gold coins)
- ▲ Amount of rice that can be purchased with 1 *ryō*
- ■ Amount of rice that can be purchased for 100 *mon* (copper coins)

The message of the data, represented in figure 2.9, is clear. The market price of rice rose dramatically, from 49 *ryō* for 100 *hyō* (or around 600 kilograms) in 1853 to 420 *ryō* in 1867, declining somewhat to 350 *ryō* in 1868. Conversely, the purchasing power of copper *mon*, the currency of ordinary people, experienced a precipitous decline: in 1853, 100 *mon* could buy 10 *gō* (around 1.5 kilograms) of rice, but in 1867, the same 100 *mon* could buy a mere 1.1 *gō*, improving only slightly in the following year. The story of skyrocketing prices, currency devaluations, and increasing poverty reflects the increasing economic difficulties of ordinary people.

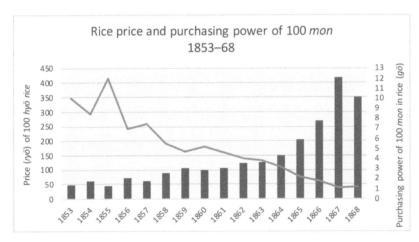

2.9. Rice price and downward-trending purchasing power of 100 *mon*, 1853–68. Source: Ka'ei nenkan yori kome sōba nedan narabi ni nendaiki kakinuki daishinpan.

The Kaei chronicle includes several events relating to economic issues during the period 1853 to 1868. Rather than fiscal policy and problems relating to foreign trade, the focus is on matters related to the livelihood of everyday people, beginning with money. Among the events for 1854, it lists the circulation of a new Isshu-gin, a silver coin. The coin, inferior in quality, was issued by the Tokugawa government

specifically to raise cash for coastal defense fortresses, or *daiba*, built to protect Edo from attack by sea following Perry's arrival.[21] It had a copper exchange value of 250 *mon* and was popularly known as Odaiba-gin because it was used as pay for one day's work on the fortresses. Its issue was the first in a series of currency manipulations that, by increasing supply, added to inflation.

Passing over the crucial gold debasement of 1860, the Kaei chronicle highlights another adjustment to the copper currency in 1863: the circulation of a new Bunkyū-sen copper coin having a nominal value of 4 *mon*. Designed to help pay for Shogun Iemochi's historic procession to Kyoto, this measure infused some 3.38 billion coins into the economy. In 1865, the chronology notes that the Bunkyū-sen had begun circulating at 8 *mon*; the Aosen, an older brass coin, had its nominal value raised from 4 to 12 *mon*. The effects on consumers were recorded in an Osaka ditty:

> It's beyond all understanding.
> Four *mon* of copper coin is now worth twelve.
> And yet everything costs more.
> How stupid the officials are![22]

The last panel, for 1868, states simply that the Bunkyū-sen coins had begun circulating as 16 *mon*, reflecting further devaluation of the currency used by ordinary people.

The Kaei chronicle reports the opening of Yokohama to foreign trade in 1859, but it offers no details on the emerging world of international commerce. Attention is focused on disruption and hardship. Among the events recorded for 1859 is the distribution of relief rice in Edo; this was probably a response to a cholera epidemic that ravaged the city that year. Following the reports of successive currency devaluations, five of the six entries for 1866, the peak year of what has been called the Great Inflation, describe a growing social crisis:[23]

21. Ohkura and Shimbo, "The Tokugawa Monetary Policy," 241–64.
22. Quoted in Adachi, *Bakumatsu Meiji bungaku*, 16.
23. Frost, *The Bakumatsu Currency Crisis*, 35–45.

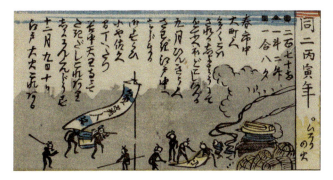

2.10. Illustration for 1866 (Keiō 2 *Heiin*): In Edo, poor camps established to alleviate poverty and hunger.

- In spring, many establishments of rich merchants are wrecked.
- Some people provide alms to help their neighbors.
- In the ninth month, rioting by impoverished people begins in Edo.
- A relief station is set up in Sakuma-chō [in the Kanda district].
- Cooked rice distributed at Yanaka Tennōji temple; crowds of people gather.
- On the 9th through the 10th day of the twelfth month, there was a great fire in Edo.

The rice price listed for the year is 270 *ryō* for 100 *hyō*; this represents an increase from 150 *ryō* in 1864 and 205 *ryō* in 1865. The representative image for 1866 depicts the rice distribution center set up in Sakuma in the Kanda district, a large banner summoning the destitute (fig. 2.10). A rice cauldron is steaming. The background depicts an empty space in foreboding gray tones in what was normally a bustling economic and industrial hub.

Contemporary reports confirm this grim image. Successive poor harvests caused in some years by drought, in other years by cold, typhoons, flooding, or insect damage, caused food shortages during the 1860s. Inflammatory posters blamed the Tokugawa government for failing to come to the aid of the people: "Because of high prices, goods are in short supply, and able officials are All Sold Out."[24] As prices

24. Minami, *Ishin zen'ya*, 91.

soared, over one hundred incidents of rioting and property destruction (*uchikowashi*) broke out across Japan, including the urban centers of Osaka and Edo.[25]

In 1867, despite a better harvest, the economic news was no better. According to the Kaei chronicle, the cost of 100 *hyō* of rice rose to 420 *ryō*. Events listed for the year were dire—"Commodity prices skyrocket; relief stations set up"—and barely imaginable—"Foreign rice sold for the first time; people buy it." Established ways of life were in danger.

Religion to the Rescue

The late Tokugawa years witnessed an explosion of millennial hopes and dreams among people in Japan.[26] New religions flourished, including Tenrikyō (founded in 1838), Kurozumikyō (founded in 1846), and Konkōkyō (founded in 1859), along with cults devoted to the worship of Miroku, Mt. Fuji, and the demonic Shōmen Kongō, a blue-faced deity with many arms associated with the Kōshin cult.[27] Shunning established sects of Buddhism and Shinto, the new religions promised healing, salvation, and renewal.[28] Some also promised gender equality: among events listed for 1860, the Kaei chronicle mentions that "women are allowed to climb Mt. Fuji." The urge to construct a new world animated the rural and urban protests documented by the Kaei chronicle for the 1860s. World renewal (*yonaoshi*) was the watchword of ordinary people who desperately sought a means to mend an imperfect world.

The Kaei chronicle pays scant attention to the informal religious concepts and practices associated with popular protest. Nor does it mention the millenarian remaking of Japan envisioned by loyalist samurai who sought an emperor-centered "world renewal" designed to wreck the Tokugawa regime and create a new imperial order. Its interest is in the festive religious events known as *kaichō*, the public display in

25. Metzler, "Japan and the World Conjuncture."
26. G. Wilson, *Patriots and Redeemers in Japan*, 82.
27. I. Hori, *Folk Religion in Japan*, especially 66–68.
28. Hardacre, "Conflict between Shugendō."

temples and shrines of religious objects usually hidden from sight.[29] Some institutions held periodic displays of their own treasures, but it was more common, especially for Edo temples, to display another temple's icons or other objects infused with spiritual power. In Edo, Ekōin, a temple on the eastern side of Ryōgoku Bridge known for its association with sumo and the beloved Asakusa Sensōji, was famous for such events, which often lasted around sixty days. Carnival-like sideshows in the form of peep shows, gaming booths, and outdoor kabuki performances were held in conjunction with the display and veneration of religious items, attracting crowds of pilgrims as well as people in search of cheap entertainment.[30] These events were often held simultaneously across Edo and attracted multitudes year after year. In 1857, for example, aside from the *kaichō* held at Ekōin, there were twelve other competing displays of religious treasures. On the one hand, these festivities, especially in tandem with various secular attractions, contained much entertainment value as well as a moment of liberation from the constraints of society.[31] Moreover, in the context of the late Tokugawa years, *kaichō* offered temporary relief and escape from the shadow of dire economic and political realities. Equally important, however, was the role of deep-felt religious sentiment in impelling people to flock to these mega temple events. As Barbara Ambros notes, "For an Edo-period audience, religious sincerity and curious attraction to sideshows even were not necessarily mutually exclusive."[32]

Of the many *kaichō* events, the Kaei chronicle mentions only five, all held in Edo and lasting for sixty days.[33] The *kaichō* held in 1857 and 1865 receive special attention, each illustrated as the defining event of its year. The illustration for the 1857 *kaichō* at Ekōin (fig. 2.11) shows crowds crossing Ryōgoku Bridge, which stretches between the carnival grounds on the eastern side of the Sumida River (the makeshift booths

29. Ambros, "The Display of Hidden Treasures"; Hur, *Prayer and Play*; Hiruma, *Edo no kaichō*.
30. Markus, "The Carnival of Edo."
31. Hur, *Prayer and Play*, 220.
32. Ambros, "The Display of Hidden Treasures," 4.
33. The *Bukō nenpyō*, compiled by Edo townsperson Saitō Gesshin (1804–1878), includes details on each of the *kaichō* noted in the Kaei chronicle. See Imai, *Teihon Bukō nenpyō*, vol. 3.

2.11. Illustration for 1857 (Ansei 4 *Teishi*): *Kaichō* of the Shibayama Niō held at Ekōin temple at Ryōgoku; crowds of people throng to the event.

can be seen in the foreground) and the sacred zone on the western side. The display items were treasures from Shibayama Niōson temple, located in present-day Chiba Prefecture, just east of Narita; they included an eleven-faced Kannon statue and two muscular Niō figures, temple guardians reputed to have been brought from India. According to the *Bukō nenpyō*, the Niō statues arrived at Ekōin in alcoves borne on the shoulders of sumo wrestlers.[34] Amulets from Shibayama Niōson bearing the image of the two Niō and promising protection against fires and theft were popular among Edo commoners.

The Kaei chronicle's illustration for 1865 (fig. 2.12) highlights a *kaichō*, also held at Ekōin, that featured a collection of religious objects from the sacred island of Kinkazan, a major pilgrimage destination located off Japan's eastern coast near Ishinomaki in present-day Miyagi Prefecture. Temporary entertainment booths, the equivalent of circus tents, are shown at the lower left of the illustration, and people make their way across Ryōgoku Bridge to Ekōin in the distance. Poles hold rows of lanterns aloft; banners proclaim the exhibition of treasures, including the statue of Benzaiten from faraway Kinkazan, while others advertise an archery shooting gallery and the display of a giant elephant.[35] The popularity of this extravaganza is emphasized by the size of the crowd, depicted as a gray mass, the bare outlines of heads crowded so tightly as to obscure any sense of individual humanity.

34. Imai, *Teihon Bukō nenpyō*, 3:93.
35. Markus, "The Carnival of Edo," 509.

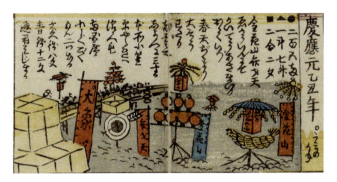

2.12. Illustration for 1865 (Keiō 1 *Itchū*): *Kaichō* of the Kinkazan Benzaiten held at Ekōin; many people gather from early in the day.

The carved wooden image of the eight-armed Benzaiten, the main object of worship at Kinkazan's Daikinji temple, was reputed to possess extraordinary powers, especially of healing and moneymaking. The *Bukō nenpyō* reports that men and women, young and old, lined up from early morning to gaze upon the goddess of good fortune and offer their prayers. People joined in wild dancing and jostled to obtain special amulets that promised salvation, if not in this world, then in the next. Their chants included references to Miroku, the Buddha of the future, who was expected to appear at the end of the world.[36] The crowds making their way to Ekōin were in search of fun and games, but given the unsettling times, they were equally in search of the salvation, healing, and renewal. Such millenarian aspirations help to explain why the Kaei chronicle and other contemporary accounts give particular attention to *kaichō* and the opportunities they offered for engagement with powerful spiritual forces.

Disaster Stories

Natural and human disasters were integral to the lives of Japanese people during the latter days of the Tokugawa shogunate. Contemporary observers stood in awe of the power of nature, listing episodes,

36. Miyata, *Miroku shinkō no kenkyū*; Miyata, *Shūmatsukan no minzokugaku*.

one after another, of earthquakes, floods, epidemics, and fires. Disasters were repeating events, requiring practical preparation and the marshalling of spiritual protection, and, as such, were the subject of record and memory.[37] The Kaei chronicle gives special attention to disasters. Of the fifty-one events it lists between 1853 and 1866, at least twelve relate to disasters and five are illustrated as the representative event of their year.

The earliest disaster mentioned was in 1853. In the opening panel illustrating Perry's historic arrival in Japan is the simple entry "Large earthquake in Odawara." The quake, which had a magnitude of 6.7–7.0 (on the Moment Magnitude Scale), did much to destroy Odawara Castle, the power base of the Tokugawa-related Ōkubo family.[38] Coming just months before the arrival of the black ships and the death of Shogun Ieyoshi (1793–1853), it was seen as an opening volley in a series of assaults on the established order of heaven and earth. A broadsheet published that year noted: "Untoward events taking place in heaven and earth resulted from a clash of yin and yang forces that produced thunder and rain in the skies and an earthquake in the ground."[39]

The Kaei chronicle makes no mention of Perry's return visit in the first month of 1854 or the negotiations that led to signing of the Treaty of Kanagawa in the third month. Rather, the defining event for 1854 is an earthquake and tsunami that occurred in the eleventh month: "Tidal wave hits Osaka at the mouth of the Kizu River; houses swept away, and bridges destroyed" (fig. 2.13). It was the culmination of a series of natural disasters that had struck Japan that year. A contemporary account of the Osaka disaster matches the illustration in the Kaei chronicle:

On the 4th of the eleventh month, between seven and nine o'clock in the morning, a violent earthquake occurred throughout the country, the effects of which were felt most severely at Osaka; many houses were overthrown, and a huge wave ran up the three mouths of the Yodogawa,

37. On the genre of disaster literature, see Köhn, "Between Fiction and Non-fiction."
38. Smits, *Seismic Japan*, 14.
39. Kinoshita and Yoshimi, *Nyūsu no tanjō*, 31.

 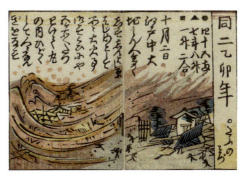

2.13. Illustration for 1854 (Ansei 1 *Kōin*): Tidal wave hits Osaka at the mouth of the Kizu River; houses swept away, and bridges destroyed.

2.14. Illustration for 1855 (Ansei 2 *Itsubō*): Great earthquake strikes Edo on the 2nd day of the tenth month. Many people killed. Several sections of the city, including Shin-Yoshiwara, destroyed by fire. Five rescue centers set up. Marunouchi particularly hard hit; many people suffer.

carrying large junks with it whose masts struck the bridges and carried them away. One hundred fifty junks of different size were destroyed. More people died by drowning than it was possible to ascertain.[40]

On the 27th day of the eleventh month, 1854, the era name was changed to Ansei, or "peaceful rule," reflecting a hope that stability would be restored. However, the events of 1855 betrayed this hope. For the eighth month alone, the *Genji yume monogatari* records floods in the Kansai region, a severe earthquake in the Tōhoku region, a great storm around Kyoto, and a massive tidal wave that hit the area around Nagoya.[41] These disasters were but a prelude to the great Ansei Edo Earthquake that struck the shogun's city in the tenth month. The Kaei chronicle's compilers chose it as the defining and only event for the year 1855 (fig. 2.14). People's lives were literally shaken. Dominating the top row of the print is a depiction of the terrible fire that followed

40. Baba, *Genji Yume Monogatari*, 10–11. See also Smits, "Warding off Calamity," 14–15.

41. Baba, *Genji Yume Monogatari*, 11.

2.15. Illustration for 1856 (Ansei 3 *Heishin*): Great storm hits the Fukagawa area [in Edo] on the 25th day of the eighth month; large floods wash many houses away.

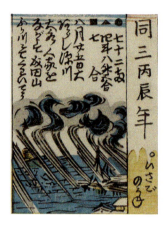

and was largely responsible for an estimated eight to ten thousand causalities and the destruction of over fourteen thousand buildings.

It resembles the scenes of destruction published in contemporary earthquake-related broadsheets.[42] Many of these so-called "catfish prints" (*namazu-e*) go beyond descriptions of physical damage to inquire into the thoughts and fears of earthquake victims. Some show people consoling the spirits of the dead; others suggest that the earthquake is benefiting the working poor and weakening the political and economic elite. In this sense, the Ansei earthquake can be seen as an instance of redistribution of wealth and a harbinger of world renewal.

The years following the earthquake offered little relief to Edo commoners. In 1856, for the third successive year, the Kaei chronicle's event of the year is another calamity, this time a flood. The illustration shows a massive rainstorm and the text reads: "Great storm hits the Fukagawa area [in Edo] on the 25th day of the eighth month; large floods wash many houses away" (fig. 2.15). The *Bukō nenpyō* reported that the rain and accompanying freak winds caused even more damage than the Ansei earthquake: areas along the seacoast and near the Sumida River flooded; the Eitaibashi bridge was washed away; and

42. Ouwehand, *Namazu-e and Their Themes*; Smits, "Shaking up Japan"; Smits, "The Ansei Earthquake and Catfish Prints"; Kitahara, *Jishin no shakaishi*. See also "Disaster Prints."

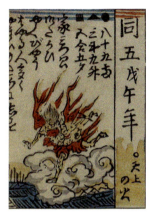

2.16. Illustration for 1858 (Ansei 5 *Bōgo*): The [cholera] epidemic spreads; many people die of the sickness.

temple buildings at Nishi-Honganji and Reiganji collapsed.[43] The *Genji yume monogatari* offered further insight: "These constantly occurring signs and wonders were attributed by the people to the anger of the gods at the continual pollution of our country by the visits of the outer barbarians."[44]

Following a one-year respite from untoward "signs and wonders," the year 1858 brought a cholera epidemic of unprecedented proportions to Japan. Rumored to have been introduced by American ships calling at Nagasaki, it spread to Kyoto and then along the Tōkaidō, reaching Edo in the seventh month, just after Tokugawa officials had signed the Treaty of Amity and Commerce in Edo Bay.[45] The cholera epidemic was at its worst in the eighth month and then gradually receded. For the compilers of the Kaei chronicle, disaster dominated for yet another year. The representative image for 1858 shows a fiery demon descending upon the city. Such evil spirits had long been associated with the arrival of other deadly scourges, such as smallpox and measles (fig. 2.16).[46] In Edo an estimated twenty to thirty thousand people died, including the great ukiyo-e artist Utagawa Hiroshige (1797–1858) and, more ominously, the thirty-five-year-old shogun,

43. Imai, *Teihon Bukō nenpyō*, 3:85.
44. Baba, *Genji Yume Monogatari*, 14.
45. Imai, *Teihon Bukō nenpyō*, 3:103–6; Gramlich-Oka, "The Body Economic."
46. Yoshida, *Edo no masukomi "kawaraban,"* 179–237.

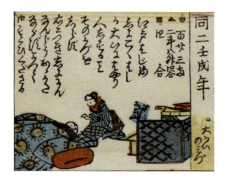

2.17. Illustration for 1862 (Bunkyū 2 Jinjutsu): Large-scale outbreak of measles in Edo and throughout Japan; number of deaths unknown.

2.18. Illustration for 1859 (Ansei 6 Kibi): In the tenth month, the main keep of Edo Castle goes up in flames.

Iesada. With coffins piled up and bodies left unattended for days, it is not surprising that a contemporary compilation of broadsheets and leaflets was entitled *Matsudai banashi hakiyose zōshi* (Swept-up stories of the latter days).[47]

The repeated outbreaks of deadly epidemics exacerbated a shared sense of distress and vulnerability. The Kaei chronicle's cover story for 1862 is the outbreak of a deadly measles epidemic (fig. 2.17). Following scattered incidents every year since 1859, the disease spread throughout Japan in the summer of 1862. According to the *Bukō nenpyō*, measles, like cholera, entered Japan from overseas in the second month, spread to Osaka and Kyoto by the fourth month, and arrived in Edo by the seventh. Affecting more than half of the population; it was the most devastating measles epidemic in Japanese history.[48] In Edo, the death toll stood at an estimated 20,952 persons, matching at least that of the cholera epidemic of 1858.[49] The illustration in the Kaei chronicle shows a concerned mother watching over a child, who appears to be at death's door.

The popular saying "Fires and fistfights are the flowers of Edo" captures the ubiquity of fires and firefighting. More than 1,800 fires,

47. Kanagaki, *Ansei korori ryūkōki*; Rendai, *Matsudai banashi hakiyose zōshi*.
48. Jannetta, *Epidemics and Mortality*, 124–39; Rotermund, "Illness Illustrated."
49. Imai, *Teihon Bukō nenpyō*, 3:143–45; Minami, *Ishin zen'ya*, 83–86.

large and small, struck the city and its wooden buildings during the 267 years of the Tokugawa period; contemporary sources reference more than five hundred fires during the years 1853 to 1868.[50] The Kaei chronicle takes note of five, including the fire that resulted from the Ansei earthquake of 1855 and the conflagration that accompanied the Forbidden Gate Incident in Kyoto in 1864.

Fire was the illustrated event for 1859. The panel for the year features the main keep of Edo Castle engulfed in red flames in a massive blaze that erupted on the 17th day of the tenth month (fig. 2.18). According to the *Genji yume monogatari*, it "consumed the shogun's residence, with all the adjoining buildings, while the flames spreading to towers of the enceinte burnt them down also."[51] Like other disasters, fires could be viewed as a criticism of the ruling elite, who were powerless to fend off the foreigners and unable to secure the welfare of their people. The *Bukō nenpyō* noted that the Edo Castle fire was one of fourteen that hit the city during 1859 alone; the Aoyama fire that began in the second month destroyed more than twenty daimyo residences and more than fifty temples along an eight-kilometer stretch between Aoyama and Zōshigaya. Throughout the year, "fires from heaven" seemed to take aim at the ruling elite, presaging the assassination of Ii Naosuke in 1860.

In 1866, the Kaei chronicle records a large fire that broke out in Edo in the twelfth month. The *Bukō nenpyō* lists some nineteen fires for that year, including one that appears to correspond to the event listed in the Kaei chronicle. Fanned by strong dry winds, it burned for two days and spread widely around the Kanda, Yaesu, and Hibiya areas, destroying daimyo residences, temples, shrines, and over one hundred storefronts.[52] The next year, 1867, also saw Edo burning. Of fifteen fires noted by *Bukō nenpyō* for this year, the Kaei chronicle singles out one that occurred at the end of the year, just before the outbreak of the Boshin Civil War (1868–1869): "Fire breaks out in Akabane on the 25th day of the twelfth month; it burns as far as Shinagawa; many people die." This fire resulted from an attack on the

50. Kuroki, *Edo no kaji*, 4.
51. Baba, *Genji Yume Monogatari*, 35.
52. Imai, *Teihon Bukō nenpyō*, 3:178–80.

Satsuma daimyo's residence in Edo, led by pro-Tokugawa forces, in which the residence was burnt to the ground.

The final disaster story covered in the Kaei chronicle takes place in 1868, when the Yodo River breached its embankments and inundated the city of Osaka: "Massive flooding in Osaka; many bridges washed away." The flood occurred in the fifth month, around the same time as the fiery attack on the pro-Tokugawa Shōgitai at the Battle of Ueno Hill in Edo, the event depicted in the last panel of the chronology. Osaka, which had suffered occupation by imperial forces and the torching of its castle earlier in the year, was doubly a disaster victim. Like the citizens of Edo forced to witness the defeat of the old regime, the people of Osaka could only gaze in terror as their great city was destroyed by flame and flood.

Conclusion

The sixteen years from 1853 to 1868 covered by the Kaei chronicle saw both the beginning of Japan's active participation in international diplomacy and trade and a process of national integration that marked the birth of modern Japan. During these years, a xenophobic response to foreign threat was transformed into a nationalism tempered with foreign engagement. Battles were fought over the leadership of the emerging national framework, resulting in the destruction of the Tokugawa political system and the advent of more centralized rule under the emperor.

But as the Kaei chronicle suggests, there are other ways to tell the story of these dramatic years. At first glance, its *sugoroku* board game format contains no overarching theme. The history of the years from 1853 emerges as a chaotic flow of seemingly unrelated events. A closer examination, however, reveals a history told from the viewpoint of people who experienced these tumultuous years. Issued in the middle of 1868, this illustrated chronology offers a contemporaneous view of the changes underfoot during the late Tokugawa years and, in doing so, suggests a different constellation of reasons for the dissolution of the old regime.

We do not know who compiled the Kaei chronicle or drew its illustrations, but the information it presents is clearly the product not only of memory but also of careful research. It begins with the 1853 arrival of Perry and his black ships and ends with the defeat of the Shōgitai in 1868, an event that presaged the end of the Tokugawa regime. Highlighted are other important turning points in the national political drama, and in the realm of economics, the Osaka market data document the relentless rise in rice prices.

The Kaei chronicle, however, is not limited to issues of diplomacy, statecraft, and economic policy. As a commodity to be sold in the late summer of 1868, it includes themes and events that sparked recognition and imagination among its intended audience, resilient urban commoners who had survived the tumultuous years of civil war and social unrest. It thus stresses the breakdown of law and order, the collapse in the purchasing power of copper currency, and overall impoverishment. Above all, it focuses on natural and human disasters—earthquakes, floods, fires, and epidemics; of the sixteen panels, five show frightful disaster-scenes as the defining event of their year. In the face of such turmoil, festive religious events assumed extraordinary importance for ordinary people. The Kaei chronicle singles out *kaichō*, the public display of religious objects, recording five and illustrating two as the event of a given year. Accompanied by carnival-like entertainment, *kaichō* offered temporary escape from a world of woe and the promise of healing and salvation.

Attention to the lived experience of ordinary people brings into view other factors that caused the Tokugawa regime to collapse. Civil disorder, economic hardship, and natural disasters discredited it through the human cost of death and suffering, the economic cost of rebuilding, and the psychological cost of anxiety and disillusionment. The Tokugawa government proved itself unable to prevent untoward events and failed to come to the rescue of the people. The Kaei chronicle's grim depiction of Edo poor camps in 1866 says it all: there is no hope for the future.

The context and end point of any narrative is important. The *Genji yume monogatari* ended its account in 1864 with Kyoto in flames: "Heaven and earth trembled and quaked, until the end of the

world seemed to be at hand."[53] However, by 1871, when the *Kinsei shiryaku* was published, Edo had become Tokyo and the new imperial regime had reestablished peace, stability, and hopes for a better future. One of the first histories of the Meiji Restoration, the *Kinsei shiryaku* concludes with a description of the wonderful changes brought by the restoration of imperial rule. "From this moment, the government power was concentrated in the family of the sovereign, and the empire was grateful for universal peace."[54]

In mid-1868, however, this happy outcome was not foreseeable. The Kaei chronicle was published while Japan's civil war was still underway and the imperial forces had yet to consolidate their victory over supporters of the old regime. To the residents of Japan's largest cities, Edo and Osaka, the future seemed bleak. The Kaei chronicle offers a portrait of ordinary people confronted by a nightmare of apocalyptic proportions. As a visual narrative, it allows us, as viewers of the past, to achieve a more vivid imagining of the sense of chaos that animated Japanese people in the middle of the nineteenth century. The Kaei chronicle is their story—the autobiography of ordinary people seeking survival in an era of political, economic, and social upheaval.

53. Baba, *Genji Yume Monogatari*, 238.
54. K. Yamaguchi, *Kinsé Shiriaku*, 148.

CHAPTER THREE

Fukuzawa Yukichi: A Petition on the Subjugation of Chōshū

This chapter is a translation of a petition submitted to Tokugawa authorities by Fukuzawa Yukichi in 1866. The petition urged the shogunate to crush Chōshū domain "rebels" and create a new centralized form of government under the shogun. It challenges the notion that Fukuzawa, Japan's great westernizer, was a disinterested observer of the events that led to the Meiji Restoration.

In his autobiography, compiled some thirty years after the Restoration, Fukuzawa claimed perfect neutrality: "I never admired the old regime of the shogun and I was not by any means endorsing the new administration."[1] *The petition, however, shows that Fukuzawa in 1866 was a fierce supporter of the Tokugawa shogunate, willing even to rely on foreign military forces for help to subdue its enemies. In 1866, he envisioned the shogun as the monarch of a centralized nation-state committed to a program of westernization.*

I began this translation in 1969 as a Harvard graduate student working under Albert Craig, a specialist on Fukuzawa Yukichi. That same year, I was drafted to serve in the Vietnam War, and in June 1970, I found myself in Fort Sam Houston, Texas, training to be a medic as a conscientious objector. Several months later, I was posted to the Army Central Hospital in Landstuhl, Germany, where I worked as a laboratory technician, testing for tuberculosis. Included among the few books I took with me was Nelson's Japanese-English Character Dictionary and an edited volume of documents relating to late Tokugawa political thought.[2] *Among the documents, I was particularly interested in*

1. Fukuzawa, *The Autobiography of Fukuzawa Yukichi*, 203.
2. Kano, *Bakumatsu shisō shū*.

Fukuzawa's 1866 petition pressing for military action against Chōshū and other anti-shogunal daimyo. Fukuzawa's bellicose position contrasted with that of Katsu Kaishū, later commander in chief of the Tokugawa military forces and advocate of a more peaceful sharing of power. I completed a rough draft of the translation in an army barracks in Germany in 1971, revised it for publication in the late 1990s during contentious debate over war in the Middle East, and revised it again for this book in 2022, with the war in Ukraine as backdrop.[3]

Fukuzawa Yukichi and the Debate on Japan's Future

The Tokugawa shogunate's collapse and its replacement, in 1868, by a more centralized regime under the Meiji emperor was by no means a foregone conclusion. From the 1850s, largely in response to the opening of the country, officials, scholars, and activists engaged in contentious debate over Japan's future system of government. The Confucian scholar Yokoi Shōnan (1809–1869), for example, supported what he called "government through open debate," an argument that provided ideological underpinning for a more inclusive political order. Other visionaries called for "unity between the court and the shogunate," a "confederation of daimyo," and even the establishment of a British-style parliamentary system. Katsu Kaishū, scholar of Western military science and Tokugawa naval officer, envisioned a national assembly that would bring about a more equal sharing of power between the shogunate, the domains, and the imperial court.[4] Supporters of a more exclusive arrangement challenged these demands. Political power, as the Chōshū domain activist Yoshida Shōin (1830–1859) argued, should be the possession of "one man." Although Shōin's ideas inspired the movement to create a centralized nation-state under direct imperial

3. Steele, "Fukuzawa Yukichi and the Idea."
4. Steele, "Katsu Kaishū and Yokoi Shōnan."

rule, they were also available to those who sought to strengthen the shogun's power.

Although Oguri Tadamasa (1827–1868) is the best-known advocate of Tokugawa absolutism, Fukuzawa Yukichi (fig. 3.1) also called for the use of military might to replace the decentralized system of shogun and daimyo with what he called a "Taikun monarchy."[5] Fukuzawa was born in 1835 into a low-ranking samurai family in Nakatsu, a domain in northern Kyushu.[6] Shortly after the 1854 opening of diplomatic relations with the United States, he began to study Dutch, first in Nagasaki and later in Osaka under Ogata Kōan (1810–1863). In 1858, he was sent by his domain to Edo to advise on foreign affairs and teach Dutch in the Nakatsu compound. In the following year, he visited Yokohama, newly opened to foreign trade, and shocked that no one understood his Dutch, he began to study English. In 1860, he boldly offered his services as translator to Admiral Kimura Kaishū (1830–1901), the chief officer of the *Kanrin Maru*, and was thus able to sail as far as San Francisco with Japan's first diplomatic embassy to the United States. Two years later, he accompanied the first Japanese embassy to Europe as one of two English translators. In 1864, he was given the status of a Tokugawa bannerman and employed in the shogunal Office of Foreign Affairs, where he translated diplomatic correspondence and gleaned information useful to the government from newspapers and other foreign sources. In 1866 Fukuzawa published his first major book, *Seiyō jijō* (Conditions in the West), which introduced Western institutions, structures of government, and national histories. It proved to be immensely popular and, according to Albert Craig, provided "templates for programs of reform."[7] Contrary to the nonpartisan image he later cultivated, Fukuzawa was a loyal supporter

5. On Oguri Tadamasa, see Wert, *Meiji Restoration Losers*, 10–41; M. Ericson, "The Bakufu Looks Abroad."

6. Fukuzawa's collected works are published in Keiō Gijuku, *Fukuzawa Yukichi zenshū*. The main source of information on his early years is Fukuzawa, *The Autobiography of Fukuzawa Yukichi*. The most detailed biography, especially of his early years, remains Ishikawa Kanmei, *Fukuzawa Yukichi-den*. See also Nakajima, *Bakushin Fukuzawa Yukichi*.

7. A. Craig, *Civilization and Enlightenment*, 146.

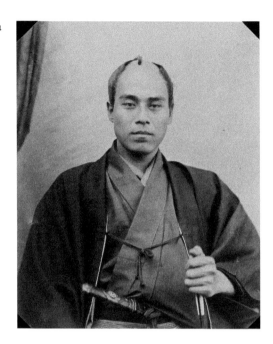

3.1. The young Fukuzawa Yukichi in 1862. Public domain, via Wikipedia Commons.

of the Tokugawa regime, thinking its openness to the West offered the best hope for Japan's future development.[8]

Fukuzawa's "Tokugawa first" advocacy was a product of his own life experiences and his fear of the growing anti-foreign movement in Japan. In a letter to his younger brother, Fukuzawa Einosuke (1847–1900), dated the 7th day of the tenth month, 1866, he wrote: "No matter how I look at it, if we don't set up a Taikun monarchy, the various daimyo will simply squabble among themselves, and our country's civilization and enlightenment will not advance."[9] Fukuzawa's petition to subjugate Chōshū, composed less than three months earlier

8. Fukuzawa, *The Autobiography of Fukuzawa Yukichi*, "A Non-Partisan in the Restoration," 178–224. Fukuzawa claimed that he calmly taught his class during the fighting between the imperial army and pro-Tokugawa supporters at the Battle of Ueno Hill: "I recall that it was a long battle, lasting from about noon to after dark. But with no connection between us and the scene of battle, we had no fear at all" (210).

9. Keiō Gijuku, *Fukuzawa Yukichi zenshū*, 17:30–32. Einosuke was born Wada Shinjirō. Fukuzawa took the unusual step of adopting him as his younger brother so that he would qualify for a Tokugawa scholarship to study in England.

and translated in this chapter, is central to the political debate over Japan's future in the period immediately before the Tokugawa shogunate's collapse.

Fukuzawa and the Two Punitive Expeditions against Chōshū, 1864–1866

The years 1864 to 1866 were especially challenging for the Tokugawa regime. In the summer of 1864, a group of pro-imperial radicals from Chōshū domain waged war in the streets of Kyoto with the aim of liberating the emperor from Tokugawa control (see chapter 2). After their attempt ended in failure, the shogunate declared a punitive expedition against Chōshū, labeling it an "enemy of the court." However, members of the daimyo coalition recruited for the expedition found excuses not to cooperate, and Satsuma domain acted independently to achieve a nonmilitary settlement. By the end of the year, the expedition had been disbanded without a shot being fired.

In the spring of 1865, shogunal leaders, aiming to reassert Tokugawa authority, announced a second expedition to chastise Chōshū.[10] Military operations did not begin until a year later, complicated by the interference of Western powers, often at odds with one another. Léon Roches (1809–1900), consul general of France in Edo, supported the campaign; his policy was to strengthen Tokugawa political and military power with the aim of eventually obtaining extensive trading privileges. The British representatives, reacting both to the French policy and to the shogunate's obvious weakness, developed sympathies with Chōshū and Satsuma. These two domains finally grew closer to each other. In the first month of 1866, Sakamoto Ryōma (1836–1867), an activist samurai from Tosa domain, mediated a secret alliance between Chōshū and Satsuma: they agreed to cooperate in a course of action designed to end Tokugawa rule.[11]

Again, various daimyo found excuses not to contribute to the war effort against Chōshū, and when Tokugawa troops finally took to the

10. A. Craig, *Chōshū in the Meiji Restoration*, 303–33.
11. Jansen, *Sakamoto Ryōma and the Meiji Restoration*.

field in the sixth month of 1866, they were soundly defeated. The death of Shogun Iemochi in the seventh month provided a pretext for temporarily halting hostilities. In the eighth month, Hitotsubashi Yoshinobu became head of the Tokugawa family and, in the twelfth month, shogun. His advisers in Edo, including Oguri Tadamasa, urged him to cooperate with Roches in carrying out military and administrative reforms designed to strengthen shogunal power. Oguri explained his plan to Katsu Kaishū, who oversaw Tokugawa naval reform:

> We are borrowing money from France and are asking for a warship and seven smaller ships to be purchased with time payments. . . . Our first task will be to subjugate Chōshū and then to smash Satsuma. . . . We intend to strip away all their lands and create a centralized state.[12]

Katsu was dismayed by Oguri's vision of autocratic Tokugawa rule. His position was that the shogun should share, rather than monopolize, political authority.

Fukuzawa's 1866 petition relates directly to this division of opinion among high-ranking Tokugawa officials. Fukuzawa saw the impending civil war in Japan in simple terms: the Tokugawa was on the side of order and progress, and Chōshū represented chaos and retrogression. Privy to diplomatic correspondence and foreign news, Fukuzawa was aware that the shogunate was in a precarious position. News of the outbreak of hostilities against Chōshū on the 7th day of the sixth month that year quickly reached his ears, probably through Kimura Kaishū, his patron since the days of the *Kanrin Maru* voyage to San Francisco. By the 2nd day of the seventh month, both Fukuzawa and Kimura knew that the war was not going well. On the 26th, Kimura was appointed acting minister of the Tokugawa navy; that day also brought the hushed news of Shogun Iemochi's death. Kimura recorded in his diary that Fukuzawa visited him that night to discuss the turn of events.[13] On the 29th, Fukuzawa brought his petition and asked Kimura to forward it to Tokugawa high officials in Osaka.

12. *Katsu Kaishū zenshū*, 11:327.
13. Quoted in Nakajima, *Bakushin Fukuzawa Yukichi*, 210.

Appended to the petition was a draft of *Seiyō jijō*, which Fukuzawa was to publish later that year.

Fukuzawa's petition drew on content he had prepared for *Seiyō jijō*. It defined four types of political systems: monarchy, republic, aristocracy, and autocracy. Monarchy was further subdivided into constitutional monarchy and despotism. Of these, Fukuzawa gave special attention to constitutional monarchy (*konsuchichutoshonaru monaruki*) in which "decisions are made in the name of the government that has one monarch and a fixed set of laws."[14] England, he implied, was a good model for Japan: its monarchy gave it central authority; its parliament provided democratic input; and the aristocracy provided stability. In 1866, Fukuzawa believed that the shogun should have the role of monarch. To that end, his petition argued, first, that Western countries should be informed through diplomatic channels and the press of the shogunate's progressive goals and the righteousness of its charges against Chōshū domain. Fukuzawa wanted these offenses to be "published every day" so that "everyone in the world will detest the crimes of Chōshū, and it will be said that those who are friendly with Chōshū do not know worldwide honor or dignity."

Fukuzawa's second recommendation focused on the use of military power to crush Chōshū domain. Reflecting the mindset that might makes right, he declared: "In all things, a just cause is determined by military might." The Tokugawa army should use all its resources to subdue Chōshū, and if necessary, it should even "use foreign military forces to crush the provinces of Nagato and Suō."[15] Japan's future was at stake. Fukuzawa maintained that the use of force was necessary to transform Japan into one of the civilized countries of the world—to make the transition from feudalism to monarchy.[16]

Far from being a singular aberration in the life and thought of one of Japan's great liberal thinkers, the 1866 petition is seminal to Fukuzawa's quest to "create in Japan a civilized nation as well equipped in

14. Fukuzawa, *Seiyō jijō*, 1, 5 recto. See also Fukuzawa, *Seiyō jijō*, Saucier and Nishikawa, eds., 14.

15. The domain of Chōshū was situated in these two provinces, Nagato and Suō.

16. A. Craig, *Selected Essays by Fukuzawa Yukichi*, trans. T. Craig, 21.

the arts of war and peace as those of the Western world."[17] A concern with strength, independence, and international standing can be seen throughout his collected works. Fukuzawa was a complex thinker, and his belief in freedom and progress was often tempered by realism. In the 1870s, his repeated linking of national independence with the cultivation of personal independence found favor even among conservative critics (see chapter 6). Later, in the 1880s, Fukuzawa declared himself to be "a follower of the way of force."[18] Looking at foreign relations, he argued that "Japan had a right and indeed duty to use force, if necessary, to make backward neighbors adopt the path of progress."[19] In 1885, an editorial published in *Jiji shinpō*, the newspaper he founded, asserted that Japan should "leave Asia and join the West" (*datsu-A nyū-Ō*).[20] In the 1890s, Fukuzawa argued that Katsu Kaishū's failure to "fight to the bitter end" against the imperial army at the time of the Meiji Restoration had injured bushido, Japan's unique fighting spirit (chapter 8). And when war broke out with China in 1894, Fukuzawa was one of its strongest supporters. It was a war, he declared in an editorial, that would decide not only Japan's future but the future of civilization.[21] Fukuzawa was a thinker who embodied the complexities and contradictions of modernity: both a democrat and a follower of Machiavelli, a spokesperson for, at once, freedom and constraint.

* * *

The original manuscript of Fukuzawa's 1866 petition on the subjugation of Chōshū domain no longer exists. A handwritten copy (fig. 3.2) made by his disciple, Yamaguchi Ryōzō (1838–1887) later came into the hands of Takimoto Seiichi (1857–1932), Keio University graduate and historian of economic thought. With the added title *Fukuzawa sensei kenpakusho* (Master Fukuzawa's petition), the document

17. Fukuzawa, *The Autobiography of Fukuzawa Yukichi*, 214.
18. Fukuzawa, *Jiji shōgen*, 33. See also A. Craig, *Civilization and Enlightenment*, 141–43.
19. Fukuzawa, *Jiji shōgen*, 210. See also Dower, "Throwing off Asia I."
20. Fukuzawa, "Good-Bye Asia."
21. Fukuzawa, "Tadachi ni Pekin o tsuku beshi."

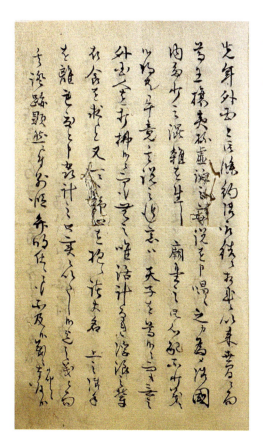

3.2. The first page of the manuscript copy of Fukuzawa's 1866 petition on the subjugation of Chōshū. Keio University Library.

eventually found its way into the Rare Book Room of Keio University Library.

Subsequently, probably between 1920 and 1922, Takimoto made plans to publish the petition with commentary but met with opposition from Kamata Eikichi (1857–1934), the president of Keio University. Until the 1950s, the document remained hidden in the library, with instructions prohibiting it from being viewed.[22] It is possible that university officials, especially in the early twentieth century, feared critical comment if it were known that Fukuzawa had held militant

22. Note dated September 11, 1962, on the envelope in which the manuscript copy of the petition is stored in the Rare Book Room of Keio University. See also Konnō, "Fukuzawa Yukichi no jōsho."

pro-Tokugawa views in the years immediately before the Meiji Restoration. The document became public in 1950 and was later included in the postwar edition of the collected works of Fukuzawa Yukichi, first published in 1963.[23]

A Petition on the Subjugation of Chōshū

The bogus and deceitful rallying cry to "respect the emperor and expel the barbarians" (*sonnō jōi*) has been trumpeted throughout the country recently, since the time when treaties were first concluded with foreign nations. For this reason, great turmoil has arisen in the country and the imperial court has been much troubled. After all, the meaning of this slogan has nothing to do with respecting the emperor or expelling the foreigners. It is simply a tricky pretext to give footloose fellows who have no means of support a chance to seek a livelihood and, further, to allow daimyo who hold sinister designs a chance to deviate further from the orders of the Tokugawa family. Since the evidence is obvious, I believe there is no need for further explanation. Among the various lords, the daimyo of Chōshū has been the first to plot action and show himself to be a rebel. Therefore, the plans now finally in place to attack and punish Chōshū domain are most welcome. Thanks to this one action, we can expect that the Tokugawa family will be brought closer to the day of its revitalization.

In fact, during these past three to five years, since even the imperial court was troubled by domestic and foreign affairs, it has been difficult for the shogunal government to take effective measures against Chōshū. There have been rumors in society of inaction and vacillation, causing me to gnash my teeth secretly in consternation. The present plan to attack and punish the Chōshū rebels offers a rare opportunity for misfortune to turn into fortune for the country. I pray that a resolute

23. The 1950 text was published in Konnō, "Fukuzawa Yukichi no jōsho." This translation is based on the text included in Fukuzawa's collected works: Keiō Gijuku, *Fukuzawa Yukichi zenshū*, 20:6–11. The editors supplied the title "Chōshū saisei ni kansuru kenpakusho" (A petition on the second subjugation of Chōshū). I have also viewed the manuscript copy held in the Rare Book Room of Keio University Library. A modern Japanese version of the petition is included in Kano, *Bakumatsu shisō shū*, 313–23.

decision will now be made to subjugate Chōshū in one fell swoop and, building on this momentum, to subjugate the other daimyo. I pray that Kyoto will also come under shogunal control and that international relations and other affairs will be conducted without anyone in any part of Japan speaking even one word in opposition. Therefore, in connection with the present expedition to punish Chōshū, there is no need for me to inquire about our chances of military success; nor do I have anything in particular to write in a petition. However, being deeply moved by these unprecedented events, I must nonetheless submit the following two or three articles.

Article 1.
To block avenues of communication between the Chōshū rebels and the foreign powers and proclaim the charges against Chōshū to the world.

Regarding the true intentions of the Chōshū rebels, although from the outset they have advocated slogans such as "respect the emperor and expel the barbarians," this is, as stated above, nothing more than a pretense. Two years ago, after their defeat at Shimonoseki, Chōshū men repeatedly approached foreigners and sent students overseas to campaign on their behalf.[24] They summoned dishonest foreign merchants to Shimonoseki and other places and engaged in secret trading, through which they are said to have purchased much weaponry. In fact, the prohibition of secret trade with foreigners is specified in the treaties, and the consuls are also expected to enforce it firmly. Previously, in the year before last, the English consul issued an edict to his country's ships regarding this matter, but simple edicts cannot prevent these abuses by greedy and dishonest merchants. Moreover, since in

24. "Their defeat at Shimonoseki" is a reference to a series of naval engagements beginning in the summer of 1863 over control of Shimonoseki, a strategic strait between the islands of Honshu and Kyushu and just off the coast of Chōshū domain. On the 10th day of the fifth month, Chōshū forces attempted to enforce an imperial order to expel the barbarians by firing on foreign ships. Joint naval forces from Great Britain, France, the Netherlands, and the United States retaliated by bombing Shimonoseki.

recent days, Chōshū has intensified its determination to fight and win, it is frantically devising evil stratagems, such as purchasing weapons from foreign countries, borrowing money, and, in extreme cases, even contracting foreign ships by depending on vagrant foreigners. Since this is treading the same path as the Taiping rebels in China, it is difficult to forecast what the eventual outcome may be. This, I believe, is what we should fear most.

Accordingly, at the present time, several shogunal warships have been dispatched to Nagato and Suō to intercept foreign ships that approach these two coasts. Furthermore, if small boats from the Chōshū rebels should approach foreign ships, the shogunate will seek to exercise strict control measures and apprehend them immediately. A few years ago, during the American Civil War also, England secretly delivered the warship *Alabama* to the Southern rebels. It also sent weapons, causing great difficulties for the North.[25] Judging from this precedent, the fact that Chōshū is now engaged in intercourse with foreign countries may well lead to serious trouble in the future. This point should, I believe, receive special consideration.

Furthermore, to proclaim the crimes of Chōshū to foreign countries, the shogunate has already sent a fourteen-point statement of such charges to the consul of each country. However, as stated above, Chōshū has dispatched students overseas to campaign on its behalf. They necessarily aim only at Chōshū's advantage, stressing far-fetched opinions and slandering the policies of our nation's government in their arguments to the whole world. Recently, there is a singular group that advocates, in newspapers and elsewhere, ideas such as that of a daimyo confederation.[26] Critical of the government's policies up to the present

25. The CSS *Alabama* was built secretly in England in 1862 for the Confederate States Navy. It captured and burned some sixty-five Union vessels, mostly merchant ships, before it was sunk in June 1864. See Fox, *Wolf of the Deep*.

26. This is a reference to a series of articles written by Ernest Satow and published anonymously in the *Japan Times* in 1866. Satow identified the daimyo, rather than the shogun or the emperor, as the real rulers of Japan: "What we want is not a treaty with a single potentate but one binding on and advantageous to the whole country. We must give up the worn-out pretense of acknowledging the Tycoon to be the sole ruler of Japan, and take into consideration the existence of other co-ordinate powers, by

day, this group holds that the existing treaties with foreign nations should be abrogated and that the various daimyo should be organized into a confederation, like the German states, and that the various lords of the new confederation should individually conclude treaties. It seems that the British envoy [Harry] Parkes and others are secretly in agreement with this proposal. Furthermore, many students from Satsuma and other domains are traveling overseas, and all of them advocate the idea of a daimyo confederation. As a matter of course, the Chōshū students overseas rely on and consult with them. If they go around expressing their opinions and writing in newspapers about a possible daimyo confederation, they may temporarily influence public sentiment in Europe, and it is not impossible that the course of each government's deliberations about Japan might change. If something like this should happen, not only will the fortunes of the Tokugawa family be placed in jeopardy, but seeds will be sown for civil war throughout the country. Torn asunder, the country will fall into a state of irreparable harm that is greater in scale than the treason currently perpetrated by the one domain of Chōshū. The government must do something immediately to prevent this from happening.

Considering this situation carefully, I pray that at this time a resident minister will be dispatched to the capital city of each nation. It is a general custom that resident ministers are exchanged between nations that have signed treaties to conduct diplomatic business. Although it was expected that our country also should have dispatched ministers immediately after signing treaties, delays have continued until the present day. That being the case, since our government must rely solely on the resident consuls to communicate its intentions to the various foreign countries, there is no way to predict what discrepancies may arise nor is a proper structure of equality maintained in the shogunate's relations with foreign nations. In this situation, people in foreign countries may fail to recognize Japan's government as equal to their own, or they may come to think that new treaties should be concluded. Therefore, if the shogunate now sends resident ministers to

treaties with the CONFEDERATE DAIMYOS of Japan." Ruxton, "Ernest Satow, British Policy," 35.

England, France, America, and Russia and conducts diplomatic business directly with the governments of these countries, I believe that all negotiations will, as a matter of course, proceed smoothly. Moreover, a proper structure of equality will be established with each nation, public sentiment in foreign countries will naturally become settled, and minds will not be swayed by the fanciful arguments of the student agitators.

In this way, if the shogunate now sends resident ministers to every country, diplomacy will proceed smoothly in all areas and our government's intentions to the other countries will be clearly communicated. However, it is the custom in foreign countries for people to discuss all matters fully. With opinions that appear in newspapers, especially, even though it is difficult to decide what is true or false or to use those opinions to secure conclusive evidence, everyone respects the written word to the point that, in major debates, newspaper opinions may even temporarily change a government's deliberations. Therefore, it is inevitable that the student agitators sent by the domains are using the power of newspapers. Accordingly, when the resident ministers are sent, newspaper announcements should be especially ordered with the sole purpose to justify and make our government's position known in foreign countries. In addition, of course, to refuting the daimyo confederation argument, a charge sheet against the Chōshū rebels should be compiled listing offenses old and new in even the smallest detail, and this should be published every day. Finally, it can be hoped that everyone in the world will detest the crimes of Chōshū, and it will be said that those who are friendly with Chōshū do not know worldwide honor or dignity.

Moreover, since decisions concerning the dispatch of these resident ministers cannot be reached in a few days, the shogunate should first secretly send agents to Yokohama. In accordance with its objectives outlined above, it should repeatedly proclaim the offenses of Chōshū, assert the intentions of the government, and arrange to make announcements through the medium of the Yokohama newspapers. Furthermore, I believe that, from time to time, all government trainees in the Netherlands, Russia, and elsewhere should also be sent official statements, along with copies of the newspapers, and ordered to publicize the content in the country in which they are stationed.

Article 2.
The need to use foreign military power to suppress domestic unrest.

Anticipating the government's impending punitive expedition against Chōshū, that domain has, for its part, been making secret military preparations during the past two years. Since it has westernized all weaponry and military tactics and its people are fiercely hostile to the imperial forces, it is not an insignificant enemy.[27] Already there is the example of the rout of the Ii and Sakakibara forces.[28] As this battle shows, even if the various daimyo have tens of thousands of old-style Japanese soldiers, they will be soldiers in name only and of no use whatsoever to the Tokugawa cause.

Accordingly, although the shogun's military forces, both infantry and artillery, are well trained, the Chōshū rebels will be fighting fiercely in a defensive war to protect their land, and they have an advantage in weaponry. In this situation, given the relative strength of each side, I am deeply worried about the outcome of the war.

Therefore, it is desirable that the government act decisively to rely on the military power of foreign countries and, with a single blow, smash the two provinces of Nagato and Suō. Of course, the government must be concerned that relying upon foreign military power will affect popular sentiment and incur enormous expenses. While discord in popular sentiment may not be a particular cause for concern in times of peace, I fear that society may suddenly be thrown into confusion. Indeed, at this present moment, our country has reached the stage of civil war. There is no more serious concern than this: in other words, popular discord is at its zenith. Therefore, with things at this pass, the government should not be swayed by groundless rumors but should simply use military might to assert its supremacy throughout the country. In all things, a just cause is determined by military might.

27. At this point, Fukuzawa conceived the "imperial army" (*kangun*) to be composed of and led by Tokugawa military men.
28. On the 13th day of the sixth month, 1866, Chōshū forces, armed with French Minié rifles, defeated Ii (Hakone domain) and the Sakakibara (Takada domain) forces who fought in traditional armor with spears and swords on behalf of the Tokugawa.

For example, when Akechi Mitsuhide forced Oda Nobunaga to commit suicide, he was immediately declared shogun by imperial decree, but when Toyotomi Hideyoshi succeeded in killing Mitsuhide, the realm immediately fell under the control of the Toyotomi family. The emperor also recognized this, and no one in society voiced doubts.[29] All of this was the result of military might. Today, the Chōshū rebels are engaged in harsh combat against the imperial [shogunal] army. If by chance they should win, their plan must be to carve their way to Kyoto. They will change their name from "enemy of the court" to "imperial loyalist" and, dreadful to imagine, give the imperial [shogunal] army the name "enemy of the court."[30] Such being the case, whether the name "enemy of the court" or "imperial loyalist" sounds correct depends entirely on military might. Such things as imperial decrees and papal edicts merely legitimize existing military power.

Consequently, there is no point in endless discussion of this situation, especially since the expedition now underway against Chōshū domain is a righteous cause that in name and, in fact, punishes a criminal of the world who has angered both gods and people. There is not a single doubt on this score. Accordingly, the shogunate should make a firm resolution to act. It should use foreign military forces to crush the provinces of Nagato and Suō and, moreover, direct the banner of subjugation immediately against those daimyo who are expressing dissenting views. Striking a decisive blow, the shogunate must, I believe, exhibit power sufficient to change completely the feudal (*hōken*) system that exists throughout Japan.

Although the shogunate will be concerned about the expenses of employing foreign military forces and purchasing weapons, here, too,

29. This is a somewhat confused account of the Honnōji Incident (1582) in which Akechi Mitsuhide (1516–1582) revolted against his master Oda Nobunaga (1534–1582), resulting in the suicide of both Nobunaga and his son Nobutada (1557–1582). Mitsuhide sought the title of shogun, but thirteen days after Nobunaga's death, he was killed by Toyotomi Hideyoshi (1537–1598) who succeeded Nobunaga as the military master of Japan. The role of naked military power in determining political authority is captured in the phrase "If you win, you are the imperial army" (*kateba kangun*).

30. At the time, the imperial court had branded Chōshū "enemy of the court" and issued imperial orders to the shogun's army to subjugate the rogue domain. Hence, Fukuzawa's use of "the imperial army" was a reference to the shogun's army.

I believe there is nothing to fear. To be precise, the annual income of the two provinces of Nagato and Suō is at present estimated at 1 million bales of rice (*hyō*) which is equivalent to about 2 million *ryō* in gold. After the shogunate has crushed Chōshū, it will gain an annual profit of 2 million *ryō* in perpetuity. Therefore, even if it now borrows 20 million *ryō* and repays with interest, the loan will be repaid in full in twenty years. Of course, there is no expectation that a huge loan of 20 million *ryō* will be made immediately. Our country is different from the various countries of the West in that we have never had a law concerning the issue of government bonds. Therefore, it is difficult to amass a large amount of money at one time. However, since the shogunate can expect an annual profit of 2 million *ryō* when the punitive expedition against Chōshū is concluded, it can take this into account in negotiations with foreign countries regarding the employment of military forces. No matter how ambitious the shogunate's plan, there will be absolutely no difficulties.

In general, Western nations issue what are known as government bonds. In England, for example, the national debt in 1862 was 890 million pounds. Since government revenue in that year was a mere 70 million pounds, this meant that proportionately for every 700 *ryō* of income there was a debt of 89,000 *ryō*. Seen in this way, Japan's government can be thought of as having the richest treasury in the world.

It would give me pleasure and happiness if the shogunate would consider and adopt the humble opinions expressed above. Furthermore, to allow verification of the trends in foreign and domestic affairs since the middle of the 8th month of last year... [text missing].[31]

31. The text ends at this point. In another hand was written: "Submitted by Fukuzawa Yukichi." This was followed by the words "I have copied this in great haste; please favor me by reading it." This salutation was signed Ryōya, identified as Fukuzawa's disciple Yamaguchi Ryōzō, and addressed to Master Ka'ichirō, identified as Kishi Ka'ichirō, otherwise known as Shōji Ka'ichirō, another Fukuzawa student from Kii domain. For details, see Konnō, "Fukuzawa Yukichi no jōsho"; Hirayama, *Fukuzawa Yukichi*, 209–10.

CHAPTER FOUR

That Terrible Year 1868: Satirical Cartoons and the End of an Era

This chapter analyzes a series of satirical cartoons (fūshiga) to gain insight into the ways ordinary people understood and experienced the traumatic events of the Meiji Restoration. It builds on my earlier work on 1868 Edo.[1] *The cartoons are drawn from my collection of woodblock prints stored in the ICU Hachiro Yuasa Memorial Museum.*[2]

The satirical cartoons were multicolored woodblock prints that took advantage of a long tradition of word play, inversion, caricature, and allegory. They were distributed cheaply as political and social comment in Edo in 1868, reaching a peak in production around the time of the surrender of Edo Castle in the fourth month. The chapter uses the cartoons to follow the course of events from the outbreak of the Boshin Civil War to the triumphal entry of Emperor Meiji into the newly named city of Tokyo.

Often humorous, the prints nevertheless show the violence and disorder of Japan's civil war. Many depict cute children playing games, but they play games of war and wield weapons as their toys. As Edo residents flee their city, the dark cloud hanging over their heads suggests that the world as they know it is about to end. Their dream of the "floating world" was in fact a nightmare of life in a "wretched world." The satirical cartoons of 1868 offer insight into the anxiety and confusion that was the common experience of ordinary people in that terrible year.

1. This chapter, much revised, was originally published as Steele, "Osoroshiki 1868 nen." See also Steele, "Edo in 1868."

2. For the exhibition catalogue of these prints, see Steele, *Poking Fun at the Restoration*.

In 1872, less than four years after pro-Tokugawa forces were defeated in the Boshin Civil War and a centralized government was created under the emperor, Itō Hirobumi (1841–1909) explained the successful transfer of power in a speech delivered in English at San Francisco on the first leg of the Iwakura Mission to the United States and Europe: "Within a year, a feudal system, firmly established many centuries ago, has been completely abolished, without firing a gun or shedding a drop of blood. These wonderful results have been accomplished by the united action of a Government and people, now pressing jointly forward in the peaceful paths of progress."[3]

Although Itō's depiction contributed to an enduring image of the Meiji Restoration as a bloodless transition of power achieved through the unity of people and government, contemporary social media, such as satirical cartoons (*fūshiga*), suggest less wondrous results. The cartoons were multicolored woodblock prints filled with references to contemporary events. Some were signed by Utagawa Hiroshige III (1842?–1894) and other well-known woodblock print artists and sold as works of art; but most, anonymous and of inferior quality, were distributed cheaply as political and social comment on the streets of Japan's largest cities. Anonymous and sold without official certification or indication of publishing house, these were illegal publications. As commodities sold for profit and targeting the interests of Edo's merchant and craftsman community, they can be considered fair representations of their consumers' political and social outlook. They reached a peak in production during the months before and after Edo Castle was surrendered in the fourth month of 1868. At this time, the Tokugawa regime's bureaucracy, including its censorship office, was in disarray, allowing a period of relative free speech and free press that lasted until the imperial government secured control over the Edo

3. Walthall and Steele, *Politics and Society*, 150. The "Speech on Japan's Future," delivered on January 18, 1872, is reproduced there. The original English version comes from Lanman, *The Japanese in America*, 13–16. And the original Japanese from Takii, Itō *Hirobumi ensetsu shū*, 11–15.

population in the autumn—after the city had been renamed Tokyo and the era name Keiō changed to Meiji.[4]

The visual and textual information found in satirical cartoons sold in Edo during 1868 offer an unusual glimpse into the social history of the Meiji Restoration. Instead of the birth of a new bright world, satirical cartoons suggest that for ordinary people—especially the relatively well-educated and worldly members of the merchant and artisan communities—the events of 1868 turned the world upside down. They were confused by the news that the Tokugawa forces had been defeated at Toba-Fushimi during the first week of the new year. They feared for their city as imperial troops advanced on and occupied Edo in the spring. They were disappointed at the news that, on the day Edo Castle was surrendered, Shogun Yoshinobu had left the city for Mito. They lamented the defeat of the Shōgitai in the battle of Ueno Hill on the 15th day of the fifth month. By late summer, they were told that their city was to be renamed Tokyo, and in the autumn, they were forced to bow before the boy emperor. By this time, nearly half of the city's population had fled. The future of Edo, like the future of Japan, was unclear as its residents tried to make sense of the upheaval that later historians called the Meiji Restoration.

The first section of this chapter introduces satirical cartoons, focusing on their use of parody, word play, and other artistic conventions. The second section analyzes a series of cartoons with the aim of understanding how the people of Edo coped with the annus horribilis that was 1868.

Satirical Cartoons as Historical Documents

It is not known how many satirical cartoons were produced and sold during 1868. One contemporary source estimated that, as early as the second month, some three hundred different prints were available

4. Minami, *Bakumatsu ishin no fūshiga*; Minami, *Edo no fūshiga*; Nagura, *Etoki bakumatsu fūshiga*; Nagura, *Fūshiga ishin henkaku*. On the consumption of satirical prints, see Koizumi, "Bakumatsu fūshiga to sono juyōsō."

for purchase in Edo.[5] Although this may have been an exaggeration, a corpus of at least 144 civil war–related prints thought to have been issued in 1868 has been identified.[6] Given at least one thousand copies per print, we can assume that no fewer than 150,000 prints were in circulation in the middle of 1868. The prints were cheap (20 *mon*, or a little more than the cost of a bowl of soba) and entertaining and were sought after for their news value. The main purchasers were Edo townsmen, but they also found their way into the collections of well-to-do farmers in the city's hinterland. The storehouse of the Kojima family in the village of Notsuda (part of the present-day city of Machida), for example, includes a trove of some twenty satirical cartoons.[7]

Since political comment was prohibited by the Tokugawa government, print artists and their publishers drew on a long tradition of word play, inversion, caricature, and allegory to depict the political debates of their day. Historical battlegrounds were revisited; kabuki plays and folk tales were given new meanings. Groups of birds, beasts, or insects, or even food items or special products might be lined up against each other, taking sides as friend and foe engaged in a struggle or contest. Most conspicuously, children were shown "at play." Lined up in groups against each other, they engaged in war games, sometimes with toy guns and cannon, throwing mud, waging water battles, fighting on stilts, engaging in sumo wrestling, or simply playing tag. Why the use of children? One answer is convention. Beginning with the celebrated ukiyo-e artist Utagawa Kuniyoshi (1798–1861), "children at play" prints were produced in response to new restrictions on publication issued as part of the Tenpō reforms of 1841–1842. Innocent children could be depicted in situations forbidden for the mature and politically aware. A second consideration may have been the youth of the main actors in the Restoration drama of 1868. The Meiji emperor was a boy of sixteen; Shogun Yoshinobu was thirty-one; the men who fought on both sides were mainly in their twenties and early

5. Quoted from *Rikō fūwa* (Tales from the lanes and villages) in Minami, *Bakumatsu ishin no fūshiga*, 131.
6. Nagura, *Etoki bakumatsu fūshiga*, 25.
7. Kojima, *Kojima shiryōkan mokuroku*.

thirties. A third factor may have been the viewpoint of the print consumers. To Edo commoners, who prized peace and prosperity, the war games of the samurai may well have appeared boorish and infantile.

Beyond the need to circumvent censorship, Restoration-era satirical prints, like political cartoons in newspapers today, relied upon humor involving puns, word play, and specialized symbolic knowledge. These textual and visual codes, however difficult for people in our day to decipher, presented little difficulty to consumers at the time: verbal and visual literacy was high among merchants, artisans, and professional workers, including entertainers, in the downtown areas of Edo. Political allegiance is sometimes indicated by a banner or inscription that viewers were expected to decode. Symbols and patterns on clothing provided clues. Shogun Yoshinobu, formerly a member of the Hitotsubashi family, is usually shown wearing a kimono patterned with the character for "one" (一/*hitotsu*) repeated in a linked series; the result resembles a brick design. Supporters of the Tokugawa side can be identified by their regional specialties: Aizu is shown with candles, Sendai with bamboo, and Kuwana with clams. On the imperial side, the chrysanthemum crest identifies the emperor, often in conjunction with the character for "gold" (金/*kin*), a homophone for the first syllable of *kintei*, the imperial palace. Satsuma is depicted with an indigo splash pattern (*kasuri*), and Chōshū with a pattern made up of bush clover (*hagi*) leaves or a butterfly (*chō*). Tosa is shown by a triad of oak (*kashiwa*) leaves, the daimyo's family crest, and Owari by one of its local specialties, a large white daikon.[8]

A detailed look at two satirical prints issued in 1868 reveals some of the artistic conventions used to represent a world that has lost coherence. *Osana asobi ko o toro ko o toro* (Children playing a game of chain tag) by Hiroshige III is an example of the use of children to portray the chaos of current events (fig. 4.1).[9] The print was entirely legal: the artist and publisher were clearly indicated, and the censor's

8. For a key to decoding the satirical prints, see Nagura, *Fūshiga ishin henkaku*, 297; Nagura, *Etoki bakumatsu fūshiga*, 41, 57.

9. This print is analyzed in Nagura, *Etoki bakumatsu fūshiga*, 28–35. A transcription of the dialogue is in Asano Akira and Katō, *Genten de tanoshimu*, 130–31.

4.1. Utagawa Hiroshige III, *Osana asobi ko o toro ko o toro* (Children playing a game of chain tag), second month, 1868. Hachiro Yuasa Memorial Museum.

seal affirmed the date of issue, the second month of 1868. The game of chain tag (*ko o toro ko o toro*) shown in the print remains popular in Japan. Children are divided into two teams, with the members of each team linked to form a chain. The teams line up facing each other and compete to capture the child at the tail end of the opposing line. Once captured, that child joins the captor's team.

In the print, the line of children to the right is headed by the personification of Satsuma domain, identified by the indigo splash pattern on his jacket; at the end of the line is the child emperor, his sleeve decorated with a stylized character for "gold," riding on the back of Chōshū, who is wearing a jacket patterned with bush clover leaves. This team, which also includes Owari (in a daikon-patterned jacket), Tosa (in a tortoiseshell-patterned jacket), and four other domains, has gained the upper hand. Having taken possession of the emperor, they are, in effect, the imperial army. By contrast, the Tokugawa

supporters, on the left, are in obvious disarray. Their leader, Aizu (identified here by linked metal rings rather than the more common candle pattern), extends his hand in a valiant attempt to catch the imperial prize. He shouts: "I'll get that kid at the tail end." His team, however, is not fully engaged in the contest. Shōnai, to the left, points his fan (on which is written サカ [saka], denoting Sakai, the daimyo of Shōnai domain) in the direction of the opponents. Kuwana (in a clamshell-patterned jacket) likewise points his finger at the opponents but turns away from the action. Looking somewhat helpless with both hands over his head, Shogun Yoshinobu (in a brick pattern of "ones") shouts words of encouragement to Aizu: "Hey, Aibō-*chan*. Hold tight! I'm right behind you, so don't worry."

Osana asobi ko o toro ko o toro reflects a widely shared contemporary understanding that the contest between the pro- and anti-Tokugawa forces was being fought over possession of the emperor. By the second month of 1868, when it was issued, the imperial forces had proven victorious at the Battle of Toba-Fushimi, and Yoshinobu, humiliated by defeat, had fled back to Edo. On the 12th day of the same month, to the disappointment of many retainers, he declared his submission to imperial rule and entered domiciliary confinement in Kan'eiji, the Tokugawa family temple on Ueno Hill. Despite the bold words attributed to him in the print, he was not about to fight. At the same time, management of the Tokugawa family passed to Tayasu Kamenosuke (1863–1940), a five-year-old boy, who can be seen in the top right corner of the print, clinging to the back of Kazunomiya (1846–1877), half-sister to the late Emperor Kōmei and widowed wife of Tokugawa Iemochi. The character for "rice field" (田 / *ta*) on his sleeve identifies Kamenosuke. These two are onlookers at the game, but they are also mediators between the imperial and Tokugawa camps. The print raises the question: who will win the game of chain tag—in other words, who will win the war?

A second satirical cartoon, *Banmin odoroki* (The people **wood** be shocked), exemplifies the role of parody and word play in representations of the upheavals of 1868 (fig. 4.2). Although there is no indication of the artist or publisher and no censorship date, context suggests it was issued just after the surrender of Edo Castle to the imperial army on the 11th day of the fourth month, 1868. Instead of cute children

THAT TERRIBLE YEAR 1868 81

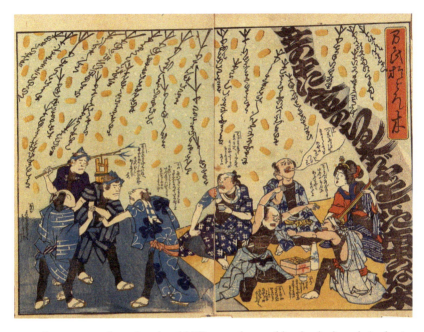

4.2. Anonymous, *Banmin odoroki* (The people **wood** be shocked), n.d. Author's collection.

engaged in war games, this print shows four ruffians sitting beneath a tree and enjoying the pleasures of wine, women, and song. They represent the occupying forces, led by Satsuma (in indigo splash pattern) and Chōshū (in bush clover leaf pattern). Kazunomiya is playing the shamisen. The party is disrupted by a group of Tokugawa supporters, led by Aizu (in a candle-patterned garment) and Sendai, who carries a bamboo stick across his shoulder; Shōnai (in oxalis pattern) urges caution. The entire political drama takes place under the branches of an unusual "money tree" (*kane ni naru ki*), a parody of the mythical trees printed on amulets believed to bring good fortune in times of distress. The money tree in the print, however, is associated with bad fortune rather than good. The large characters that make up the trunk make this critical difference clear: the tree that once rained down gold coins is suddenly raining down "difficultrees throughout the city" (市中なん木 / *shichū nanki*). Some twenty-eight "difficultrees" are listed in the small script that make up the branches of the tree.

They include "no industree," "the rich treemble," "people flee to the countreeside," "commoditree prices high and exchange rates low," "the rice exchange is all boarded up," "confusion reigns throughout the countree," and "the hardships of the lower branches are extreme." While the light of Kyoto shines brightly, the people of Edo can only lament that the future is "emptree."

These two examples by no means exhaust the variety of satirical prints that, alongside other textual, visual, and even audible media, were consumed by Edo commoners in 1868. Some, like *Osana asobi ko o toro ko o toro*, offered information on the course of events. Others, like *Banmin odoroki*, served as social commentary, encouraging readers to add their own frustrations to the list of "difficultrees." Still others criticized the petty or violent behavior of the samurai masters. Rarely, however, were they a call to action. Through humor, satire, and snippets of information, they presented a distorted mirror of society that invited people to reflect on a world that seemed to be falling apart.

Japan's Civil War as Seen in Satirical Cartoons

The series of events that led to the Meiji Restoration of 1868 were initiated in the tenth month of the previous year, when Shogun Yoshinobu offered to return his governing powers to the imperial court. A woodblock print by Utagawa Yoshimori (1830–1884), *Ryūkō shokan uketorisho* (Townspeople offering up petitions), issued in the tenth month of 1867, depicts Edo commoners praying for a good outcome to the struggle between the god of war (upper right) and the god of abundance (upper left) (fig. 4.3). The woman at lower right pleads: "Please let me have a bellyful of tempura." The geisha in the middle says: "Please let me have lots of customers . . . and get rich." One old woman wants to have her teeth back, eat sweets, and live long. She prays: "Let me live to be one hundred! No, two hundred! No, one thousand, two thousand. Oh, please let me live to be three thousand years old!"

Betraying these wishes, the New Year saw impoverishment, insecurity, displacement, and bloodshed. The Boshin Civil War began with

4.3. Utagawa Yoshimori, *Ryūkō shokan uketorisho* (Townspeople offering up petitions), tenth month, 1868. Author's collection.

the Battle of Toba-Fushimi on the 3rd day of the first month, 1868.[10] Satirical cartoons informed Edo residents that the Tokugawa forces had been defeated. An anonymous print, *Toba emaki mono no uchi he gassen* (The Toba war of farts), depicts the battle between pro-imperial forces on the right and supporters of the Tokugawa on the left (fig. 4.4). The victory of the imperial side is attributed to its superior farting power! The joke relies on the similarity in pronunciation between "farting power" (*heryoku*) and "military power" (*heiryoku*). However, the use of the farting metaphor suggests that the Tokugawa defeat may be only a temporary setback. In the end, a fart is just hot, smelly air, something of little consequence.

In the early stages of the civil war, political cartoons often depicted Yoshinobu as a heroic figure, leading his forces against the imperial

10. Sasaki, *Boshin sensō*; Hōya, *Boshin sensō*; Nagura, *Boshin sensō no shinshiten*, 1; Hōya, "A Military History."

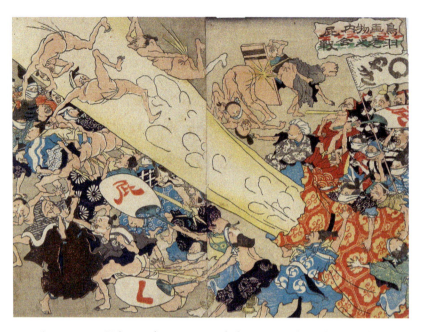

4.4. Anonymous, *Toba emaki mono no uchi he gassen* (The Toba war of farts), n.d. Author's Collection.

army headed by Satsuma and Chōshū. One example, *Osana asobi ko o toro ko o toro*, is described above. Another is *Kodomo asobi mizu gassen* (Children at play: A water war), which likens the war to a water fight between rival gangs of children (fig. 4.5). The print is anonymous and undated, but from context it appears to have been issued in the late second month or early third month of 1868, when news the approaching imperial army was causing alarm in Edo. To the right of the print are the Tokugawa loyalists. Their leader, Aizu, whose loincloth bears the mark of a local candle shop, engages in hand-to-hand combat with Satsuma, identified by the indigo splash pattern on his jacket. Other gang members splash and squirt each other vigorously. The members of the imperial army, on the left of the print, appear to have the upper hand, thanks to their more powerful water cannon. Chōshū, in the center, identified by the bush clover leaf pattern on his clothing, leads the charge. The imperial banner is in the upper left corner. On the upper right, Yoshinobu (again in a brick pattern of "ones"), takes an

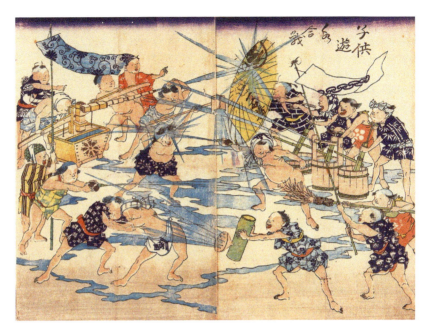

4.5. Anonymous, *Kodomo asobi mizu gassen* (Children at play: A water war), n.d. Hachiro Yuasa Memorial Museum.

active part in the fight, using an umbrella to shield others from attack. Perhaps this portrayal of Yoshinobu reflects the kind of leadership Edo citizens expected of the shogun.

In the end, however, Yoshinobu failed to fulfill the role of savior. After he withdrew to Kan'eiji, as a sign of submission to the imperial court, satirical prints poked fun at his indecisive and seemingly cowardly behavior. For example, in *Kodomo asobi takeuma zukushi* (Children at play: A battle on stilts), issued probably in early summer, two groups of children fight each other on stilts (fig. 4.6). To the right are members of the imperial army, led by Satsuma; to the left are the supporters of the Tokugawa family. Kazunomiya is holding the hand of the young emperor, who bears the imperial standard aloft. In the upper left, Yoshinobu, with in his typical pattern, is portrayed as a coward, fleeing from the action: "It is far better to run away," he says.

Another example is *Tōsei mitsuji no tanoshimi* (Enjoying the shamisen), which portrays Yoshinobu turning his back on his

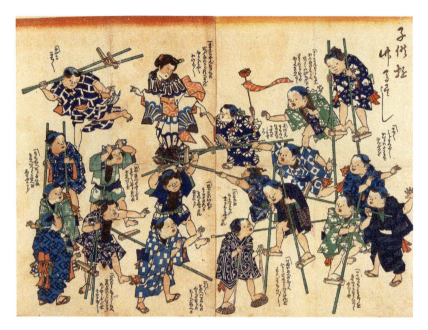

4.6. Anonymous, *Kodomo asobi takeuma zukushi* (Children at play: A battle on stilts), n.d. Hachiro Yuasa Memorial Museum.

supporters (fig 4.7). The print depicts the space of Edo as a practice room for students of the three-stringed shamisen. The teachers, shown on the right, are Kazunomiya and Atsuhime (1836–1883), widow of Shogun Iesada and adopted daughter of a former Satsuma daimyo. The students, shown in the center, are representatives of the pro-Tokugawa domains of Aizu, identified by a candle pattern, and Shōnai, by an oxalis. Also represented are two of the three Tokugawa branch families: Kii, identified by a *mikan* pattern, and Owari, by a daikon. Outside, a group of pro-imperial students seek admission to the school; they include Chōshū, who holds the boy emperor, and Satsuma. From inside, Owari looks favorably in their direction and calls: "Come on in." His actions suggest that, despite being a Tokugawa branch family, he supports the imperial cause. However, the cat, curled up below him, is suspicious: "Your heart is like a two-pronged daikon," he says. "We wonder where your true allegiance (*honne*) is." Amid this confusion, Yoshinobu, in his brick pattern of "ones," has turned his back on the

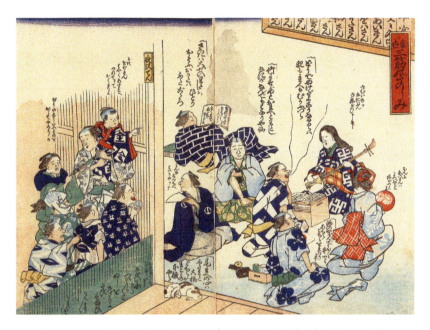

4.7. Anonymous, *Tōsei mitsuji no tanoshimi* (Enjoying the shamisen), n.d. Author's collection.

events taking place. He is reading a book on which is written: "I'll be in a real fix if I act now; better wait until later." He confirms his indecisive behavior by muttering: "There are so many of them, and I am all alone; I had better think twice about this."[11] In fact, once the imperial forces took possession of Edo Castle, the former shogun left Kan'eiji for the domain of his father, Tokugawa Nariaki (1800–1860). This print, issued probably around the time of Yoshinobu's withdrawal to Mito, reflects a sense of disillusionment at the apparent lack of leadership displayed by the Tokugawa family.

Early in the third month of 1868, the imperial army took up positions on the outskirts of Edo and an attack on the city was scheduled for the 15th of the month. However, on the 13th and 14th, Katsu Kaishū met with Saigō Takamori to negotiate a conditional surrender of Edo Castle. The negotiations remained secret, as did the deliberations over

11. Nagura, *Etoki bakumatsu fūshiga*, 41–47.

88 CHAPTER FOUR

4.8. Anonymous, *Shinsaku ukiyo dōchū* (On the road to the floating world: A reissue), n.d. Author's collection.

the terms of surrender. Unaware of these maneuvers, Edo commoners prepared for the worst; confronted with the possibility of death or destruction, some packed up and fled to the countryside. Several panic prints (*awate-e*), first issued in 1863, when the murder of a British citizen had roused fears of war, became the basis of a new set of prints issued in the spring of 1868.[12]

One example of a recycled panic print, *Shinsaku ukiyo dōchū* (On the road to the floating world: A reissue), reflects Edo residents' confusion and panic (fig. 4.8).[13] It is early spring, and cherry trees are in full bloom. A sign on the far right of the print says: "This place is called the Field of Courage." A drinking party is underway, confirmed by words

12. Minami, *Bakumatsu ishin no fūshiga*, 139. On the panic prints of 1863, see pages 58–78.
13. Minami, *Bakumatsu ishin no fūshiga*, 142–43, has a detailed examination of the print and a transcription of the words.

hidden in the grass: "Mr. Given-Up-to-Despair and Mr. I'll-Be-Alright are holding a big drinking party." A text box in front of the cherry tree explains what is going on: "The wife of one of the men who is rowdily drinking and dancing asks her husband to stop and consider their position. However, he refuses her request and tells her to close up the house and set off by herself to Move-Away Hill." Hanging over the revelers is a foreboding "dark cloud" (*yami kumo*). On Rumination Bridge, two men hesitate, "racking their brains over which way to go, forward or back." In the center left of the print is a signpost: "Go left for Panic Park." A man shouldering a big wicker chest holds his wife's hand while another pushes a heavy cart up the hill. Rising above them is Surprise Forest and a note: "People who pass through here are different from those who remain on the Field of Courage: they lack guts and are cowards." Climbing Move-Away Hill are cargo carriers and others with large packs on their backs, including an old man with a walking stick. According to the text box, "This slope leads away from the land of comfort that people have become accustomed to. Passing over Hardship Summit, it leads down to a lonely and desolate place."

Seen in the far distance at the upper left is Mt. Peaceful. The text box notes: "This is a mountain famous for its money trees. Located at its base are Rich Man's Village and Rice-Rich Village and the Temple of Abundant Harvest." The print's title suggests that the travelers are on the "road to the floating world" (*ukiyo dōchū*), but will anyone make it to Mt. Peaceful? Probably not. Like other political cartoons of the day, *Shinsaku ukiyo dōchū* contrasts present-day realities with the "floating world," a carefree place in which people live in comfort, without worries for their future. Its anonymous creator draws on the dual nature of the word *ukiyo*, at once "this floating world" 浮世 and "this wretched world" 憂き世.[14] Which *ukiyo* defines the world of the people of Edo in 1868? The dark cloud hanging over their heads leaves little doubt: the world as they knew it is about to come to an end—and there appears to be no escape.

Fortunately for Edo and its inhabitants, in the fourth month, rumors of the negotiations between Katsu and Saigō began to circulate,

14. See "Tokugawa Literature," 134; Barber, "Tales of the Floating World," 25.

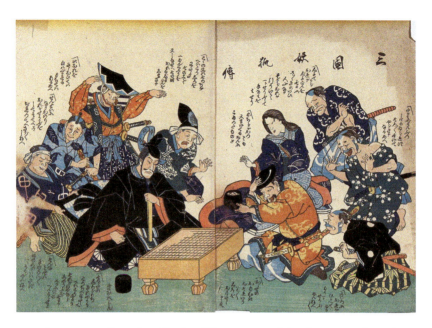

4.9. Anonymous, *Sangoku yōko den* (The romance of the three countries and the magic fox), n.d. Author's collection.

relieving many and angering others. An anonymous and undated satirical cartoon depicts the moment when Edo Castle was surrendered to the imperial army. Entitled *Sangoku yōko den* (The romance of the three countries and the magic fox), it parodies a scene from the fourth-century Chinese historical novel *The Romance of the Three Kingdoms*, in which victory in a decisive battle was portrayed as a skillful chess move (fig. 4.9). The cartoon uses the chess metaphor to depict Edo Castle's surrender. The player on the left is the emperor, identified by the chrysanthemum crest on the hem of his court robe. He is surrounded by men from Satsuma, Chōshū, Tosa, and Owari; the Tokugawa branch family of Owari is identified by the iconic dragon-like creature on his clothing. The player on the right, dressed in Chinese fashion, is Yoshinobu. The Chinese dress reflects both the print's exotic theme and Yoshinobu's reputed pro-Western views. (At the time, the word *tōjin*, or "Chinese people," referred to foreigners in general.) Yoshinobu is humbly handing over the white stones, a symbolic gesture of defeat, to his opponent. The phrase *shiro o watasu*

(hand over the white stones) is a homophone for "hand over the castle." Yoshinobu's supporters, Sendai and Aizu, watch in disbelief and plead for another match. The widow Atsuhime, who has intimate connections with both sides, looks on anxiously: "Whoever wins or loses, it will be truly distressing."

As imperial forces took possession of Edo Castle and the former shogun left for Mito, some Tokugawa troops were already defying orders to remain in place. Taking their weapons, they joined pro-Tokugawa supporters in the northeastern provinces, where they carried out resistance operations with some initial success. Within Edo, conditions remained unstable. Newly burdened with the maintenance of law and order, the imperial army was obliged to rely on former Tokugawa officials such as Katsu Kaishū. Meanwhile, a group of young Tokugawa loyalists, the Shōgitai, set up their headquarters at Kan'eiji, recently vacated by Yoshinobu. Originally employed to help keep the peace, they soon became agents of urban unrest, launching forays against the imperial occupiers.[15] One month after the surrender of Edo Castle, Katsu's diary reflects deep anxiety over conditions in Edo:

> The people in the city are seized with apprehension and follow blindly any wild argument. Because of this, noisy ruffians look and commit murders. . . . Merchants have closed their doors, and the impoverished people have lost their means of livelihood. The streets at night are deserted. Is this not a sign of the degenerate world?[16]

The breakdown of law and order in Edo and the growing strength of the Shōgitai threatened the new government's legitimacy. Action was required. Ōmura Masujirō (1824–1869) from Chōshū made the decision to attack the Shōgitai. At dawn on the 15th day of the fifth month, the imperial army opened fire on the stronghold at Ueno Hill. By nightfall, Kan'eiji lay in ashes, and the northeastern section of Edo was in flames. The Battle of Ueno Hill was a decisive turning point in the Boshin Civil War, giving the new government undisputed control of Edo.

15. Steele, "The Rise and Fall of the Shōgitai."
16. *Katsu Kaishū zenshū*, 19:57.

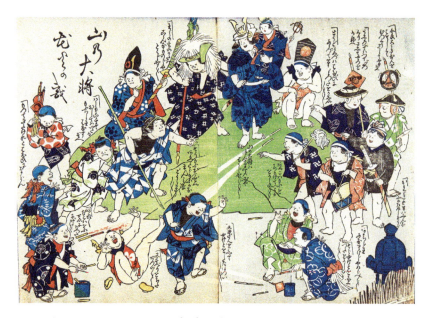

4.10. Anonymous, *Yama no taishō hanabi no nigiwai* (Children playing king of the mountain with firecrackers), n.d. Hachiro Yuasa Memorial Museum.

Among the numerous satirical cartoons that focus on the Battle of Ueno Hill is *Yama no taishō hanabi no nigiwai* (Children playing king of the mountain with firecrackers) (fig. 4.10). This anonymous and undated print, probably issued soon after the battle, shows children playing a popular game in which players attempt to knock the current king off the mountain and take his place. Satsuma and Chōshū are at the top of the peak, with Chōshū holding the boy emperor aloft. However, Aizu and other Tokugawa supporters, located lower down, are not ready to give in and appear determined to retake the mountain. Firecrackers are exploding noisily everywhere. These explosions are an obvious reference to the roar of the Armstrong cannon and the barrage of Snider guns that secured the imperial victory at Ueno Hill on that fateful summer day.

The defeat of the Shōgitai and the outbreak of hostilities in the northeast heightened unease in Edo. One satirical cartoon portrays the depressed state of people caught in the middle of a civil war: *Ichinagashi ukiyo yokuaka* (Rinsing away greed and grime in the bathhouse

THAT TERRIBLE YEAR 1868

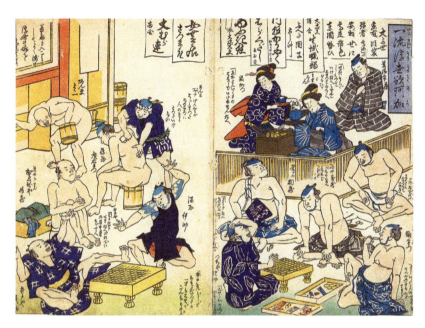

4.11. Anonymous, *Ichinagashi ukiyo yokuaka* (Rinsing away greed and grime in the bathhouse of the floating world), n.d. Author's collection.

of the floating world) (fig. 4.11).[17] The Edo-era bathhouse was often represented as a space where people could enjoy themselves and express their naked opinions on everyday affairs. The bathhouse of the print, however, is not a happy place. In the upper right corner, the bathhouse owner, identifiable as Yoshinobu by the brick pattern of "ones," looks downcast. He can think only of leaving the city: "These times are so bad I can't make a living. I'll have to close the shop and move to the countryside." The bathers, who include supporters on both sides of the civil war, boast of their military prowess. The two women attendants, Kazunomiya and Atsuhime, look on. Kazunomiya, in the floral print kimono, laments: "All this talk of war is really

17. The title suggests a connection with Shikitei Sanba's 1809 comic novel *Uki-yoburo*. See Leutner, *Shikitei Sanba and the Comic Tradition*. My translation of the title attempts to take account of word plays and homophones. The Museum of Fine Arts, Boston uses "A Stream of Desire in the Floating World."

distressing." On the wall above them, strips of paper are hung with messages such as:

"What's in abundance? Military uniforms."
"What's cheap? Copper coins."
"What's expensive? Everything."

And, referring to the civil war underway, "The East looks strong."

On the 6th day of the fifth month, days before the Battle of Ueno Hill, Aizu, Sendai, Yonezawa, Shōnai, and other pro-Tokugawa domains formed a league to resist the imperial forces. Conflicting reports of battles and bloodshed reached Edo in rapid succession. Who was fighting whom, and why? A satirical cartoon entitled *Tomo kenka* (A fight among friends) depicts the war as a street brawl among blind men (fig. 4.12). Anonymous and undated, it was probably issued in the hot summer months of intense fighting. Unlike earlier cartoons, there are no clear sides; it is impossible to tell friend from foe. In the center of the melee and seemingly under attack from all sides, Satsuma shouts out in defiance: "I'll take the prize and rise to the top, and if anyone stands in my way, I'll crush him!" Chōshū, identified by the butterfly on his sleeve, pulls at Satsuma's leg. Aizu, identified by a pair of crossed candles, grapples with Satsuma; unwittingly, he strikes his former master, Yoshinobu, causing a large welt on his head. At the same time, the former shogun is being bitten by a dog. What confusion! Viewers of this cartoon, while laughing, would have been hard pressed to pick the winning side; the civil war made no sense.

During 1868, the city of Edo underwent a transformation. Early in the year, most daimyo, their families, and their retainers had returned to their domains. In the summer, former Tokugawa retainers and their families left on foot for their new home in Shizuoka. By early autumn, the exodus of samurai and commoners had depleted the city's population, once around one million, to about six hundred thousand. Meanwhile, from the summer months, increasing numbers of imperial troops were stationed in Edo, making it the headquarters of the new imperial government. This arrangement was formalized on the 17th day of the seventh month, when, at the suggestion of Ōkubo

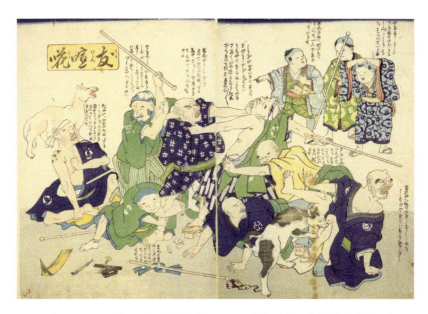

4.12. Anonymous, *Tomo kenka* (A fight among friends), n.d. Digital Collections, National Diet Library of Japan.

Toshimichi (1838–1878), the city's name was changed to Tokyo, the eastern capital.

A satirical cartoon, *Tōsei nagatchiri na kyakujin* (Guests who have overstayed their welcome), produced by Hiroshige III and issued in the eighth month, reflects a sense of frustration at the extended military occupation of the city (fig. 4.13). The setting is a tea house named the Eastern Pavilion, a reference to the newly named Tokyo. In the upper right of the print, lingering over their meal, are Satsuma, Chōshū, and Tosa and the chief guest Prince Arisugawa Taruhito (1835–1895), then the commander in chief of the imperial army and de facto governor of Tokyo. Satsuma is identified not by the usual indigo splash pattern but by a basket weave (*kagome*) pattern, recalling his hometown of Kagoshima. In a drunken state, he sings a popular imperial army marching song as others join in the chorus: "Miya-sama, Miya-sama / What's that fluttering in front of your noble horse? / Know you not? / It's the imperial brocade banner / *Tokoton*

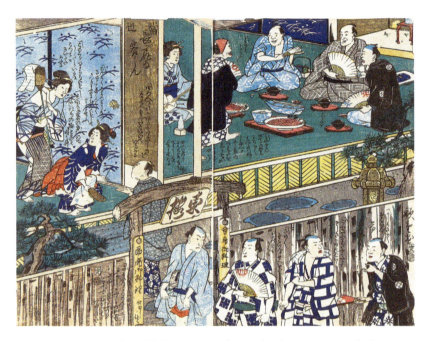

4.13. Utagawa Hiroshige III, *Tōsei nagatchiri na kyakujin* (Guests who have overstayed their welcome), n.d. Author's collection.

yarena."[18] The shamisen-playing geisha is identified by the rice field character on her kimono as Tayasu Yoshinori (1828–1876), father of the six-year-old Kamenosuke, who had been made successor to the Tokugawa family. He is forced to sing along: "*Ariya ariya / tokoton tokoton*." At the entrance, the tea house operators, Kazunomiya and Atsuhime, are determined to get rid of their overstaying guests: "Oh my, oh my. Those dreadful guests have stayed here long enough. Let's jinx them to make sure they hurry away." Kazunomiya turns their sandals upside down, suggesting that this will send them home. Atsuhime resorts to another remedy: "I think this spell will do the trick; they will learn their lesson and leave." She points to an upside-down

18. The imperial army marched on Edo to the beat of the Miya-sama song, attributed to Shinagawa Yajirō (1843–1900). It later made its way to England, incorporated into Gilbert and Sullivan's *The Mikado*. For a description and lyrics, see Walthall and Steele, *Politics and Society*, 132–37.

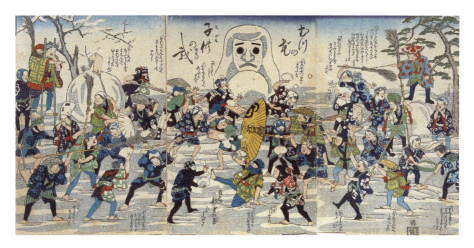

4.14. Utagawa Hiroshige III, *Mutsu no hana kodomo no asobi* (The flowers of Mutsu: Children having fun), tenth month, 1868. Hachiro Yuasa Memorial Museum.

broom with a wet rag on it—a sure strategy for dealing with guests who outstay their welcome. Waiting at the pavilion gate to replace the unwanted guests are Sendai, Aizu, Yonezawa, former shogun Yoshinobu, and Shōnai. At the time this print was issued, the northeastern domains were under siege and would soon be forced to surrender to the imperial forces, but the print suggests that residents of the city that was once Edo still held out hope for the old regime's return.[19]

Another satirical cartoon by Hiroshige III reflects hope for a different ending to the year of conflict. *Mutsu no hana kodomo no asobi* (The flowers of Mutsu: Children having fun), issued in the tenth month, was one of the last of the civil war prints (fig. 4.14). Already, the imperial forces had defeated Yonezawa domain early in the ninth month. After a month-long siege, Aizu was defeated on the 22nd of the ninth month. Shōnai announced its surrender on the 25th and Morioka on the 28th, signaling the defeat of the league of northeastern domains. The print, however, presents an alternate reality. Snow falls like blossoms in the far northeastern province of Mutsu. Directed

19. Nagura, *Etoki bakumatsu fūshiga*, 222–25; Asano and Katō, *Genten de tanoshimu*, 136–37.

by Rinnōji-no-miya (1847–1845), shown in the upper right corner, the league of northeastern domains engages in a snowball fight with the imperial army.[20] The imperial side is under the command of Prince Arisugawa, who is shown on stilts in the upper left corner, carrying the boy emperor on his back. In this imagined rematch, the northeastern domains appear to have the upper hand. The domains of Morioka, Shōnai, Aizu, Yonezawa, and Sendai are fighting with determination and optimism. Even the former shogun, Yoshinobu, strikes a defiant pose, replaying the heroic role he displayed in the water war print, *Kodomo asobi mizu gassen*, issued early in the year. Both eyes of the giant daruma snowman are painted in, suggesting that the Tokugawa side has been granted its victory wish.[21]

The reality of military victory over the northeastern league prompted the new government on the 8th day of the ninth month to announce the change in era name to Meiji. Soon after, the young Emperor Meiji left Kyoto with a retinue of some 2,300 persons, arriving in Tokyo twenty-two days later. People bowed as the emperor passed through the streets, and cheap woodblock prints commemorated the event. One example is *Tōkyō Edo Shinagawa Takanawa no fūkei* (A scene of Shinagawa and Takanawa in Tokyo-Edo) by Utagawa Kuniteru (1830–1874), which is dated the tenth month of 1868 and bears an official censorship seal (fig. 4.15). Like the snow fight in Mutsu, the view of the imperial procession was imagined; indeed, it was issued ahead of the event as advertisement and souvenir. In contrast to the rowdy violence and humor of the satirical cartons, this woodblock print conveys a sense of tranquility, order, and pageantry, signaling an end to a year of bloody warfare. The bay is calm, with cargo-bearing boats and one larger foreign ship floating quietly. Even the artificial islands lack any hint of their original military purpose. The grand imperial ox cart, surrounded by a retinue of imperial attendants, is shown in

20. Rinnōji-no-miya, also known as Prince Kitashirakawa Yoshihisa, was brother-in-law to Emperor Kōmei, uncle to Emperor Meiji, and abbot of Kan'eiji. After the Battle of Ueno Hill, he fled north with the Tokugawa supporters and, under the name of Emperor Tōbu, became the nominal head of the league of northeastern domains.

21. Nagura, *Etoki bakumatsu fūshiga*, 234–40.

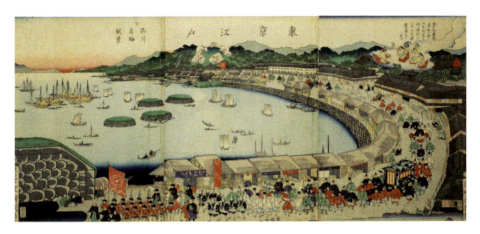

4.15. Utagawa Kuniteru, *Tōkyō Edo Shinagawa Takanawa no fūkei* (A scene of Shinagawa and Takanawa in Tokyo-Edo), tenth month, 1868. Author's collection.

the lower right, proceeding slowly near the front of the procession. People bow to the invisible emperor inside.[22] The use of perspective in depicting the Tōkaidō as it curves around Shinagawa, the entry point into the capital, makes the grand imperial procession appear endless. In the distance, the rising sun blesses the event, and the local gods, shown in the upper right corner, welcome the emperor: "The gods from around the city of Edo extend their welcome. They offer escort and protection along the route of the imperial procession."

On the 23rd day of the tenth month, two weeks after the emperor's entry into Tokyo, sake was distributed, and a two-day holiday was declared as an unusual but effective strategy designed to win over the hearts of Edo residents.[23] The wine was carried in the manner of festive god-carts decorated with banners proclaiming that the sake had been bestowed by the emperor. The streets were decorated with freshly cut bamboo and pine as though for New Year festivities. This was an occasion to cast off the dark cloud that had hung over the city

22. On the invisibility of the emperor in early Meiji prints, see Fujitani, *Splendid Monarchy*, 166. By contrast, the satirical prints of 1868 freely depicted the emperor as a young boy, even as a baby, requiring adult protection and guidance.

23. Nagura, *Nishiki-e kaiseki*.

throughout the year. For the residents of the new eastern capital, it marked the end of a terrible year.

Conclusion

Although Itō Hirobumi, speaking in 1872, argued that the Meiji Restoration was achieved "without firing a gun or shedding a drop of blood," the satirical cartoons examined in this chapter suggest a less peaceful transition of power. The Boshin Civil War, like the American Civil War and the Italian and the German wars of unification, all fought in the 1860s, was won by soldiers, rifles, cannon, killing, and property destruction. The death toll of Japan's civil war was over eight thousand, not comparable with the more than six hundred thousand soldiers who died in the American Civil War, but bloody enough.

A few contemporary woodblock prints offered direct depictions of the destruction, displacement, and death of 1868. One example is the anonymous *Shinkei hōseiki* (Chronicle of the world of divine grace), which, though undated, was most likely issued in the autumn of 1868 (fig. 4.16). Judging from style, the artist was probably Tsukioka Yoshitoshi (1839–1892), famous for his so-called bloody prints (*muzan-e*).[24] The print shows a vision of 1868 as apocalypse. The imperial banner in the upper right corner discharges a deadly bolt of light. Surrounding it, various gods, including the sun goddess Amaterasu, as well as deified court nobles and warriors, strike defiant poses. The blue banner of Satsuma flutters above the title panel. In the center top of the print, other heavenly beings, including long-nosed, winged *tengu* goblins, cast malevolent spells; one *tengu* scatters religious amulets bearing the name of Daijingū, the Ise Grand Shrine. Below him, Daikokuten, the god of good harvest, joins the attack; further down, Shōki, the demon queller, raises his sword. From the bottom right, real-world soldiers, including Satsuma and Chōshū, aim cannon at the Tokugawa forces on the left. With devastating results,

24. Yoshitoshi was eyewitness to the Shōgitai's defeat at the Battle of Ueno Hill and sketched the bloody bodies of the dead Tokugawa loyalists. See Koike and Ōuchi, *Tsukioka Yoshitoshi*; Stevenson, *Beauty and Violence*.

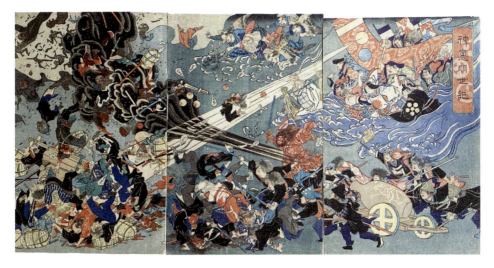

4.16. Anonymous, *Shinkei hōseiki* (Chronicle of the world of divine grace), n.d. Author's collection.

the cannon blast merges with the heavenly bolt of light. At the bottom center, troops advance with sword and lance. On the Tokugawa side, evidently no one has survived. The mangled corpse of the last shogun, Yoshinobu, identified by his brick-pattern of "ones," lies on a pile of bodies. Even among bloody prints, this depiction of death and devastation has few rivals in Japanese woodblock prints of the mid-nineteenth century. The scene of carnage, replete with corpses and body parts, raises the question of the title. *Shinkei hōseiki* 神恵朋世記 may be translated as the "Chronicle of the World of Divine Grace," but when word plays and homophones are considered, the title becomes 真景崩世期, pronounced the same (*shinkei hōseiki*), but this time meaning "A True Portrait of a Disintegrating World."

Like the bloody prints, the satirical cartoons of 1868 relied on techniques of exaggeration and caricature to depict a year of extraordinary violence. Children were featured, but the children at play were men at war; pop guns were rifles; water pumps and bags of fart were powerful cannon; and the dream of the "floating world" was the nightmare of life in a "wretched world" of gloom and unease. But while the direct depiction of violence in the bloody prints demanded

a strong visceral response, the satirical cartoons invited a more complex set of emotional responses. Through humor, satire, and snippets of information, they presented a distorted mirror of society through which viewers could reflect on their own situation. Although late Tokugawa satirical prints were rarely a call to action, their very cute charm and wit encouraged a critique of what could be perceived as the childish behavior of the warrior class.

Satirical cartoons are extraordinary historical documents that provide a "record of how public matters struck a people at the instant of their happening."[25] Fanciful, sharp-witted, and provocative, Japanese civil war cartoons offer insight into the reality of bloodshed, dislocation, and unease that was the common experience of ordinary people in that terrible year, 1868.

25. Spielmann, *Cartoons from "Punch"* (1906), as quoted in Kemnitz, "The Cartoon as a Historical Source," 81.

CHAPTER FIVE

Negotiating Modernity: Sada Kaiseki and the Movement against Imported Goods

This chapter takes a new look at the old story of Japan's westernization in the Meiji era. It focuses on the thought and activities of Sada Kaiseki, a Buddhist thinker and activist who supported the call to "expel the barbarians" (jōi) before the Meiji Restoration and emerged as the leader of a spirited movement in the 1870s and early 1880s to halt the import of Western goods into Japan. Sada offered a vision of Japan's future disentangled from deep ties to the West. He urged a policy of enriching the country and its inhabitants by developing Japan's distinctive economic and cultural resources.

I first became aware of Sada in the late 1990s, when I was assigned to teach a course on "The Modernization of Japan." The course description I inherited, written probably in the 1970s, focused on the singular success of Japan's modernization. I had just purchased an 1873 woodblock print, included in this chapter, that showed the early Meiji period as a battleground between the forces of tradition and change. This led me to Sada Kaiseki and his campaign against westernization, which encouraged me to focus the class on Japan's more contradictory and ambiguous experience with modernity.

As Sada's thought and activities show, the early Meiji years were marked by serious debate over questions of national identity and the direction of Japan's future. Sada argued against adopting Western "civilization and enlightenment" maintaining that Japan should preserve its own distinct civilization and enlightenment. He criticized the shortsighted economic thinking that produced tremendous profits for the importers of foreign goods, warning that, in the long run, imported goods would lead to loss of cultural identity and to national

bankruptcy. Sada's conservatism was more than an emotional attachment to times past: it demanded a new economics to create a better future.

Although Sada's name is hardly known today, his views, well-known in his day, show the complex and contested reality of Japan's modern transformation. This chapter draws on my previous work on Sada in the early Meiji period.[1]

In the late 1860s, Fukuzawa Yukichi coined the phrase "civilization and enlightenment" to denote what he believed to be a new stage in human history, one developed first in Western countries and characterized by advances in science and industry and by a transformation in morality and politics. Fukuzawa's best-selling *Seiyō jijō*, published between 1866 and 1870, described these new institutions and ideas and proposed them as templates for national reform in Japan.[2] Following the 1868 Meiji Restoration, "civilization and enlightenment" emerged as the quintessential slogan for Japan's quest to catch up with the West.

However, the effort to transform Japan along Western lines did not proceed unchallenged. Opinion leaders inside and outside government launched powerful arguments on behalf of civilization and enlightenment as a keystone of national policy, but other, less dominant voices warned against change. As an 1873 woodblock print by Utagawa Yoshifuji (1828–1887) suggests, the early Meiji period was a battleground, sometimes literally so, between the supporters of tradition and change (fig. 5.1). The print depicts various contests underway: the *jinrikisha* versus the palanquin, Western umbrellas versus Japanese parasols, Western shoes in contest with Japanese wooden *geta*, the postbox struggling with the overland runner, and, prominently, the bright lights of the West grappling with Japanese lanterns and candles.

1. Steele, "Casting Shadows on Japan's Enlightenment"; Steele, "Nosutarujia to kindai."
2. A. Craig, *Civilization and Enlightenment*, 144–65.

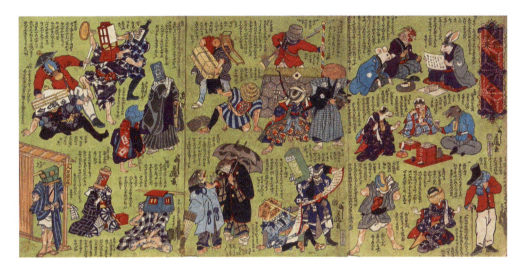

5.1. Utagawa Yoshifuji, *Honchō hakurai nigiwai dōgu kurabe* (A contest between things foreign and native), 1873. Author's collection.

One early Meiji opponent of westernization for whom Japanese lanterns and candles were especially important was the Buddhist thinker Sada Kaiseki.[3] He was born into the Hirose family of Buddhist priests in a small village of Kumamoto domain and was later adopted as successor to the head priest of Shōsenji temple, whose family name was Sada. Since Shōsenji was in the castle town of Kumamoto, Sada had access to advanced studies at the domain academy, where he concentrated on Confucian classics. At the age of eighteen, he moved to the prestigious Nishi-Honganji in Kyoto and devoted himself to a study of Buddhist cosmology, while also delving into nativist studies (*kokugaku*) and Dutch studies (*rangaku*). He also trained in Zen at Nanzenji. Sada's initial fame came as a critic of Western astronomy. In 1862, he wrote a monumental defense of Indic astronomy, rejecting the notion that the earth revolved around the sun. After the Restoration,

3. On Sada's life and thought, see Tanikawa, "'Kijin' Sada Kaiseki no kindai"; Oku, *Bunmei kaika to minshū*; Tanaka Satoshi, *Kaibutsu kagakusha no jidai*; Honjō, "Sada Kaiseki no hakuraihin." On his interest in astronomy, economics, and cultural politics, see Rambelli, "Sada Kaiseki"; Rambelli, "Buddhism and the Capitalist Transformation."

he moved to Tokyo, and at the same time that Fukuzawa and others were spreading the gospel of westernization, Sada emerged as a champion of conservative causes.

A charismatic speaker, Sada toured the Japanese countryside with his message of opposition to westernization, predicting that the importation of foreign goods, ideas, and religion would cause the cultural and economic bankruptcy of Japan. Adopting techniques of the freedom and people's rights movement and using the new mass media to spread his message, he held speech meetings, submitted petitions, established associations, and wrote popular books and newspaper editorials. He was especially concerned about the introduction of Western lamps. In the rhetoric of civilization and enlightenment, the spread of Western lighting devices could be equated with the "bright" rule of the Meiji emperor and the end of a dark and barbaric past. Coal oil lamps and gas streetlights thus emerged as central symbols of Japan's push toward modernity; Sada saw them, however, as agents of national collapse. As an antidote, Sada argued the need to strengthen Japan's own civilization and enlightenment, arguing on behalf of autarky, or self-sufficiency, and an economy that depended more on domestic production and consumption than on international linkages.

This chapter focuses on the final decade of Sada Kaiseki's extraordinary career, the ten years before he died in 1882 at the age of sixty-four. It focuses on his economic thought, his critique of westernization, and his campaign to create an alternate future for Japan.

Critics of Westernization

Opposition to westernizing reforms was widespread in the early years of the Meiji government. Schools were set on fire by local people who resisted the imposition of a new educational system, and a number of "blood tax" riots followed the announcement of mandatory national conscription.[4] Writers, poets, and artists also gave voice to those in

4. Platt, *Burning and Building*; Figal, *Civilization and Monsters*; Ravina, *The Last Samurai*; Vlastos, "Opposition Movements in Early Meiji."

"modernizing Japan" who failed to embrace modernity.[5] In his 1871 short story *"Aguranabe"* (Sitting cross-legged at the beef pot), the author and journalist Kanagaki Robun (1829–1894) offered a comic discourse on the virtues of beef eating: "Samurai, farmer, artisan, or trader; / oldster, youngster, boy or girl; / clever or stupid, poor or elite, / you won't get civilized if you don't eat meat!"[6] Seeming to advocate Western-style cuisine, Robun was in fact striking a blow at Fukuzawa's definition of civilization and enlightenment. Another powerful critic, the illustrator and woodblock print artist Kawanabe Kyōsai (1831–1889) issued a satirical cartoon series, *Kyōsai rakuga* (Kyōsai's drawings for pleasure), in 1874. One cartoon shows monsters learning how to be civilized in a "school for spooks" (*bakebake gakkō*). In another, the Buddhist god of fire, Fudō Myōō, reads a modern newspaper while an acolyte cuts up his meat. Enma, hell's gatekeeper, has his hair cut in Western fashion so that he can wear a top hat; other demons are having their horns cut off.[7]

Mantei Ōga, a prolific comic writer, was Kyōsai's close friend and collaborator. In the early 1870s, he wrote a series of attacks on the new modernity, many of them directed against Fukuzawa Yukichi.[8] The main character of his 1874 novella *Kinsei akire gaeru* (A toad fed up with modernity) is a giant toad who stands guard at a deserted pond in central Tokyo.[9] The pond has become polluted because butchers dispose of blood and meat waste in it at night. The toad warns people not to drink the polluted water and lectures them on his various disappointments with the new age. An illustration by Kyōsai shows the toad expressing his opinion on gas streetlamps: "The new night lights illuminate the way for passersby but fail to shed light on the darkness of the human soul" (fig. 5.2). As John Mertz notes, "The image of the 'fed up toad' is a displacement of Ōga's own desire to make his readers aware of the devastating consequences of modernization."[10]

5. Nara, *Inexorable Modernity*; Jordan, "Potentially Disruptive," 17–47.
6. Mertz, *Novel Japan*, 1.
7. T. Clark, *Demon of Painting*, 126–27.
8. Mertz, *Novel Japan*, 68–78.
9. Okitsu, *Meiji kaikaki bungakushū*, 1:197–200.
10. Mertz, *Novel Japan*, 77.

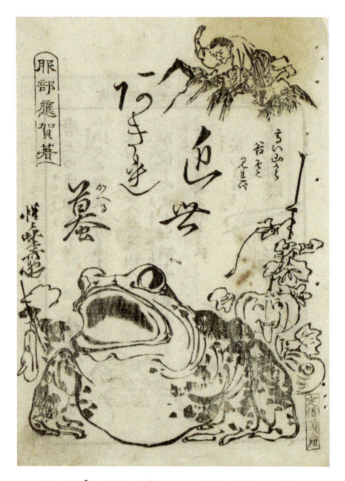

5.2. Mantei Ōga, *Kinsei akire gaeru* (A toad fed up with modernity), 1874. Illustration by Kawanabe Kyōsai, 1874. Author's collection.

In 1875, Ōga issued a damning parody of Fukuzawa's popular text *Gakumon no susume* (An encouragement of learning). The opening lines of Ōga's book, *Gakumon suzume* (Sparrows at the gates of learning), were a frontal attack on Fukuzawa: "Heaven does create some people above and others below!" A translation of the first installment of Ōga's parody of Fukuzawa's most famous work follows in chapter 6.

Sada Kaiseki and the Movement to Reject Imported Goods

Among the critics of Meiji westernization, Sada Kaiseki stands out as an activist intellectual whose arguments were founded on Buddhist theology and cosmology and on views of national affairs, which he developed in the closing years of the Tokugawa era. After the opening of foreign trade and relations in the 1850s, Sada's Buddhist ideas took on a new urgency. Equating the duty of "protecting the dharma" (*gohō*) with that of "protecting the nation" (*gokoku*), Sada was concerned about warding off what he saw as harmful Western influences.[11] In 1862, he wrote a rebuttal of a foreign geography primer, *Chikyū setsuryaku* (Outline of the earth), that had been published two years earlier in Japanese translation.[12] Originally written in Chinese by an American missionary, the primer stated unequivocally that the world was round and that the earth moved around the sun. Not only did Sada reject the book's reliance on Copernican astronomy, but he was also incensed by its statement that Japanese people had cowered before the power of American warships in agreeing to open their country to foreign trade. Under the provocative title *Tsui chikyū setsuryaku* (Smashing outline of the earth), Sada countered Western heliocentrism, using both spherical earth theory and Buddhist cosmology to support his view of the cosmos.

Saka also became an active participant in national politics in the 1860s, linking his criticism of Western cosmology with a denunciation of Western political and economic activities. Rising to defend the physical and cultural space of his world, he developed sympathies with the "expel the barbarian" movement. In 1863, tensions mounted between the shogunate and pro-imperial activists, and there were rumors in Kyoto and Edo that the shogun was planning a military expedition against Chōshū domain (chapter 2). Sada sympathized with Chōshū's demand to close Japan to foreign trade, but he feared that civil war would invite further Western encroachment. Using his association

11. Tsunezuka, "Sada Kaiseki no ningenkan," 22.
12. Iwane, "*Chikyū setsuryaku*," 125–31; Tanikawa, "'Kijin' Sada Kaiseki no kindai," 67.

with Nishi-Honganji, which allowed him to communicate directly with high-ranking officials, Sada addressed an unsuccessful petition to Hitotsubashi Yoshinobu, the future shogun, and to Matsudaira Yoshinaga (1828–1890), the powerful daimyo of Kaga domain. He urged them to stop hostilities and focus instead on enriching the country. He offered to travel to Chōshū to help negotiate a peaceful settlement:

> At this time, while we make the foreign barbarians our enemies and conduct a policy of "expelling the barbarians," we must work above all to realize a policy of "national enrichment" (*fukoku*). Quarrelling among ourselves will achieve nothing; instead, it will only play into the hands of the foreign barbarians.[13]

In the years following, Sada is known to have lodged as many as thirty petitions to Tokugawa authorities and to the imperial court. His outspoken views roused sufficient suspicion that he was reportedly arrested and punished on numerous occasions.[14]

In 1870, at age fifty-two, Sada moved to Tokyo, where he continued his campaign on behalf of national enrichment. He no longer spoke of "expelling the barbarians," but taking cues from other critics of the Meiji regime's westernizing policies, he shifted his focus to the protection of Japan's distinctive culture and economy. As in the 1860s, he submitted petitions to the government, this time, however, as a private citizen, often publicizing them in newspapers. In his first petition, *Fukokuron* (On enriching the country), presented in 1873, he urged the repayment of foreign loans, the return of cash used to buy foreign goods, and the accumulation of foreign cash reserves through the export of distinctively Japanese products.[15]

Sada expanded his argument in a massive sixty-five-thousand-character petition, organized in twenty-three articles, that he submitted the following year.[16] Concerned by government debt and widespread poverty, he urged a fundamental change in national policy: instead of

13. Umebayashi, "Sada Kaiseki ryaku nenpyō," 5.
14. Honjō, "Kaidai-hen," 8.
15. Tanikawa, "'Kijin' Sada Kaiseki no kindai," 70.
16. The text of the petition is in Irokawa, *Meiji kenpaku shūsei*, 3:926–31.

emulating the West, the new government should strengthen Japan's own economic, environmental, and cultural resources. Challenging the basic premise of the thinking advanced by Fukuzawa and others, he wrote: "What is called 'civilization and enlightenment' is not confined to the West. The West has unique Western aspects to its civilization and enlightenment; likewise, Japan has unique Japanese aspects to its civilization and enlightenment." Sada pointed to the Western fascination with novelty: "Western people place value on newness and look down on things that are old; Japanese and Chinese people place value on age and look down on things that are new." Rather than invention, he argued that gradual refinement over time was the basis of Japan's civilization and enlightenment:

> In general, civilization and enlightenment depend upon advances in the quality of products over time. A country's products may originally be coarse but, after a way to purify and beautify them is opened, they become useful to the people of that country. Such is the nature of civilization and enlightenment. . . . Opening a path by which what is coarse is transformed into something pure and beautiful and what is useless is transformed into something useful can be called our Japan's own civilization and enlightenment.

In listing the differences between Japan and the West, Sada acknowledged Western superiority in some areas: "Westerners excel in making things by machine; Japanese excel in making things by hand." Moreover, "Westerners have a great passion to trade with foreign countries, whereas we Japanese are still immature, underdeveloped, and lacking in spirit." Sada praised the quality of Japanese goods, however, precisely because they were made from Japan's own natural resources: "Products imported from overseas are all manufactured (*jinkō*) whereas the products Japan ships overseas are, for the most part, natural (*tenkō*)." It was these specifically Japanese products that, in Sada's argument, formed the basis of national enrichment. In other words, Japan should reject imports and focus on expanding the consumption of domestic goods.

In 1878, Sada published a book entitled *Saibai keizai ron* (An argument on nurturing the economy) that won much praise from a

range of politicians, journalists, and scholars, including bureaucrat Inoue Kowashi (1844–1895), historian Shigeno Yasutsugu (1827–1910), diplomat and journalist Kurimoto Jōun (1822–1897), and even Nakamura Masanao (1832–1891), the translator of Samuel Smiles's *Self Help* and founding member (in 1874) of the Meirokusha, an intellectual society devoted to the popularization of Western ideas.[17] Sada's book was published in the same year that the liberal economist Taguchi Ukichi (1855–1905) issued his *Jiyū kōeki Nihon keizai ron* (A discussion of free trade and the Japanese economy). Both authors stressed the need to "enrich the country"; Sada, however, reprised his argument that Japan's enrichment depended on the promotion of domestic, rather than international, commerce and manufacture.

Sada noted that the ways different countries carried out economic exchange depended on time, place, climate, culture, and physical environment.[18] Accordingly, although Western countries maximized foreign trade over the domestic market, Japan's particular civilization and enlightenment demanded that priority should be given to the domestic economy and that trade relations with foreign countries should be limited. Sada recognized agriculture as the basis of the Japanese economy, but he was no agrarian fundamentalist. His book offers many examples of wealth gained through the spread of new techniques and new technologies. Moreover, in contrast with earlier Confucian economic thinking, he stressed the importance of consumption, declaring that money spent on luxury goods, and even on prostitutes, would enrich the country. The key was to avoid the lure of foreign goods, which would harm rather than help the economy. He was thus in favor of growth, change, new products, and new techniques so long as they contributed to Japan's cultural and economic integrity; in this point, like his archrival Fukuzawa, he was very much a child of the enlightenment.

Sada's movement to resist the intrusion of foreign goods attracted widespread attention. He was an impressive orator, and up to the moment of his death (while lecturing to an audience in Jōetsu) in 1882, he spoke to packed audiences in merchant shops and homes, public halls,

17. Sada, *Saibai keizai ron*; reprinted in Honjō, *Sada Kaiseki: Saibai keizai ron*. For a detailed analysis, see Rambelli, "Sada Kaiseki," 117–26.

18. Sada, *Saibai keizai ron*, 1, 5.

schools, and temples throughout Japan, day after day, and sometimes twice a day.[19] His speeches invariably warned that imported goods would destroy the country. In February 1880, he spoke twice in the Mita Lecture Hall on the campus of Keiō Gijuku, founded by Fukuzawa. After Sada's February 28 lecture "Fukoku sanpō" (The three principles of enriching the country), Fukuzawa delivered a speech "Kangaku no setsu" (On Chinese studies).[20] During the last three years of his life, Sada founded, or was linked with, some twenty associations, many having nationalistic names such as Aikokusha (Patriotic Society), Hōkokusha (National Service Society), Gokokusha (Protect the Country Society), and Yūkokusha (Country First Society). Associations in Tokyo, Osaka, and Kyoto successfully recruited members from Japan's conservative political, economic, and academic elite. Some boasted membership rosters that far outstripped the political clubs and societies that were being founded to promote liberty and popular rights. The Osaka National Service Society, founded in 1880, had some 54,625 members and over eighty branch organizations in and around the city. Its statement of purpose included the warning that imported goods would impoverish Japan materially and culturally.[21]

In January 1880, Sada issued a woodblock print as a visual aid to reinforce his message (fig. 5.3). Entitled *Fukoku ayumi no hajime* (First steps toward a wealthy country), the print includes both illustration and text. The illustration represents the island of Japan as a steamship loaded with an extraordinary assortment of foreign goods introduced into the country since the opening of international trade. From left to right, the items include Western dogs; Chinese goods, including books, stationery, and rosewood chopsticks; Western fabrics and papers; utensils made of tin (*buriki*); fly-repellent balls (*hai yoke dama*); cloth and leather tobacco pouches; Western hoes, wheels, pots, and pans; carbonated drinks; Western books; lamps, kerosene, and oil; woolen blankets, Western clothing, and suitcases; umbrellas; photographic equipment; Western medicines, gunpowder, clocks, and glassware—to name just a few. The ship of state, however, has no clear bow or stern

19. Tanikawa, "'Kijin' Sada Kaiseki no kindai," 84–85.
20. Matsuzaki, "Mita seidankai," 8.
21. Tanikawa, "'Kijin' Sada Kaiseki no kindai," 88.

5.3. Sada Kaiseki, *Fukoku ayumi no hajime* (First steps toward a wealthy country), 1880. Author's collection.

and appears to be caught between west (marked on the left) and east (on the right). Two people look toward the west, ready to disembark: a Chinese merchant, holding a box of one thousand gold coins, and a Western merchant, whose box contains ten thousand gold coins. The three Japanese aboard: a man sitting in front of a coal oil lamp, a man in the middle admiring Western clothing, and a man in the clock section wearing a gold watch on a chain, are all facing east, going nowhere.

The message of the picture is made clear in the accompanying text. Sada had earlier linked Japan and China in drawing distinctions with

the West. Here, however, he states that Japan is threatened by imports from China as well as from the West. In simple, repetitive language, he explains that, once a person boards the ship, he cannot control the direction in which he travels: the ship will inevitably carry him west. By extension, anyone who engages in the import business will fall under the power of foreign merchants, and no matter how hard he works, his assets—principal and interest—will disappear. At a national level, the cumulative effect of everyday purchases of foreign goods, even small, such as a pair of chopsticks, will result in Japan's impoverishment. The only possible remedy is to stop purchases from abroad and build an economy based on the domestic consumption of goods made in Japan.

First Steps toward a Wealthy Country
(a English translation of *Fukoku ayumi no hajime*)

This picture shows that there are two types of imported goods, Chinese and Western. Those who engage in commerce and promote industry of both types will certainly cause their own bankruptcy.

For example, even if someone aboard a steamship advancing west attempts to head east, they will be drawn by the power of the ship and be forced to return to the west. The reason is that their body and feet are completely aboard the ship, and even if they think they are heading east, it is as though they are approaching the west without knowing it, drawn by the power of the ship. Take the case of persons who, discarding our Japanese clothing, food, and housing, engages in commerce and promotes industry in Western clothing, food, and housing. Even if they think they are promoting national wealth and enriching themselves by that commerce and industry, they are, day by day and without knowing it, decreasing national wealth and shortening the life of the nation as well as shortening the life of their own fortune. Consequently, those who engage in commerce and work hard in industry using imported goods are, logically speaking, not Japanese merchants nor are they Japanese workers. Accordingly, those who engage in commerce using imported goods must be the agents of foreigners and the assistants and head clerks of foreigners. Moreover, since those who specialize in promoting industry using imported goods work under foreigners, they must be considered the subordinates of foreigners. Therefore, those who engage in commerce and work in industries using imported goods are like the person who is attempting to head east on the steamship that is advancing west. No matter how hard they exert themselves at commerce and are diligent at industry, all their principal and interest are, nevertheless, loaded on that import cargo ship. As a result, even while they think they are increasing their personal fortunes and promoting national wealth, without their knowing it, neither the principal nor the interest is advancing the wealth of Japan. There is no way other than for all of it to advance the profits of foreign countries. Therefore, the greater the quantity of goods people import, the more they will decrease the wealth of the 35 million inhabitants of Japan and the life of their own fortune. This is an increasingly urgent situation. Not only will the import of foreign goods cause an outflow of Japanese gold currency, but hindered by those imported goods, a great number of products relating to Japan's distinctive clothing, food, and housing will also be destroyed. Think of it this way. If the gold specie

exported to pay for foreign goods amounts to 10 million yen, it follows that, because of these imported goods, 10 million yen worth of products distinctive to Japan will be lost. And, in turn, will not the combined loss to Japan total 20 million yen? No matter what foreign goods are imported, a double loss must be incurred. What this means is that if every one of Japan's 35 million inhabitants uses foreign goods worth 0.027 yen [daily], by the end of one year, the total amount of gold specie exported to foreign countries will amount to 35 million yen! Even though people may think that spending 0.027 yen on imported goods is just a trifle, in one year, it adds up to 35 million yen! Since 1 yen is worth 10 kanmon, or copper coins, if we divide those 10 kanmon by 360, we get 0.027 yen. Therefore, if one person spends 0.027 yen every day on imported goods, will not the amount spent per person per year be 1 yen, and the total for 35 million people be 35 million yen? Does not the grand total from spending a mere 0.027 yen [daily] reach 35 million yen by the end of one year? Why are people not worried about the terrible problem of the imported goods on which they spend such a large amount of money? Some people think that imported goods are limited to Western things, but there are also many imported goods coming from China. Consider letter paper, books, and Chinese rice paper used by cultured people. The volume of just these three items used daily is enormous. From stationery items, tea preparation items, and rosewood and cassia bowls to everyday chopsticks and other things made from rosewood and cassia, these must be called luxuries that destroy the country. What should people do about the future? As the ancient poet said, "Know that things are transient. Do not throw them away. Even a speck from our seas or our mountains is our country's treasure." It is my hope that we hold deeply our patriotic spirit and do not seek commerce and industry outside our national products.

Meiji 13 January [1889]
Created and published by Sada Suigen [Kaiseki] of Kumamoto Prefecture
Tokyo, Koishikawa Tosaki-chō 67, Ankanji

Sada's poetic conclusion urges vigilance in protecting the physical and cultural integrity of Japan: "Even a speck from our seas and our mountains is our country's treasure."

Looking to a Bright Future

Like Robun, Kyōsai, and Ōga, Sada used wit, satire, and playful prose to advance his campaign against the westernization of Japan. In 1882, he published a five-page selection of popular anti-Western jingles, entitled *Yo naoshi iroha uta* (Songs that change the world). One of the verses ridicules people who persist in using coal oil lamps even after their house has repeatedly burned to the ground.[22]

A broadsheet entitled *Baka no banzuke* (A ranking of fools) that Sada issued in 1878 was especially successful in popularizing his arguments (fig. 5.4).[23] Parody versions of sumo ranking sheets (*banzuke*) were common in the Tokugawa period. They were used to give rankings (scholars, prostitutes, beauty spots, fools) or provide information ("Where is the best place in Edo to eat grilled eel?"), usually with humorous and satirical intent.[24] Like the sumo ranking sheets used in real life, Sada's *Baka no banzuke* lists the wrestlers in two divisions, East (on the right) and West (on the left). The highest-ranking wrestlers—or the greatest fools—are the *ōzeki* of each division. In the East, the *ōzeki* is "the Japanese person who turns down rice and other grains and instead professes a love of bread." In the West, it is "the person who gives up using domestically produced rapeseed oil or fish oil and instead depends on imported coal oil for lighting." Other ranked fools include the farmer who turns his rice paddies into tea and mulberry fields, the assemblyman who holds a meeting at a Western-style restaurant to discuss the imbalance in imports and exports, and the scholar who can speak foreign languages fluently but is unable to manage his personal affairs. In all, Sada holds forty-two fools up to ridicule for abandoning Japanese products in favor of imports. His message,

22. Sada, *Yo naoshi iroha uta*.
23. Iwaki, "Ishin to bunmei kaika," 108–17.
24. Ishikawa Eisuke, *Dai Edo banzuke jijō*; Hayashi, *Banzuke de yomu Edo jidai*.

5.4. Sada Kaiseki, *Baka no banzuke* (A ranking of fools), n.d. but around 1878. Author's collection.

A Ranking of Fools
(a translation of Sada Kaiseki's *Baka no banzuke*, n.d. but around 1878.)

WEST

Ozeki
- The person who gives up using domestically produced rapeseed oil or fish oil and instead depends on imported coal oil for lighting

Sekiwake
- The merchant who ends long-standing commercial activities and forms a company (*kaisha*) and goes bankrupt as a result.

Komusubi
- The speechmaker who can speak fluently in foreign languages about national economic issues, but does not know how to order his own life

Maegashira
- The person who abandons the use of domestically produced cotton headgear and instead covers his head with a scarf that resembles a *furoshiki* wrapping cloth
- The person who gets rid of his Japanese dog and instead prizes Western dogs
- The Japanese person who tears down houses made of wood and builds instead houses made of brick and stone
- The Japanese person who no longer drinks sake but instead prefers to drink beer and champagne
- The tea master who no longer uses domestically produced pottery, but instead uses Chinese cups made with red-tinged clay
- The Shinto practitioner who no longer follows the practices of Shinto unique to Japan, but instead respects Western ways
- The person who thinks that allowing one's hair to grow indiscriminately is a mark of civilization
- The Japanese person who abandons the use of brush and ink and instead uses pens
- The Japanese person who hates to wear silk and cotton undergarments and instead wears [Western] shirts
- The person who thinks that anything with a peppermint taste in a tin container is good medicine for all ills
- The girl who no longer plays with Japanese string balls (*temari*) but instead prefers playing with imported balls
- The Shinto practitioner who does not know the proper pronunciation of Japanese words but likes to read Western books
- The fashionable person who no longer wears Japanese hoods but instead prefers to wear a chapeau
- The person who gives up using lacquer that is deemed excellent beyond comparison in foreign countries, and instead uses a foreign varnish
- The person who takes delight in wearing rings made from foreign silver
- The Japanese person who abandons the use of a *kotatsu* table and instead warms himself with a fireplace
- The commoner who no longer uses Japanese lanterns but instead walks around with square hand lanterns
- The person who neglects their primary occupation and takes up hunting as a side job

EAST

Ozeki
- The Japanese person who turns down rice and other grains and instead professes a love of bread

Sekiwake
- The person who destroys perfectly good rice fields and instead seeks to harvest tea and mulberry for silk

Komusubi
- The assemblyman who decries the imbalance of exports and imports, but who holds parties in Western-style restaurants

Maegashira
- The person who rejects the use of umbrellas made in Japan and instead insists on using imported Western "bat" umbrellas
- The person who pulls out Japanese bushes and in their place plants Arabic gum trees
- The person who abandons the use of Japanese silk and cotton and takes delight in wearing Western clothes
- The person who abandons use of Japanese paper deemed excellent beyond comparison in foreign countries, and instead insists on using imported paper
- The person who disparages Japanese lanterns and instead uses gas lamps
- The Buddhist priest who wears white robes but preens about with a Western haircut
- A common girl with a ne'er do well face but who keeps her teeth white
- A common man who endures painful feet but insists on wearing imported shoes
- The person who throws away his Japanese cushions and instead puts imported carpets on the floor
- The person who thinks that even horse piss, if put in an imported bottle, will be transformed into excellent medicine
- The child who prefers to play with balls rather than fly Japanese kites
- The Buddhist priest who is attracted to Western learning and entertains doubts in Buddhist teachings
- The person who prizes foreign hardwoods in favor of fine native wood such as mulberry black persimmon
- The person who washes his private parts with imported soap and is cursed at [by people] in the bathhouse
- The Japanese person who rides in a small Western boat and falls into the river
- The Japanese person who abandons Japanese musical instruments such as the *koto* and *shamisen* and instead takes delight in Western music boxes
- The Japanese person who abandons domestic wood strips (spills) for lighting fires for the use of matches
- The person who applies red to their eyes in imitation of the natural appearance of [people] in foreign countries

Kanjinmoto Sponsors
Merchants of imported goods that betray the lifeblood of their country
Japanese craftsmen who have abandoned fine craftsmanship and instead prefer things made by machines

written in the center of the ranking sheet, is unmistakable: "There are many different types of fools in this world, but there is no greater fool than the one who fails to use domestic products and instead demands the use of imports. Their actions cause, day by day and month by month, an increase in the amount of capital flowing out of the country and leads the country to ruin."

It was no accident that the person using imported coal oil for lighting was at the top of Sada's ranking of fools. The first gas streetlamps in Japan were installed in Yokohama in 1872. Their use spread to Tokyo and other parts of Japan and emerged as one of the chief symbols of the nation's new age of enlightenment.[25] Sada took aim frequently at these bright streetlamps and lanterns, so closely tied with the westernizing policies of the Meiji government. In 1880, in a Tokyo daily newspaper, he published a major attack under the title "Ranpu bōkoku ron" (Lamps and national collapse).[26] In it, he listed sixteen ways that the use of foreign lamps causes great injury to Japan:

1. They waste money every night.
2. They destroy domestic industries.
3. They disrupt the circulation of currency.
4. They hurt the occupations of farming and industry.
5. They cause the price of lumber to rise.
6. They encourage the expansion of Western iron.
7. They encourage the import of foreign goods.
8. They even overwhelm our firefighting techniques.
9. They cause death by fire.
10. They will eventually cause the entire country to go up in flames.
11. They create new fire hazards.
12. They will eventually burn down towns and villages.
13. They increase the five vices and cause a decline in morality.
14. They cause an increase in crime and the number of criminals.
15. They damage eyesight.
16. They cause smoke damage to houses and property and even to people's noses and eyes.[27]

25. Nihon Gasu Kyōkai, *Nihon toshi gasu sangyōshi*; Yokohama-shi Gasukyoku, *Yokohama gasushi*; Edo-Tōkyō Hakubutsukan, *Akari no ima mukashi*.
26. Sada, "Ranpu bōkoku no imashime."
27. Honjō, "Kaidai-hen," 37–38.

Although Sada was concerned about fire, morality, and failing eyesight, his main argument was economic: the introduction of kerosene lamps would destroy native industries and make Japan dependent on foreign resources; the candle industry would collapse; the rapeseed and fish oil industry would be destroyed. In all, Sada calculated that the introduction of lamps would lead to the destruction of 131 domestic industries.[28]

In 1881, Sada announced the invention of the *kankōtō*, a Japanese lamp "brighter than [Western] lamps" that used domestically produced rapeseed oil. He argued that this and other Japanese inventions would save the country from financial ruin.[29] An advertisement for the Japanese lamp listed some seven advantages over imported models, which can be summarized as follows: first, it would end Japan's dependence on foreign coal oil, producing an annual savings of over ten million yen. Second, it would be brighter and whiter. Third, it would be less harmful to the eyes. Fourth, it would be less prone to fire. Fifth, it would not produce black soot. Sixth, it would secure for farmers the several tens of millions of yen they earn from their spring rapeseed crop. Seventh, it would invigorate the domestic fertilizer industry, using the byproduct of rapeseed oil production.[30]

In addition to his "made in Japan" lamp, Sada sought patents for other Japanese versions of Western imported goods. His *kankō* umbrella, for example, looked very much like a Western umbrella but used bamboo slats for the ribs and water-repellent Japanese paper for the canopy. Sada encouraged people "with patriotic spirit" to switch from imported leather sandal straps to what he claimed were cheaper and more durable straps made from Japanese paper. He decried the use of imported sugar in Japanese sweets and devised a recipe for *kankō dango*, dumplings sweetened with pure Japanese sugar. Turning entrepreneur, he founded Kankōsha, a company that specialized in the sale of domestic products. The word *kankō* 観光 was taken from line 4 of hexagram 20 of the *Book of Changes*: "To contemplate the light of

28. Honjō, "Kaidai-hen," 39.
29. Asano Kenshin, "Sada Kaiseki no daiyōhin undō."
30. Honjō, "Kaidai-hen," 65–66.

the kingdom." Sada used the term to accentuate the importance of domestic products, which he saw as the shining light of Japan.

Conclusion

How does a study of Sada Kaiseki and other opponents of westernization shed light on Japan's modern experience? The introduction of foreign things and ideas on a massive scale after the Meiji Restoration challenged and, in many cases, dislodged existing political, economic, social, and cultural institutions. Although a new world resulted, the process of making it was not immediate, nor did it go uncontested. From the outset, it was subject to question and criticism. Even Fukuzawa encouraged a spirit of skepticism. Distancing himself from other so-called teachers of enlightenment, who "believed in the new through the same faith with which they once believed in the old," he criticized the superficiality of those who uncritically accepted the superiority of Western things.[31]

Among those who questioned the scale of westernization, Sada was known for his stalwart opposition to Japan's entry into the international trading world. Drawing on ideas of autarky from the Tokugawa period, he promoted self-sufficiency, declaring it was necessitated by Japan's form of civilization and enlightenment. The Japanese system, he declared, was different from, though not necessarily superior to, Western systems that used unfettered trade to pursue national wealth. Sada encouraged what he saw as a virtuous cycle of domestic consumption and production that would result in the creation of national wealth while at the same time preserving Japan's distinctive cultural traditions.

Although Sada's ideas may seem naive, and his rhetoric sometimes bombastic, he made continuing, serious efforts to understand conditions in Japan and in the wider world. As a student of Buddhist cosmology in the late Tokugawa period, he linked a critique of Western cosmology, including a rejection of the Copernican "theory" that the earth moved around the sun, with a more skeptical perspective on

31. Fukuzawa, *An Encouragement of Learning*, 111–12.

Dutch studies. After the opening of the country in the 1850s, he supported arguments to "expel the barbarians" and, in the 1860s, when the influence of international trade began to be felt, he linked expulsion with positive policies aimed at national enrichment.

Sada's understanding of the world evolved further after the Meiji Restoration. In these final years of his life, he recognized the coexistence of different views of the universe. Moreover, his passionate desire, obviously impracticable, of keeping foreign people and goods out of Japan, was modified to a "Japan first" policy that minimized foreign exchange and maximized Japan's internal market. His economic model was based on the use of national resources to make products in Japan, by Japanese workers, for Japanese consumers. Sada also found himself praising the West—sometimes. He took advantage of new technologies, published his opinions in new media, and traveled by train when possible. But he saw the dangers of being trapped in a free-trade world in which benefits accrued for Western nations while Japan lost its own economic and cultural assets. Aware of the widespread poverty and property destruction that characterized the years immediately before and after the Restoration, he aimed to enrich the country and its inhabitants. It is not accidental that, in the early Meiji years, his ideas received a sympathetic hearing among scholars and government leaders.

Sada, in other words, was not an untutored eccentric. His autarkic vision, even when expressed in a satirical jingle or a sumo ranking sheet, was the product of lifelong learning. As Fabio Rambelli notes, he could quote from Montesquieu's *Spirit of the Laws* (in Japanese translation) to argue that old customs should be changed only when they had become harmful and only when new customs that might prove more beneficial were available.[32] Nor should his disavowal of Western-style industrialization mark him as a utopian reactionary. For Sada, and for others in the late nineteenth and early twentieth centuries, the pursuit of autonomy and self-sufficiency was as modern as the pursuit of free trade.[33] Sada's struggle against seemingly inexorable global forces is a reminder that modernity, in Japan as elsewhere, is a negotiated process, looking back at the same time as it looks forward.

32. Rambelli, "Sada Kaiseki," 127.
33. Helleiner, "The Return of National Self-Sufficiency?"

CHAPTER SIX

Mantei Ōga: Sparrows at the Gates of Learning

This chapter is a partial translation of Mantei Ōga's parody of Fukuzawa Yukichi's monumental work advocating Western learning: Gakumon no susume *(An encouragement of learning) published between 1872 and 1876. Ōga, like Sada Kaiseki, championed the conservative cause at a time when many were enchanted by the clarion call of civilization and enlightenment. In the four-year period between 1872 and 1875, he published a remarkable series of over thirty booklets poking holes in the arguments of those who sought to transform Japan into a Western-style country. Fukuzawa was Ōga's prime target. His parodic work* Katsuron gakumon suzume *(Sparrows at the gates of learning: A spirited debate) was published in 1875.*[1]

The Japanese sparrows in Ōga's parody challenge Fukuzawa's assumptions. The vigorous debate that ensues reflects the complexity and ambiguity of Japan's embrace of modernity in the 1870s and draws attention to the role played by Ōga and other serious-minded humorists in encouraging reflection on social and cultural issues.

1. Hattori [Mantei] Ōga, *Katsuron gakumon suzume*, 6 vols., 1875. I first learned of the rivalry between Fukuzawa and Mantei Ōga in Mertz, *Novel Japan*, 56–112. For my work on Ōga, see Steele, "Meiji Twitterings"; Steele, "The Unconventional Origins of Modern Japan"; and Steele, "Kindai Nihon no honpō naru kigen." While he was better known under his pseudonym, Mantei Ōga, his family name was Hattori, by which he is sometimes referred.

Fukuzawa Yukichi published *Gakumon no susume* in seventeen sections between 1872 and 1876. At a time when Western things and ideas were inundating Japan, Fukuzawa aimed to promote a broad cultural revolution based on Western ideas. He set out to confront and replace Confucian ways of thinking, emphasizing practicality over metaphysical speculation and independence of mind over ingrained subservience. Although Fukuzawa's writings stimulated widespread interest in Western values such as equality, independence, utility, freedom, and civic engagement, it also invited strong criticism.

Mantei Ōga was one of Fukuzawa's best-known adversaries in the first half of the 1870s. Active since the late 1840s as a writer of playful prose and poetry (*gesaku*), Ōga was a master of multiple genres, including so-called funny books (*kokkeibon*), collections of jokes and riddles (*chaban*) and serious work, such as his fifty-eight volumes on the life of Shakyamuni. In the years after the Meiji Restoration, he joined other writers and artists in opposing attempts to westernize Japan. Fukuzawa was their common enemy. Between 1872 and 1875, Ōga published a series of thirty booklets, many of them in multiple volumes, marshalling his wit against Fukuzawa and others who, he believed, sought to destroy the established social, cultural, and intellectual order. Although Ōga's writings by no means reached the best-seller status of Fukuzawa's books, his public attack on Japan's most famous westernizer attracted widespread attention. Forgotten today, Ōga was well known in the 1870s for his conservative views.

Katsuron gakumon suzume (Sparrows at the Gates of Learning: A Spirited Debate), published in 1875, is a parody of the first three sections of *Gakumon no susume* and Ōga's most sustained critique of Fukuzawa's writings. The titles of the two works are homophones: Fukuzawa's *Gakumon no susume* 学問のすすめ, meaning "encouragement of learning," is echoed in Ōga's *Gakumon suzume* 学門雀, which translates literally as "sparrows at the gate of the school."[2]

2. The words *gakumon suzume* 学門雀 reminded contemporary readers of the proverb *Kangakuin no suzume ga Mōgyū o saezuru* (The sparrows of Kangakuin can twitter the *Mōgyū*). The proverb refers to sparrows (or lowborn youth) who, by spending time around the gates of the ancient academy of Confucian studies, came to chirp the *Meng qui* (*Mōgyū*), a Tang-dynasty (618–907) primer.

Ōga's book takes the form of a series of debates between two sparrows, a western sparrow who presents Fukuzawa's position and an eastern sparrow who responds with the supposed common sense of Japanese society.[3] For example, after the western sparrow cites Fukuzawa's famous opening words, "It is said that heaven does not create people above or below each other," the eastern sparrow counters: "Heaven does create some people above and others below. For proof, look at the world today." The eastern sparrow also challenges Fukuzawa's advocacy of independence and freedom, arguing that strong government and the rule of law, which necessarily restrains some freedoms, is the true mark of a civilized society. During the debate, the western sparrow is reduced to a mere cipher who, by parroting the words of the great westernizer, offers clear evidence of Fukuzawa's failure to cultivate independent thinking.

Ōga's parody extended to the books' physical appearance. His *Gakumon suzume* and Fukuzawa's *Gakumon no susume* looked the same: both measured nineteen centimeters, were bound in Japanese fashion (*watoji*), and consisted of twelve double-leaf pages. Both texts were similar in appearance and grammatical usage, although Ōga added captioned illustrations by the virtuoso artist Kawanabe Kyōsai, which allowed readers to grasp his message at a glance. Abandoning the puns and playful irreverence of his earlier "funny books," Ōga's language in his parody version followed Fukuzawa's straightforward style. The similarities invited inspection—and inspection revealed messages that were poles apart.

Translated here is section 1 (in two parts) of *Katsuron gakumon suzume*, in which Ōga critiques section 1 of Fukuzawa's *Gakumon no susume*.[4] Derived from a speech given in his hometown of Nakatsu in northern Kyushu in 1871, Fukuzawa's section 1 was originally intended

3. Since the twittering of the western sparrow is taken nearly word for word from Fukuzawa's *Gakumon no susume*, I have relied largely on the translation by David A. Dilworth: Fukuzawa, *An Encouragement of Learning*. I also consulted Koizumi, *Gakumon no susume*; and Saitō, *Fukuzawa Yukichi, gendaigo yaku Gakumon no susume*.

4. Several versions of Ōga's text are available. I have used the text held in the library of the National Institute for Japanese Language (Kokuritsu Kokugo Kenkyūjo): Mantei Ōga, *Katsuron gakumon suzume*, 6 fascicles, 1875. A facsimile edition of this text is published in *Mantei Ōga sakuhinshū*, 197–339. I have also examined a text

to stand alone as a basic statement of his approach to learning. Ōga's response, reflected in his parody, allows readers today to understand something of the fluidity and complexity of the debate on civilization and enlightenment that took place in Japan in the early 1870s.

Sparrows at the Gates of Learning
A Spirited Debate

> Learning is something that lacks beams and pillars, shadows, and shape. These days, people try to make distinctions in learning, as they do with material goods, saying this is Chinese and that is Western, but when it comes to how learning is used, no distinction exists, regardless of the task. Learning assumes a concrete form only as a matter of convenience in the performance of that task. Therefore, people who encourage others to pursue learning should first remove the Chinese and Western pillars on which they are leaning. By clarifying their own wisdom, they should set out on the Great Way independently and investigate social and human affairs deeply. If they achieve this, they will not fail to hit the mark in all they see and do. Such people are the true scholars.

Copyright November 11, Meiji 8 (1875)

Sparrows at the Gates of Learning
Section One, Part One
Hattori Ōga

A Debate between Two Sparrows

Our government's laws have recently been in a state of flux. Several books in wide circulation advocate enlightenment and encourage us to change our old ways, even including the words we speak and our clothing, food, and shelter. However, since most of these books—seven or eight out of ten of them—simply mimic the words of foreigners and

available online from Waseda University Library and a copy of a British Library text that is included in the archives of the Kawanabe Kyōsai Memorial Museum.

strive to explain things and ideas from overseas in Japanese, they contain the name of the person who translated the text but make it difficult to discern the real author. These books flourish in competition with each other, like clusters of fresh green sprouts appearing from the stump of a mulberry bush. Each title is cleverly distinct, but since all come from the same rootstock, when they are published and spread their leaves throughout the city, it becomes clear that they are all the same mulberries. People laugh when they realize that they have spent their precious coppers to buy the same thing with a different name. Among some, however, resentment at the monopolistic greed of the rootstock holder grows and tongues begin to wag.

So far, these precious new books have not gone beyond things connected with the human world. Therefore, even if enlightenment spreads throughout society, except for those humans who rule over everything in our country, nothing in the cosmic universe, beginning with the movement of the sun and moon, will change from its ancient ways. All will remain the same. As in the past, water will be cold, fire will be hot, plum blossoms will not bloom on willow trees, cucumbers will not ripen on pumpkin vines, cows will moo, horses will neigh, and sparrows will twitter.

Recently, sparrows with an odd-sounding chirp have appeared at the radiant East Gate of the Rising Sun.[5] These sparrows, born and raised in our land so blessed with happiness and abundance since the days of our ancestors, suffer from a condition called "night blindness," which makes them unable to see the treasures in front of their eyes. They have assembled similar birds and, forming a flock, recklessly covet things and ideas from other countries. They snatch up civilization and novelties, and their chirping of senseless talk creates a real uproar. Their behavior is essentially different from the independence of the phoenix and the crane. They flock together, gather their friends, and use the power of others to infest society. In the world of humans, they would be like firemen and soldiers; in the world of fish, like pilchards; in the world of dogs, like wolves; in the world of insects, like frogs and ants; in the world of plants, like thorny weeds; in the world of birds,

5. This is a reference to Japan.

like starlings. Since they are mere [West Gate] sparrows, the horned falcons pay them no attention and the sage crane presents no threat.

But the sparrows who live under the eaves of the East Gate are worried that the loose chatter of these West Gate birds is on the rise. They fear that if ordinary birds are lured from the correct path, the lifeblood of our country will eventually be lost. Now the East Gate birds are mounting a concerted defense against the turbulent waves of fashion. If they fail to use sharp, even abusive, language to criticize the leader of the western birds and are laughed at derisively at home and abroad, we will surely not escape disgrace. Therefore, for the sake of the Japanese people, the eastern birds feel compelled to confront the leader in spirited debate. At points, the Western Gate sparrows express their opinion in a high-pitched trill. The exchange is as follows.

The text below presents the main point of the debate, excluding the unimportant.

○ indicates arguments made by the West Gate sparrow
● indicates responses made by the East Gate sparrow

○ It is said that heaven does not create people above or below each other. Therefore, when people are born from heaven, all are equal and there is no distinction at birth between high and low or noble and mean. As the lords of creation and through the working of their bodies and souls, people may use the myriad things of the world to satisfy their needs for clothing, food, and dwelling. Freely, but without obstructing others, all may thereby pass their days in comfort. Such is the intention of heaven.

● Shut your bill for a minute, and listen to what I have to say. I don't agree with your argument! Heaven does create some people above and others below. For proof, look at the world today. All countries and places called countries, even though they have different names, have one person at the top as ruler, just like the emperor in our country. There is no country without a ruler who takes charge of the government and the welfare of the people. Moreover, it is customary that each country naturally includes people who are noble and mean, rich and poor, wise and stupid.

Children born into the families of the noble and rich, beginning with the ruler at the top, know nothing of learning while still in the womb; they know neither black and white nor east and west. But as they advance from diapers to ceremonial dress, their names become well-known throughout their country; they receive the respect of officials and grow up in affluence. Is there anything these children receive other than from heaven? In the slums, by contrast, are many poor people whose precarious living depends on the work they can get day by day. Children born to such people lack clothing and food from infancy; in cases of extreme deprivation, they may be placed in orphanages or allowed to die. Again, is there anything these children receive other than from heaven?

Although all children are born in the same state of innocence, people can immediately see the distinction between noble and mean without waiting for your pronouncement. Regardless of whether these newborn children are good- or ill-natured, a physical distinction between noble and mean exists. Moreover, as proof that distinctions in human nature do not depend on physical attributes, we can point to high-ranking people who lack a noble heart, such as Emperor Buretsu in Japan and King Zhou and others in China.[6] At the same time, there are many historical examples of lowborn people with noble hearts, such as the dutiful son of Mino in Japan.[7] In China, too, there are examples such as Emperor Shun.[8] It is thus clear that everyone is not the same as everyone else, there being a distinction at birth between

6. Buretsu, the twenty-fifth emperor of Japan according to the traditional listing, was believed to have reigned between 489 and 507. He was noted primarily for his credulity and wickedness and is often referred to as the "evil emperor." According to the *Nihon shoki*, Buretsu "worked much evil and accomplished no good thing." King Zhou (Di Xin) of Shang is known as a king of the Shang dynasty (c. 1600–1046 BCE). His reign (1075–1046 BCE) was marked, according to legend, by corruption, cruelty, and immorality, making him one of the most corrupt kings in Chinese history.

7. Japanese parodies of the Chinese classic *The Twenty-Four Paragons of Filial Piety* (*Ershisi xiao*) were popular during the Edo period. Perhaps the best-known Japanese paragon of filial piety was the dutiful son of Mino, who gathered wood to warm his aged father and, unable to provide wine, gave him water from the Yōrō Waterfall; the gods rewarded this filial devotion by turning the water into wine.

8. Emperor Shun was one of the three legendary sage kings who, by traditional reckoning, lived sometime between 2294 and 2184 BCE. He lived humbly and became

noble and mean. Therefore, heaven does indeed create people above and below each other.

Now, you may well quote ancient texts declaring that people are the "lords of creation," but it is obvious that this is a title assumed by humans out of pride and not one that the lord of creation has used to praise them. Look at the people who have made up the world from the past to the present. How many among them deserve to be called lords of creation? Although the number of fools is beyond reckoning, even among those known as wise men and scholars are people who are inferior to birds and beasts. Indeed, when we look with the eyes of heaven, few in all creation are as base as human beings.

Again, you state that "people may use the myriad things of the world to satisfy their needs for clothing, food, and dwelling. Freely, but without obstructing others, all may thereby pass their lives in comfort. Such is the intention of heaven." But does not this also hold true for birds, beasts, fish, and insects? Isn't it simply impossible that all those born into the world as human beings can freely satisfy their need for clothing, food, and shelter? From the time babies are born and drink their mother's milk, they are often deprived of autonomy and freedom, making for many tears and few smiles. As they grow up, their parents encourage them in skills and learning, but since the children often oppose these aspirations, the parents are daily deprived of freedom. Moreover, when the children, constrained by the guidance of teachers and parents, try to escape from their lack of freedom, the angry voices of the parents and the screams of the children resound endlessly through their homes. This lack of freedom for parents and children is a general condition of society. Indeed, among the various books of learning in the world today are many that caution against people's freedom. Moreover, it is a treasure of this country that, with the judicial and police systems established by government law, indolent people who use their freedom to steal the belongings of others and cause them harm are censured.

When you speak of people today not obstructing others, don't you realize that not obstructing others is a constraint that restricts one's own freedom? These days, flocks of sparrows twitter with abandon

known for his compassion and filial piety. Hearing of his virtue, the reigning emperor Yao bypassed his own son and chose Shun as his successor.

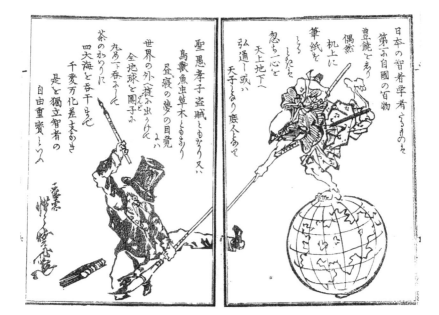

6.1. Mantei Ōga, *Gakumon suzume* (Sparrows at the gates of learning), section 1, part 1, 1875. Centerfold: "The battle between the eastern and the western sparrow." Illustration by Kawanabe Kyōsai. National Institute for Japanese Language and Linguistics.

The text reads:
Those who are the wise and learned of Japan should know above all the abundance of the myriad things in their own country.

By chance, when I took up brush and paper at my desk, my mind expanded suddenly to embrace everything above and below. I became prince and commoner, saint and fool, filial son and robber, and bird, beast, fish, insect, grass, and tree.

Waking from my midday dream, I set out on a journey outside the world. I shaped the Earth into a sweet rice ball and gulped it down in one mouthful. In place of tea, I drank dry the four seas.

Unhindered by countless changes—such is the freedom and the treasure of the independent and the wise.

about the ideas of autonomy and freedom, but these puny birds have no understanding of the thinking of the giant golden-winged Peng who sits high in the heavens.[9] If people try to control others, to the contrary,

9. The golden-winged Peng was a Buddhist bird deity of Hindu origin. He was the offspring of the phoenix, the leader of flying beings. Echoing the Japanese proverb *Neko*

they themselves become controlled. Is this not laughable? A Chinese text tells the story of a person who asked a wise man where he might find a place of respite. The wise man pointed to a mounded grave and declared that only there could a person, once born, find rest. With reason, Buddhist texts also preach this world to be one of suffering and defilement. Since heaven and earth are themselves not free, climates are harsh, abundant harvests are rare, and flood and drought are frequent. Therefore, among those born as humans into this world, even the emperor cannot be said to live in comfort because he must conduct national affairs from the very beginning of the year. How much more difficult must it be for ordinary people!

From times past, even though wealthy and poor households alike have worked diligently, some have found it difficult to obtain adequate clothing, food, and housing. For people who are unaware of this and seek to live in comfort, only two paths lie ahead: either they will bequeath debts to their descendants, or they themselves will fall into destitution. Nothing in this world that is called comfort is true comfort; the world is but a temporary resting place of suffering. Even if heaven endeavors to have all people pass their lives in comfort, such an outcome will not easily be achieved. The reason is that suffering is the seed of happiness and happiness is the seed of suffering. Since these two have been inseparable from ancient times, you should simply eliminate the two characters for comfort (*anraku* 安楽) from your discourse.

○ As I said before, taking a wide view of the world, we find people who are wise and ignorant, rich and poor, noble and mean. The reason for this is all too clear. The *Jitsugokyō* (Teachings of true words) tells us that a person who does not study will not become wise, and a person without wisdom is a fool.[10] Therefore, the distinction between the wise and the foolish depends on whether they have studied or not. Again, people who undertake difficult tasks in society are called people of high social rank, and people who undertake easy tasks are said

wa tora no kororo o shirazu (A cat cannot fathom the thinking of the tiger), the text implies that the western sparrows are unable to grasp the big picture.

10. *Jitsugokyō* was a children's primer of Confucian and Buddhist moral teachings used in commoner schools during the Edo period.

to be people of low social rank. Thus, doctors, scholars, and government officials as well as large-scale merchants and farmers are people of importance and high standing. Naturally, from the viewpoint of lowly people, the wealth of these families appears beyond reach. However, if we inquire into its origins, we find that the difference in wealth comes from whether learning has taken place. Heaven gives riches and status not to people but to their labor. Therefore, people who study will become wealthy and high-ranking, while people who do not study will become poor and lowly.

● What you are saying now is like turning snow into cotton. Treating the whiteness of snow as cotton may be advantageous for your argument, but as cotton, snow is useless. The reason is that, whether we quote from the *Jitsugokyō* or the *Gaigokyō* (Teachings of foreign words), we will find that that wisdom or foolishness and high or low rank are certainly not determined by learning; they derive rather from innate human nature. Although it may seem old fashioned, the following testimony should be taken to heart and clearly understood:

> The master said, "Highest are those who are born wise. Next are those who become wise by learning. After them comes those who must toil painfully to acquire learning. Finally, to the lowest class of the common people belong those who toil painfully without ever managing to learn."[11]

Setting out thus the four levels that lie between wisdom and stupidity, this ancient text of two thousand years ago contains illustrious words that fall like drops of water over people who live not only in Japan today but also at the far reaches of heaven and earth. I do not revere these words because they issued from the mouth of Confucius; here, I hold them as proof because they conform well to reason. For example, if we were to enroll one hundred pupils in school today, begin their instruction at the same time, and examine them later at the same time, they would not reach the same academic level. Indeed, only a few would advance to a high level; many would remain in a low grade.

11. Waley, *The Analects of Confucius*, 16:9, 206.

If rice is fed to one hundred people, all one hundred will fill their stomachs equally. We must understand, however, that learning does not follow this logic.

Similarly, although you say that people's social standing will be high or low depending upon whether they do heavy or light work, such distinctions in work are not easily fixed. For example, work that is difficult for one person may be enjoyable for another. Work may be easy or difficult, but if a person is skilled, the work will be easy. Look at the world around us! Young people, even when given important duties for their family business, will fall asleep working late at night, but engrossed in the songs and dances that they love, they will easily stay awake until dawn. Therefore, if you look at the doctors, scholars, government officials, large-scale merchants, and farmers whose work you consider to be difficult and the stout rice-bale cart pullers whose work you consider to be easy, should we urge people to work diligently at a job on the grounds that it is easy?

Moreover, learning may at times separate the wise from the foolish, though it is difficult to accept this argument when it comes to large-scale merchants and farmers, who place priority on profit. Doctors take responsibility for people's lives and place benevolence at the forefront and profit at the rear; this is called the way of medicine. Scholars, who within the limits of their lives, exert themselves to the utmost for the sake of the country, likewise give precedence to benevolence over profit. For this reason, we know that every year the government dedicates a great deal of money to medical and other schools, treating them differently from ordinary businesses. Except for those who, by taking advantage of changes in the world, make great profits from translating foreign books, doctors and scholars, in ages past and present, have rarely become rich from their work.[12] Is not the four-character phrase "honorable poverty, selfish wealth" indeed appropriate?

As for large-scale merchants and farmers, although there are many in cities and prefectures throughout Japan, I do not know of any who have advanced their status through education. All belong to families

12. "Make great profits from translating foreign books" is a not-so-veiled reference to Fukuzawa, who was rumored to have made a fortune by translating books about the West.

who received their inheritance from their ancestors and placed a premium on frugality, but although their foundation was solid, many are now falling into ruin through an attraction to new things. A popular verse has it: "Bring ten rich men together, and you will find that nine of them are illiterate and unschooled." This jest notwithstanding, learning should not be neglected; it is an important undertaking that requires effort. However, what shall we do with those who are taught but fail to learn and those who study but fail to do what they are taught? In the world today, among people who wantonly indulge in drinking, eating, and prostitution and who engage in violent behavior are many who can read texts well and know the difference between right and wrong. At the same time, among those who recognize the needs of the times, obey government regulations carefully and, along with their wives, children, and others, support themselves through menial tasks, live simply, and enjoy happy times, are many who are unschooled. Accordingly, look carefully and know that learning does not make a person noble or happy and lack of learning does not make a person poor or lowly. [End of Section One, Part One.]

Sparrows at the Gates of Learning
A Spirited Debate

> Among the books that receive the equivalent of official authorization, many that introduce the principles of learning have copyright protection.[13] Therefore, people compete in applying to enter the gates of learning. By contrast, my little book, like a lowly sandal minder stationed outside those gates, is insignificant. Nevertheless, people who study various ideas under the guidance of a teacher should exercise vigilance toward his way of instruction. They should know that the ancient ideas of the classics reflect the reality of the passage of time and that the ideas of foreign countries reflect differences in climate and human nature. Moreover, if they stubbornly adhere to the precepts of a particular teacher, they will not be able to use their own

13. This is a reference to *An Encouragement of Learning* and other books by Fukuzawa that were granted official copyright protection. Fukuzawa was an early advocate for copyright, which he termed *senbai no ri* 専売の利 and later *hanken* 版権. See Konicki, *The Book in Japan*, 250; Horii, "Bakumatsu ishin-ki."

> intelligence to correct his mistakes. Consequently, deeming a teacher to be one who instructs about East and West at the same time, students should encourage their teacher to be a true teacher. Such is the keen eye of youth.

<div style="text-align:center">Copyright November 19, Meiji 8 (1875)</div>

Sparrows at the Gates of Learning
Section One, Part Two
Hattori Ōga

○ Learning does not simply mean the mastery of accomplishments that are of no real use in the world, such as knowing difficult words, reading ancient texts, or composing poetry. For this reason, since time immemorial, there have been few scholars of Chinese classics who were good household providers. Rare, too, have been farmers or merchants who were both accomplished in poetry and skilled in their family businesses. Consequently, it is only natural that farmers and merchants become concerned when their children take to learning, fearing that they will ruin the family fortune. Therefore, such learning should be relegated to a secondary position. Instead, priority should be given to learning that serves people's everyday needs, such as penmanship, the abacus, and the use of scales. For subjects such as geography, natural philosophy, history, economics, and ethics, people should study Western books that have been translated into Japanese, or if they are talented in letters, they should be made to read Western languages so that they may all know the underlying principle of real things. With such learning, all people, without distinction of high or low, can exert themselves in carrying out their family business and achieve personal independence, the independence of their households, and the independence of the nation.

● You so-called sparrows of learning! When you open your squid-like beaks, what a noise! You sound like woodpeckers drilling away on hardwood. Let me respond to you with a story. Some sweet sticky rice balls were set out in front of a certain fool. The rice balls were so delicious that the fool hurriedly opened his mouth and gulped them all down at once; but they got stuck in his throat, and in the end, he

choked to death. In this way, even something sweet and delicious, encouraged improperly and without looking carefully at its recipient, can become a weapon that kills a person. A sword is not the only thing that can kill a person. Even medicine can murder.

Now, to reply in some detail to what you say, first, you err when you distinguish poetry from real learning and reject poetry as of no practical use. How could poetry ruin the fortunes of people? They should instead depend upon it! I will take up the virtues of formal poetry later, but let's start with underground verse: crazy poems, short poems, and satirical verse. These are termed comic verse, but with just a few characters they critique the rationale of all things, and by inquiring deeply into people's thoughts, they clarify the difference between good and bad. Just one verse can often move a person in the direction of either wisdom or folly. Right now, people steal this and that from half-baked scholars, stitching all together front and back; they make fat books and sell them at a high price. Competing in this way, they make huge profits, as swiftly as if they had completed a ten-day trip in one day.

Regarding formal poetry, my understanding is limited. I can say, however, that although the virtues of Japanese *waka* poems are not yet known overseas, within the imperial land of Japan, *waka* has had the virtue of softening the hearts of people from the time of the gods. It has moved heaven and earth and even stirred the hearts of demons and deities. Through ages eternal, our emperors have customarily held poetry meetings. It is only you who do not know these things!

Now, I agree with what you say about practical learning that serves people's everyday needs. However, you go on to introduce other kinds of learning, and I have doubts that ordinary people can master these. If a person likes an area of learning and works hard at it, he may gain mastery. However, if the same subject is taught to the rank and file, they will surely not understand it in depth. To wit: the cost of acquiring such learning is great. Moreover, a person's time and lifespan are limited, and everyone must work to earn a living. If people are working hard each day to earn their living, they don't have a separate body for study; without the help of a body double, education is impossible. There is no place that will allow a person to live without paying rent while studying. Nor can one study without eating. Money does not come down from heaven.

Imagine a person engaged in the various kinds of learning you mentioned earlier. Even if he staves off the elements by wrapping himself in a straw coat, unless he has accumulated a great fortune in addition to practicing thrift, he won't be successful. And in this world today, how many people, say among one thousand, have accumulated such a great fortune? You should make that calculation! Of all the people in Japan from ancient times to the present, how many, again out of one thousand, have traveled to see even the famous places and historical sites of their own country? The number must be around ten. Rare are the people who have visited even the famous places of the district in which they were born. Surely none of these people who have yet to see their own country's famous places would be willing to risk their precious lives to take a dangerous trip of one or two thousand *ri* across seas and mountains, with no chance of making money but every chance of spending a fortune?[14] Surely no one would want to do this. What use would it be to have such people study a guidebook to the climate and cultures of the world? I would like to know the value in this. Moreover, although Western languages are necessary for communicating with foreign people, they do not make the slightest difference when it comes to communications among Japanese people inside Japan.

Now, you said that all people, without distinction of high and low, can, by exerting themselves, achieve personal, family, and national independence. However, the word "independence"—consisting of the two Chinese characters 独 (*doku*) and 立 (*ritsu*)—does not mean the "standing alone" of a one-year-old child who cannot stand without holding on to something for support. As I already stated in my opening words, one becomes a pillar for the nation not by depending on the ideas of others but by becoming personally independent. If I look at your ideas, however, I see the lack of any substance of personal independence. Encouraging others to be independent without being independent oneself is like encouraging someone to eat something that one cannot eat oneself. Although anyone can spout out the words "independence of civilization" (*bunmei no dokuritsu*) from their mouth, if those words coming from the mouth are unknown to the heart, the person who says them will be a civilized person in word only.

14. One *ri* 里 is equivalent to 3.9 kilometers.

○ In the pursuit of learning, one should know one's obligations. Men and women are naturally free, but the borderline must be drawn between freedom and selfishness. For instance, when using one's own money, it may seem that one is free to indulge in dissipation, but this is not so. If what one does is bad for others, the offense should not be pardoned. Moreover, our country Japan until recently shunned contact with foreign countries; it survived on its own products and was not in want. However, from the Kaei period, Japan began to trade with foreign countries.[15] Among the imports, the ideas of freedom and independence were introduced to society. Commoners were allowed to use family names and ride horses. A basis to unify the four status groups was established so that rank was no longer attached to a person at birth. Now, a person's status is determined only by his talent and virtue and his place of residence (*kyosho* 居所).[16]

● What you say about obligations is certainly accurate when it comes to learning, but you are wrong to think that anyone can become a scholar simply by engaging in learning. I replied to this point earlier, but I see that I was not able to communicate my ideas conclusively, so I will make my response again.

At the time of the old government, there were establishments for *go* (checkers) and *shōgi* (chess). In both instances, the establishments were managed by families who were awarded a hereditary stipend and placed under the supervision of the city office. Of course, families who had a son would necessarily make that child study the family profession from his youth. However, there were many families who had to adopt an heir from another family. Recently, Itō Sōin, the son of the Itō family of *shōgi* masters, won the first prize in a national competition.[17] Originally from the Ueno merchant family, Sōin was from

15. The Kaei period spanned 1848–1855. Although the Treaty of Kanagawa was concluded in 1854, trade was permitted only after the 1858 Treaty of Amity and Commerce.

16. In Fukuzawa, *An Encouragement of Learning*, 7, Dilworth and Hirano translate *kyosho* as "accomplishments": "A man will have rank only by dint of his talents, virtues and accomplishments." The literal translation used here, "place of residence," matches the rebuttal of the eastern birds that follows.

17. Itō Sōin (1826–1893) was a well-known *shōgi* player in the years before and after the Meiji Restoration. Born into the Ueno merchant family, he was adopted in

MANTEI ŌGA 143

6.2. Mantei Ōga, *Gakumon suzume* (Sparrows at the gates of learning), section 1, part 2, 1875. Centerfold: "The Great Way and the side roads." Illustration by Kawanabe Kyōsai. National Institute for Japanese Language and Linguistics.

 The text on the right page reads: The classic texts of Confucian scholars are like the Great Way. Popular writings are like side roads. Those who travel on the Great Way sometimes find it difficult to enter the side roads. But no one who travels on the side roads fails to follow the Great Way. Doubtless, the Great Way relates to Confucius and popular writings relate to Zhuang Zhou.

 The text on the left page reads: Ordinarily, travel on the Great Way is best, but as things stand today, to educate the ignorant, it is reasonable to turn off the Great Path and proceed on the side roads if they are nearby.

 On the Signpost in the center is written:
Main Highway—requires a life span of about 50 *ri*
Short-cut to Learning—leads to the Village of Popular Writings

his youth naturally gifted in *shōgi* and was adopted into the Itō family

1845 into the Itō school, took the name Itō Sōin, and later became the head of the Itō family. In the early Meiji years, he dominated the game, winning match after match. He also worked to modernize the chess world, founding a publishing house and reporting on tournaments in newspapers. In 1879, he was made the game's eleventh lifetime champion (*meijin*).

as heir. In this way, a child who has skills that are of no use to his own family's business may move to another family and, with official blessing, become the head of the adoptive family and succeed to its business. Or, remaining in his own family, he may follow another profession instead of succeeding to the family business. Isn't this often the case in families that are dependent upon artistic talents and skills? Does it not mean setting aside one's own child and passing on the family name to another? Yes! This is evidence that a business will not succeed simply through learning; to understand this principle is to know the obligations of learning.

Now, again, you say that both men and women are naturally free, but this is the argument of a frog at the bottom of a well. Here is my reasoning. The heavenly creator is said to have dispersed living things widely across the earth. However, it is an exceedingly compassionate blessing for the citizens of our country that the government uses the binding power of national law to place physical restraints on all—birds and beasts as well as humans. Look at the proliferation of lawsuits that exist precisely because of these restraints. If they were to be loosened, there would be no stopping people from riding roughshod over the heads of their masters or disobeying their parents. For this reason, we can say that the laws of this country are like amulets that protect the people of the country; even though it means not being free, it is good for people to wear them throughout their lives. Since not being free is part even of work today, there are people who walk the streets enduring blisters from their shoes and people who climb up to high windows even though they get dizzy. It is said that freedom means that one can move about at will and that selfishness means acting as one pleases. Not understanding the distinction between these two is like failing to make the distinction between frugality and stinginess. I replied to this point earlier.

The fact that we can't use our own money as we please is the same as being not free. And even if the government's intention in allowing commoners to use family names and ride horses should be applauded, many of the commoners who have been fortunate enough to receive these new privileges are unable to discipline themselves; consequently, they allow the horses to run about recklessly to the harm of others and to themselves. Encouraging the independence of the individual in such

a way is like giving a nursing child a gold coin and in this way using treasure to cause harm. Thus, it was well said by the ancient sage that one should not talk about advanced topics with middling people and below.[18] Moreover, you asserted that a person's rank is determined by his ability and virtue and by his place of residence. Although it is natural that people will rise in rank according to their ability and virtue, to use place of residence as the basis of rank is unacceptable. Even though a person lives in a thatched hut and wears rags, if he is pure in heart and civilized, then he deserves true rank in society. But look at what takes place in the world today! Black-hearted people adorn themselves on the outside, wearing ceremonial clothes to conceal their impure hearts. Cunning people devise schemes to attract the wealth of others by using their place of residence. However, since evil cannot overcome righteousness, we can see any number of examples in which evil, though in fits and starts, is nonetheless undone. You should know this by looking at what is happening in the municipalities and prefectures in recent days.

○ During the time of the former government, when the shogun's tea vessels or the shogun's falcons and horses passed along the Tōkaidō, fearing the two characters "Official Use," superiors and inferiors alike followed the ugly custom of cowering in respect. This practice did not derive from the value of the things themselves; it was a craven means of expanding the authority of the government and, by demeaning the people, of restricting their freedom. One may call it empty pretense without substance.

● Wait a minute! You are talking nonsense! In addition to the shogun's tea vessels and his falcons and horses, there were many similar instances of showing respect. For example, shogunal power in those days was reflected in the practice by which even a one-million-*koku* daimyo bowed down before the lesser officials who preserved the lives of the Tokugawa family. From about the Keichō era, various warlords were marching their armies into battle and the whole country

18. This is a reference to *Analects* 6.21: "The Master said: To men who have risen at all above the middling sort, one may talk of things higher yet. But to men who are at all below the middling sort it is useless to talk of things that are above them." Waley, *Analects of Confucius*, 120.

was constantly at war.[19] It was because Tokugawa Ieyasu finally united the country and, with benevolence and authority, crushed the power of the warlords that the mind of the emperor could be put at ease and the people could sleep in peace.[20] The warlord families submitted to Tokugawa authority and, in obedience to shogunal decree, undertook duties to serve the country. That the peace of the entire country endured was thanks to the legacy of shogunal authority.

This use of shogunal authority cannot be compared to the violence of slashing the bellies of pregnant women or burning people alive for wanton pleasure. To call it the craven means of an ugly custom is the slanderous speech of a person who does not understand the intention of the former government. You are saying now what you didn't say then because at that time you were a samurai who could sleep peacefully while basking in the glory of the Tokugawa government. To ridicule shogunal authority now—is this not like a criminal turning the tables on those who helped him and repaying kindness with enmity? Whether to rule a country with virtue or to rule a country with authority depends on the spirit of the people at the time. From ancient times, I have yet to hear of anyone who, on becoming an adult, censured his mother, defiling the love she bestowed upon him as a child. Base your knowledge on this principle!

○ Nowadays, the bad customs mentioned before are being reformed and if the people have any complaint of injustice against the government, they should present their argument without hesitation. If their case is in accord with natural principles and human feeling, they should fight for it even at the risk of their lives. Such is the obligation of the citizens of a country.

● Please listen carefully to what I have to say. It is well-known by all that the government from ancient times set up a system of courts to listen to the complaints of the common people. Moreover, for you to declare that it is the obligation of citizens to fight even by laying down their lives is like brewing discontent among innocent people.

19. The Keichō era spanned 1596–1611. The Battle of Sekigahara in Keichō 5 (1600) led to the establishment of the Tokugawa shogunate.
20. Tokugawa Ieyasu (1543–1616) was the founder of the Tokugawa shogunate.

Isn't it better for you to stop this argument and instead encourage a situation in which complaints will not be made?

○ As I have said before, if there is any threat to an individual country or an individual person, those threatened should not hesitate to take up arms against all countries of the world, nor should they fear even government officials. Moreover, since rational persuasion is useless to rule over stupid people, governments resort to harsh methods of control. Those born into this world and who are patriotic of mind must not fail to toughen their bodies, rectify their behavior, devote themselves to study, and work together to preserve the peace of the nation. This alone is the reason why I advocate the encouragement of learning.[21]

● Now, at the end of your discourse, for the first time I hear rhetoric that gives me great happiness. The sparrows of learning must also agree with this argument. But since we see things that need yet to be said, there will likely be further arguments. Make your next statements without reserve and we will respond to all.

21. In urging people to toughen their bodies, Ōga misrepresents Fukuzawa's original text. See *An Encouragement of Learning*, 9: "One who is patriotic of mind in contemporary society should not be anxious to the extent of disturbing his body and soul."

CHAPTER SEVEN

Katsu Kaishū: Looking Back at the Restoration

This chapter examines changing historical narratives of the Meiji Restoration by focusing on the ideas and actions of Katsu Kaishū, a former retainer of the Tokugawa family. How did Katsu, looking back after twenty years, recall and interpret the events that led to Japan's modern transition? In the 1880s and early 1890s, Katsu compiled and edited a series of histories of the Tokugawa family's military, diplomatic, and financial fortunes. In addition, he published several accounts of the events of the late 1860s based on his personal experience. In Bakufu shimatsu (The last days of the shogunate), published in 1895, he argued that the peaceful transfer of Edo Castle that he had negotiated on the order of Shogun Yoshinobu contributed to a smooth transfer to the new imperial regime.

My doctoral dissertation on Katsu was based largely on his diary. I examined his role as military commander in the final years of the Tokugawa regime and negotiator of the surrender of Edo Castle in 1868. This chapter on Katsu as archivist and historian is based on an article that I wrote in 2007, influenced by the continuing debate over accounts of Japan's wartime and colonial past presented in government-authorized secondary school textbooks.[1]

I examined Katsu's efforts to gain recognition for the contributions of the Tokugawa shogunate and showed that historical interpretations of the Meiji Restoration reflected unfolding domestic and international policies.

1. Steele, "Katsu Kaishū and the Historiography." Revised and translated as chapter 4 of Steele, *Meiji ishin to kindai Nihon*, 153–78.

This chapter argues that Katsu played a central role in the mid-Meiji debates on the nature of the Meiji Restoration. His positive evaluation of the contributions of the Tokugawa shogunate challenged and complicated the emperor-centered historiography of the Meiji Restoration.

Constructing a historical narrative was of crucial importance to the Meiji government. In 1869, a bureau was established by imperial edict to edit documents and compile a "definitive history" (*seishi*) of the Meiji Restoration, focusing on thought and actions of activist samurai in the restoration of imperial rule.[2] In addition, influenced by Fukuzawa Yukichi and a historiography that centered on the progress of civilization, scholars outside the government added their endorsement of the Meiji emperor as the embodiment of civilization and enlightenment.

These establishment views, however, did not go unchallenged. Leaders of the freedom and people's rights movement from the mid-1870s into the 1880s saw continuities between the despotic rule of the shogun and the domination of the government by a clique from Satsuma and Chōshū. Even more influential in contesting the emerging narrative were the histories written by former Tokugawa retainers who had been on the losing side of Japan's civil war. Among them, Katsu Kaishū was active in preserving and organizing the shogunal archives in the 1880s and early 1890s. He compiled a series of institutional histories covering the Tokugawa family's military, diplomatic, and financial fortunes. In addition, Katsu published several accounts of the events of the 1860s based on his personal experience. His retrospective view of the Meiji Restoration and his evaluation of the legacy of Tokugawa rule offered an influential alternative interpretation of the transition to modern Japan.

2. The translation of *seishi* as "definitive history" follows Mehl, *History and the State*, 66.

This chapter examines the construction of histories that challenged and complicated the historiography of the Meiji Restoration. Specifically, it attempts to answer two questions. First, what was the view of the Restoration promoted by the early Meiji government? Second, how was this view challenged in the 1880s and 1890s, especially by Katsu Kaishū and others who were not part of the winning coalition of activist samurai? The conclusion evaluates Katsu's contribution to the mid-Meiji debate over the meaning of the Meiji Restoration. Regarding the "bloodless" surrender of Edo Castle, it suggests that, for both Katsu and Fukuzawa Yukichi, interpretations of the past related to contemporary domestic and foreign issues.

Creating an Orthodox View of the Meiji Restoration

What was the Meiji Restoration? When did it begin and end? What was its significance? In the late 1860s, responses to these questions varied. Some commoners interpreted the upheaval in millennial overtones, believing that a divine emperor would usher in a new age of social renovation. Adherents of the nativists' teaching envisioned the restoration of ancient imperial rule, in which Japan would sweep away the pollution of foreign Chinese and Western influences. The Satsuma and Chōshū men and women who engineered the palace coup in late 1867 used the imperial symbol with the aim of uniting the nation and carrying out reforms designed to preserve Japanese independence. Foreign observers were divided in their immediate evaluation of the events of 1868. The British press hailed the revolution that would place Japan on the path of civilization, while the American press was more cynical. The *New York Times* described the inauguration of the new imperial regime as follows:

> The Mikado, who has been slowly and painfully emerging from the seclusion of centuries, like a butterfly from its chrysalis, has at length consummated the act, thanks to my Lord Satsuma, and has celebrated it by a royal coronation. In the imperial city of Kioto, at 8 o'clock A.M., on Oct. 12, year of grace 1868, the splendid farce was enacted, and the

poor boy, born a priest and educated [as] a woman, was dragged out to play the King for the pleasure of the Southern Daimios.[3]

Enomoto Takeaki and others who had fought the new regime to the bitter end had harsher words. The new government was a sham, he wrote in 1868: "The deliberations of the imperial government do not result from public discussion, but simply from the private views of one or two domains."[4] He attempted to set up a rival regime, a republic, in Hokkaido.

By the spring of 1869, the civil war was over, and the imperial forces were in firm control of the country. Gradually, the differing views of what had taken place in 1868 coalesced into a common narrative.[5] That year was not a revolution, but the restoration of imperial rule. It marked a new beginning, like the inaugural rule of Emperor Jimmu who, legend has it, began his reign in 660 BCE. The corrupt, weak, and self-serving rule of the Tokugawa family had been replaced by the enlightened and selfless rule of Emperor Meiji. Under his leadership, Japan would lay the foundation for a strong, rich, and independent nation-state.

As early as 1869, an imperial edict ordered the compilation of a history of Japan to "set right the relation between monarch and subject, to make clear the distinction between civilization and barbarity, and to implant the principle of virtue throughout the empire."[6] The Bureau of Historical Compilation, or Shūshikan, was established in 1877.[7] Along with the compilation of a national history, it was charged with collecting documents relating to the Meiji Restoration. Although the national history did not proceed as planned, the *Fukkoki* (Records of the Restoration) and *Meiji shiyō* (Outline of Meiji history) were

3. "Japan: The Boy King," 12.
4. Tōkyō Daigaku Shiryō Hensanjo, *Fukkoki*, 7:215.
5. Ōkubo, *Nihon kindai shigaku no seiritsu*, 39–58; Tanaka Akira, *Meiji ishinkan no kenkyū*, 6–24.
6. Quoted in J. Numata, "Shigeno Yasutsugu," 265. For the original text, see Kindai Shigaku Kenkyūkai, *Meiji Taishō Shōwa sandai shōchokushū*, 18. For an English translation, see Brownlee, *Japanese Historians and the National Myth*, 82.
7. Satō, "Meiji Dajōkan-ki no Shūshi bukyoku."

completed in 1889.[8] The massive *Fukkoki*, in its modern reprint edition, consists of fifteen thick volumes of documents. Although high standards of positivistic research were employed, it was clearly intended to provide legitimacy to the imperial government. Document after document showed that "men of determination" and loyalist daimyo had fought for the imperial cause in the waning days of Tokugawa rule.[9]

Complementing the work of the government scholars, other schools of history emerged in the 1870s, including the "history of civilization" (*bunmei shiron*) school influenced by Henry Buckle's *History of Civilization in England* and François Guizot's *General History of Civilization in Europe*. The concern with progress and development lent weight to arguments that the old regime had hindered Japan's advance toward the goal of civilization. Such was the conclusion of historian and economist Taguchi Ukichi's *Nihon kaika shōshi* (A short history of Japan's enlightenment), published in 1877.[10] Fukuzawa, another proponent of enlightenment history, wrote in *Bunmeiron no gairyaku* (An outline of a theory of civilization) that, before the Restoration, "the Japanese people had suffered for many years under the yoke of despotism. Lineage was the basis of power. . . . Throughout the land there was no room for human initiative; everything was in a condition of stagnation."[11] Fukuzawa recognized, however, that there were glimmerings of discontent within the Tokugawa order. Perry's arrival in the 1850s had provided a stimulus for action: "People actually set eyes on foreigners and heard them speak, read Western books and translations, increasingly broadened their horizons, and then woke up to the fact that a government, even a demonic one, could be overthrown by human powers."[12] The Meiji Restoration was thus the occasion for "bright rule," bringing an end to the darkness that had long prevailed over the Japanese people. Enlightenment scholars like Fukuzawa were easily able to accommodate themselves to establishment

8. Tōkyō Daigaku Shiryō Hensanjo, *Fukkoki*; Tōkyō Daigaku Shiryō Hensanjo, *Meiji shiyō*.
9. Tanaka Akira, *Meiji ishin-kan no kenkyū*, 71–89.
10. Tanaka Akira, *Meiji ishin-kan no kenkyū*, 32.
11. Fukuzawa, *An Outline of a Theory of Civilization*, 65. On Fukuzawa's view of history, see A. Craig, *Selected Essays*, 3–18.
12. Fukuzawa, *An Outline of a Theory of Civilization*, 67.

views of the Restoration.[13] The emperor was doubly confirmed as the legitimate force behind Japan's struggle to gain recognition as one of the civilized nations of the world.

Alternative Narratives

In the first decade of the Meiji era, few contested these views of the past. The Meiji Restoration had been the work of patriotic young men from the southwestern domains, especially Satsuma and Chōshū. They had restored the emperor to his rightful place, and under his leadership, they were aiming to create a new Japan. By the late 1870s, however, Ueki Emori (1857–1892) and others connected with the freedom and people's rights movement could see in the Meiji Restoration the onset of despotic rule rather than its destruction.[14] Gotō Shōjirō (1838–1897), leader of a movement to unite opposition parties in the 1880s, went so far as to dismiss the emperor from the center of the Restoration. Instead, he saw the events of the late 1860s as a failed revolution fought for people's rights and national independence.[15] Gotō found inspiration in the "public discussion" (*kōron*) discourse of the late Tokugawa period and called for a "second Meiji Restoration" to replace autocratic rule with a parliamentary system.

Another challenge to establishment historiography came from an unexpected source: the reminiscences of former daimyo who had lost power because of the centralizing policies of the new government. During the Satsuma Rebellion of 1877, Shimazu Hisamitsu (1817–1887), regent to the last Satsuma daimyo, ordered the compilation of records relating to his elder brother, Shimazu Nariakira (1809–1858). In 1884, he expanded the work to include documents from before, during, and immediately after the Restoration. In 1888, the Imperial Household Ministry, which had already published its own history of imperial rule, ordered the former daimyo of Satsuma, Chōshū, Tosa, and Mito to compile a record of national affairs (*kokuji*) in their

13. Tanaka Akira, *Meiji ishin-kan no kenkyū*, 36–37.
14. Tanaka Akira, *Meiji ishin-kan no kenkyū*, 51–56.
15. Steele, "Integration and Participation," 132.

individual domains during the years 1853 to 1871.[16] This group, expanded to include other daimyo and the court nobles Sanjō Sanetomi (1837–1891) and Iwakura Tomomi (1825–1883), was the nucleus of the Society for the Narration of History, or Shidankai, established in 1889.[17]

The society aimed to collect and publish documents relating to the "great achievement of the Meiji Restoration." Its leading members were former daimyo and members of the court nobility, many of whom were active supporters of imperial loyalism. Yet also aware that the Restoration was equally realized through the actions of lesser men and women, the society aimed to investigate events, large and small, with a spirit of justice, and without prejudice or party. Taking advantage of the stenographic techniques newly developed for parliamentary proceedings, it vowed "to record the conditions at that time exactly as they were and to make every effort not to misrepresent the truth."[18] Although some former daimyo submitted documents individually to the Imperial Household Ministry, the society's major contribution to Restoration historiography was a monumental oral history project. Between 1892 and 1938, the society published some 411 volumes of interviews with men and women connected with the Restoration under the title *Shidankai sokkiroku* (Stenographic records of historical narratives).[19]

Further complicating the ongoing debate over the meaning of the Meiji Restoration were accounts of former Tokugawa retainers.[20] Kurimoto Jōun, Kimura Kaishū, and other prominent members of the Edo Association (Edo kai), aimed to establish a positive public memory of Tokugawa society.[21] The first issue of the *Edo kaishi* (Journal of the Edo Association) was published on August 26, 1889, exactly three

16. The history of imperial rule published by the Imperial Household Ministry is Iwakura et al., *Taisei kiyō*.

17. Ōkubo, "Ōsei fukkō shikan." See also Takagi and Botsman, "Restoration: Memory Commemoration."

18. Tanaka Akira, *Meiji ishin-kan no kenkyū*, 182.

19. Shidankai, *Shidankai sokkiroku*; see also Kikuchi Akira, *Bakumatsu shōgen*.

20. Tanaka Akira, *Meiji ishin-kan no kenkyū*, 149–80; Ōkubo, *Nihon kindai shigaku no seiritsu*, 354–75. See also Wert, *Meiji Restoration Losers*, 42–73.

21. Karlin, "The Tricentennial Celebration of Tokyo," 219–20.

hundred years after Tokugawa Ieyasu's entry into Edo in 1689, the center of his new domain. The journal emphasized the debt owed by modern Japan to its Tokugawa past, notably a tradition of peace, stability, and moral integrity. According to association members, the Tokugawa era was "the period in which Japanese civilization achieved its greatest progress and development."[22] Instead of promoting progress, they feared that the Meiji government was leading Japan in the wrong direction.[23]

Fukuchi Gen'ichirō (1841–1906), former Tokugawa retainer and editor of the *Tōkyō nichi nichi* newspaper, also highlighted the Tokugawa side in a series of histories on the Restoration. In *Bakufu suibō ron* (On the decline of the shogunate), published in 1892, he stressed the newness of his approach: "Earlier works may have been studies of the Meiji Restoration, but they failed to describe the fall of the shogunate."[24] Fukuchi defended the Tokugawa family against charges of disloyalty to the emperor. Moreover, while recognizing that the narrowness of the Tokugawa regime was partly to blame for its downfall, he credited it with the ability to carry out reform. It was the shogunate, he noted, that had decided to open the country to the outside world in the 1850s, and it was the anti-foreignism of Chōshū and Satsuma domains that was to blame for instability of the late 1860s.

Katsu Kaishū: Archivist and Critic

Another Tokugawa retainer, Katsu Kaishū, added much to the debate regarding what had happened in 1868. Katsu is known primarily for his role as mediator during the last days of Tokugawa rule.[25] He was born in 1823 in the merchant district of Edo; his father, Katsu Kokichi, was an impoverished retainer of the Tokugawa family.[26] As a young

22. Quoted in Gluck, *Japan's Modern Myths*, 24.
23. Tanaka Akira, *Meiji ishin-kan no kenkyū*, 152–53.
24. Fukuchi, *Bakufu suibō ron*, 5. On Fukuchi, see Huffman, *Politics of the Meiji Press*.
25. Matsuura, *Katsu Kaishū*; Ishii, *Katsu Kaishū*; Steele, "Katsu Kaishū and the Collapse"; Hillsborough, *Samurai Revolution*.
26. On Katsu Kokichi, see T. Craig, *Musui's Story*.

man, he trained in swordsmanship and then in Dutch studies, focusing on Western military science. After Perry's arrival in 1853, Katsu's expertise caught the attention of ranking shogunal officials, who assigned him first to translation duties in Shimoda and then, in 1855, to Nagasaki, where he served as trainee supervisor and instructor at the newly established Nagasaki Naval Training Center. In 1860, he was appointed head of the Edo Naval Training Center and was captain of the *Kanrin Maru* as it sailed across the Pacific as part of the first Tokugawa mission to the United States. Placed in charge of naval reform for the shogunate on his return, he tried unsuccessfully to establish a national navy. At the national level, he advocated power sharing among the shogunate, the court, and the various domains. This earned him the favor of Satsuma and Chōshū activists, including Saigō Takamori. It was Katsu who carried out the negotiations with Saigō that led to the peaceful surrender of Edo Castle in the spring of 1868.[27]

Katsu served as advisor to the Meiji government and between 1872 and 1875 held office as naval minister.[28] However, he did not slacken his commitment to the Tokugawa family. He helped to establish a banking institution designed to grant loans to needy Tokugawa-related persons. He organized fundraising societies for the repair and preservation of Tokugawa family temples and shrines, including the upkeep of the Tōshōgū shrine in Nikko. Finally, Katsu worked for reconciliation between the imperial household and the Tokugawa family, aiming to erase the stigma "enemy of the court" (*chōteki*), which had hung over the Tokugawa family since 1868. In 1898, the year before his death, Katsu was successful in arranging an audience for former shogun Yoshinobu with the Meiji emperor and empress. In his diary he recorded in an unsteady hand: "Have my efforts for the past thirty years at last made some headway?"[29] For Katsu, the Meiji Restoration may have begun with the Restoration of Imperial Rule edict in 1867, but it ended only in 1898, with the restoration of honor to the Tokugawa family (fig. 7.1). Katsu died at the age of seventy-seven in January 1899.

27. Steele, "Against the Restoration."
28. Matsuura, *Meiji no Kaishū to Ajia*; Matsuura, *Katsu Kaishū*.
29. *Katsu Kaishū zenshū*, 21:516.

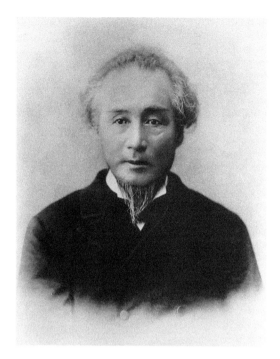

7.1. Katsu Kaishū in his later years, in the 1880s or 1890s. Public domain, via Wikimedia Commons.

During the 1880s, Katsu focused his activities on the compilation and editing of documents relating to the history of the Tokugawa shogunate, especially in its final years. Working with some sixteen former Tokugawa retainers, most of whom had held positions in the Tokugawa Bureau of Finance (Kanjōsho), he compiled and edited records relating to the fiscal and economic administration of the shogunate. The work was published in 1890 under the titles *Suijinroku* (A record of dust blown away) and *Suijin yoroku* (Additional record of dust blown away).[30] Again with the help of former shogunal officials, he edited two military histories, *Kaigun rekishi* (History of the navy), and *Rikugun rekishi* (History of the army); both were published in

30. *Katsu Kaishū zenshū*, vols. 6–10.

1889.[31] A history of late Tokugawa foreign relations, *Kaikoku kigen* (The origins of the opening of the country), was published in 1893.[32] Katsu began, but did not complete, a compilation of documents relating to the history of Edo Castle. Considering its scope and depth, Katsu's archival work has received surprisingly little scholarly attention. In addition to preserving copies of important Tokugawa documents, his publications complement and, in some cases, offer a corrective to the "definitive history" of the Meiji Restoration.

Suijinroku was Katsu's major project during the 1880s. Based on the now-lost archives of the shogunal Bureau of Finance, it includes edited documents on population, tax, currency, mining, river management, and stipends, and it remains an invaluable resource for students of Tokugawa-period social and economic history. The work coincided with a period of serious financial and economic challenges that followed the Satsuma Rebellion of 1877. Facing unsustainable levels of inconvertible paper currency and runaway inflation, the government, led from 1881 to 1889 by Minister of Finance Matsukata Masayoshi (1844–1897), reduced the money supply through agricultural and consumer tax increases, spending cuts, and public bond issues.[33] The subsequent depression had a particularly devastating impact on rural communities, causing widespread indebtedness and the pawning of agricultural land. Hardship was exacerbated by a cholera epidemic in 1882 and a series of poor harvests in 1884 and 1885.

Sensing a resonance between the problems of the 1880s and those confronted by the shogunate in its final years, Katsu showed an initial draft of his document compilation, at that time titled simply *Keizai zassan* (A miscellany of economic records), to Matsukata in 1884.[34] Matsukata, in turn, was sufficiently impressed with the project that, when the basic work was completed in 1887, he secured government financial support for the final editing, which was completed that same year. In 1890, the work was published by the Ministry of Finance in

31. *Katsu Kaishū zenshū*, *Kaigun rekishi* (History of the navy), vols. 12–13; *Rikugun rekishi* (History of the army), vols. 15–17.

32. *Katsu Kaishū zenshū*, *Kaikoku kigen* (Opening of the country), vols. 1–5.

33. For a reevaluation of Matsukata's policies, see S. Ericson, *Financial Stabilization in Meiji Japan*.

34. Katsu, *Keizai zassan*.

two massive volumes under the title *Suijinroku*; the *Suijin yoroku* was published at the same time. The first volume contained an epigraph by the Minister's office that read in part: "Distressed that there was no book describing the actual financial situation of the shogunate, the Ministry of Finance consulted Count Katsu. As a result of the Count's efforts, this book was compiled."[35]

Katsu offered his own explanation of the title. In his preface, he alluded to Huangdi, the legendary Chinese Yellow Emperor, who dreamed of dust being swept from heaven and interpreted it to indicate the arrival of an able administrator who could help in governing the realm:

> All who see this book say that it will benefit the economy. In ancient times, the Yellow Emperor saw a dream in which a great wind arose, and all the dust (*suijin*) of the world was blown away. This book neither denotes the dream of the Yellow Emperor nor should it be known as such. For the time being, I use the title *Suijin* (Dust blown away) and, awaiting the future, will put it to the test.[36]

Although Katsu modestly denied that his book could be associated with Huangdi's dream of good government, he believed that the "dusty" records of the Tokugawa shogunate contained valuable lessons for addressing contemporary problems. Matsukata and others in the government supported his conviction. Impressed by Katsu's work with the Bureau of Finance records, officials in the Ministry of the Army and the Ministry of the Navy approached him to oversee a similar compilation of Tokugawa military documents.[37] Katsu's documentary histories of the Tokugawa army and navy were published by the respective ministries in 1889.

One reason for linking Katsu's work with a legendary search for reform could be found in Katsu's own activities as archivist and political critic during the 1880s. On May 8, 1887, while in the final stages of preparing *Suijinroku* for publication, Katsu was awarded the title of

35. Katsu, *Suijinroku*, 1: epigraph.
36. *Katsu Kaishū zenshū*, 6:iii, 446–68.
37. Matsuura, *Katsu Kaishū*, 670.

count (*hakushaku*). He accepted the honor reluctantly and, pleading illness, did not attend the award ceremony. Later that month, ostensibly to express his gratitude, he visited Itō Hirobumi, prime minister and leader of the dominant Chōshū faction. Katsu used the occasion to hand him a twenty-one-point critique of the government's functioning and policies; he had shown the document to Kuroda Kiyotaka (1840–1900), the leader of the Satsuma faction, on the previous day.[38]

The first three points dealt with the disharmony between the two cliques that had dominated politics since the Restoration—and that Katsu saw as the major obstacle to the realization of good government: "If there is discord within a country, or even within a family, and agreement is not reached, the wealthy family will turn into a poor family and the country will be impoverished."[39] Citing examples from history, he contrasted the political infighting that had sabotaged shogunal reforms in the 1840s with the Tokugawa family's ungrudging acceptance of its reduced circumstances in 1868. It was the Tokugawa magnanimity and unity in purpose that had made possible the gradual improvement in people's lives in the Meiji era. Japan's future, Katsu argued, demanded that the Satsuma and Chōshū factions work together in harmony and not against each other.

A second concern of Katsu's critique related to economic issues. Although he acknowledged that the land tax was lower than in Tokugawa days, the level of taxation overall was higher, and in recent years "poverty at the lowest echelons of society has become extreme."[40] At the same time, some former low-ranking samurai were suffering social exclusion and poverty. Using the language of the Tokugawa era, he called upon the government to pay particular attention to its obligation of "caring for the people" (*bokumin*). In contrast with the hardships of the poor were the excesses of those at the very top of society: "Recently high officials, unbefitting their station, have attended parties and night entertainments and [have been] in other ways swimming in extravagance."[41] Here Katsu was pointing his finger at

38. *Katsu Kaishū zenshū*, 14:255–58; Matsuura, *Katsu Kaishū*, 612–16.
39. *Katsu Kaishū zenshū*, 14:451.
40. *Katsu Kaishū zenshū*, 14:451.
41. *Katsu Kaishū zenshū*, 14:256; Matsuura, *Katsu Kaishū*, 615.

members of the Japanese political and social elite, including Itō and Matsukata, who were reported to have danced away the night while government policies cut deep into the livelihood of the poor.[42]

A final group of problems concerned foreign affairs, particularly relations with China. Distancing himself from Fukuzawa's call to "leave Asia and join the West," Katsu stated that China should be given the respect it deserved: "China is our neighbor and the source of our country's institutions, learning, and arts. It is my wish that, after such a long time, we do not see China as our enemy but pursue cordial relations in good faith. Not to do so would be a national disgrace."[43]

Katsu concluded that the experience of the Tokugawa period remained relevant to the problems confronting Japan since the Meiji Restoration. The last of his twenty-one points read: "In general, relations with foreign countries must not be carried out in a biased manner; we must not fall into the trap of hating some countries and loving others. Already there are instances in which we are following in the ruts of the former government."[44] There were positive lessons to be learned and warnings to be heeded.

Katsu's Restoration

In addition to his archival work, Katsu composed several narrative accounts of the Meiji Restoration drama. He wrote often from firsthand experience, relying on his diary. These works, produced in the last fifteen years of his life, include unpublished essays, published books, and published stenographic records of conversations and interviews.[45] Among them, *Bakufu shimatsu* (The last days of the shogunate), published privately in 1895, offers an interesting contrast to the orthodox views of the Meiji Restoration that were emerging around

42. Itō hosted a fancy dress ball at his official residence less than two months before the meeting with Katsu. See Shively, "The Japanization of Middle Meiji," 95–96.

43. *Katsu Kaishū zenshū*, 14:454.

44. *Katsu Kaishū zenshū*, 14:456.

45. *Kainanroku* (An account of my tribulations), written in 1884; *Dachō no ki* (A heartrending narrative), published in 1888; and *Gaikō yōsei* (The flow of diplomatic relations), published in 1890, are included in *Katsu Kaishū zenshū*, vol. 11.

the same time.[46] It was originally prepared in Japanese for E. Warren Clark (1849–1907), a chemistry graduate from Rutgers University who had come to Japan at Katsu's invitation in 1871. Clark taught at Shizuoka Academy and at Kaiseijo, the school that would become Tokyo Imperial University, before returning to the United States in 1875.[47]

Visiting Japan in 1894, after an absence of nearly twenty years, Clark renewed his acquaintance with Katsu. In a postscript to *Bakufu shimatsu*, Katsu's long-time protégé, Tomita Tetsunosuke (1835–1916), wrote that Clark asked Katsu repeatedly about what he considered an enigma: the respect and high social standing given in the Meiji era to the former shogun, Yoshinobu, and to Katsu and other former Tokugawa retainers. Katsu's answer, detailed in his essay, characterized the Meiji Restoration as a smooth and peaceful transition of power brought about by concessions and sacrifice on both sides. The restoration of imperial rule was, he argued, a compromise; the new Japan was built upon old foundations.[48]

As the title suggests, *Bakufu shimatsu* paid scant attention to the young Meiji emperor and the samurai who fought in his name. Katsu's hero was the former shogun Yoshinobu, and the climax of his drama was the peaceful surrender of Edo Castle in the spring of 1868—not the military coup that restored the ancient imperial system in the last month of 1867 or the imperial army's victory in the bloody civil war that continued until the summer of 1869. And while not denying the criticisms of the shogunate made by Fukuzawa and other enlightenment thinkers, Katsu argued that Tokugawa-era ideals, such as public

46. Katsu, *Bakufu shimatsu*.
47. Candee, "E. Warren Clark."
48. According to Tomita, Katsu wrote *Bakufu shimatsu* from his sickbed; Tomita published it privately in 1895 for distribution to family and friends. See Katsu, *Bakufu shimatsu* and its text in *Katsu Kaishū zenshū*, vol. 11. A letter written by Clark to William Griffis in 1895 suggests that Katsu (whom Clark described as "old & feeble") had wanted his views published in English. Although Clark had a translation made at the American Legation in Tokyo and submitted the manuscript to Harper & Brothers for publication, it was rejected as not being "long enough" (Clark to Griffis, November 17, 1895, William Elliott Griffis Collection). Sections from this translation appear in E. W. Clark, *Katz Awa*.

service, impartial justice, and righteousness, contributed to the success of the new imperial government.

Bakufu shimatsu is in two parts. The first part offers a brief history of shogunal rule from the establishment of the first shogunate in Kamakura in 1192 to the return of governing authority to the emperor in 1867. Its main point is that during these seven hundred years, each successive shogun was the servant of the emperor and ruled on his behalf. The second and longer part details Katsu's own involvement in the Restoration drama, centering on his role in negotiating the peaceful surrender of Edo Castle. It opens with the arrival of Yoshinobu in Edo on the 12th day of the first month of 1868, following the defeat of his troops at the Battle of Toba-Fushimi. He had spent his entire time as shogun—from the summer of 1866 until the abolition of the shogunate in late 1867—in Kyoto and Osaka. Stirred by news of the Tokugawa defeat and the approach of the imperial forces along the Tōkaidō, impassioned groups throughout Edo prepared to defend the city:

> After Yoshinobu returned to Edo and entered the castle, the excitement of the bannermen, various officials, and their retainers was extreme, and their frenzy spread even to the townspeople. Their words made no sense; just wild with anger and riotous, they were out of control. They were like a huge hive of wild bees broken loose.[49]

Yoshinobu called his senior retainers to the castle to debate their next move: should they pursue war or peace? Oguri Tadamasa and other pro-war advocates pressed him to continue the fight: "We can stop the imperial army at Hakone Pass, unite the lords of the Kantō, and make a solid defense."[50] Some wanted to send warships to attack Osaka. Others argued that if Yoshinobu personally led the troops, he could invigorate their warrior spirit. Many simply shouted: "Subdue Satsuma and Chōshū!"

49. *Katsu Kaishū zenshū*, 11:258; E. W. Clark, *Katz Awa*, 47.
50. *Katsu Kaishū zenshū*, 11:259; E. W. Clark *Katz Awa*, 48.

According to *Bakufu shimatsu*, Yoshinobu announced his decision to submit to the emperor on the 12th day of the second month:

> For many years I have lived in close quarters to the imperial palace, and I am not at variance with the court. I failed in my command at the battle of Fushimi and was unexpectedly named enemy of the court. Now I accept that. I earnestly respect the imperial decision and apologize for the errors I have committed. Although you have reason to be resentful, if we fight and there is no resolution, our nation will collapse, and the people will suffer great hardship.[51]

Yoshinobu asked Katsu, the commander of the Tokugawa armed forces, for his opinion. Katsu laid out two possible paths forward. The first was the path to war. He outlined an elaborate strategy in which he would lead Tokugawa forces on land and sea to halt the advance of the imperial army at Suruga (present-day Shizuoka Prefecture).[52] Following this victory, he would lead three warships to Osaka and "reduce the city to ashes." Katsu warned, however, that peace would be short-lived, since any expansion of Japan's civil war would inevitably lead to foreign intervention: "Even so, the nation would collapse, as the daimyo throughout the country would compete with each other, trying to strengthen their advantage by forming connections with foreign countries."[53] Fearing such a conclusion, Katsu outlined a second path, one that led to peace:

> If we could only demonstrate our peaceful intention, with the sole purpose of tranquility, for the happiness and safety of the people, and show that we are willing to sacrifice our personal interests and possessions,

51. *Katsu Kaishū zenshū*, 11:259. See also Katsu's diary entry in *Katsu Kaishū zenshū*, 19:15.

52. *Katsu Kaishū zenshū*, 11:259–60; E. W. Clark, *Katz Awa*, 48–50. In recording Katsu's "bellicose speech," Clark noted: "Had the plan been carried out, thousands of men on both sides would have perished. But this is precisely the sort of sectionalism that led, only six years previous, to our own Civil War—a war which our Lincoln tried to avert, but, unfortunately, was less successful as a peacemaker than Katz Awa."

53. *Katsu Kaishū zenshū*, 11:260. See also Katsu's diary entry in *Katsu Kaishū zenshū*, 19:16.

to surrender even our arms and castles, thus leaving the fate of the House of the Tokugawa to the will of heaven, and this for the sake of our common country, then will nothing be able to harm us.[54]

The call for peace thus accorded with Yoshinobu's decision to surrender. At the former shogun's request, Katsu reluctantly assumed responsibility for conducting negotiations with Saigō Takamori, the leader of the imperial army. For his part, Yoshinobu retired to Kan'eiji, the Tokugawa family temple in Ueno, "leaving Edo Castle without a lord."[55]

Many Tokugawa retainers were outraged with the decision to seek peace: "We will cut off Katsu Awa's head and offer it as a sacrifice to the god of war, as he is surrendering us into the hands of the enemy."[56] Katsu, however, noted his own heroic resolve: "Not a shadow of doubt did I have that I was proceeding right. I resolved that if, in the imminent danger to the city, we could not save the innocent multitude, we should, at least, be the first to sacrifice ourselves."[57]

The decisive meeting took place on 14th day of the third month. Katsu handed Saigō a statement in which he expressed regret for the Battle of Toba-Fushimi that had triggered the ongoing civil war. Katsu's prime concern was to prevent an expansion of hostilities, which would cost the lives of thousands, and he warned Saigō that the responsibility for peace lay with both sides:

> If the imperial army launches a fierce attack and with swords unsheathed violently threatens defenseless people, we will be forced to take up arms and return fire. In such circumstances, will not more and more innocent people die and the suffering of their spirits last forever? If the imperial army desires to be truly loyal to the entire nation, you should be aware of all principles and conditions before opening hostilities. On our side as well, we must reflect on what is righteous and what is not, and we must not recklessly enter battle.[58]

54. *Katsu Kaishū zenshū*, 11:260; E. W. Clark, *Katz Awa*, 50–51.
55. *Katsu Kaishū zenshū*, 11:261.
56. *Katsu Kaishū zenshū*, 11:261; E. W. Clark, *Katz Awa*, 51.
57. *Katsu Kaishū zenshū*, 11:262; E. W. Clark, *Katz Awa*, 51–52.
58. *Katsu Kaishū zenshū*, 11:262–63; E. W. Clark, *Katz Awa*, 52–53.

Katsu's statement invoked the negative moral legacy that a continuing civil war would bequeath to the nation: "Ah! The destruction of the Tokugawa family would allow no one to die in peace, preserving honor and the great principle (*daijōri*); it would, rather, leave only generations of regret and invite scorn and ridicule from abroad."[59]

In the ensuing negotiations, Katsu proposed that the new imperial government would make Edo the nation's capital; it would also decide on the disposition of the Tokugawa domain. Regarding foreign affairs, he maintained that the Tokugawa government had acted for the benefit of the nation rather than for any private advantage; he urged the incoming government to heed the lessons of India and China, where civil war had led to foreign intervention. Katsu's final argument was that a just settlement would ensure the legitimacy of the new government, both among the Japanese people and in the eyes of the world:

> Today, here in the nation's capital, it is not Yoshinobu's desire, grieving over the fate of the Tokugawa family, to take up arms and kill our citizens. We have only one request: that the settlement will be just and reasonable so that there will be no shame before heaven and the imperial court will thereby prosper. Once the correctness of this development is observed, its light will immediately spread throughout the nation. Foreign countries, hearing of this, will renew their trust in our nation and peaceful relations will be increasingly secured.[60]

According to *Bakufu shimatsu*, Saigō accepted Katsu's arguments and countermanded the order for the city's assault, scheduled for the next day. Following extensive preparations on both sides, the imperial army presented its terms of surrender on the 4th day of the fourth month. The first article stated that, although Yoshinobu had committed flagrant offenses against the imperial court, because of his repentant attitude and the good service of his ancestors to the country, he would be offered clemency: "The Tokugawa name and family shall continue.

59. *Katsu Kaishū zenshū*, 11:263.
60. *Katsu Kaishū zenshū*, 11:263.

Yoshinobu's sentence of death is hereby commuted. He shall retire to Mito and live there in seclusion."[61]

On the 11th day of the fourth month, the imperial army took possession of Edo Castle in a formal ceremony, conducted without incident. On the following day, Yoshinobu left Edo for Mito, where his father, Tokugawa Nariaki, had ruled as daimyo. Later that month came the announcement that the boy Tayasu Kamenosuke would succeed Yoshinobu as the sixteenth head of the Tokugawa family, assuming the name Tokugawa Iesato; the Tokugawa family and its retainers would relocate to Shizuoka.[62]

The peaceful surrender of Edo Castle and the generous treatment of the Tokugawa family mark the culmination of Katsu's narrative of the Meiji Restoration. He gives only passing attention to the expulsion of the Tokugawa diehards, the Shōgitai, from their headquarters in Kan'eiji on the 15th day of the fifth month and to the series of battles that led to the defeat of the pro-Tokugawa league of northeastern domains.[63] These episodes were not part of Katsu's Restoration. He downplayed the political and military activism of the imperial loyalists from Satsuma and Chōshū before the Battle of Toba-Fushimi. Instead, he focused on the subsequent actions on the Tokugawa side to protect the national interest.

However, in relating the events after the Battle of Toba-Fushimi, Katsu emphasized the restraint shown by those on both sides, arguing that peace negotiations cut short Japan's civil war and laid the foundation for national unity and cooperation between the old shogunal and new imperial regimes. He asserted that the process of national unification "owes much of its success to the heroic sacrifice of brave men, who forgot themselves, their own homes and lives, for the lasting good of their common country."[64] Such was Katsu's answer to Clark: the prosperous and progressive Japan that appeared before his eyes in 1894 was the result of continuity rather than change in Japanese leadership and its ideals.

61. *Katsu Kaishū zenshū*, 11:265; E. W. Clark, *Katz Awa*, 55–56.
62. *Katsu Kaishū zenshū*, 11:266–68.
63. *Katsu Kaishū zenshū*, 11:269.
64. *Katsu Kaishū zenshū*, 11:268; E. W. Clark, *Katz Awa*, 57.

Conclusion

By the late 1880s, the terms "loyalty to the emperor" and "expel the barbarian" had lost their magic touch in histories of the Meiji Restoration.[65] In the "crowded discursive field" that was emerging, historical narratives placed emphasis variously on public and popular opinion, on the need for a "second restoration" to complete the fight against absolutism, on the experiences of former daimyo and others in the domains, and on Tokugawa contributions to the new nation-state.[66] In addition, a modern, European-influenced school of critical history at Tokyo Imperial University, led by Shigeno Yasutsugu and Kume Kunitake, aimed at systematic interpretation based on verifiable facts.[67] As Shigeno proclaimed in the first issue of the *Shigaku zasshi* (The journal of historical studies), which he helped to found in 1889, "historians must be impartial."[68]

Continuity, rather than change, was the keyword in Katsu's historiography of the Meiji Restoration. He was among the earliest to link the Tokugawa heritage with what he saw as the success of the Meiji Restoration. In contrast with imperial histories that traced Japan's origins back to the reign of Emperor Jimmu, *Bakufu shimatsu* praised Tokugawa Ieyasu, founder of the government that had unified the country and maintained peace for over 250 years. Even its closing years, the shogunate had opened the country to foreign relations, westernizing the armed forces, opening schools of Western learning, and inviting foreign specialists to help introduce new technologies. It had sent diplomatic missions to America and Europe and honed skills in diplomatic practice. Although its limitations were undeniable, the Tokugawa government contained positive lessons that were valid for its Meiji successor. National seclusion was not its primary legacy, but peace, stability, and even openness to innovation when in the national interest. Katsu argued especially that Yoshinobu's decision

65. A. Craig, "Fukuzawa Yukichi," 144; Gluck, *Japan's Modern Myths*, 23–24.
66. The "crowded discursive field" is discussed in Keirstead, "史学 Shigaku / History," 3.
67. Yijang Zhong, "Formation of History," 3–20.
68. Shigeno, "Shigaku ni jūji suru mono," 1–3.

to surrender Edo Castle reflected Tokugawa values of impartial justice, self-sacrifice, and public service. The concessions made on both sides halted the expansion of civil war and set the conditions for a smooth and peaceful transfer of power.

Fukuzawa Yukichi also joined the mid-Meiji debate over the meaning of the Meiji Restoration. By this time, more a proponent of nationalism than individualism, he was especially critical of the narratives that praised Tokugawa efforts to achieve a peaceful transfer of power. In 1891, four years before the publication of Katsu's *Bakufu shimatsu*, Fukuzawa sent a draft of an essay titled *Yasegaman no setsu* (On fighting to the bitter end) to Katsu, Enomoto Takeaki, Kimura Kaishū, Kurimoto Jōun, and other eminent survivors of the old regime. (A translation of the essay follows in chapter 8.)[69] Fukuzawa attacked Katsu and Enomoto for failing "to fight to the bitter end" in Edo and Hakodate, respectively: "Although their actions produced a temporary benefit for the Japanese economy, the damage to the Japanese warrior spirit, which had evolved over many hundreds of years, was by no means insignificant." For Fukuzawa, praise for the peaceful surrender of Edo Castle ignored its dangerous implications for national security: "Those who lack the spirit of fighting to the bitter end in internal affairs will likewise lack it when confronting external threats."

Katsu's *Bakufu shimatsu* and Fukuzawa's *Yasegaman no setsu* were thus central to the ongoing debate on the nature of the Meiji Restoration. At stake were two diametrically opposite views of the Restoration as history and two contesting ways of relating past to present. Fukuzawa's emphasis on "fighting to the bitter end" reflected his concerns about Japanese foreign policy in the 1880s and early 1890s. Peaceful negotiations were no substitute for military readiness; Japanese citizens had to be prepared to sacrifice their lives in defense of their country. Katsu thought otherwise. He lamented the loss of life in war and argued that Japanese aggression in Asia would benefit only the Western powers; cooperation, not contest, was necessary between Asian nations.[70] Like Fukuzawa, Katsu looked back to the values of the Tokugawa samurai but, instead of the spirit of "fighting to the

69. The quotations that follow are taken from the translation in chapter 8.
70. Matsuura, *Meiji no Kaishū to Ajia*.

bitter end," he championed their advocacy of patience and restraint to overcome all difficulties.[71]

In 1897, two years before his death, Katsu used history to criticize the government's failure to respond adequately to problems of pollution and flooding caused by the Ashio Copper Mine: "The present government is supposed to be civilized, while the shogunate is supposed to have been barbarian, but look what the so-called civilized government in doing to the people in Ashio. . . . Is not civilization something that accords with principle and makes sure the people do not fall into harm's way?"[72] Historians, even today, debate the meaning of the Meiji Restoration—and they continue to find relevance in those now ancient history wars.

71. *Kainanroku, Katsu Kaishū zenshū*, 11:355–56.
72. Matsuura, *Meiji no Kaishū to Ajia*, 177–78.

CHAPTER EIGHT

Fukuzawa Yukichi: On Fighting to the Bitter End

This chapter is a translation of Fukuzawa Yukichi's critique of Katsu Kaishū and Enomoto Takeaki, Tokugawa retainers who chose, in 1868, not to fight vigorously in defense of the shogunal regime. Yasegaman no setsu *(On fighting to the bitter end) was written in 1891 but was published only ten years later. Predating* Bushido: The Soul of Japan, *written by Nitobe Inazō (1862–1933) in 1899, Fukuzawa's work was one of the first texts to celebrate traditional martial values, including loyalty and the determination to "fight to the bitter end," as the wellspring for modern Japanese nationalism.*

The strident attack on Katsu and Enomoto, written by Japan's most famous westernizer, appears to contradict the focus on freedom, independence, equality, and rationality—the values of "civilization and enlightenment"—that characterized much of Fukuzawa's earlier writings. However, Fukuzawa, guided by utilitarian and pragmatic ideas, was constantly engaged in the political and economic realities of his day. His 1866 petition to the shogunate (chapter 3) advocated military force to create a centralized government under the Tokugawa. In the 1880s, his much-publicized call for Japan to "leave Asia and join the West" was an attempt to validate Japanese imperialism in Asia. In the 1890s, Fukuzawa celebrated Japan's victory in the Sino-Japanese War (1894–1895), claiming that bushido values were responsible for its success. Katsu Kaishū, on the other hand, had opposed Fukuzawa's plan to rejuvenate Tokugawa hegemony in 1866, had negotiated the peaceful surrender of Edo Castle in 1868 (chapter 7), and consistently cautioned against military expansionism and colonial ventures, including the war with China. Katsu easily became a target of criticism by Fukuzawa

and others who called upon patriotism and the use of force to enhance Japan's position in the world.

This is a revised version of a translation I published in 2002 in response to a resurgence of nationalist and militaristic sentiment following the terrorist attacks of September 11, 2001.[1] *In classes, I used the translation to encourage students not only to revisit the debate over the so-called bloodless surrender of Edo Castle but also to consider the role of military values in the contemporary world.*

Fukuzawa Yukichi's essay *Yasegaman no setsu* (On fighting to the bitter end), written in 1891, reflected conservative trends in Japan in the late 1880s and Fukuzawa's own growing commitment to martial values as the foundation for Japanese nationalism.[2] It criticized the actions of Katsu Kaishū and Enomoto Takeaki, who, according to Fukuzawa, had not only failed to fight to the bitter end in defense of the Tokugawa shogunate but had gone on to enjoy wealth and high social status under the new Meiji government. Katsu had played an important role in the so-called bloodless surrender of Edo Castle: his negotiations with Saigō Takamori in the spring of 1868 form one of the most famous episodes in modern Japanese history.[3] Enomoto had initially resisted the imperial takeover, fleeing with the Tokugawa navy to Hakodate and attempting to set up a republic; under fire, however, he surrendered and, after a brief imprisonment, joined the Meiji government.[4] Both Katsu and Enomoto rose in service to the imperial government. Katsu was chief minister of the navy in the 1870s and later served as a member of the Privy Council; Enomoto had an illustrious career as a diplomat and, following the establishment of the cabinet system in 1885, served as minister of communications and, from 1889,

1. Fukuzawa, "*Yasegaman no setsu*: On Fighting to the Bitter End," translated with commentary by Steele.
2. On Fukuzawa's nationalism, see A. Craig, "Fukuzawa Yukichi"; and Nishibe, *Fukuzawa Yukichi*.
3. Steele, "Against the Restoration."
4. Tanaka Akira, *Hokkaidō to Meiji ishin*, 81–118.

minister of education. In May 1891, while Fukuzawa was writing his essay, Enomoto was appointed foreign minister. Both Katsu and Enomoto had been awarded titles of nobility in recognition of their service to the nation.

Fukuzawa and Katsu were rivals of long standing.[5] Katsu was born in 1823 and Fukuzawa in 1835. They both owed their early advancement to Dutch studies, through which they had gained specialized knowledge of the outside world. In 1860, their lives came together on board the *Kanrin Maru*, which accompanied the official embassy sent to ratify the Treaty of Friendship, Commerce, and Navigation between the United States and Japan. Katsu was its captain, and Fukuzawa traveled as attendant and translator for Kimura Kaishū, the chief Tokugawa official on board. Fukuzawa criticized Katsu as "a very poor sailor—he did not leave his cabin during the whole journey across." Of himself, he wrote: "I seemed to be physically fit and did not suffer from seasickness at all."[6]

From the mid-1860s, the two men developed sharply opposing solutions to the problems confronting the Tokugawa regime. Fukuzawa, in 1866, argued on behalf of a "Taikun monarchy" (chapter 3). Katsu opposed any notion of absolutism: inspired by demands for a more "public" political space, he supported the establishment of a parliamentary system that would guarantee an equal sharing of power among the shogunate, the court, and the various domains.[7] In the spring of 1868, Katsu's negotiations with Saigō Takamori led to Shogun Yoshinobu peacefully giving up Edo Castle and, in effect, to the emergence of the new imperial government. At that time, since the slogan of the imperial loyalists was "respect the emperor and expel the barbarian," Fukuzawa, by contrast, feared that an imperial restoration would undo the progress made in opening Japan to the West.

Even after it was clear that the Meiji regime was committed to westernization, Fukuzawa and Katsu remained poles apart, especially concerning Japan's position in Asia (chapter 7). In the 1880s, while

5. Ida, "'Yasegaman no setsu' to 'Hikawa seiwa.'" See also Wert, *Meiji Restoration Losers*, 54–58.
6. Fukuzawa, *The Autobiography of Fukuzawa Yukichi*, 109–11.
7. Steele, "Public, Private, and National."

CHAPTER EIGHT

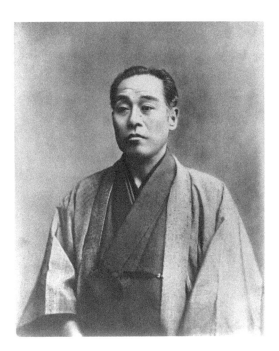

8.1. Fukuzawa Yukichi in 1901, shortly before his death. Public domain, via Wikimedia Commons.

Katsu encouraged a union of Asian countries to counter possible Western imperialism, Fukuzawa urged Japan to "leave Asia and join the West."[8] Moreover, Katsu objected to the outbreak of hostilities with China in 1894 and expressed doubts about Japan's decision to follow the lead of Western imperialism.[9] Fukuzawa, on the other hand, was overjoyed at the news of Japan's victory: "The Sino-Japanese War is the victory of a united government and people. There are no words that can express my pleasure and thankfulness: to experience such an event is what life is for."[10] In the 1890s, both Katsu and Fukuzawa were sage-like figures, eager to reflect on the past, though with

8. For an English translation, see Fukuzawa, "Good-Bye Asia."

9. Matsuura, *Katsu Kaishū to Ajia*, 153–74; Matsuura, *Katsu Kaishū*, 675–731.

10. Fukuzawa, *The Autobiography of Fukuzawa Yukichi,* 335, translation revised.

competing narratives of how that past related to Japan's present and future (fig. 8.1).[11]

Yasegaman no setsu consists of three parts. It opens with the enigmatic statement, "The founding of a nation derives from private rather than public principles." With this, Fukuzawa rejects the traditional Confucian understanding that a "public and common spirit" began the process by which "all under heaven" (C. *tianxia*, J. *tenka*) came to be ruled by men of talent.[12] Influenced by Western thinkers such as Adam Smith (1723–1790), Fukuzawa argues that self-interest and private emotions, such as loyalty and patriotism, are essential to create a nation whose citizens (*kokumin*) "prioritize the interests and glory of their own nation to the near exclusion of all else." A confluence of private emotions is thus the wellspring for the making of a public entity, the nation, and foremost among these emotions is the spirit of fighting to the bitter end. Patriotic citizens in Japan and elsewhere should be prepared to fight and die for their country, even if there appears to be no chance for victory: "No one in the real world, past and present, has ever aimed to establish what came to be called a nation and sought to maintain and preserve it without depending on this doctrine."

The next sections of the essay critique the actions of Katsu and Enomoto during and after the Meiji Restoration. Fukuzawa finds fault with the "mathematical reasoning" that led "peace advocate" Katsu to negotiate the surrender of Edo Castle, thereby "harming the warrior spirit that constitutes the founding of the nation." Moreover, he castigates Katsu for aligning himself with his former enemies by accepting high positions in the new imperial government; rightfully, he should have committed suicide or lived as a recluse. On Katsu's behalf, Fukuzawa composes a confession in which Katsu openly acknowledges his guilt for having betrayed the all-important principle of fighting to the bitter end. The confession concludes: "Those who hope to build up their country and establish good relations with foreign countries

11. Fukuzawa's autobiography was first published in 1898; Katsu published his autobiographical reminiscences, *Hikawa seiwa* (Pure words from Hikawa), in the same year.

12. Legge, *The Book of Rites*, bk. 7: Li Yun, sec. 1.

in future generations should never study my conduct during the Restoration. . . . Put plainly, the expression 'He's a disgrace to the samurai class' refers to me."

Fukuzawa directs similar censure at Enomoto. Although Enomoto had initially rallied his "death-defying warriors" against the imperial forces at Hakodate, once he realized that there was no chance for victory, he urged his men to join him in surrender. Many had already died on the battlefield, and others refused the call to put down arms: "If the commander wishes life, go and surrender! We will fall in battle in line with our bushido spirit." Fukuzawa compares Enomoto unfavorably with the ancient Chinese hegemon-king Xiang Yu, who chose to fight to the death, even after being offered a route of escape. After his inglorious surrender, Enomoto, like Katsu, joined the new government and accepted a succession of ministerial positions. Fukuzawa nonetheless imagines that the former Tokugawa officer will never be free of "the pitiable spectacle" of those who followed him into battle and died. Alone at night and reflecting on his actions, Enomoto must feel "his manly guts of steel" being torn to shreds.

Although the intensity of feeling displayed in his portrayal of Katsu and Enomoto smacks of personal animosity, Fukuzawa claims that he is acting only in their best interests. His admonitions are meant to give them one last chance to make amends: "It is not yet too late. We can only pray that both men will resolutely withdraw from the world, rectify the wrongs they have committed since the Restoration, and thereby perfect their former great achievements."

According to Higuchi Takehiro, Fukuzawa began to write *Yasegaman no setsu* in late 1890, soon after he had visited a stone monument erected at Seikenji temple in Shimizu, Shizuoka Prefecture, erected to the victims of the *Kanrin Maru* incident (fig. 8.2).[13] The monument

13. Higuchi, *Hakodate sensō to Enomoto Takeaki*, 216–18. See also Ichige, *Kogōsan Seiken Kōkokuzenji*, 285–87. On October 4, 1868, Enomoto Takeaki fled from Tokyo with eight Tokugawa warships. Among them was the *Kanrin Maru*, commanded by Haruyama Benzō (1817–1868), who had close ties to Katsu Kaishū. The *Kanrin Maru* suffered storm damage and took shelter in the port of Shimizu, where, on October 26, it was attacked by forces of the new imperial government. All on board were killed and the corpses were thrown overboard. On April 17, 1887, a stone monument to the fallen sailors was unveiled in the presence of more than one hundred

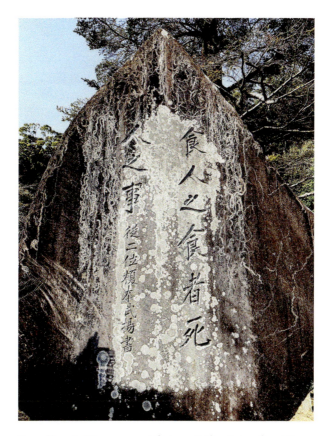

8.2. *Kanrin Maru* memorial stone, Seikenji temple, 1887. The inscription reads: "One who eats another person's food shall serve that person until death"; calligraphy by Enomoto Takeaki, Junior Second Rank. Author's photograph.

bears an inscription in Enomoto's calligraphy that stresses a retainer's duty to remain loyal to his lord: "One who eats another person's food shall serve that person until death."[14] The inscription set Fukuzawa

former Tokugawa retainers, many of them survivors of the Boshin Civil War. Although Enomoto was unable to attend, he was represented by Sawa Tarōzaemon (1835–1898), who had studied with him in Leiden and fought with him at Hakodate.
 14. The inscription, taken from *Records of the Grand Historian*, refers to the absolute loyalty of Han Xin (?–196 BCE), a general and politician who played a major role in the founding of the Han dynasty. The full quotation is: "He let me ride in his

thinking and angered him: how could Katsu and Enomoto, men who had surrendered, reconcile their present exalted positions with their actions in 1868? Had they not as Tokugawa retainers betrayed the spirit of fighting to the bitter end?

The commemoration of in the *Kanrin Maru* incident in 1887 was closely connected to historiographical debates that were taking place over the meaning of the Meiji Restoration (chapter 7). Fukuzawa's idiosyncratic *Yasegaman no setsu* grew out of these debates and reflected his long-held commitment to militant nationalism. At the same time, it is likely that Fukuzawa, himself a former Tokugawa retainer, was reviewing his own actions during the Meiji Restoration and his efforts to transform Japan into one of the civilized countries in the world (chapter 3). Fukuzawa's essay thus adds complexity to our understanding of his role in Japan's modernization: the westernizer was at once a nationalist; the rationalist was at once motivated by private emotions.

Yasegaman no setsu also broadens our understanding of the Meiji Restoration. It reminds us of the Tokugawa role in transforming Japan and demonstrates the extent to which the traumatic events of 1868 remained vivid in social memory more than two decades later. Both Fukuzawa and Katsu consciously used the past to deal with present realities. When the Sino-Japanese War broke out in 1894, Fukuzawa urged all Japanese people "to devote each word, action, and material good to the promotion of a Japanese victory."[15] Katsu, on the other hand, nearly alone in opposing the war, argued that inter-Asian cooperation was the only way to avoid being "trampled underfoot by the West."[16]

On November 27, 1891, Fukuzawa sent copies of his manuscript to Katsu, Enomoto, Kimura Kaishū, and a few other former Tokugawa

chariot, let me wear his clothes, and gave me some of his food to eat. I've heard it said that if you ride in another's chariot, you must share responsibility for the misfortunes they encounter; if you wear another's clothes, you must resolve their worries, and if you eat another man's food, you must be loyal to him unto death. How could I abandon morality and justice for the sake of self-interest?" Sima Qian, *Records of the Grand Historian*, vol. 1, pt. 5, "The Biography of the Marquis Huaiyin (Han Xin)."

15. Keene, "The Sino-Japanese War of 1894–95," 149.
16. *Katsu Kaishū zenshū*, 18:50.

retainers. He informed them of his intention to publish it and invited them to express their opinions and report any factual mistakes. Enomoto replied curtly, informing Fukuzawa that he was too busy to read it any time soon. Katsu thanked Fukuzawa for his deep concern but added: "I take responsibility for my actions, but praise or blame is the task of others. I neither make claims nor bother myself with such matters."[17] Ten years later, two years after Katsu's death and a month before his own, Fukuzawa published *Yasegaman no setsu*.[18] It was his last publication.

* * *

This translation is based on the text in *Fukuzawa Yukichi zenshū*. I have also profited from the various commentaries as well as two translations into modern Japanese.[19]

Yasegaman no setsu: On Fighting to the Bitter End

The founding of a nation derives from private rather than public principles. Being separated by mountains, seas, and other natural borders, the many millions of people who live on the face of the earth inevitably form groups in some places and divide themselves off in others. However, since each place has its own resources in food and clothing, people need to use these to live their lives. Moreover, since each place has surpluses and deficiencies, it is good for people to trade with each other. In other words, because of the blessings of nature, people farm for food, manufacture for use, and trade for convenience. Beyond this, they need have no other desires. Why, then, do people find it necessary to divide themselves into man-made countries and establish man-made boundaries? Having divided themselves into countries, do they not engage in boundary disputes with their neighboring countries? Do

17. Fukuzawa, *Meiji jūnen tenchū kōron · Yasegaman no setsu*, 1999, 71.
18. Fukuzawa, *Meiji jūhen tenchū kōron · Yasegaman no setsu*, 1901.
19. Fukuzawa, "Yasegaman no setsu," in Keiō Gijuku, ed., *Fukuzawa Yukichi zenshū*, 6:555–84. For text and commentary, see Fukuzawa, *Meiji jūnen tenchū kōron · Yasegaman no setsu*, Hirayama, ed.; Fukuzawa, *Meiji jūnen tenchū kōron · Yasegaman no setsu*, Sakamoto, ed. Modern Japanese versions include Fukuzawa, "*Yasegaman no setsu*," Nagai Michio, ed; Yamamoto Hirofumi, *Gendaigo yaku: Fukuzawa Yukichi bakumatsu-ishin ronshū*, 49–77.

they not disregard the sufferings of their neighbors and seek only their own advantage? Do they not elevate a single leader in their country, look up to him as master, and serve him as their lord? Do they not deplete the lives and property of the masses on account of this master and lord? Do they not further divide each country into numerous smaller units, each presided over by a chief, and do they not only obey the chief but also pursue their separate interests in constant competition with their neighboring units?

All of this derives from the private emotions of human beings and not from natural or public principles (*kōdō*).[20] Nonetheless, if we observe the course of events in the world from the beginning of creation until the present day, we find that all varieties of people have divided themselves into groups, each having its own common language and script and its own common history and legends; through marriage and friendship, members of each group have become intimate with each other and have come to share tastes in drink, food, and clothing. Naturally, having stayed together through thick and thin, they cannot easily be separated again.

Such is the reason for founding a nation and establishing a government. Once people give their nation a name, they become increasingly attached to it, making clear distinctions between themselves and others. They refrain from showing the slightest concern or affection toward any other country or government and in all areas—light and shade, fore and aft—they prioritize the interests and glory of their own nation to the near exclusion of all else. It is indeed curious that people who most actively emphasize this way of thinking are given designations such as "loyalty" and "patriotism," which are thereby identified as the highest virtues of a citizen. Therefore, although the words "loyalty" and "patriotism," understood philosophically, indicate purely private human emotions, in the situation of the world to date, they are termed praiseworthy virtues. In other words, the private emotions of philosophy become public principles for the founding of nations. Public recognition of these public principles and virtues is not limited to the

20. The concept of *kōdō* 公道, or "the public way," refers to universal principles, particularly justice, which should be impartial and not dependent on private emotions (*shijō*) unique to particular people or places.

national unit: when there are several smaller subdivisions in the country, each is governed by its own specific interests, and what are private interests when directed toward the outside are recognized internally as public principles. For example, it is natural that the various countries of the West are in competition with each other and that Japan, China, and Korea, which border each other, have differing interests. Further proof can be seen in the reality of the feudal era in Japan: with the shogun's government at the center and the country divided into three hundred domains, each domain prioritized its own interests and gave little attention to others. It was as though the height of competition was to secure one's own advantage, even if this caused harm to others.

The process of implementing public principles for founding a nation and establishing its government is relatively easy in times of peace, but as times change, a nation will surely face vicissitudes. Once it enters a downward course, a nation cannot maintain its position. It is the natural result of human feelings that, even after a nation's downfall is clearly at hand, there will be some who, hoping against hope, do not capitulate but in fact exert themselves to the utmost. This is like the efforts of children who, knowing that their parents have been struck with an incurable disease, do not stint medications or care right up to the actual moment of death. Philosophically speaking, if a sick person is close to death, it is wise to administer drugs such as morphine that allow an easy death rather than vainly prolonging the person's sufferings by aiming at a hopeless recovery. From a child's point of view, however, even with only a trillion-in-one chance of recovery, hastening a parent's death is emotionally unbearable.

Consequently, when facing the decline of their country, or even a situation in which there is no chance of victory over the enemy, and confronted by a myriad of difficulties, people will fight with all their might. Only at the point of defeat will they, for the first time, sue for peace or decide on death. Their actions reflect the public principles on which nations are founded and the obligations of national service. Commonly put, this is "fighting to the bitter end" (*yasegaman*). In confrontations between the strong and the weak, the spirit of fighting to the bitter end allows the weak to hold their own, if only briefly. It is not limited to times of war; even in international relations during ordinary times, it must not be forgotten. In Europe, small countries

such as the Netherlands and Belgium maintain their small governments, though surrounded by France and Germany. It might be convenient to merge with a larger country, but the determination to preserve its own independence must be seen as the small country's willingness to fight to the bitter end and through its endurance maintain the honor of being an independent country.

In Japan's feudal past, although daimyo with domains of only ten thousand *koku* existed alongside large domains of over one million *koku*, these smaller daimyo conceded nothing whatsoever as daimyo. Their stance was no doubt due to their spirit of fighting to the bitter end. In a different arena, moreover, during this same time, when the government of the realm was in the hands of the military, it was as though the imperial court did not exist for several hundred years. If extraordinary measures were necessary, various ad hoc expedients existed, including the sharing of power between the imperial court and the military government. Nonetheless, the court was able to protect its position and, in the face of nearly insurmountable difficulties, uphold the principle of imperial inviolability. For example, when the well-known court noble, Chief Councilor Nakayama Naruchika, was summoned to Edo, he referred to the Tokugawa family as the emperor's "eastern deputy."[21] Considering the situation at that time, his indiscreet remark was none other than an example of the spirit of fighting to the bitter end. Indeed, such dogged endurance is the reason that the imperial court retained its high esteem.

Again, regarding the beautiful traditions of the warriors of old, no one surpassed the Mikawa warriors.[22] Each of these warriors had individual strengths in learning, martial arts, wisdom, and bravery, but during the factious warring states period [1467–1590], they were all bannermen of the Tokugawa family. Making clear distinctions

21. Nakayama Naruchika (1741–1814) was a high-ranking court noble involved in the so-called Songō Incident of the late 1780s and early 1790s, a dispute between the Kyoto imperial court and the shogunate over the right to grant imperial titles. Summoned to Edo to explain the imperial position, Nakayama is reputed to have spoken bluntly, referring to the Tokugawa family as the emperor's "eastern deputy." See Totman, *Early Modern Japan*, 374.

22. Tokugawa Ieyasu was born in Mikawa (in present-day Aichi Prefecture); his men, known for their loyalty and bravery, came to be called Mikawa warriors (*bushi*).

between themselves and others, their minds were undivided. Right or wrong, they knew the Tokugawa as their lord and looked to no other. No matter how great the misfortunes they encountered or the privations they suffered, they never despaired. If it was for the sake of the Tokugawa family and the sake of their lord, they pressed forward, regardless of the certain defeat or certain death before them. Such valor was the distinguishing mark of all Mikawa warriors and the tradition of the Tokugawa family. This explains why Ieyasu, the first shogun of the Tokugawa family, though small in stature, could oversee the four directions and finally seize control of the entire country. The good fortune of the Tokugawa family should be seen as the reward of fighting to the bitter end.

In this way, the doctrine of fighting to the bitter end derives originally from the private emotions of human beings; to analyze it with cold logic would inevitably be considered akin to child's play. Nevertheless, no one in the real world, past and present, has ever aimed to establish what came to be called a nation and sought to maintain and preserve it without depending on this doctrine. During Japan's feudal era, the competition among the various domains to cultivate military valor also depended on this doctrine. The feudal system has now been abolished and replaced by the united Great Japanese Empire. Further, even as we broaden our horizons and seek to establish our independence with dignity in the civilized world, we must continue to depend on this doctrine.

Therefore, so long as affairs in human society remain as they are today, despite superficial changes in the direction of civilization or barbarity, some fragment of the spirit of fighting to the bitter end will be valued as the foundation of the nation one hundred, or even one thousand, years from now. It is important to cultivate this spirit ever more and assist in the development of its elements. As an example of why moral teaching for a nation is so important, consider the deliberations in the court of the Southern Song.[23] A division emerged between two groups, one pro-war and the other in favor of capitulation and peace. Nearly all the pro-war group retreated and some even committed

23. Deliberations were conducted at the court of the Southern Song dynasty (1127–1279) on how best to respond to the threat of a Mongol invasion (1235–1279).

suicide. Opinion in later generations scorned the unrighteous behavior of the peace faction; no one lacked sympathy with the solitary loyalty of the proponents of war. In fact, the weak Song court had fallen on hard times and there was no doubt that it would suffer defeat even if it fought one hundred battles. Indeed, it might have seemed advantageous for its supporters to suppress their feelings of shame and sue to keep the house of Zhao in power, if only for one day.[24] However, when rulers in later times placed importance on establishing order and cultivating martial spirit, they necessarily rejected the temporizing of peace advocates and adopted the stance of fighting to the bitter end as proposed by pro-war supporters. This explains why, even up to the present day, these two positions are perceived as foul and fragrant, respectively.

However, it is regrettable that in Japan, at the time of the restoration of imperial rule more than twenty years ago, this important principle of fighting to the bitter end unfortunately suffered a great blow. In the last days of the Tokugawa family's rule, one group of retainers realized that events had already turned against them, and making no effort to resist the enemy, they sued for peace zealously and by themselves dissolved the government of the Tokugawa family. Although their actions produced a temporary benefit for the Japanese economy, the damage to the Japanese warrior spirit, which had evolved over many hundreds of years, was by no means insignificant. Here it must be said that any gain obtained was incommensurate with the loss suffered.

Even though the Restoration was accomplished in the august name of the imperial court, it was in fact the actions of two or three strong domains who were hostile to the Tokugawa family. At that time, the old spirit of the Mikawa warriors seemed to animate one group of Tokugawa retainers. Although they were defeated in battle at Fushimi and returned to Edo, they issued orders to various pro-Tokugawa domains and made plans to regain power.[25] They decided to fight and fight

24. The house of Zhao, rulers of the Southern Song dynasty, resisted the Mongol invasion. After a major Mongol victory in 1279, eight-year-old Zhao Bing (1272–1279) and his councilors committed suicide, bringing an end to the dynasty.

25. The Battle of Toba-Fushimi, conducted in the first month of 1868, marked the beginning of the Boshin Civil War. Even after their defeat, some Tokugawa supporters, including Oguri Tadamasa, pressed to continue hostilities against the imperial army.

again to regain power and, if ultimately unsuccessful, retreat to defend Edo Castle. If for even one day they extended the fortunes of the Tokugawa family but, against all hope, failed in the end, they would fall fighting with the castle as their deathbed. This, as I said before, is no different from praying for even one more day of life during a major illness of one's father or mother. Indeed, it is a perfect example of the doctrine of fighting to the bitter end.

Nonetheless, that peace advocate Katsu Awa and his followers exerted their influence in every way, saying that the shogunate should not resort to military force, that Satsuma and Chōshū should not be provoked, that the peace and order of society should not be disturbed, that the life of their lord was in danger and, in an especially loud voice, that the calamity of internal strife was harmful to foreign policy. Moreover, at times even placing his own life in danger, Katsu did not hesitate to argue on behalf of peace negotiations. In the end, Edo Castle was surrendered and, with the creation of a new Tokugawa domain of 700,000 *koku*, all was settled without incident. This was indeed a puzzling turn of events. The commentary of one foreigner at the time was as follows:[26]

> In general, everything that has life will attempt to resist when death is near. Even a puny insect, when about to be crushed by a heavy steel hammer, will normally stretch its legs, and assume a position of defiance. By contrast, the powerful 270-year-old government of the shogun, when confronted by the military might of two or three strong domains, showed no sign of hostility but only earnestly sued for peace and repeatedly begged for mercy. This is something unprecedented in the history of the world.

It was with reason that the foreigner was secretly laughing at Japan.

Probably, Katsu and his followers thought that a civil war would cause unsurpassed damage and useless loss of lives and money. They had faith in the mathematical reasoning that, if their side had no prospect of victory, it was best to sue for peace and quickly restore order. Listening to Katsu's words, we might think that the safety of his

26. This quotation is from an unknown source; it may be a literary invention.

lord and the interests of diplomacy were at stake. Sounding out the inner workings of his heart, however, we realize that in Katsu's philosophical outlook, fighting to the bitter end was useless in the conduct of human and national affairs. If we judge him to be a person who, in the confusion of the moment, betrayed the great principle that had been valued by the upper echelons of Japanese society from ancient times, he can offer no rejoinder. A one-time act of courage can rouse the spirit of a coward and a single deceptive word can seduce the young. However, a man of discernment and intelligence will not in the end be deceived or taken aback.

At that time, I knew, as well as Katsu, that the weakened Tokugawa government had no prospect of victory. Nonetheless, arguing from the viewpoint of maintaining the warrior spirit, one should not discuss the prospect of victory while being pressed by a crisis of national survival. Does it not often happen that, counting on certain victory, one suffers defeat and that, expecting certain defeat, one scores a victory? Katsu however, had from the beginning expected certain defeat and, before actually suffering defeat, jettisoned the ruling authority of the Tokugawa family of his own accord and made zealous efforts to obtain peace. Although he mitigated the calamity of death and destruction caused by the scourge of war, he cannot escape blame for harming the warrior spirit that constitutes the foundation of the nation, that of fighting to the bitter end. Killing people and destroying property are temporary scourges, but maintaining the warrior spirit is an eternal necessity. Pawning this to buy that—whether a good deed makes up for the bad is a question that is not easily decided.

It has been argued that the struggle to restore imperial rule was a domestic affair, in other words, simply a fight among brothers and friends. At that time, so the argument goes, although the eastern and western domains were engaged in hostilities, the reality was that they were, at once, enemies but not enemies. In any case, it is claimed that the shogunate's decision not to fight to the death but instead dismantle its own government was a skillful response to the times. Although some people cleverly make this argument, it is nothing more than an evasive and self-serving excuse. Even if the Restoration was an internal matter and fought between friends, once hostilities break out, an enemy

is an enemy. But what about those who instilled in their men the ideas of peace and safety, saying that to engage enemies in battle would be unnecessary, reckless, and the cause of national collapse? If Japan was suddenly threatened by a foreign enemy, would they, leading these same men, have the capacity to rouse their fighting spirit and enable them to endure extreme suffering? Those who lack the spirit of fighting to the bitter end in internal affairs will likewise lack it when confronting external threats. Although is inauspicious to put this into writing, what would we say if, by some chance, the Japanese people, in the face of foreign enemies, were to calculate the direction of historical change and skillfully take it into their own hands to dismantle their government? We would have to say that the events surrounding the dismantling of the shogunate created a precedent, even though they were domestic in character.

Nonetheless, Katsu was a hero. At that time, he overcame criticism from within the shogunate, calmed the indignation of its retainers and, sacrificing himself, dismantled the government. In this way, Katsu paved the way for the success of the imperial restoration. Consequently, we must say that his meritorious deeds in saving many lives and ensuring the safety of property were not inconsiderable. In this regard, I am not one to look lightly upon Katsu's activities. However, what I find questionable is the fact that after the Meiji Restoration he aligned himself with warriors from former enemy domains and proudly advanced to a position of honor and wealth.

(From the standpoint of what is commonly termed the morally correct relationship between lord and vassal [*taigi meibun*], all Japanese people are subjects of the imperial court, and among these compatriot subjects, there should be neither enemies nor friends. In fact, however, the situation at that time was different. In the last years of the shogunate, warriors from the strong domains arose and turned against the Tokugawa central government. At this hostile juncture, they dedicated themselves in loyal service to the imperial court, and reforming the structure of the Tokugawa government, they returned to the past when emperors ruled. This undertaking is called the "restoration of imperial rule." Although the court is revered on high, apart from the world of politics, and bestows its blessings on everyone alike, when

disputes break out between people in the mundane world, distinctions between friend and foe are unavoidable. The truth cannot be disguised. Therefore, although there may be some who argue that the term "enemy domains" used in this text is disquieting, judging from the real situation at the time, I cannot avoid using the word "enemy.")[27]

If one were to follow the examples from Chinese and Japanese histories, it should not have been easy for a person such as Katsu to live out his life in peace. For example, Emperor Gaozu of the Han dynasty executed Minister Ding; the Kangxi emperor of the Qing dynasty expelled the surviving retainers of the Ming dynasty.[28] In Japan, Oda Nobunaga executed Oyamada Yoshikuni, the unfaithful servant of Takeda Katsuyori, who was about to betray his master to Oda.[29] Toyotomi Hideyoshi was angered by the actions of Kuwada Hikoemon, the wicked retainer of Oda Nobutaka; Hideyoshi had Kuwada crucified in front of Nobutaka's grave, ordering that he be made an example to the world because he was disloyal and unrighteous.[30] Such examples are too numerous to mention.

27. In the original text, this paragraph is enclosed in parentheses, setting it off as a note that explains Fukuzawa's use of the term "enemy domains."
28. Gaozu (256–195 BCE), founder and first emperor of the Han dynasty (202 BCE–9 CE, 25–220 CE) had Ding Gu (?–202 BCE), also known as Ding Gong, executed for disloyalty in showing mercy to one of the emperor's enemies. The Kangxi Emperor (1654–1722) was the third emperor of the Qing dynasty (1636–1912); he reigned for sixty-one years and is considered one of China's greatest emperors. In the 1660s he suppressed a resistance movement by loyalists of the former Ming dynasty (1368–1644).
29. Oyamada Kuniyoshi probably refers to Oyamada Nobushige (1540?–1582), a warring states warrior who served under Takeda Shingen (1521–1573) and later Takeda Katsuyori (1546–1582). In 1582, after the Takeda clan was defeated by Oda Nobunaga, Oyamada attempted to switch sides; but instead of welcoming him, Oda had him executed for disloyalty.
30. Oda Nobutaka (1558–1483) was the third son of Oda Nobunaga. Kuwada Hikoemon may be a mistaken reference to Kōda Hikoemon, also known as Kōda Tadayuki (?–1583). Kōda was the son of Nobutaka's wet nurse and became one his trusted generals. After Nobunaga died at Honnōji in 1582, Nobutaka surrendered to Toyotomi Hideyoshi and was forced to commit suicide. Fukuzawa's reference to a crucifixion may have been based on a fictional account; the historic Kōda died fighting Hideyoshi at Gifu Castle in 1583.

When enemies and friends confront each other in turbulent times, it may happen that a strategist emerges on the enemy side who advocates peace. Even though he may not be duplicitous, if there is an advantage to those on the opposing side, they may, at that time, use the opportunity to treat him amicably in secret. However, after hostilities have ceased, the leaders of the winning side will emphasize social order and, making firm the foundation of the new government, will set up plans for one hundred years. To establish a country based on public principles, they will abandon all private emotions. This may well mean that the person from the enemy side, originally valued for the opportunities he offered, will be judged as unfaithful and disloyal. Perhaps he will simply be ostracized and shunned from society, but there have been many cases when such persons were executed. Although it was indeed cruel, leaders would enforce this policy, though with regret, as one way to govern the country.

In other words, this was a customary practice among despotic Oriental states, and if someone like Katsu had lived in those despotic times, he would perhaps have met a similarly cruel fate. This could have been used to admonish the subjects of the new government. Fortunately, there is no despotic ruler in the Meiji government; political power is in the hands of those meritorious subjects who carried out the Restoration. Their policy has been to follow the example of the civilized countries of the world in everything, both good and bad. Placing priority on generosity in all areas, they did not ostracize people from the former enemy side. Moreover, what were once temporary opportunities became long-serving assets. Throwing off the past customs of the shogunate, many former retainers became new persons of distinction in the new government. That they are enjoying their days and that no one has even once thought it strange must itself seem curious, something unprecedented since ancient times.

At this point, while it is an extremely pitiful situation for Katsu as a private individual, I have a small request that is not without reason. The situation, as stated above, is that Katsu's efforts resulted in the smooth dismantling of the former government. Consequently, his achievements in avoiding the calamity of killing and property destruction were both unusual and great. However, when we look from a different angle, we see that, with friend and foe facing off against each

other but not yet engaged in battle, Katsu realized early, by himself, that there was no prospect of victory and acted submissively. Outwardly, various excuses were given to the imperial army, but the inner reality was that the Tokugawa government did not have the courage to fight two or three large feudatory domains, and without attempting battle, it surrendered. Consequently, not only did Katsu betray the spirit of the Mikawa warriors, but he also violated the great principle of fighting to the bitter end that is the special characteristic of our Japanese people. He therefore cannot escape the charge of having weakened the samurai spirit that is the foundation of the country. Avoiding temporary military calamity and inflicting eternal harm on the Japanese samurai spirit—does the good balance out the bad?

Since future generations in Japan may well come to hold settled opinions, for Katsu's sake, my small request is that he might say as follows:

> Even if, following the civilized trends of today, I have been fortunate to live out my life in peace since the Restoration, when I reflect on my actions, I accept guilt in having harmed the elite samurai spirit that is extremely great and extremely important for the foundation of our nation. My actions before and after the Restoration were based on temporary expediency, and my pragmatic pursuit of peace negotiations and my efforts to smooth matters over were simply because I feared the ravages of war at that time and wanted to rescue the people from distress. However, the essential point in the founding of our nation lies in the one principle of fighting to the bitter end. How much more is this true if there is the possibility of being threatened in the future by a foreign enemy? In facing such a crucial situation, one should not fear the turmoil of war. Those who hope to build up their country and establish good relations with foreign countries in future generations should never study my conduct during the Restoration or adopt those expediencies. Put plainly, the expression "He's a disgrace to the samurai class" refers to me. Let future descendants not repeat these actions.[31]

31. This confession of guilt is a literary invention that allows Fukuzawa to detail his case against Katsu.

Having said this, if Katsu were to decline categorically all special favors from the government, to abandon his titles and relinquish his stipends and, departing alone, to live as a recluse—if he were to do all of these things, people in society would, for the first time, know the sincerity of his actions and be impressed by his innocence. Katsu's handling of the collapse of the old government would also truly count as a great achievement. At the same time, his actions would uphold to a small degree the moral teachings of our society.

This is my hope, but as of today, it is not realized. Katsu remains as a distinguished national figure, living out his days with his head held high. There is no need to turn to the writings of austere Mikawa warriors to censure him; appealing to the common sense of the nations of the world, one cannot avoid feeling shame. It is not just that I feel regretful for the sake of Katsu personally; I am also deeply saddened on behalf of the moral teachings supported by leading members of our society.

Enomoto Takeaki is a person like Katsu. I must take this opportunity to add a few words about him. During the last years of the Tokugawa shogunate, he and Katsu held different views. Enomoto wanted, above all else, to maintain the Tokugawa government, and he exerted his efforts to this end. Leading several ships belonging to the Tokugawa navy, he fled to Hakodate. Although he resisted the western forces and fought bravely, in the end, driven into a corner, he surrendered.[32] At that time, having been defeated at Fushimi, the Tokugawa government had no intention of fighting further. It simply appealed earnestly for mercy, and its spirit was already broken. Although there was clearly no chance of victory, Enomoto's insurgency reflected the so-called pride of the warrior, in other words, the spirit of fighting to the bitter end. In his heart he secretly expected defeat, but for the sake of bushido, Enomoto nevertheless dared to fight. Shogunal retainers and groups of pro-shogunate samurai from various domains made him their commander and followed him. Obeying his orders in all things, they advanced and retreated together. In naval battles in the northern seas and at the siege of Hakodate, the loyalty and bravery they displayed

32. "He resisted the western forces" is a reference to the imperial forces led by the southwestern domains of Satsuma and Chōshū.

in these desperate and hard-fought battles were magnificent.[33] In the light of the moral teachings of the Yamato spirit, if we compare Enomoto's conduct with that of Katsu, we cannot speak of the two men in the same breath.

However, Enomoto's decamped warriors were never at an advantage, and the enemy forces gradually closed in upon them. Having reached a hopeless situation, the commander and a group of his men realized that all was lost and, changing their minds, surrendered to the enemy. Although it was their misfortune to be captured and sent to Tokyo, both victory and defeat are the ordinary course of events for military men and not something for which they should be blamed. The new government, as it were, hated the sin but did not hate the sinner. That it reduced Enomoto's death sentence and released him may be seen as the benevolence of civilization.[34] Both his revolt and the new government's treatment of him are illustrious stories with universal appeal and should not be criticized. However, the fact that after his release Enomoto set his sights on high office once again and gained employment as an official of the new government is something I cannot admire.

Since ancient times, there have been many examples of men who, after their defeat, came to serve their former enemy. Especially in times of transition, members of a former government, having lost their means of support, sought employment in the new government to sustain their livelihood. These stories are commonplace throughout the world from ancient times to the present and are not considered strange; nor should such people be criticized. However, there is a reason that Enomoto should not be included among these common examples. That

33. The first major naval engagement was conducted at Miyako Bay in the third month of 1869. Land battles around Hakodate began at the end of the fourth month and ended with Enomoto's surrender in the fifth month of 1869. See Higuchi, *Hakodate sensō to Enomoto Takeaki*.

34. Fukuzawa himself worked to secure generous treatment for Enomoto. He helped Enomoto's mother obtain permission to visit her son in prison by writing a request in her name. Moreover, he joined Kuroda Kiyotaka in recommending that Enomoto be pardoned to complete his translation of a Dutch book on international maritime law. See *Fukuzawa Yukichi zenshū*, 20:20–21; Fukuzawa, *The Autobiography of Fukuzawa Yukichi*, 255–59; Hirayama, *Fukuzawa Yukichi*, 240–45.

reason is Japanese warrior sentiment. Not only did Enomoto enter the new government and sustain his livelihood, but in successive promotions, he was appointed special envoy and finally elevated to minister of state. Although it is wonderful that he thus realized his dream of high office, if I look back and reflect on his past, there is something that arouses strong emotions within me.

At the time of his insurgency, Enomoto rallied the death-defying warriors, and they fought desperately in a corner of Hokkaido. They were no match for the cold north wind, and in the end, surrender was unavoidable. From the beginning, however, the decamped troops had relied on Enomoto as their leader; for him they fought against all odds, and for him some died in battle. In this situation, if Enomoto were to surrender and even if some of his men agreed, those who did not agree would seem to have been abandoned, and their despair and disappointment would have been undeniable. How much more so for those who had already died in battle? If the dead have spirits, they must certainly be crying out in the world below at this great injustice. From what I have heard, at the time of the siege of the Goryōkaku fort at Hakodate, Commander Enomoto communicated his private thoughts to his subordinates and urged them to surrender with him. Hearing this, one group of men were greatly angered and cried:

> From the outset we have had no expectation of winning this insurgency. In accordance with our military training, by dying, we seek only to repay our debt of 250 years. If the commander wishes life, go and surrender! We will fall in battle in line with our bushido spirit.[35]

These men continued to fight desperately. It is said that among them were fathers and sons who fought together to their deaths.

Enomoto's response contrasts with that of the Chinese general Xiang Yu, whose feelings were recorded in the following poem: "The waters of the River Wu were shallow and easy for my horse Zhui to cross, but a modicum of righteousness prevented me from going

35. This quotation may be a literary invention. The 250 years refers roughly to the duration of the Tokugawa shogunate.

east."[36] In the distant past, during the war fought between the Han and the Chu, the Chu troops were at a low ebb. Xiang Yu fled as far as the bank of the Wu River. At this time, one man urged him stay his death and cross the river, insisting that there was hope for a comeback, but Yu did not listen, saying:

> At the beginning, I led eight thousand sons to the west and saw them die in several bitter engagements. Now not one of them is left. After such failures, what honor would I have in returning east of the river and seeing the fathers and elder brothers of the dead?[37]

This passage reflects the feelings of Xiang Yu as he prepared to commit suicide.

The society described in the ancient military tales of Han and Chu is far different from that of today's Meiji era. Although it may be close to absurd to use the three-thousand-year-old example of Xiang Yu in finding fault with Enomoto, human emotions are forever unchanged. Even though Enomoto achieved his dream of high office in the Restoration government and rose in wealth and social standing, there must be times in which he reflects on his past at Hakodate. He must have heard about and imagined the pitiable spectacle in which the subordinates who had followed him at that time died in battle or were wounded. He must also be aware of the reality in which the parents and brothers they left behind have continued to mourn the deaths and are wandering the roads, confused about their own direction. At such times, consequently, Enomoto's manly guts of steel must be torn to shreds. And when, on rainy nights, unable to sleep because of the autumn cold and with the last candlelight flickering he is alone with

36. Xiang Yu (c. 232–202 BCE) was the hegemon-king of Western Chu whose defeat in battle and heroic suicide led to the establishment of the Han dynasty. Sima Qian's "The Basic Annals of Xiang Yu" narrates that as Xiang Yu was considering whether to cross over to the east side of the Wu River, the head of the village of Wujian arrived in a boat and begged him to cross to the other side. Yu sent his trusty horse to safety with the boatman but remained to fight and die. Fukuzawa probably drew on the version of the Xiang Yu story included in the popular *Tsūzoku kanso gundan* (Military tales of the Han and the Chu, easy-to-read version).

37. This is a paraphrase of "The Basic Annals of Xiang Yu," 47.

his thoughts, it may happen that the spirits of the dead and the living and innumerable other phantoms of darkness appear clearly before his eyes.

Probably, in the bottom of his heart, Enomoto does not think, even to the present day, that he abandoned those decamped troops; glorifying their insurrection, he feels pity for their deaths. One evidence for this is the stone monument located in the grounds of Seikenji in Suruga. The monument was erected previously to commemorate the decamped troops under Haruyama Benzō, who died in action when the shogunal warship *Kanrin Maru* was attacked at the port at Shimizu.[38] On the reverse side of the monument, nine Chinese characters were written in large script, proclaiming: "He who eats another man's food must serve him to the death." The name "Enomoto Takeaki" was inscribed alongside. If we look at Enomoto's behavior in committing these words without hesitation to public view, we can understand generally what was in his heart. In other words, Enomoto is someone who once ate the food of the Tokugawa family.[39] Although unfortunately he himself lost the opportunity to die for the Tokugawa, when he saw that others had died for this reason, he could not suppress his deep and bitter regrets. Finally, we may assume that, out of great respect, he had these characters carved in stone.

It is unavoidable because of our innate human emotions that, when praising the loyalty and bravery of others, we reflect on ourselves at the same time and even feel a little uneasy. Therefore, if we try to imagine what Enomoto is feeling, we may find that at times, he is content with his present wealth and high social standing and is absorbed in a life of comfort and luxury. At other times, however, thinking back on the pitiable spectacle of the past, he may feel shame. Alternating constantly between joy and sadness, grief and happiness, Enomoto may never have perfect peace of mind or pleasure until the end of his life.

38. See footnotes 13 and 14 above.
39. Since "food" (*shoku* 食) here can also mean "stipend," this sentence can be read to mean that Enomoto once received a stipend from the Tokugawa family, confirming his original identity as a Tokugawa retainer whose duty was to remain loyal to his lord until death.

Here, therefore, is my plan for Enomoto. I do not necessarily recommend that simply because he has eaten the food of another person, he should die for that person. However, taking human emotion into account, I think that he should always act humbly toward other people. There have been people in Enomoto's situation who, following the custom of ancient times, have withdrawn from the world to become a priest and prayed for the sufferings of the dead. If, however, in the social climate of today, it is not appropriate to take the tonsure and enter a monastery, Enomoto's main goal should be to resolve as follows: to hide himself in the shadows of society and live a simple life, and to be humble in all things and detach himself from the eyes and ears of the world.

In short, the failure of the insurrection by the decamped troops at the time of the Restoration meant Enomoto's political death. Even though he did not die physically, accepting his obligation not to reenter politics, he should just live humbly. First, he should pray for the spirits of his followers who died in battle and comfort the families of the dead in their misfortune and injustice. Moreover, speaking from a general perspective, a person who assumes leadership of a major undertaking is responsible for its success or failure and can by no means escape this responsibility. To make clear the principle that, if a person wins, he basks in glory and if he loses, he accepts the suffering must be an important moral teaching of warrior society. This is one aspect of my request regarding Enomoto's future course of action, and it is not for his personal sake only. In the design of our nation's next hundred years, it should not be treated lightly for the sake of the rise or fall of the warrior spirit.

In the above essay, I have not attempted to launch an attack on these two men, Katsu and Enomoto. The tip of my brush has been lenient, and I have not used harsh words. Not only have I preserved the honor of these two men, but in fact, I have also recognized to a fault the ingenuity, loyalty, and bravery of their great achievements. However, in the course of one's life, if one chooses wealth and high social standing, one may forfeit great achievement; conversely, if one wants to complete a great achievement, one may have to abandon wealth and high social standing. Both men illustrate the correctness of this observation. Although Katsu's advocacy of peace negotiations

and his dismantling of the shogunate was a truly skillful and ingenious achievement, by dismantling the shogunate, he brought about the downfall of the Tokugawa family. The aftermath of this downfall, by chance, became the means through which one former retainer gained wealth and high social standing. Even if Katsu did not personally seek out that wealth and social standing but received it unexpectedly, when we consider that he was a retainer of the Tokugawa family, who were themselves descendants of the Mikawa warrior clan, his hard-earned and admirable achievement must lose its luster in the eyes of society.

Enomoto adopted a pro-war position and decamped and, until finally worn out and defeated, did not turn his back on his duty as a shogunal retainer. His loyal and brave achievement was glorious. However, the fact that, after his surrender and pardon, he again aspired for high office and sought and gained riches and high social standing in the new government cannot but show his lack of shame toward all those men who accompanied him in his insurrection, from the dead and injured who first shared his loyalty and bravery, to the drifters and impoverished men who came later. Likewise, it diminishes the value of his great achievement. In other words, since the wealth and high social standing of both Katsu and Enomoto are themselves the means by which their great achievements have been rendered hollow, it is not yet too late. We can only pray that both men will withdraw resolutely from the world, rectify the wrongs they have committed since the Restoration and thereby make whole their former great achievements. Whether in future generations their names are fragrant or foul depends on the level of resolution in their hearts. They must make strenuous efforts.

However, the human heart is feeble, and there may be circumstances in which my words cannot be heeded. Unavoidable as that may be, the fact that during the Meiji period there was one who wrote these words and evaluated these two men may itself sustain the warrior spirit among future generations. If this is so, my writing will not be labor lost.

CHAPTER NINE

When East and West Meet: Japan's *Mingei* Movement

This chapter suggests that modernity in Japan is the product of cultural hybridity and, ironically, anti-modernity. As an undergraduate interested in Japan, I was attracted to Japanese folk craft, or mingei, especially pottery. I read Bernard Leach's translation of The Unknown Craftsman *by Yanagi Sōetsu and was impressed both by Yanagi's love for everyday objects and by his disdain for machine-made goods. I also read* The Book of Tea *by Okakura Kakuzō (1863–1913) and* Zen and Japanese Culture *by Suzuki Daisetsu (1870–1966). These books all described an aesthetic associated with Japanese culture that prized simplicity, warmth, harmony with nature, and frugality—so different from the cold, bureaucratic, and wasteful society that I saw in the United States. I learned later, however, that the East-West dichotomy was not defensible. Many of the Japanese masters had foreign partners: Okakura Kakuzō worked with Ernest Fenollosa (1853–1908), Yanagi Sōetsu with Bernard Leach, and Suzuki Daisetsu with Paul Carus (1852–1919). Even Mashiko pottery village was a modern creation, established only in the late 1920s by Hamada Shōji (1894–1978), a Tokyo native who had studied at the Tokyo Institute of Industrial Arts and trained for three years under Bernard Leach in England.*

From the mid-nineteenth century, the rise of industrialism, urbanization, and mechanization led people in Japan and the West to place value on earlier times and other places where simplicity, community, and a concern for beauty and authenticity prevailed. This chapter examines the mingei *movement in Japan within this context. It discusses the early interest in Japanese craftsmanship shown by the American zoologist and collector Edward Sylvester Morse (1836–1925) and other foreign residents of Japan. It then examines the ideas and activities of*

Okakura Kakuzō and his mentor Ernest Fenollosa in confronting what they saw as the threat posed by modern industrialism and warfare on the arts of Japan and the integrity of Japanese culture. The conclusion suggests that mingei *may be considered a metaphor for Japan's modernity, looking to the future as well as to the past, seeking cultural uniqueness within and union between East and West without.*

From the middle of the nineteenth century, as nationalism dominated political identities and international relations, growing cultural interactions between Japan and the West contributed to an emerging age of globalism and cultural hybridity. While Western technology, ideas, and values inspired the Meiji enlightenment, Japanese art, crafts, and design captured the imaginations of Europeans and Americans. At the same time, the urge to preserve their past animated Japanese conservatives. National boundaries evaporated in the work of modern Japanese artists, such as Kuroda Seiki (1866–1924), who studied in France from masters, who were themselves influenced by Japanese woodblock prints.[1] Similarly, Edward Sylvester Morse, author of *Japanese Homes and their Surroundings*, influenced Frank Lloyd Wright (1867–1959) and, through him, modern architecture. The preface of a reprinted edition of Morse's book claims: "Taking a broad view of architecture in the twentieth century, one may say that no traditional style has contributed as much to a universal domestic house design as has the Japanese tradition."[2]

One important element in the increased cultural interaction between Japan and the West was a shared commitment to conserve a disappearing past. Across the globe, the rise of industrialism, urbanization, and mechanization led some—primarily intellectuals, artists, and the educated elite—to place value on earlier times and other places where simplicity, community, and concern for beauty and authenticity appeared to prevail. Such anti-modernist trends had a decisive impact,

1. Tōkyō Kokuritsu Bijutsukan, *Tanjō 150 nen*.
2. Barrow, "Introduction to the New Edition," xxiv. See also Benfey, *The Great Wave*, 70.

though not simply as a conservative movement slowing the process of change. As T. J. Jackson Lears has argued, by embracing intense forms of physical and spiritual experience, including a concern with handwork and a return to the "simple life," anti-modernism ironically helped ease accommodation to a new secular society.[3]

The *mingei*, or folk craft, movement in Japan reflected the confluence of these seemingly contradictory ingredients: cultural hybridity and anti-modernism. Yanagi Sōetsu, who is often credited with the discovery of *mingei*, at the same time argued forcefully against the separation of East and West. He explained his position in conversations with J. W. Robinson Scott, an English journalist who spent the years of World War I (1914–1918) searching for the foundations of Japan in its villages and hamlets:

> It is deplorable that the world should think there is such a complete difference between East and West. It is usually said that self-denial, asceticism, sacrifice, negation are opposed to self-affirmation, individualism, self-realization; but I do not believe in such a gap. I wish to destroy the idea of a gap. It is an idea which was obtained analytically. The meeting of East and West will not be upon a bridge over a gap, but upon the destruction of the idea of a gap.[4]

Yanagi's long friendship and collaboration with the British potter and craftsman Bernard Leach is testimony to the hybrid roots of *mingei* (fig. 9.1). Soon after Leach came to Japan in 1909, the two met and bonded, Yanagi sharing his knowledge of Japanese aesthetics and Leach communicating the ideals of the English Arts and Craft movement. In 1914, Yanagi praised Leach for his role in creating a new worldview: "It is not the addition of the East plus the West, but an organic combination. Should this artist have a mission to fulfill in the future it is the marriage of the East and West by means of his art."[5]

3. Lears, *No Place of Grace*, 59–96.
4. Robertson Scott, *The Foundations of Japan*, 100–101. See also Y. Kikuchi, "The Myth of Yanagi's Originality" and "Hybridity and the Oriental Orientalism."
5. Quoted in R. Wilson, "Modern Japanese Ceramics," 18.

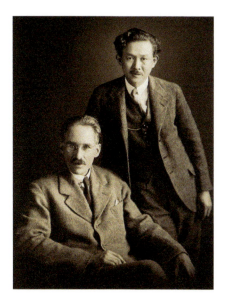

9.1. Bernard Leach and Yanagi Sōetsu in Tokyo, 1935. Crafts Study Centre, UK. From the collections of the Crafts Study Centre, University for the Creative Arts, UK, Reference number BHL/6723.

Both Yanagi and Leach looked back to a past in which unknown artisans created beautiful objects, relying on handwork and the use of natural materials; modernity, by contrast, was responsible for mechanization, greed, and individualism. Under their inspiration and guidance, the *mingei* movement emerged as the prime example of antimodernism in modern Japan.[6]

The Western Discovery of Japan's "Arts of the People"

In 1925, Yanagi Sōetsu and two friends, the potters Kawai Kanjirō (1890–1966) and Hamada Shōji, traveled by train to Wakayama Prefecture to view wood carvings of the Buddhist priest Mokujiki Shōnin (1718–1810). On or around this trip, they are said to have invented the term *mingei* to refer to the "arts of the people" as opposed to the arts of the elite.[7] All three were active in what came to be called the *mingei*

6. Y. Kikuchi, *Japanese Modernisation and Mingei Theory*, 12–15.
7. Brandt, *Kingdom of Beauty*, especially 38–82; Kumakura, *Mingei no hakken*.

movement. However, the fact that more than five thousand pieces of Japanese daily use pottery, classified according to locality and standards of craftsmanship, had been assembled by Edward Sylvester Morse in the late 1870s and early 1880s, suggests that the *mingei* movement was not simply the creation of Yanagi, Leach, and their colleagues.[8] They were building on the insights of connoisseurs, antquarians, and even nonspecialists who, from the mid-nineteenth century, had been impressed with the variety and refinement of Japanese arts and crafts. Many of these pioneers were Westerners, some resident in Japan and others writing on Japanese craftsmanship from their home countries. The discovery of the genius of Japanese folk craft—*mingei*—was thus informed by diverse trends in Europe and the United States.

In the 1860s, Rutherford Alcock (1809–1897), British consul general and minister plenipotentiary in Japan, was attracted to the distinctive qualities of Japanese crafts and artisanship: "In their porcelain, bronzes, their silk fabric, their lacquer, and their metallurgy generally, including works of exquisite art in design and execution, I have no hesitation in saying that they not only rival the best products of Europe, but can produce in each of these departments works we cannot imitate or perhaps equal."[9]

By this time an Arts and Crafts movement was emerging in England among those concerned to restore ideals of manufacture based on beauty, utility, and simplicity.[10] As early as 1829, the historian and philosopher Thomas Carlyle (1795–1881) expressed concern over the dehumanizing effects of the Industrial Revolution: "Men are grown mechanical in head and in heart, as well as in hand."[11] His friend and disciple John Ruskin (1819–1900) responded in 1853 with a call to return to the standards of medieval craftsmanship: "(1) Never encourage the manufacture of any article not absolutely necessary. (2) Never

8. Baxter, *The Morse Collection*.
9. Alcock, *The Capital of the Tycoon*, 2: 243.
10. Triggs, *The Arts and Crafts Movement*; Penick and Long, *The Rise of Everyday Design*.
11. Carlyle, "Signs of the Times," 233–36. See also Moeran, *Lost Innocence*, 10.

demand an exact finish for its own sake. (3) Never encourage imitation or copying of any kind."[12]

The textile designer William Morris (1834–1896) followed Ruskin's lead in calling for a return to simplicity and handwork.[13] Morris, however, looked to the East as well as to the past as a source of authenticity and as salvation from the ills of modern civilization. He was responding to an explosion of interest in Japan that followed its opening to the West in the 1850s. To Morris and a generation of men and women disillusioned by what they saw as the "overcivilization" of their societies, Japan appeared to be a society that prized craftmanship, functionality, simplicity, harmony with nature, and true beauty.[14] International expositions in London (1862), Paris (1867), Vienna (1873), and Philadelphia (1876) showed Japan to be an extraordinary repository of artisanship and refinement. Visitors to the Centennial Exposition in Philadelphia, for example, found in Japanese handicrafts "a grace and elegance of design and fabulous perfection of workmanship which rival or excel the marvels of Italian or ornamental art at its zenith."[15]

The Arts and Crafts movement spread to the United States in the 1890s.[16] In 1897, a Society of Arts and Crafts in Boston was founded under the leadership of Charles Eliot Norton (1827–1908), a close friend of Ruskin. In 1901, Gustav Stickley (1858–1942), a furniture maker and designer based in Syracuse, New York, launched *The Craftsman*, a monthly journal that promoted the American Arts and Crafts movement.[17] Published between 1901 and 1916, the journal ran nearly forty articles devoted exclusively to Japan. In 1905, it introduced the life of a Japanese craft artisan; in 1906, it published an article entitled "The Simple Life in Japan—Achieved by Contentment of Spirit and a True Knowledge of Art." Stickley, who had never been to Japan, admired

 12. Ruskin, *The Stones of Venice*, 1:166. See also J. D. Rosenberg, *The Genius of John Ruskin*, 80–81.
 13. Mason, *William Morris*.
 14. Y. Kikuchi and Watanabe, "The British 'Discovery' of Japanese Art."
 15. Quoted in Harris, "All the World a Melting Pot?," 30.
 16. Lears, *No Place of Grace*, 59–96; Lucie-Smith, *The Story of Craft*, 221–32.
 17. All issues of *The Craftsman* (1901–1911) are accessible online from the University of Wisconsin-Madison Library.

Japanese house design for its simplicity, its absence of ornamentation, and its interrelationship with nature. Articles in *The Craftsman* portrayed Japan as the antithesis to the artificiality and disregard for beauty that had come to characterize America. As Anna H. Dyer wrote in 1906 of her experience in Japan, "The cheap and ugly is unknown there; but the cheap and beautiful surrounds you like the air you breathe." This she contrasted with the situation in her home country: "It is reserved for America, the richest of nations, to realize the minimum of beauty for the maximum of cost."[18]

Basil Hall Chamberlain (1850–1935), who lived and worked in Japan between 1873 and 1911, would have agreed with Dyer's praise for the "perfectly developed sense of beauty" that characterized Japanese domestic architecture.[19] Writing in 1905, he concluded that "Japanese taste in painting, in house decoration, in all matters depending on line and form, may be summed up in one word—sobriety. The bluster which mistakes bigness for greatness, the vulgarity which smothers beauty under ostentation and extravagance, has no place in the Japanese way of thinking."[20] At a time when Japan was rapidly absorbing "civilization and enlightenment" from the West, Chamberlain, Morse, and others maintained that the West had much to learn from Japan. Chamberlain, who had come to value Japan for its simple refinement, lamented: "When will Europe learn afresh from Japan that lesson of proportion, of fitness, of sobriety, which Greece once knew so well? When will America learn it.... But it seems likely that instead of Japan's converting us, we shall pervert Japan. Contact has already tainted the dress, the houses, the pictures, the life generally of the upper class."[21] And yet hope could still be found. Well before Yanagi, Chamberlain had praised the artistic sense of ordinary people:

> It is to the common people that one must now go for the old tradition of sober beauty and proportion. You want flowers arranged? Ask your house-coolie. There is something wrong in the way the garden is laid out?

18. Dyer, "Japanese Wall Papers," 398, 402.
19. Dyer, "Japanese Wall Papers," 398.
20. Chamberlain, *Things Japanese*, 449.
21. Chamberlain, *Things Japanese*, 450.

It looks too formal, and yet your proposed alterations would turn it into a formless maze? Call in the cook or the washerman as counselor.[22]

Morse, who lived in Japan intermittently between 1877 and 1883, was even more enthusiastic. A zoologist known primarily for his discovery of the Ōmori shell mounds in Tokyo and for his contributions to the development of natural sciences in Japan, Morse was also a close observer of Japanese daily life and a collector of daily use items.[23] Traveling in the countryside, he saw a sense of beauty reflected in the homes of "common country farmers."[24] He was delighted by "the beautiful hedges along the road, the clean-swept walks before the doors, and in the houses everything so neat and the various objects in perfect taste; the dainty teacups, teapots, bronze vessels for holding the burning charcoal, beautiful gained panels, odd knots from tress, and woody fungus hallowed out to hold flowers."[25] Like Dyer and Chamberlain, Morse drew attention to what he called the "infinitely greater refinement" of Japanese people in their methods of house adornment as an antidote to Victorian excess: "They attain a simplicity and effectiveness that we can never hope to reach."[26] As early as 1885, Morse expressed his satisfaction that Japanese decorative style had already begun to modify Western design and ornamentation: "Under the benign influence of this new spirit it came to be realized that it was not always necessary to tear a flower in bits to recognize its decorative value; and that the simplest objects in Nature—a spray of bamboo, a pine cone, a cherry blossom—in the *right place* were quite sufficient to satisfy our craving for the beautiful."[27]

22. Chamberlain, *Things Japanese*, 450.
23. Morse published two major books based on his experiences in Japan: *Japanese Homes and Their Surroundings*, published in 1885, and *Japan Day by Day*, published in 1917. The Edward Sylvester Morse Collection at the Peabody Essex Museum includes material objects, journals, sketches, and photographs that document daily life in Japan in the 1870s and 1880s.
24. E. S. Morse, *Japan Day by Day*, 1:55.
25. E. S. Morse, *Japan Day by Day*, 1:54–55.
26. E. S. Morse, *Japanese Homes*, 347, 309.
27. E. S. Morse, *Japanese Homes*, xxvi–xxvii.

9.2. Edward Sylvester Morse in Boston, around 1930. Boston Society of Natural History and Percy R. Creed, *The Boston Society of Natural History, 1830–1930* (Boston: 1930), p. 59. Public domain, via Wikimedia Commons.

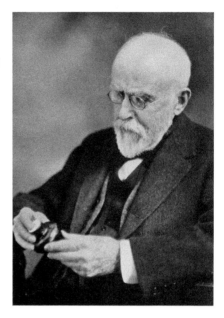

Even more than his writings, Morse's attention to the rustic and simple pottery of artisans working in small kilns throughout Japan qualify him as a founder of the Japanese *mingei* movement (fig. 9.2). According to the Boston journalist and author Sylvester Baxter (1850–1927), Morse became interested in Japanese pottery, originally as a hobby, after encountering prehistoric remains in the Ōmori shell mounds.[28] Aware that the increasing production of intensely decorative ("altogether too gaudy and violent") porcelain to suit Western tastes threatened the survival of traditional provincial potters, he resolved, "before it was too late, to make an exhaustive collection of the pottery of the empire, comprising its prehistoric, mediæval, and modern features."[29] Morse was attracted to the sober, undecorated bowls and other pottery connected with the tea ceremony, prizing their

28. Baxter, *The Morse Collection*, 7–8.
29. The description "altogether too gaudy and violent" is from E. S. Morse, *Japanese Homes*, xxxvii. Morse's resolution to collect Japanese pottery, "before it was too late," is from Baxter, *The Morse Collection*, 7.

"rigid simplicity, approaching an affected roughness and poverty."[30] He took lessons in the tea ceremony and studied clays, glazes, and techniques of firing. He met with Japanese connoisseurs and mastered skills in dating pots and identifying potters, glazes, and kiln sites. Within a few years, Morse had an extraordinary collection of Japanese ceramics and gained a reputation as a leading authority on the techniques and aesthetics of Japan's provincial potters.[31]

After his return to the United States, Morse's enthusiasm for Japanese culture and aesthetics became well known through the writings, lectures, and storytelling that he continued until his death in 1925. He shared his passion for Japanese pottery and aesthetics with connoisseurs and collectors, including Ernest Fenollosa, William Sturgis Bigelow (1850–1926), Charles Lang Freer (1854–1919), and Charles Weld (1857–1922), thereby helping to establish major Japanese art collections in American museums. In 1890, he transferred his pottery collection to the Museum of Fine Arts in Boston. In a letter dated February 28, 1889, Denman Waldo Ross (1853–1935), professor of design at Harvard University, urged the Boston museum to purchase the Morse collection, because it so visibly represented the aesthetics of Japanese craftsmanship:

> The Japanese artist takes a typical form of pot and devotes years, or even his whole life, to the production of exquisite examples of it; and he labors, not for gain, not for the public, not even for the amateur, but to realize the idea of the imagination, the idea of his soul.... You remember what the old philosopher said: "A little thing makes perfection, perfection which is not a little thing." This is the lesson which Professor Morse's pots and jars teach us. The differences between one example of a type and another are slight; but every example represents a distinct effort to realize the ideal. While we are satisfied to hand on the type which we have invented to the mechanic, to be reproduced by machinery, the Japanese artist prefers to improve and perfect his type every time he reproduces it.[32]

30. Baxter, *The Morse Collection*, 7.
31. Cohen, *East Asian Art*, 26.
32. Wayman, *Edward Sylvester Morse*, 349–50.

The letter contained the kernel of ideas that thirty years later were central to Yanagi Sōetsu's understanding of *mingei* and his exposition of the "way of folk craft."

Okakura Kakuzō and the Aesthetics of Craftsmanship

During the early Meiji period, as champions of progress led by Fukuzawa Yukichi looked forward to higher levels of prosperity and civilization, others looked backward.[33] The explorer, cartographer, and antiquarian Matsuura Takeshirō (1818–1888) is a good example of the Meiji fascination with the past (fig. 9.3). Following his explorations around Ezo, the old name for Hokkaido, as a retainer of the Tokugawa shogunate, in 1869 Matsuura was appointed by the new government to the Hokkaido Development Commission. After one year, however, he severed his connections with government service and, according to Henry Smith, "entered a new period of exploration, the exploration of artifacts of the Japanese past."[34]

The business of buying and selling antiques boomed in the Meiji era. According to Morse, "The collector of brac-a-brac finds Japan a veritable paradise, for wherever he goes, he finds second-hand shops, known as *furui doguya*, displaying old objects of every description.... In the smallest villages through which one rides, one finds some shop of this description with a modest assortment of old things."[35] Like other antiquarians, Matsuura traveled extensively. When he entered a town, he found people waiting with old objects for him to evaluate and perhaps buy. Matsuura sent most of his purchases to Osaka for resale, keeping the best for his own collections. In 1877, he published the first volume of *Hatsuun yokyō* (The pleasures of scattering clouds), a lavishly illustrated catalogue of his antiquities, including stone implements, old coins, and earthenware; a second volume followed in

33. Suzuki, *Antiquarians of Nineteenth-Century Japan*.
34. Smith, *Taizansō and the One Mat Room*, 17. See also Suzuki, *Antiquarians of Nineteenth-Century Japan*, 128–29.
35. E. S. Morse, *Japan Day by Day*, 1:105.

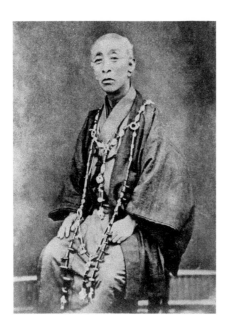

9.3. Matsuura Takeshirō in Tokyo, 1885. He is wearing a necklace to display his *magatama* collection. Public domain, via Wikimedia Commons.

1882.[36] Among those impressed with Matsuura's antiquarian expertise was Edward Sylvester Morse, who in *Japan Day by Day* described meeting "this antiquarian of some note" in late 1882 to examine his collection of comma-shaped *magatama* beads.[37]

Similarly motivated by a love of the past but also drawn by the intrinsic beauty of Japanese art forms were the art critic Okakura Kakuzō and Ernest Fenollosa.[38] Fenollosa graduated from Harvard College in 1874 and, three years later, accepted an invitation from Morse to teach philosophy and political economy at Tokyo Imperial University. One of his first students was Okakura. The two bonded over their interest in Japanese art and religion, and in 1879, they founded the

36. Suzuki, *Antiquarians of Nineteenth-Century Japan*, 173–74.

37. E. S. Morse, *Japan Day by Day*, 2:365–66. See also Suzuki, *Antiquarians of Nineteenth-Century Japan*, 129.

38. On Okakura, see Hashikawa, *Okakura Tenshin: Hito to shisō*; Kinoshita, *Okakura Tenshin*; Okakura T., Okamoto, and Miyataki, *Okakura Tenshin: Shisō to kōdō*; Weston, *Japanese Painting and National Identity*; J. Clark, "Okakura Tenshin and Aesthetic Nationalism."

Ryūchikai (Dragon Pond Society) with the aim of conserving and celebrating Japan's cultural heritage.

In 1881, Okakura and Fenollosa were employed by the Ministry of Education in an official project to locate and register Japan's most important art treasures and thereby prevent their export (fig 9.4).[39] In the following year, in a Ryūchikai speech attended by the minister of education, Fenollosa declared that Japanese art was superior to "modern cheap Western art that describes any object at hand mechanically, forgetting the most important point, of how to express Idea." Why, he wondered, do Japanese people despise their classical paintings? They should not: "The Japanese should return to their nature and its old racial tradition, and then take, if there are any, the good points of Western paintings."[40]

Okakura was similarly engaged in defending Japanese traditional art forms. In 1882, he engaged in a public debate with Koyama Shōtarō (1857–1916), a leading spokesman for Western-style painting, on the artistic value of calligraphy. Against Koyama's contention that calligraphy, like Western handwriting, was no more than a linguistic sign to convey meaning, Okakura argued that, in "striving as much as possible to consider contextual balance, by taking into account the construction of each character, and pursuing cultivation, our calligraphy reaches the domain of art."[41] He professed horror at Koyama's suggestion that calligraphy was useless because it could not be sold abroad with high value. Foreshadowing the arguments of Yanagi and other anti-modernists, Okakura condemned the commodification of art:

> Alas, Western civilization is a civilization of greed. A civilization of greed discards virtue, destroys elegance, and turns a person into a mere moneymaking automaton. The poor get poorer, the rich get richer, and

39. On Fenollosa, see Chisolm, *Fenollosa: The Far East*.

40. Fenollosa's speech, "Truth of Fine Arts," was delivered to the Ryūchikai on May 14, 1882. The original has been lost, but survives in Japanese translation: "Bijutsu shinsetsu," in Yoshino, ed., *Meiji bunks zenshū*. The English translation is quoted in Nute, "Ernest Fenollosa," 26.

41. Okakura, "Reading 'Calligraphy Is Not Art,'" 169.

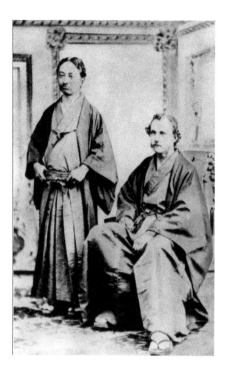

9.4. Okakura Kakuzō and Ernest Fenollosa in Tokyo, 1882. Japan Archives, 1850–2100, https://jaa2100.org/entry/detail/034702.html.

it is impossible to increase general happiness. Considering the current state of affairs, how wonderful it would be to disseminate artistic ideas, to savor the beauty of all things in the world without regard to their low or high origin, and to delight in these ideas even in the humblest objects of everyday life. It is a great mistake to speak of financial gain and loss when discussing art, for it debases its dignity and loses sight of everything that makes art what it is.[42]

In 1886, Okakura and Fenollosa traveled to the United States and Europe as members of an Imperial Art Commission to survey Western art education as preparation for the establishment of the Tokyo School of Fine Arts in 1889. On their advice, the school was dedicated exclusively to the preservation and advancement of Japanese art. Fenollosa taught aesthetics and Okakura served as president in its early years. Also in 1889, Okakura cofounded *Kokka*, an art journal devoted to

42. Okakura, "Reading 'Calligraphy is Not Art,'" 174.

East Asian, and especially Japanese, art: "*Kokka* also desires to preserve the true essence of Japanese art, and hopes that Japanese art will make advances by building on its distinct characteristics. The art of the future will be the art of the people. *Kokka* will not stop calling upon the people to protect and preserve the art of their country."[43]

Amid the heightened nationalism of the 1890s, critics and the popular press linked traditional Japanese culture, including the arts and crafts, with national character. In his 1891 booklet, *Shin zen bi Nihonjin* (Truth, goodness, beauty: The Japanese), the philosopher, journalist, and former Fenollosa student Miyake Setsurei (1860–1945) urged Japanese people to take pride in the aesthetic quality of their everyday life:

> Even in poor households, one can see color prints affixed to the walls and vases in which seasonal flowers have been arranged. . . . and in affluent households, there are scrolls hanging in the *tokonoma* and plaques above the transom. Even the iron kettle, the earthenware teapot, and the tea bowl vie with one another in beauty, antiquity, and elegance. Moreover, all these decorative articles have in common an ingenious sense of design and tasteful workmanship.[44]

Okakura would have agreed. Although he mentored Yokoyama Taikan (1868–1958) and other elite artists of the Nihonga genre of modern Japanese painting, Okakura also found beauty in the work of unknown local artisans. From 1901, he spent two years of reflection in India, where he surprised Rabindranath Tagore (1861–1941) by his attention to objects of everyday use: "He was fascinated by the beauty he saw in the simple earthen oil jars used by farmers. . . . and exclaimed that these rustic villagers were unconscious creators of beauty and refinement."[45]

43. Quoted in Hanley and Watanabe, "*Kokka*, Okakura Kakuzō, and the Aesthetic Construction," 6.

44. Motoyama, *Miyake Setsurei shū*, 216. For the quote in English, see Guth, *Art, Tea, and Industry*, 166–67.

45. Hashikawa, *Okakura Tenshin: Hito to shisō*, 121.

In the early years of the twentieth century, Okakura emerged as Japan's most influential spokesman against Western industrial modernity. In a speech given in 1904 at the International Congress of Arts and Sciences in St. Louis, Okakura attacked industrialism as a threat to art and lamented Japan's willingness to follow the path taken by the West:

> We of the East often wonder whether the West cares for Art.... In the rush for wealth there is no time for lingering before a picture. In the competition of luxury, the criterion is not that the thing should be more interesting, but that it should be more expensive. The paintings that cover the walls are not of your choice, but those dictated by fashion. What sympathy can you expect from art when you offer none? Under such conditions, Art is apt to recoil either with incipient flattery or with brutal sarcasm. Meanwhile the true art weeps. Do not let my expressions offend you. Japan is eager to follow in your footsteps, and is fast learning not to care for arts.[46]

Okakura's books in English, including *The Ideals of the East*, *The Awakening of Japan*, and *The Book of Tea*, spoke to the value of Eastern, and especially Japanese, traditions.[47] *The Book of Tea*, published in 1906, praised Japanese refinement, simplicity, purity, and artisanship. Okakura held up the tea ceremony as an antidote to the "Cyclopean struggle for wealth and power"[48] that threatened to envelop the world: "Nowadays industrialism is making true refinement more and more difficult all the world over. Do we not need the tearoom more than ever?"[49] Okakura's praise of the tea ceremony was received eagerly at a time when many feared the world was heading in the direction of universal ugliness and global war. His appeal for refinement, sobriety, and the vitality of tradition coincided with arguments made by Western critics of modernity.

46. Okakura, "Modern Art from a Japanese Point of View," 203.

47. All three books, *The Ideals of the East* (1903), *The Awakening of Japan* (1904), and *The Book of Tea* (1906), in various editions, remain in print.

48. Okakura, *The Book of Tea*, 20.

49. Okakura, *The Book of Tea*, 99.

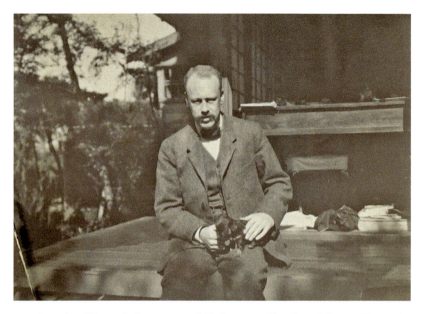

9.5. Langdon Warner in Izura, 1906. MS Am3138, Houghton Library, Harvard University.

Okakura's concern with the beauty of everyday objects can be seen in the training he provided to the young Langdon Warner (1881–1955). A Harvard graduate who had studied Asian art and archaeology, Warner arrived in Japan in 1906 and lodged at Okakura's house in Izura (fig. 9.5). When he approached the master for instructions on how to study art, Okakura urged him to see and judge Japanese art with his own eyes: "Don't go to the museums too often."[50] Okakura arranged for Warner to study under Niiro Chūnosuke (1869–1954), "a sculptor who rooms in a temple and knows no English." Under Niiro's guidance, Warner gained an appreciation of craftsmanship that remained with him for the rest of his life. In *The Craft of the Japanese Sculptor*, published in 1936, Warner detailed his admiration for the artist as artisan. In 1942, after the outbreak of the war with Japan, Warner delivered a commencement address to the Rhode Island School of Design. Quoting a passage from Ecclesiastes, "All their desire is in

50. Bowie, *Langdon Warner through his Letters*, 20.

the work of their craft," Warner argued the importance of craftsmanship for the survival of human civilization.[51]

Okakura pushed Warner in two directions. One was toward China, to study the source of Japanese Buddhist art in the Longmen Grottoes. The other was toward the Japanese countryside, where the wellspring of Japanese artistic creativity could be seen in the humble kilns and workshops of unknown artisans. In 1909, at Okakura's urging, Warner traveled to Okinawa. According to his diary, he collected examples of Okinawan folk craft, including local pottery, for the Peabody Museum at Harvard.[52] Warner also visited the ruins of the Shuri Palace, which, to his chagrin, had been transformed into a workshop to train Okinawa youth in modern production methods. Some rooms contained hand looms where girls learned cloth making; others had "foot-power lathes where boys turn out atrocities of woodwork to be lacquered still more atrociously by other boys."[53] Nonetheless, he encountered one authentic artisan:

> One spirit we did find which though utterly different was not discordant with the place, a little eager man—an artist. He was the lacquer teacher to the school boys. . . . He showed me his pupil's work as a matter of duty, and then when I seemed to be interested, pulled out odd notions of his own invention. New colors which he had learned to apply with the lacquer juice, plain blacks which required 37 separate coatings and polishings to get their jet-like luster, powderings of silver and of gold, and designs of his own which had the hallmark of the artist. It was plain that this impossible small person living in a bare cell with his few poor treasures in a corner of the rambling palace had more right there than the looms from Osaka and the lathes, though he too was not of the old regime.[54]

Warner had discovered his unknown artisan and recognized the intrinsic beauty of what would later be termed *mingei*, the arts of the

51. Warner, "All Their Desire."
52. Warner, *Kobe to Luchu,* November 9, 1909.
53. Warner, *Kobe to Luchu.*
54. Warner, *Kobe to Luchu.*

people. As teacher, scholar, and curator at Harvard University, he became known for his emotional approach to art and his devotion to the artisan's point of view, reflecting his enduring interest in "the robust splendor and refinement" of Japanese folk art.[55] In 1929, the student of Okakura began a lifelong friendship with Yanagi Sōetsu when he invited Yanagi to spend one year at Harvard as lecturer in Oriental art and fellow of the Fogg Museum. The highlight of Yanagi's stay was the 1930 exhibition *Japanese Peasant Painting*, which featured Ōtsu-e, the rustic, humorous, and often anonymous woodblock prints that Yanagi believed to represent Japanese folk art in its purest form.[56]

Conclusion

Mingei derived from a complex and ambiguous array of social and historical forces in Japan and in the West from the late nineteenth into the early twentieth century. This chapter has argued that Yanagi, often associated with the discovery of *mingei* in the 1920s, was not the first person to seek redress for the perceived moral disintegration caused by the advance of capitalist society. Nor was he the first to turn to the countryside as a repository of values such as frugality, altruism, harmony, and cooperation. Although the links between Japanese *mingei* in the early twentieth century and the English Arts and Crafts movement of the mid-nineteenth century are well documented, less well-known are the contributions of antiquarians like Matsuura Takeshirō; the zoologist turned pottery collector Edward Sylvester Morse; Okakura Kakuzō, who wrote in English on the Japanese tea ceremony; and Langdon Warner, Okakura's student and later professor and curator of Asian art at Harvard University.

What linked these various participants in the origins and development of craft production and craftsmanship in the modern world? First was an active acceptance of cultural hybridity. Craft items were sometimes used to celebrate an aesthetic of national uniqueness; the more common approach, however, was to seek the union of East and West.

55. Rowland, "Langdon Warner, 1881–1955," 447.
56. Sang, "Japanese Folk Art."

Although Yanagi claimed that he was not influenced by the writings of Ruskin or Morris, Yuko Kikuchi calculated that by 1927 some 102 items, including journal articles, monographs, and translations, had been published on Ruskin in Japanese, and 139 items on Morris.[57] Yanagi's assertion that the beauty of *mingei* derived from function, his celebration of the unknown artisan, and his use of natural materials can be traced back to the English Arts and Crafts movement.

Second, the various participants in the *mingei* movement were linked by an anti-modern impulse to rescue art from what Okakura called "the cold-blooded hand of the machine." The Japanese *mingei* movement, like its British and American counterparts, evolved in reaction to the problem of rapid industrialization and military buildup. As Okakura wrote in *The Awakening of Japan*, "It is sad for us to contemplate that our truest friend is still the sword. What mean these strange combinations which Europe displays—the hospital and the torpedo, the Christian missionary and imperialism, the maintenance of vast armaments as a guarantee of peace? . . . Europe has taught us war; when shall she learn the blessings of peace?"[58]

There was, however, no single folk craft movement. In Japan, anti-modern protest spurred the development of several schools of *mingei* thought, practice, marketing, collection, and exhibition. On the one hand, *mingei* called for a return to the "simple life" as a solution to the problems of overcivilization. After working with Bernard Leach for three years at his studio in St. Ives, in Cornwall, the potter Hamada Shōji returned to Japan in 1923 and set up his kiln in rural Mashiko, seeking freedom from technical concerns and academic requirements. And yet both Hamada and fellow potter Kawai Kanjirō had received a solid education in the Department of Ceramics of the Tokyo Higher Industrial School, the forerunner of the Tokyo Institute of Technology. As Kawai recalled, "If I had not learned science at the Higher Industrial School, I would have been useless as a potter."[59]

The 1920s saw an explosion of interest in what came to be called *mingei*, with artists and those skilled in folk craft experimenting in

57. Y. Kikuchi, "The Myth of Yanagi's Originality," 254.
58. Okakura, *The Awakening of Japan*, 223.
59. R. Wilson, "Modern Japanese Ceramics," 13.

various directions.⁶⁰ In 1921, fifteen years before Yanagi opened his Japan Folk Crafts Museum, Shibusawa Keizō (1896–1963) made his collection of daily life objects, especially toys, available to the public in his aptly named Attic Museum, which he opened in the loft of his garden shed in the Tokyo suburb of Mita.⁶¹ The potter Tomimoto Kenkichi (1886–1963) studied in England and made no secret of his debt to the English Arts and Crafts movement. According to Richard Wilson, "He was a sharp, no-nonsense craftsman aiming for the highest level of refinement in hand work."⁶² Nevertheless, Tomimoto embraced machine production as a means of supplying affordable goods to the masses. Members of the Decorative Arts Society (Sōshoku Bijutsuka Kyōkai), founded in 1919, held that craft should be artistic and practical at the same time. The Akatsuchi ceramics-as-art group, created in 1919 and reformed as the Radiance Society (Yōyōkai) in 1927, insisted that function was a necessary accompaniment of artistic quality. In 1933, a group of metal artisans, led by Takamura Toyochika (1890–1972), founded the Existing Crafts Art Society (Jitsuzai Kōgei Bijutsukai) with the motto "Function equals beauty" (*yō soku bi*).⁶³ Yanagi was thus not alone in advancing the production and collection of folk craft items as an antidote to the ills of modern society.

Finally, the impulse to collect, conserve, and celebrate the "arts of the people" was not unique to Japan. According to Brian Moeran, "The philosophy of *mingei* is the sort of moral aesthetic that tends to arise in *all* industrializing societies that experience rapid urbanization and a shift from hand to mechanized methods of mass production."⁶⁴ Nonetheless, it was the genius of Yanagi and his associates in the 1920s to inspire and combine these disparate elements into a worldwide movement that sought to restore beauty in an age dominated by cold machines and deadly torpedoes.

60. Ajioka, "Aspects of Twentieth-Century Crafts."
61. Christy, *A Discipline on Foot*.
62. R. Wilson, "Modern Japanese Ceramics," 21.
63. Y. Kikuchi, *Japanese Modernisation and Mingei Theory*, 86; R. Wilson, "Modern Japanese Ceramics," 21.
64. Moeran, *Lost Innocence*, 21.

CHAPTER TEN

Nationalisms and the Anglo-Japanese Alliance

This chapter discusses the variety of nationalisms that inspired Japan in the late nineteenth and early twentieth centuries, focusing on the rise of a popular nationalism that linked patriotism with peace and international standing. This peace-oriented and catch-up nationalism was at odds with nationalism derived from military might. The chapter is based on a paper prepared for a symposium held in 2002 to celebrate the one-hundredth anniversary of the signing of the Anglo-Japanese Alliance.[1] *The symposium was a grand event held at the International House in Roppongi, in the shadow of the fifty-four story Mori Tower building then under construction. In spirit, however, it took place in the shadow of the September 11, 2001 terrorist attacks on the high-rise buildings of the World Trade Center in New York and on other targets. What followed was a burst of militant nationalism and patriotism around the world.*

The chapter examines the reception in Japan of the Anglo-Japanese Alliance signed on January 30, 1902. How did the alliance influence the ways in which ordinary people thought about their country and its role in the world? Contemporary newspaper accounts and visual materials are used to document the nationwide speeches, celebrations, parades, illuminations, and songs that greeted news of the alliance. Japan had apparently at long last achieved priority seating at the table of civilization. On the one hand, the new treaty heralded a nationalism based on the promise of peace and prosperity. But it would not be long before equally energized masses would demand more than peace and

1. Steele, "The Anglo-Japanese Alliance."

diplomatic standing, spurred on by a nationalism akin to militarism and xenophobia.

The 1902 Anglo-Japanese Alliance has often been studied as a milestone in modern diplomatic history, marking the end to the so-called British era of "splendid isolation." Until the signing of the treaty with Japan, Britain's diplomatic practice had been to avoid permanent alliances with other countries. Its change in direction was based on concerns, shared with Japan, about Russia's expansion into Asia, especially the Russian occupation of parts of Manchuria after the Boxer Rebellion of 1900. The treaty, negotiated between British Foreign Secretary Lord Lansdowne (Henry Petty-Fitzmaurice, 1845–1927) and Japan's chief diplomat, Hayashi Tadasu (1850–1913), was signed on January 30, 1902. It was renewed and expanded in 1905 and again in 1911, after Japan's annexation of Korea. The Anglo-Japanese Alliance formed the basis of British and Japanese policy in Asia through World War I before being terminated in 1923 as part of a postwar diplomatic realignment.

In Japan, the Anglo-Japanese Alliance was widely celebrated, but not for its geopolitical results. It failed to prevent the outbreak of war with Russia, and in the years afterwards was described as an "alliance in decline."[2] It was, however, celebrated as a clear sign of Japan's admission into great power status and intensified the surge of patriotic thought and behavior that followed its victory in the Sino-Japanese War of 1894–1895. After the alliance was publicly announced on February 12, 1902, the *Japan Times* predicted it would be hailed "not only by the press but by the public at large. For Japan has entered into an alliance with the greatest Power in the world."[3] Indeed, there were multiple strands of nationalism at work in Japan and elsewhere at the turn of the twentieth century. The Japanese popular reception of

2. Nish, *The Anglo-Japanese Alliance*; Nish, *Alliance in Decline*.
3. "The Anglo-Japanese Alliance," February 13, 1902.

the Anglo-Japanese Alliance suggests that, in addition to military might, Japanese nationalism was equally the product of peaceful diplomatic achievement.

Celebrating the Alliance: "A Garden of Peace the East to Make"

Although negotiations between Japan and Britain had been going on for years, news of the Anglo-Japanese Alliance came as a shock to the Japanese public. On February 12, 1902, Prime Minister Katsura Tarō (1848–1913) approached the rostrum of the House of Peers and amid silence announced that a treaty had been signed in London on January 30. After hearing the text of the convention, the floor showed "a demonstration of great and universal enthusiasm and satisfaction in the shape of almost frantic and prolonged applause such as been seldom witnessed in the Upper House."[4]

The press was highly pleased with the sudden revelation of Japan's entry to the "comity of civilized nations."[5] The *Jiji shinpō*, founded by Fukuzawa Yukichi, had long advocated stronger economic and political ties with Great Britain. Its editors declared that the dream of equality with the West had been realized:

> Japan, despite being in the East, has in fact achieved equality with the great powers. At the time of the Sino-Japanese War, some forty years after the opening of the country, Japan was able, for the first time, to demonstrate its national strength. Now, a mere five or six years later, for our country's standing in the world to be thus elevated and be aligned, in both name and fact, with the great powers of the world seems like an idle dream. But this is no dream; this is reality.[6]

4. "The Anglo-Japanese Alliance," February 13, 1902.
5. Nish, *The Anglo-Japanese Alliance*, 226–27.
6. "Nichi-Ei kyōyaku shukuga."

From the outset, the new treaty was linked with peace and peacekeeping. The *Jiji shinpō* went on to stress the prospects for peace that would mark the twentieth century: "It is indeed a signal event that the leading Power of the world in civilization, wealth and strength should have joined with Japan for the purpose of preserving the peace of the East."[7] Other newspapers basked in the honor conferred upon Japan by an alliance with the British superpower. The editors of the *Kokumin shinbun* saw 1902 as a momentous event in Japanese history: "Our long dream has become a reality. . . . the agreement constitutes full recognition of Japan's place in the comity of nations."[8] The *Japan Times* summed up the near universal feeling that Japan had come of age as a nation-state:

> We imagine that by this time every *subject* of His Most August Majesty the Emperor who can read and think is filled with the sensation of one who has suddenly awakened from dreams of youthful ambitions and vague aspirations to the consciousness of the fact that he has become a grown-up person of high position, of great reputation, and with a consequential burden of onerous responsibilities. It is well that there should occur such an awakening in the career of every adolescent, for it can never fail to make thenceforth a real man of him. So it is in the career of a nation and such an awakening has come upon Japan in a manner as Japan has never before experienced.[9]

For over a month after the announcement of the Anglo-Japanese Alliance, celebratory events were held throughout Japan. The True Constitutional Party (Kensei Hontō) held a banquet, in which Ōkuma Shigenobu (1838–1922), founder of Waseda University and former and future prime minister, praised the "combination of immense power" that was certain to guarantee "a period of peace in the East and the preservation of China and Korea."[10] The Tokyo Chamber of

7. "Nichi-Ei kyōyaku shukuga."
8. "Nichi-E dōmei oyobi sono shōrai."
9. "The Anglo-Japanese Alliance," February 13, 1902.
10. "The Anglo-Japanese Alliance," February 13, 1902.

Commerce joined with other industrial and commercial societies to organize "a grand entertainment in honour of the Anglo-Japanese alliance," during which British residents in Japan presented a pair of ornate silver vases to Emperor Meiji of Japan and King Edward of England.[11]

Perhaps the most impressive celebration was the torchlight procession organized by students of Keiō Gijuku on February 14 (fig. 10.1).[12] Around five o'clock, some 1,500 students gathered at the Mita campus and precisely at six began their march to the imperial palace. At the head of the procession was a rectangular lantern inscribed with the words "To Celebrate Anglo-Japanese Alliance" and depicting two women, Japanese and English, bowing to each other. Behind it were the national flags of Great Britain and Japan. Fukuzawa Yukichi's son, Ichitarō (1863–1938), and another school official followed on horseback. The student band came next and, behind it, the rank and file, each boy carrying a torch fastened to a pole.

The procession made its way through Shiba Park, Kyōbashi, and Nihonbashi, amid the incessant applause of spectators assembled on both sides of the streets. The *Japan Times* reported: "Here and there the Banzais broke forth from within the houses and they were each time responded to by the students."[13] At the Nijūbashi bridge in front of the imperial palace, the band played Japan's national anthem. "Banzais for Their Majesties were cried aloud from thousands of enthusiastic throats."[14] The same shouts were given at the British Legation, where the band struck up "Rule Britannia," and Claude Macdonald (1852–1915), the consul general, received the greetings of the students. As they marched, the students sang a song composed especially for the occasion by Obata Tokujirō (1842–1905), Fukuzawa Yukichi's close associate and successor as chancellor of Keiō Gijuku:

11. "The Alliance."
12. "Torch-light Procession"; "Keiō Gijuku seito no kyoka gyōretsu." For another description, see "The Alliance."
13. "Torch-light Procession."
14. "Torch-light Procession."

10.1. Torchlight procession organized by students at Keiō Gijiku. *Jiji shinpō*, February 15, 1902.

I.
Hail to the day! The gladsome day
The East and the West have met!
The Land where shines the Morning Sun
And the Land where he never can set!
Round each other their flags are furled
Signaling peace throughout the World!

II.
Brave is the hand noble the heart
That causes war to cease!
From North to South the Orient
Shall be a garden of peace.
Round each other their flags are furled
Signaling peace throughout the World!

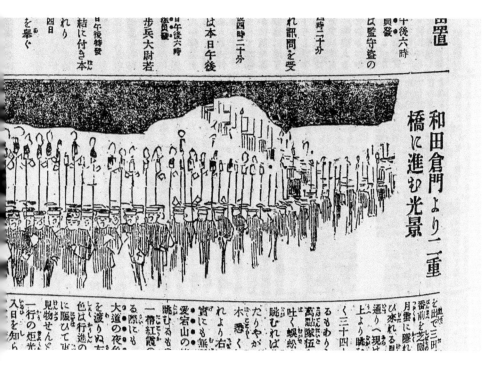

III.
Hail Hinomoto country dear!
Hail reign of Meiji!
Hail great and glorious Emperor
Two nations bow to Thee!
As round each other their flags are furled
Signaling peace throughout the World!

IV.
Hail to the day! For every Land
Knows of this compact sure—
That the hands are strong that are entwined
Because their hearts are pure!
That the flags that round each other are furled
As a guardian of peace throughout the World![15]

15. "Torch-light Procession." This is a more poetic version of the *Japan Times* translation published one day earlier: "Song of Anglo-Japanese Alliance."

The Keiō student procession set the stage for a succession of parades, firework displays, banquets, speech meetings, and general celebrations that were held from one end of Japan to the other. A survey of advertisements and news items published in major Japanese newspapers between February 15 and March 2, 1902 show that celebrations were held in Nagasaki (2/15), Naoetsu (2/18), Matsumoto (2/18), Takasaki (2/19), Hakodate (2/21), Gifu (2/22), Yokkaichi (2/23), Aizu (2/23), Takayama (2/23), Kōfu (2/23), Fukuoka (2/23), Nagoya (2/23), Akita (2/23) Matsue (2/23), Osaka (2/24), Ōtsu (2/24), Tottori (2/24), Kōchi (2/24), Tokushima (2/24) (where spontaneous dancing *teodori* took place), Kagoshima (2/24), Kobe (2/25), Kyoto (2/25), Maebashi (2/25), Yokohama (2/25), Moji (3/2), Mito (3/2), and Nagasaki (3/8). Commemorative coins and medals were struck, commemorative postcards were issued (fig. 10.2), photographs of Emperor Meiji and King Edward VII were everywhere on display, and even the grave of Will Adams (1564–1620), the English advisor to Tokugawa Ieyasu, was refurbished in honor of the historic ties between the two nations.

In Osaka on February 24, the crossed flags of the two countries were raised at the corners of major streets, lanterns decorated with the Hinomaru and the Union Jack were distributed, and two giant archways bore the English-language mottos "In Commemoration of the Anglo-Japanese Alliance" and "Unity is Strength." Nishinoshima Park, site of the main celebration, was awash in red-and-white bunting, reflecting the national flags of the two countries. Both national anthems were played, and over two thousand people listened to a series of congratulatory speeches. Afterward, they joined in a deafening chorus of banzai shouts to the royalty of Japan and England, followed by loud and systematic clapping. Refreshments were served and amusements provided, including day fireworks and a magic show.[16]

Celebrations in Yokohama followed a similar pattern. The two countries' flags were exhibited everywhere. Fireworks signaled the start of a lantern procession of some 2,500 residents; the lanterns featured English and Japanese men shaking hands. The procession separated into three groups, each heralded by a brass band, and then reunited in front of the Kanagawa governor's office. After the singing of the

16. "Ōsaka no Nichi-Ei dōmei."

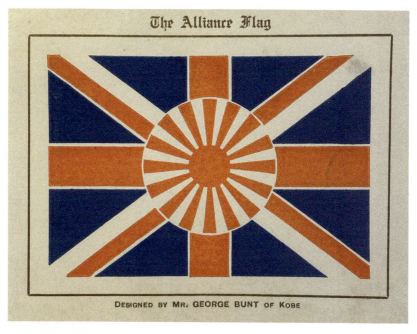

10.2. "The Alliance Flag," postcard commemorating the Anglo-Japanese Alliance, 1902. Author's collection.

Japanese national anthem, there were three loud banzai shouts to the Japanese empire (*Nihon teikoku banzai*) and three to Great Britain (*Gurēto Buriten banzai*). The procession moved along the harbor, in front of the Grand Hotel, through Chinatown, and down Honchō-dori. Those who joined in along the way included foreigners.[17]

Kobe hosted festivities celebrating the new alliance on February 25. The port city was bedecked with the crossed flags of Japan and Great Britain, and festoons of flags lined the road to the front entrance of Nankōji temple, where the celebrations took place. Around two thousand people assembled in the temple grounds, including Europeans and Chinese residents. The mayor's speech was greeted with loud cheers:

17. "Yokohama Nichi-Ei dōmei."

Gentlemen, by the virtue and glory of the rulers of Japan and of Great Britain an alliance has been accomplished between the two countries. This guarantees the peace of the Orient and must assist and reassure commerce. There can be no doubt that Kobe, one of the most important trade centers in the Far East, will share in the great benefits from the Alliance. Nothing can be more felicitous! We have assembled here to commemorate the event, and I ask everyone to raise his cup and drink to the success of this great event, which will, I hope, advance the prosperity of Kobe and the welfare and happiness of all present."[18]

The band played "Kimigayo," followed by the British national anthem. The mayor then proposed three banzai cheers for the rulers of the two nations, which were given with great enthusiasm. Cups for refreshments, made especially for the occasion, had the British and Japanese flags painted on them. High winds forced the cancellation of a balloon ascent and parachute descent by Okuda, the famed daredevil. In the evening, a lantern procession passed through the city streets.[19]

On February 27, court honors were conferred on Prime Minister Katsura, Resident Minister Hayashi, and Minister for Foreign Affairs Komura Jutarō (1855–1911) for their roles in concluding the alliance. The promotions and awards resulted in further celebrations. A cartoon in the satirical newspaper *Maru maru chinbun* showed a newly honored Count Katsura reveling in his new popularity: "Not only are the people drunk on Alliance wine, but the Count is helping himself to food and drink."[20] The *Japan Times* noted that the three men had been responsible for "raising inestimably the status of the country" and assuring "a long period of peace and prosperity" in Asia.[21]

The national euphoria, or "Alliance craze," as the press put it, continued well into March 1902, causing the *Japan Times* to express concern that "country people, who are very probably not the best persons in the world to grasp the meaning and intent of the alliance, should go mad over that event just because someone set them an

18. "The Anglo-Japanese Alliance," March 1, 1902.
19. "The Anglo-Japanese Alliance," March 1, 1902.
20. "O te shaku."
21. "Alliance Honors," 2.

example of rejoicing."[22] It was afraid that the "childish" behavior of the people was not becoming for "the inhabitants of a wealthy nation." The *Yorozu chōhō* newspaper chided the people for believing that Japan was as strong, prosperous, and civilized as Great Britain. The alliance had intoxicated people with delusions of grandeur.[23] The *Japan Times* recognized, nevertheless that the festive spirit that celebrated the Anglo-Japanese Alliance could be equated with the war spirit that would result if Japanese were called to war:

> We sometimes think it childish when we see our soldiers marching down the streets singing war songs in broad daylight and going through similar exercises in the morning and in the evening at their barracks; but we cease to think so when we remember that they are the very soldiers who have established for Japan the reputation she now enjoys in the two campaigns in China. Besides, if the alliance is such an important event that those concerned in its conclusion should be rewarded with unusual marks of honour, the country it appears to us has good reason to rejoice over it. Childish or not childish, the "alliance craze" which has seized on the heart of the country is at least a sign of the universal good will with which the nation welcomes it. It is also a sign of the united backing which the now joyful and feasting country would give the alliance if called upon, just as our singing and romping soldiers become one of the best fighting armies of the world at a bugle's sound.[24]

Conclusion: Catch-up Nationalism

The "Alliance craze" of 1902 is a good example of the complex and often ambiguous nature of nationalism in modern Japan; it does not fit expected molds. National euphoria over victory in war is to be expected, but in 1902, the near-universal understanding of the alliance among people in Japan was as a prelude to peace. Nearly all major Japanese newspapers touted it as guaranteeing peace in Asia and even

22. "Editorial," March 4, 1902.
23. "Dōmei shukuga ni yōbekarazu."
24. "Editorial," March 4, 1902.

in the world.[25] The Keiō Gijuku students sang that the alliance promised to make the East into a "garden of peace" (*heiwa no rakuen*). Although government and military leaders considered the possibility of war and territorial aggrandizement, ordinary people celebrated the Anglo-Japanese Alliance for its promise of peace and prosperity. Moreover, although popular support for Japanese unilateral action is easily understood, the banzai shouts in 1902 went up for both Japan and Great Britain, the flags of the two countries were crossed in union, the portraits of Japanese and English royalty were displayed side by side, and people sang the national anthems of both members of the alliance (fig. 10.3).

The jubilation and patriotic glee that greeted news of the alliance in Japan was not matched in Great Britain. There it was generally well received, but there were no fireworks. The treaty was a diplomatic achievement, rather than a cultural or national turning point. The *Graphic* newspaper described the treaty as "a brilliant stroke of diplomacy," arguing that it "vastly strengthens the British position in the Far East." Noting that the region had been "a veritable powder magazine to the peace of the world," it saw the alliance with Japan as especially important: "The new Treaty establishes a political equilibrium in the Far East, and thus renders peace almost certain."[26] The *Manchester Courier and Lancashire General Advertiser* agreed:

> The two Powers were created to be friends and allies, notwithstanding their geographical remoteness from each other. Like England, the archipelago of Japan contains an active, enterprising population, which has outgrown its bounds, and which requires convenient markets for its new manufactures.... The alliance places Japan in the front rank amongst the great nations, and at the same time it promises to bring credit to British diplomacy for it must prove a powerful check on any effort to secure particular advantages for any one Power, and thereby lessen the danger of rupture.[27]

25. One major exception was the Osaka *Niroku shinpō* newspaper, which argued that the alliance would involve Japan and Russia in hostilities. "Nichi-Ei dōmei," February 14, 1902.

26. "An Anglo-Japanese Alliance," February 22, 1902.

27. "The Anglo-Japanese Agreement."

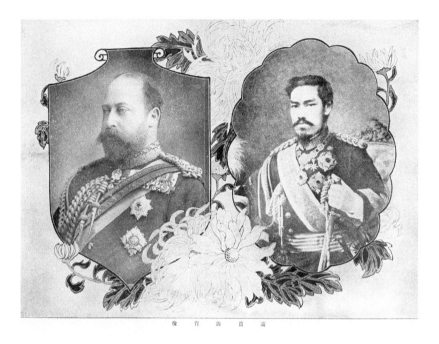

10.3. The imperial portraits of King Edward VII and Emperor Meiji. Frontispiece entitled "The Anglo-Japanese Alliance," *Taiyō*, March 5, 1902.

Some reservations were expressed in Britain on the wisdom of the quitting the diplomatic practice that had led to Britain's "splendid isolation."[28] Members of the Liberal Party declared the alliance unnecessary, worrying that relations with Japan would only worsen British rapprochement with Russia. Others warned that the treaty would inevitably lead to war between Japan and Russia, upsetting the peace in the Far East rather than sustaining it. Dissenting arguments were sometimes based on long-standing prejudice. The *Manchester Guardian*, for example, declared Japan to be a country of markedly inferior status, lacking qualification to be treated as an equal to the great powers of the civilized world. The *Economist* went one step further: by concluding an alliance with Japan, Great Britain had decidedly abandoned "that unwritten alliance of all white Powers against all coloured races

28. Daniels, "The Anglo-Japanese Alliance."

and through which alone the supremacy of Europe over Asia and Africa can finally be established."[29]

In Japan, however, it was precisely the achievement of equality, albeit imaginary, with Great Britain and, by extension, with the West that offered cause to celebrate. Editorials and speeches dwelled on these themes. Katō Tadaaki (1860–1926), a former foreign minister, stated that it was impossible to overestimate the importance of the alliance for Japan, which "having been a few years ago an insignificant, 'half-civilized' country, has now been placed on the same lotus-blossom with Great Britain."[30] A young student, Kumoura Tōgan, used the same theme to win second prize in an essay contest sponsored by the youth magazine *Shōnen sekai*:

> This year we have concluded an alliance with England, the world's largest and most powerful nation. Is this not the most wonderful event of the present age? Before the Sino-Japanese War, European countries did not even know our country's name. So now, when we are suddenly arm and arm with Great Britain, known throughout the world as the leader of the civilized countries of Europe, I can only express my abundant joy!"[31]

Equality was also depicted visually. The portraits of Emperor Meiji and King Edward VII presented them as equals, two modern monarchs of two powerful countries, both committed to world peace and the spread of civilization (fig. 10.3). This conclusion was even more forcefully presented in cartoon form. An illustration in the *Jiji shinpō* shows Britannia and Princess Yamato hand in hand, looking down with benevolence and concern on the tiny figures of China and Korea (fig. 10.4). Princess Yamato was a legendary figure from Japan's ancient past who passed a magical sword to the prince Yamato Takeru no Mikoto to help him subdue the Ebisu barbarians. Although the cartoon thus identifies Japan with military power and the spread of civilization, its most obvious message is that the two figures stand before

29. "The Treaty with Japan." Quoted in Daniels, "The Anglo-Japanese Alliance." See also Best, "Race, Monarchy, and the Anglo-Japanese Alliance."
30. "Mr. Kato and Count Okuma."
31. Kumoura, "Nichi-Ei dōmei o iwasu."

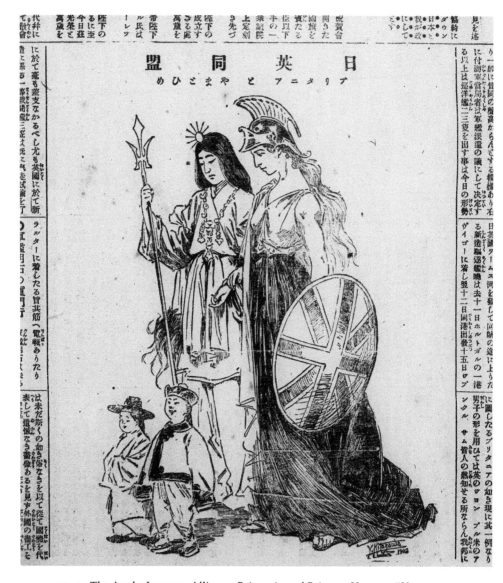

10.4. The Anglo-Japanese Alliance: Britannia and Princess Yamato. "Yamato-hime," *Jiji shinpō*, February 18, 1902, 3.

the world as towering equals. It is thus a perfect representation of Japan's success in escaping from Asia (*datsu-A*), a policy long advocated by Fukuzawa Yukichi, one of the most powerful voices of nationalism in the Meiji period.[32]

Nationalism, as political principle and unifying sentiment, is not inherently xenophobic or imperialistic; it can equally inspire peace and cosmopolitanism. It has been used to legitimize ethnic and religious divisions, but also to encourage pride in national achievements, even those beyond national borders. The response of the Japanese public to the Anglo-Japanese Alliance reflected what has been called "catch-up nationalism." Just as matching China was a motive force for Japan in the premodern era, catching up, or even overcoming, the West provided the inspiration and energy for Japan's modernization. Drawing abreast of England became a national dream. The dream came true in 1902, when Japan and England stood together as allies, carrying the responsibility to advance world peace and civilization. The Anglo-Japanese Alliance was thus the crowning achievement of the new age: Japan had become the "England of the East" and a full-fledged member of the community of civilized nations. At the same time, however, the alliance contained the possibility of a more militant national spirit—one that required a willingness to sacrifice for the national cause of Japan's advance into Asia.

32. A. Craig, "Fukuzawa Yukichi."

CHAPTER ELEVEN

"To Help Our Stricken Brothers": The Great Tōhoku Famine of 1905–1906

This chapter examines the domestic and foreign response to a devastating famine that struck three prefectures in northeastern Japan in 1905–1906, immediately after the Russo-Japanese War (1904–1905). These two nearly synchronic events, one fought with military might, the other mitigated with transnational humanitarian aid, one remembered as marking Japan's elevation to great power status, the other largely forgotten, each invite reflection on the trajectories of modern Japanese history.

The Great Tōhoku Famine resulted in widespread suffering and deprivation, but it was also the occasion of an extraordinary outpouring of transnational goodwill in the form of humanitarian aid. Within Japan, Christian missionaries and Buddhist organizations organized relief efforts; businessmen, politicians, and the imperial family gave donations. From overseas, money and other gifts came from individuals, governments, and the Chinese empress dowager. Foreign and Japanese newspapers issued reports on famine conditions and created sites for collecting donations. The Japanese Red Cross, which had established a reputation for humanitarian service in the Russo-Japanese War, committed its resources to the distribution of donated money, food, and other goods to the distressed. Separate from the Japanese government's relief programs, some two million yen were sent to the famine-stricken region from Japan and abroad.

The success of humanitarian aid efforts to release the Tōhoku region from famine bequeathed a legacy of international goodwill, especially between Japan and the United States. At the same time, fundraising campaigns and sensational reports of starvation and distress highlighted images of needy, backward, and even shameful circumstances

in Japan's northeast. *The chapter relies on domestic and foreign newspaper accounts of the famine, many sympathetic to the plight of the famine victims, others that confirmed negative perceptions of Japan's northeast. The conclusion suggests that Japan's early twentieth-century experience of humanitarianism as a recipient and giver of aid forms the basis of an alternative narrative of Japan's modern history.*

I began research on the Tōhoku famine and famine relief operations soon after the earthquake, tsunami, and nuclear meltdown of 2011 brought disaster to northeastern Japan—the same area that had been affected by the 1905–1906 crisis.[1]

The March 11, 2011, triple disaster of earthquake, tsunami, and nuclear meltdown that struck Japan's Tōhoku region was one of the most deadly and costly events in world history. It also ranks as an extraordinary example of transnational humanitarian aid to a people and a nation in need. In just over a year after the catastrophe, cash, goods, and services were sent to the affected areas from some 163 countries and a variety of donors, including domestic and international NGOs, NPOs, corporations, and private individuals.[2] Despite the outpouring of support, however, recovery in the region was slow. "What happened," asked the English-language *Asahi shinbun* in September 2020, "to the government's slogan of 'No regeneration of Japan without Tohoku reconstruction?'"[3] After newly elected Prime Minister Suga Yoshihide had failed even to mention the Tōhoku region in his outline of national challenges, the newspaper suggested that government priorities had shifted.

This chapter examines the response to an earlier disaster that imperiled Japan's northeast: the Great Tōhoku Famine of 1905–1906. The summer of 1905 was cold, wet, and sunless, generating fears among farmers of a poor harvest. In Fukushima Prefecture, the July

1. Steele, "The Great Northern Famine of 1905–1906: Two Sides of International Aid," revised and translated as "Tōhoku kikin: Kindai no ura-omote."
2. Ministry of Foreign Affairs of Japan, "List of Relief Supplies."
3. "Reconstruction of Tohoku Region."

temperature dropped some forty degrees Fahrenheit below the annual average; nearly every day was wet.[4] August rainfall was well above average, and the fifty-four hours of sunshine fell well below the annual average of eighty-six hours. In September, the weather in the Tōhoku region turned hot and dry, but this caused the rice heads to shrivel. By the October harvest season, little but straw remained. Farmers in Miyagi were able to harvest just 12 percent of an average year's crop; Fukushima, 25 percent; and Iwate, 33 percent.[5] The three prefectures of Miyagi, Fukushima, and Iwate, having a combined population of some 2.8 million, lost almost their entire rice harvest. The losses were centered on the city of Sendai, running up and down the eastern coast about 160 kilometers in both directions.

Coming on the heels of Japan's victory in the Russo-Japanese War, the disastrous crop failure in the Tōhoku region attracted global attention. It quickly became an early example of transnational humanitarian aid. The *New York Times* ran a series of reports that highlighted the sufferings of people in the three northeastern prefectures, claiming that thousands were on the verge of starvation, forced to live on roots, tree bark, and acorns. The *Christian Herald*, a popular Christian weekly published in the United States between 1878 and 1992, appealed for contributions to alleviate the distress of the victims, whom it described as "a community of skeletons."[6] In an appeal to the American people made in February 1906, President Theodore Roosevelt (1858–1919) requested that contributions for famine relief be sent to the American Red Cross for transfer to the Japanese Red Cross.

Within Japan, missionaries in Sendai were active in fundraising and setting up relief stations, but so were Buddhist groups and prominent businessmen and politicians. The Japanese Red Cross distributed donated money, food, and other goods to distressed people in the northeast. It was, at that time, the world's largest Red Cross organization and had recently engaged in extensive humanitarian activities during Japan's war with Russia. Newspapers such as the *Asahi shinbun* and

4. Fukushima-ken Shobō Bōsaika, *Fukushima-ken saigai shi*, 152.
5. Lampe, *Report of the Foreign Committee*, 1–2; Miyagi-ken, *Meiji sanjūhachinen Miyagi-ken kyōkō shi*, 1–80.
6. "Japan's Famine Appeal Is Heard."

the *Jiji shinpō* issued daily reports on famine conditions and created special sites for the collection of relief funds (*gienkin*), publishing contributors' names and the amount donated. In the end, separately from tax relief and government relief programs, some two million yen was raised and put to good use. Although hardships continued, the year-long famine was declared over in May 1906.

The foreign and Japanese news media, missionary records, and diplomatic correspondence introduced in this chapter illuminate contemporary debates in Japan on humanitarian aid: how to balance local recovery with national development? What were the respective roles of direct aid and job creation projects? Was the acceptance of humanitarian aid shameful? Worldwide media coverage of the stricken farmers in Japan's northeast produced an outpouring of foreign and domestic sympathy and humanitarian aid; at the same time, however, it confirmed the backward condition of the Tōhoku region, thereby reinforcing its status as Japan's "constructed outland."[7] The concluding section attempts to situate transnational humanitarian aid in the broader narrative of modern Japanese history.

Transnational Humanitarian Aid

Organized appeals for donations of money and goods to unknown people in distant locations began only in the late nineteenth century. Christian journalism, supported by advances in communications and international banking (Western Union pioneered international money transfers by telegraph), encouraged fulfillment of the moral obligation to help the poor, no matter where in the world. After Louis Klopsch (1852–1910), a former missionary in India, took charge of the New York-based *Christian Herald* in 1890, he used it as a vehicle for fundraising to aid the victims of natural disasters.[8] In 1892 alone, the *Herald* raised one million dollars in goods and services for famine relief in Russia. Using exaggerated accounts of starvation and guilt-inducing

7. Kawanishi, *Tōhoku: Japan's Constructed Outland."* See also Hopson, *Ennobling Japan's Savage Northeast.*

8. Pepper, *Life Work of Louis Klopsch.*

appeals for support, Klopsch was similarly successful in raising funds for famine relief in India in 1897 and 1900. His efforts to help people in Russia, India, Armenia, Cuba, Finland, Sweden, Macedonia, China, Italy, and Japan earned Klopsch the moniker "modern knight of mercy."[9]

The International Committee of the Red Cross, founded in Geneva in 1863 as an organization for the care of wounded soldiers, undertook disaster relief operations from the 1880s. The Japanese Red Cross Society was founded in 1887, six years after the establishment of the American Red Cross. It gained recognition within Japan for its humanitarian activities during the Sino-Japanese War of 1894–1895 and the Russo-Japanese War. In 1904, the explorer, reporter, and war correspondent George Kennan (1845–1924) wrote that the Japanese Red Cross had some 847,760 regular members, making it the largest humanitarian organization in the world.[10] In addition to wartime service, the society also conducted natural disaster relief operations, first after the massive eruption of Mt. Bandai in Fukushima Prefecture in July 1888 and three years later after the Nōbi earthquake in Gifu Prefecture killed more than seven thousand people.[11] On June 15, 1896, an earthquake and tsunami struck the Sanriku region of northeastern Japan, eerily close to the epicenter of the 2011 disaster, leaving over twenty thousand dead. The Japanese Red Cross sent doctors and nurses, organized field hospitals, and set up shelters for the homeless.[12]

The Tōhoku famine of 1905–1906 was the first major example of joint domestic and international disaster relief operations. As crop conditions worsened during 1905, William Lampe (1875–1950), a German Reformed Church missionary stationed in Sendai, recognized the scale of the calamity that would soon engulf the northern prefectures. In November 1905 he wrote:

9. This is the subtitle of Pepper, *Life Work of Louis Klopsch*. For Klopsch's efforts on behalf of Japan, see 202–18.

10. Kennan, "The Japanese Red Cross," 33; "The Red Cross in Japan"; Kower, *Historical Dictionary of the Russo-Japanese War*, 444.

11. Kawamata, *The History of Red Cross Society*, 46–54, 74–77.

12. Scidmore, "The Recent Earthquake Wave," 285–89. See also Hosogoe, "Meiji Sanriku Ōtsunami."

Officials were buying up seed rice in other provinces as it was evident that there would be no seed in what was now the famine district. As even the straw was worthless, many fields were left uncut. Work became scarce and soon farm laborers had no employment whatsoever. Many persons who used to ride were now compelled to walk and jinrikisha men with large families became distressed. The chronic poor were lost sight of altogether and their condition became pitiful. The dark days had come and there was consternation on many faces.[13]

Lampe described the origins of what would become a worldwide campaign to aid the victims of famine in northern Japan:

On the afternoon of Thanksgiving Day the Americans of Sendai and Morioka met for a service of praise and prayer. After a meeting, a consultation was held to consider how we could best help our stricken brothers. Five persons were appointed to represent those present, and when two days later these five met, it was unanimously decided to invite a representative of England and one of France to join, thus forming a committee of seven.[14]

This group, led by Lampe and John Hyde DeForest (1844–1911), an American Board missionary and educator also stationed in Sendai, constituted the Foreign Committee of Relief (fig. 11.1). Its immediate goal was to secure international sympathy for the distressed and to serve as a "bureau of information" about the famine in Japan's northeast.[15]

The winter of 1905–1906 was unusually severe, and heavy snows put an end to the gathering of food from forests and hillsides. In December 1905, Sendai Foreign Committee members began sending regular reports on the famine to friends and organizations in Japan and their home countries. In response, national and local newspapers outside Japan carried articles with titles such as "The Famine in Japan:

13. Lampe, *The Famine in North Japan*, 2. Lampe produced three pamphlets on the famine, all available in Princeton University Library: *The Famine in North Japan*, *Christians and Relief Work in Northern Japan*, and *Report of the Foreign Committee of Relief for the Famine in Northern Japan*.
14. Lampe, *The Famine in North Japan*, 3.
15. Lampe, *Report of the Foreign Committee*, 3.

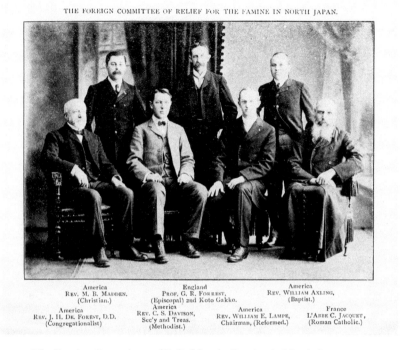

11.1. The Foreign Committee of Relief for the Famine in North Japan, 1906. Source: William E. Lampe, *The Famine in North Japan*. Courtesy of Princeton University Library.

Selling the Children for Money," "Japan Famine Most Terrible of Late Years," and "From Japan Comes Reports of Famine and Starvation in Many Districts." The January 20, 1906 *New York Times* proclaimed: "680,000 Japanese are Now Starving: Tokio Government Would Welcome Aid from Abroad: People Selling Children: Eating Roots and the Bark of Trees and Living in Dugouts—Misery Due to Failure of Crops."[16] On February 21, it reported: "Many Japanese Perishing. Misery in the Famine Region Increased by the Bitter Cold."[17]

16. "680,000 Japanese Are Now Starving." As early as October 28, 1905, the *New York Times* had briefly noted the threat of famine in Japan's northeast in "Famine in Japan Feared."

17. "Many Japanese Perishing."

The *Christian Herald*, edited by Louis Klopsch, was particularly receptive to the accounts of famine in Japan. On January 31, 1906, it reported that letters had been arriving from Christians in Japan for nearly a month and explained that, in the aftermath of the war against Russia, there was need for help from outside: "[The government] is doing what it can to stem the tide of suffering; but the long war which robbed Japan of hundreds of thousands of her bravest sons has so depleted the national resources that the help afforded from that quarter is quite inadequate. Therefore the missionaries have appealed for aid from America as the friend of Japan." It quoted from a letter sent by the Foreign Committee of Relief that included crop and population details of Fukushima, Iwate, and Miyagi: "Already thousands in these three provinces are reduced to shrub roots and the bark of trees, by which mere life may sustained, but at the best calculation 680,000 people are now facing extreme conditions. What this means for their poor women and children we who live in the centre of this oncoming misery find no words to describe. . . . In the name of common humanity we appeal for quick and generous aid." The *Herald* warned: "Northern Japan is usually one of the finest granaries of the nation; yet such is its present condition that unless help providentially comes, the wolves of famine will claim more victims than the totals of the killed and wounded in all the battles of the Manchurian war!" It announced the creation of a Japan Relief Fund and urged its readers to make contributions, with a guarantee of recognition: "Every gift in aid of the relief work will be acknowledged in the columns of this paper."[18] In a separate editorial, the *Herald* compared the famine with the Russo-Japanese War: "The nation which only a few months ago was shouting of victory and patriotically rejoicing over the conclusion of peace, is now stricken with sorrow. It finds itself face to face with a foe stronger and more relentless than the Russians."[19]

Relying primarily on missionary reports, the *Herald* detailed the calamity unfolding in northern Japan in successive weekly installments. On February 7, it offered details under the heading "Fighting Back Famine in Japan: Northern Provinces in a Pitiful Plight—

18. "Japan in Famine's Grasp."
19. "Japan Needs Our Aid."

Multitudes Living on Roots and Bark—Relief Committees Appeal for Aid." It appealed for donations that would be used to send "a cargo of foodstuffs" to the afflicted areas: "Every reader of this paper who wishes to have a share in this life-saving work is invited to contribute toward this great international charity. . . . Any gift, however small, will be welcomed, and may be the means of saving a precious life." The first donation, of one hundred dollars, came from Klopsch.[20] On February 14, the *Herald* focused on the plight of the weakest members of society:

> People who live in lands of plenty, where such a condition of things is unknown, can form no idea of the character of the suffering, nor of the straits to which these poor villagers have been driven, to keep the life within their miserable bodies. They are for the most part like a community of skeletons; and if it had not been for the aid rendered by government relief, small and totally inadequate as it is, they would have perished ere now. It is impossible to describe the situation in these village homes of the simple Japanese farmers. . . . The children especially had become thin and pale, the result of the meager supply of food—often of the most wretched sort—with which they were fed. "Nourishment" is a word not to be used in this connection; it is simply a fierce battle for existence. Gaunt-eyed, hollow-cheeked mothers, with hopelessness written on their faces, look at their weak little ones who are growing feebler daily.[21]

The article concluded with an appeal to contribute to the Japan Relief Fund. The names of some 174 donors were listed, most giving one or two dollars, some only twenty-five cents; a few gave ten to twenty-five dollars.

By February 21, the *Herald* could report progress: "Christian America is coming to the rescue of the suffering people of northern Japan and contributions to the Relief Fund are now pouring in in a steady stream in response to our appeal on behalf of the famishing people." A summary of the "sad glimpses" received by Lampe and others on their latest tour of the famine districts was followed by a list

20. "Fighting Back Famine in Japan."
21. "Japan's Famine Appeal Is Heard."

of some 320 names of new donors. The newspaper also reported that a committee of Japanese residents of the United States had launched an additional appeal through the consul general in New York.[22]

On February 28, the *Herald* announced that, on learning the extent of the famine in Japan, President Theodore Roosevelt had been moved to address an appeal to the American people:

> The famine situation in northern Japan is proving much more serious than at first suspected and thousands of persons are upon the verge of starvation. It is a calamity such as may occasionally befall any country. Nations, like men, should stand ever ready to aid each other in distress, and I appeal to the American people to help from their abundance the suffering men of the great and friendly nation of Japan.[23]

Already, the newspaper noted, the "great heart of our nation" had been deeply touched by the descriptions of the famine in its columns, prompting contributions to the Japan Relief Fund to flow in from across the United States (fig. 11.2). On February 14, the fund was able to cable its first advance of ten thousand dollars to Matsukata Masayoshi, president of the Japanese Red Cross, through the American Red Cross. Klopsch had personally requested that the money be used "exclusively for the purchase of food to be distributed among the most needy people within the famine area." By telegraph, the American Red Cross acknowledged receipt of the money and the instructions for its use.[24]

On March 7, the *Herald* reported new intelligence received by way of a passenger steamer that had recently arrived in Vancouver: "In the famine zone, hundreds of persons, including women and children, are perishing from starvation, aggravated by the bitter cold." Alarmed, the newspaper had sent a second 10,000 dollars in aid from the Japan Relief Fund to the Japanese Red Cross.[25] In response, readers of the *Herald* contributed with even more enthusiasm. Included in

22. "All Eager to Save Japan."
23. "First $10,000 for Starving Japan." The president's appeal was reported in the *New York Times* on February 14: "President Aids Japanese."
24. "First $10,000 for Starving Japan."
25. "Hundreds Now Dying of Famine."

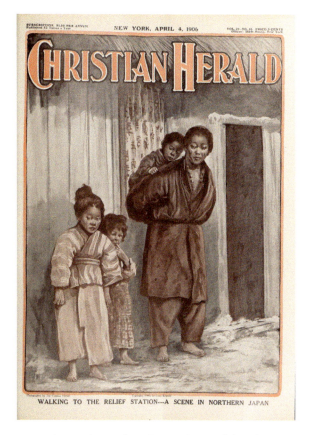

11.2. A scene in northern Japan: Cover of the *Christian Herald*, April 4, 1906. Courtesy of Harvard Divinity School Library.

the March 14 famine update was a full-page table of more than eleven hundred new donors, listed by state.[26] Similar full-page listings appeared weekly, until May 30. On March 22, President Roosevelt sent a telegraph to Klopsch, thanking the *Christian Herald* "for the admirable work done in connection with the famine sufferers in Japan. You have now raised $100,000 and you have rendered a very real service to humanity and to the cause of international good will."[27] On March 28,

26. "Scenes in the Land of Famine."
27. "The President and the Famine Fund."

the *Herald* announced the dispatch of 50,000 dollars, which, in addition to the 20,000 dollars remitted by the Red Cross, "makes a grand total of $105,500 thus far sent from America to the famine field."[28]

On May 2, the *Herald* released the happy news that "the long and severe famine in the northeastern provinces is now practically over." Thanks to international and domestic efforts, food was being supplied regularly to the needy people, and with its goal successfully accomplished, the Japan Relief Fund was to close on May 10.[29] Although the *Herald* offered no final accounting, a rough count based on the donor lists suggests that the fund had received donations from around thirteen thousand people. The *New York Times* reported that as of March 31, 1906, the *Christian Herald* had sent 125,000 dollars to Japan for famine relief.[30] In July, the American National Red Cross reported that it had forwarded a total of 265,855.67 dollars to the Japanese Red Cross, of which 200,000 dollars had been received from the *Christian Herald*.[31]

Other American public and private organizations, including Harvard University, engaged in fundraising projects to aid famine victims in Japan. On March 27, 1906 the *Harvard Crimson* reported: "In response to an appeal from President Roosevelt and to direct appeals from Harvard men and other foreign residents in Japan, the Harvard Mission has undertaken to raise by general subscription in the University a substantial sum of money toward the fund for relieving the famine in the north of Japan."[32] It described the famine in Japan's northeast, warned that the suffering would get worse, and stressed the need for outside aid: "The Japanese government is doing all in its power to relieve the famine by the postponement and remission of taxes, opening of public works and distribution of food at cost and, where necessary, free; but the authorities are unable adequately to meet the need. The appeals for aid, however, have emanated not from the Japanese themselves, but from foreign residents in the provinces affected."[33] On

28. "Christian America's Gift to Japan."
29. "Japan's Famine Siege Lifted."
30. "More Aid for Japanese."
31. "Japanese Famine Fund."
32. "Japan Famine Relief Fund."
33. "Japan Famine Relief Fund."

April 23, the *Crimson* announced that the Harvard Mission had cabled 379.63 dollars to Komura Jutarō (1855–1911), an 1878 graduate of Harvard Law School, who, as foreign minister, had helped to conclude the Anglo-Japanese Alliance in 1902.[34] Most of the money raised in the United States was forwarded through the Red Cross to the Japanese government and then to the three prefectural governments; some was sent directly to the Sendai-based Foreign Committee of Relief.

Although the United States was the leading donor, money and goods reached Japan from across the world. According to the final statement of receipts and expenses prepared in yen by Lampe, a Mansion House Famine Fund established in London cabled several hundred thousand yen to Japan. Australia and Canada sent shipments of flour and a combined total of around 100,000 yen. The German government gave approximately 25,000 yen. The king of Siam sent rice worth 15,000 yen. Indian merchants contributed 10,000 yen. From China, the empress dowager contributed 150,000 yen from her private purse. Lampe commented on her generosity: "Such a gift is without precedent and should do much to draw together the hearts of these two great peoples of the East." In addition to the money forwarded through the Red Cross, Lampe's Foreign Committee of Relief received some 230,000 yen in direct donations, of which about 25,000 yen came from foreigners living in Japan. The statement concluded: "Other gifts came from all quarters of the globe. Although larger amounts have been given in time of famine in other parts of the world, this famine called forth such an expression of worldwide sympathy as has never before been known in the world's history."[35]

The Response from Within

Although prefectural governors and the Japanese-language press warned of the oncoming disaster in the Tōhoku region from October 1905, the national government was cautious in its response. One reason

34. "$379.63 for Japan Relief Fund."
35. "Final Statement of the Foreign Committee." See also Lampe, *Report of the Foreign Committee*.

was the timing. Japan's much-celebrated military victory over Russia earlier that year had left it with a heavy burden of debt, a severely depleted workforce, and significant social and political unrest; riots had erupted in the Hibiya area of downtown Tokyo in September 1905.[36] Another consideration was national pride. The national government was ill-disposed to publicize news of regional impoverishment and suffering for fear of damaging Japan's international reputation. Moreover, as a matter of policy, it was reluctant to give money or even food directly to the needy, preferring to foster what it saw as "a spirit of self-help among the people rather than a spirit of dependence on charity."[37] In January 1906, Hioki Eki (1861–1926), chargé d'affaires in Washington, explained this position in his response to a US Department of State inquiry regarding the desire of many Americans to send contributions of aid:

> The Government is contriving all means of relief and although they are not at present counting upon outside aid, any voluntary contributions of charitable parties will be gladly accepted by them. It being the scheme of the Government, however, to establish works and give employment to the distressed population instead of promiscuously distributing money among them, so as to enable them to earn their own livelihood without depending upon charity, the Government would desire that the disposition of such relief funds may be entirely intrusted to them.[38]

In line with the national policy of avoiding simple one-time handouts, the prefectural governments of Miyagi, Fukushima, and Iwate worked to develop scientifically sound policies that could be expected to produce long-term benefits. They requested funds from the central government to advance rice field rationalization, while at the same time providing seed rice for spring planting, encouraging the cultivation of barley and vegetable crops, and promoting mulberry plantations. They secured tax postponements and exemptions and cheap

36. Gordon, "The Crowd and Politics."
37. "The Famine in the North," March 3, 1906. On the limitations of Meiji government relief programs, see Huffman, *Down and Out*, 120–22.
38. "Reply from the Japan Legation."

sales of military surplus, access to government forest products, and the reduction of freight charges for the transport of commodities. Public works projects, including road repairs, bridge building, and flood control, offered paid work rather than the "pauperizing influence of giving outright."[39] Finally, the prefectural governments facilitated temporary migration to Hokkaido and Sakhalin and the placement of some 825 "famine waifs" in the Okayama Orphanage founded by the Christian child welfare worker Ishii Jūji (1865–1914).[40]

On October 26, 1905, *Asahi shinbun* reported the near total failure of the rice harvest in several northeastern prefectures.[41] By the end of the year, correspondents sent by the *Asahi* and *Jiji shinpō* newspapers were sending in regular dispatches from the affected areas. Beginning on November 5, the *Jiji* ran a series of articles under the general title *Tōhoku kikin shisatsu* (Observations of the Tōhoku famine).[42] Lampe wrote in February 1906 that "tales of woe and misery" from correspondents in the famine districts filled column after column of the Japanese press.[43] These eyewitness accounts sometimes contained heartwarming examples of charity in action; more often they carried sensational reports of people suffering from starvation and cold.[44] The *Kinji gahō*, a popular illustrated news magazine known also as the *Japanese Graphic*, devoted its entire February 1, 1906 issue to the Tōhoku famine. Heartrending stories written in Japanese and imperfect English accompanied realistic images of famine victims (figs. 11.3–11.5).[45] Other visual mediums were also employed to heighten awareness of the tragedy unfolding. Picture postcards

39. See "Famine in Japan," diplomatic correspondence between the Japanese chargé in Tokyo and the secretary of state in Washington, DC. On the measures implemented, see Miyagi-ken, *Meiji sanjūhachinen Miyagi-ken kyōkō shi*, 305–603; *Fukushima-ken kyōsaku kyōsai gaiyō*; "Government Famine Relief."

40. "Sheltering Japan's Famine Waifs." See also "The Famine," in *The Christian Movement in Japan*; Kikuchi Yoshiaki, "Tōhoku sanken kyōsaku"; Maus, "The Recollections of Tetsu."

41. "Tōhoku kikin to Shinpotō."

42. "Tōhoku kikin shisatsu." See also Tsuchida, "1905 nen Tōhoku sanken kusaku," 57.

43. "To the Editor of the *Chronicle*," February 22, 1906.

44. "Tōhoku kyōsaku no kekka."

45. *Kinji gahō*, "Tōhoku kikin-gō."

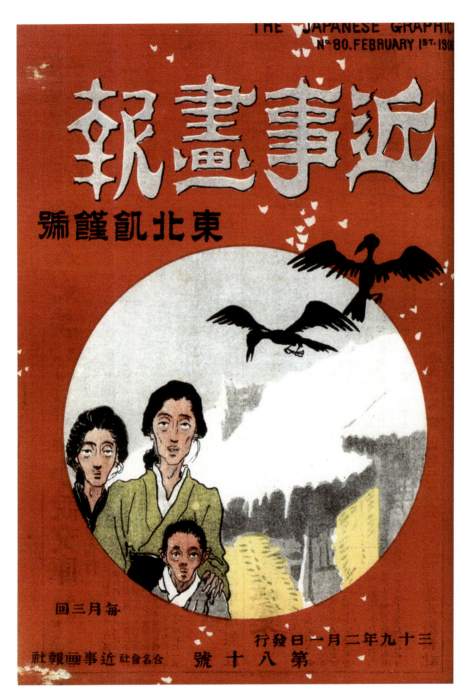

11.3. Cover of a special issue on the Tōhoku famine, *Kinji gahō*, February 1, 1906. National Museum of Modern Japanese Literature.

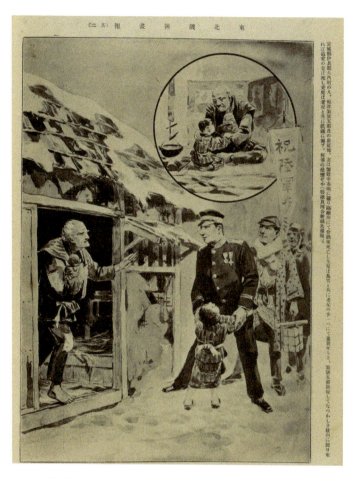

11.4. "In the Famine-Stricken Districts: A soldier returns from Manchuria," *Kinji gahō*, February 6, 1906. National Museum of Modern Japanese Literature.

Our artist writes: "Umezu Kesagorō of Ouichi-mura in Miyagi-ken is truly to be sympathized. He has recently come back from Manchuria to find that during his absence his wife died having been attacked by dysentery while in confinement. His old father, to whom fell the duty of bringing up the baby she had left as well as another child, the returned soldier found on the verge of starvation."

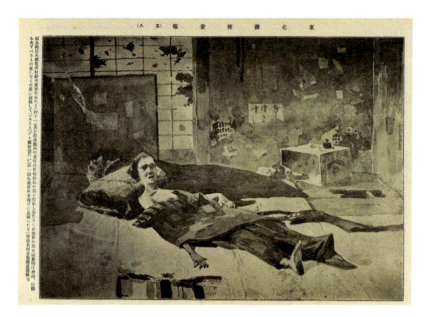

11.5. "In the Famine-Stricken Districts: At death's bed," *Kinji gahō*, February 6, 1906. National Museum of Modern Japanese Literature.

Our artist writes: "Two sick old women in the village of Arai in Fukushima-ken died the other day from lack of nourishing, saying all the while, 'How I wish I could eat some rice.'"

featuring photographs of distressed villagers and wasted rice fields were placed on sale, and between February and April 1906, a series of magic lantern presentations at the Ikeda Toraku studio in Tokyo's Asakusa neighborhood dramatized the plight of the famine victims.[46]

On November 7, 1905, the *Jiji shinpō* began to solicit contributions for famine relief; the *Asahi* announced its fund on January 23,

46. "Gentō saishin eiga Tōhoku kikin." See also Ogawara, "Meiji sanjūkyūnen Tōhoku kikin," 88, 92, on magic lantern presentations for fundraising by Buddhist groups.

1906.⁴⁷ As in the *Christian Herald*, which opened its fund at the end of that month, donors' names were printed in columns almost every day. When the *Asahi* campaign closed on April 11, some 9,744 persons had contributed a total of 51,379 yen; additional contributions amounting to nearly 1,500 yen flowed in until early May.⁴⁸ The *Jiji shinpō* closed its fund on April 27; its final statement reported a total of just over 53,062 yen.⁴⁹ Tokyo's leading satirical journal, *Tōkyō Puck*, also solicited donations. To spur generosity, on February 1, 1906, it ran a satirical cartoon criticizing wealthy people who found more important uses for their money than contributing to a famine relief fund (fig. 11.6).⁵⁰

Buddhist groups were among the first to engage in famine relief operations. In October 1905, before Lampe and DeForest began to organize the Christian community, the Rinnōji Zen temple in Sendai established an all-Buddhist fund to help the needy in Miyagi Prefecture. A Buddhist newspaper, the *Chūgai nippō*, followed the activities of the Sendai temples and other Buddhist groups, advertising their fundraising campaigns and listing the names of donors. In February 1906, the Tokyo-based Buddhist Newspaper and Magazine Alliance prepared one hundred thousand "charity bags" (*jizen bukuro*), each filled with one *shō* (1.8 liters) of rice, to be distributed to parishioners in need.⁵¹

On January 31, 1906, a telegram informed the three prefectures that the emperor and empress would contribute 50,000 yen to the relief effort: 25,000 for Miyagi, 15,000 for Fukushima, and 10,000 for Iwate. Donations from princes, members of the cabinet, and others

47. For the *Jiji shinpō*, "Tōhoku chihō kyūmin kyūjutsu." For the *Asahi*, "Kyōsaku kyūsai gienkin." The *Asahi* was among the earliest newspapers in Japan to use the power of the press to solicit disaster relief funds. It first used this format in 1885 to aid victims of a destructive flood in Osaka. See "Gikin," July 3, 1885.

48. "Shakoku."

49. "Tōhoku kikin kyūsaikin boshū shimekiri."

50. "Money Which Might Be Contributed."

51. Ogawara, "Meiji sanjūkyūnen Tōhoku kikin." See also "Miyagi-ken kikin kyūsai gien."

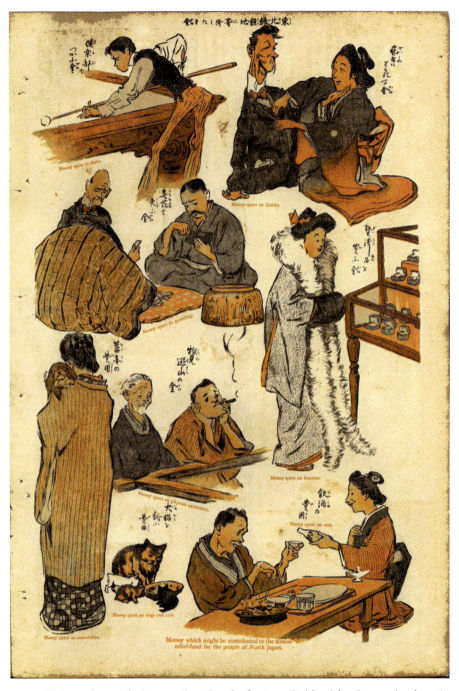

11.6. "Money that might be contributed to the famine relief fund for the people of north Japan." *Tōkyō Puck* 2, no. 4 (February 1906): 52. Author's collection.

followed.⁵² Among wealthy industrialists, the Mitsui and Iwasaki families each gave 25,000 yen, and Yasuda Zenjirō (1828–1921) 15,000 yen.⁵³ Already, on January 26, leading citizens from Miyagi, Fukushima, and Iwate Prefectures, including members of both houses of the Diet, formed the Tōhoku Sanken Kyūjutsukai (Association for Relief to the Three Tōhoku Prefectures) in Tokyo.⁵⁴ The city's newspapers nominated representatives from the *Tōkyō nichi nichi* and the *Asahi* as members. Tomita Tetsunosuke, a Sendai native, businessman, and former governor of Tokyo, was chosen as president. Criticizing the government's relief measures as inadequate, the association urged all newspapers in Tokyo to open subscription lists to "rouse the public to a commensurate sense of the necessity of giving liberal and speedy aid."⁵⁵ The *Asahi* reported that, as of May 8, the Association for Relief had raised just over 188,500 yen; an additional 1804.77 yen was later recorded.⁵⁶ Following the model of the imperial donation, funds collected for the three prefectures were divided 50, 30, and 20 percent among Miyagi, Fukushima, and Iwate, respectively.

Given the variety of sources of direct and indirect aid, it is impossible to know exactly how much was collected in money, goods, and services for famine victims. Miyagi Prefecture calculated that, separately from tax relief and government relief programs, it received a total of 894,285 yen in overseas and domestic donations; of this, 227,957 yen came from the American Red Cross.⁵⁷ Fukushima Prefecture recorded a total of 508,491 yen, of which just over 130,228 yen came from the American Red Cross.⁵⁸ Iwate Prefecture, for which no accounting is available, probably received somewhat less. In addition to these funds, Lampe reported that the Foreign Committee of Relief

52. "Kyōsakuchi gokyūjutsu." See also Miyagi-ken, *Meiji sanjūhachinen Miyagi-ken kyōkō shi*, 606–8.
53. "Fugō no gien."
54. Tsuchida, "1905 nen Tōhoku sanken kusaku," 60. See also *Fukushima-ken kyōsaku kyōsai gaiyō*, 11–12; and "The Famine-Stricken Districts."
55. "The Famine-Stricken Districts."
56. "Tōhoku sanken kyūjutsukin." See also "Tōhoku kyūjutsukai heisa" and "Kyōsakuchi gienkin."
57. Miyagi-ken, *Meiji sanjūhachinen Miyagi-ken kyōkō shi*, 605, 618–19.
58. *Fukushima-ken kyōsaku kyōsai gaiyō*, 41–43.

received some 220,179 yen, mostly from overseas donors and from the foreign community in Japan, for distribution to the three prefectures.[59] The above figures produce a total of 1,622,955 yen. If an estimate for Iwate is added, it can be concluded that around two million yen was raised in one of the first examples of transnational humanitarian aid.

Despite this outpouring of sympathy and cash donations, there were concerns, especially in the early months of 1906, that assistance and relief measures were insufficient. On February 14, the *Asahi shinbun* professed incredulity that anyone, in the reign of Emperor Meiji, would be allowed to die of starvation. The imperial family and charitable citizens had donated money, but still people were dying. The *Asahi* blamed government officials, especially in the Home Ministry, for offering famine victims "industry instead of rice, work instead of money."[60]

Other newspapers, including the overseas press, criticized both public and private sectors: The *Poverty Bay Herald*, for example, noted: "There is a good deal of money in Japan at the present time, yet people are not contributing as they might be expected to do to the needs of the three northern prefectures of the Japanese Empire." It added: "The Japanese people are still elated with their victory over the Russians, and are ready enough to spend money in celebrating their victory. They are, however, . . . too insensible to the miserable plight in which the northern provinces are lying."[61] The bulk of blame, however, was directed at the government.

The Kobe-based *Japan Weekly Chronicle* agreed. On February 15, after acknowledging the donations of the imperial family and other prominent citizens, it declared that:

> Great as these individual contributions are, they are only sufficient to give very temporary relief to 680,000 persons, the number, we are informed,

59. "Final Statement of the Foreign Committee." From the money it received, the committee sent just over 10,000 yen to the Okayama Orphanage and to the Sendai Christian Orphanage founded by the Methodist Episcopal missionary Frances E. Phelps (1860–1923).
60. "Seidai ni gashisha."
61. "The Japanese Famine."

who are in an absolutely starving condition. Several days ago the public were told that a Bill was to be introduced into the Diet, voting "immediate" relief, a word that will surely be bitter irony to the thousands who are now starving and waiting for the sustenance that is promised them.[62]

The *Chronicle* even speculated that "in the days when Japan was under an older form of rule such distress as is now being witnessed would have been immediately relieved by shiploads of rice and remission of taxes.... The system is now different; the machinery of government is complicated and slow-moving, and before real, substantial help can reach these starving unfortunates much suffering and misery must be experienced."[63]

Lampe also worried that government programs designed to give work to the unemployed would fail to help those most in need. Not everyone was strong enough to work, nor was work available for everyone in need of help, especially in the dead of winter. On January 11, 1906, he wrote:

So far relief works have not been begun except by a few philanthropic individuals, but after work is begun even the able-bodied must rest many days when snow is falling or on the ground. The nations of Europe and America do not as governments dispense charity and here at this time in Japan there is as yet no provision for the sick and aged and those who for any reason cannot work.[64]

Lampe later described the plight of some "25,000 to 40,000 sick and aged persons and helpless children, not one of whom can support himself by his own labour and who must be helped for some months whether it snows or not. How bitter is their lot in this severe winter."[65]

The Japanese government was nonetheless adamant in defending its policy of "self-help" toward famine victims. As the Japanese Red

62. "The Famine."
63. "The Famine."
64. "To the Editor of the *Chronicle*," January 11, 1906.
65. "To the Editor of the *Chronicle*," February 22, 1906.

Cross informed its American counterpart, "Before distributing the money which you sent to us, we very carefully investigated the best methods by which no peasant there should 'laze' away his time, simply relying upon such helps."[66] The final report of Foreign Committee of Relief restated this approach: "Self help is the official cry and the efforts of the officials met with great success. While actual deaths from starvation were very few, it was thought necessary to save the spirit of the people and better to allow some suffering, while making everyone feel his responsibility for his own support, than to use large sums of money and make chronic paupers, lazy and unwilling to work."[67]

A subtext to government inaction was the widely held belief, found even in the missionary community, that the people of the Tōhoku region were less industrious and less intelligent than people in other parts of Japan. Diet debates over famine relief often included references to Tōhoku "backwardness." On February 23, 1906, Abe Tokusaburō (1867–1918), Lower House representative from Iwate Prefecture, put it this way in arguing for government relief: "As we all know, the Tōhoku, compared with the rest of Japan, is extraordinarily deficient in terms of wealth, and its standard of living is also low. Therefore, when a famine like this comes and not even one grain of rice can be harvested, even those who may have aspired to join the middle class are forced to remain among the poor and distressed."[68]

A merchant contributor to the Yokohama newspaper *Eastern World* was more blunt in evaluating the intellectual and moral character of Tōhoku people:

> Large sums continue to be collected and sent for the benefit of the famine sufferers in the North, but in view of the fact that these people seem to be unwilling to do anything for themselves, it seems to us that much of the money contributed for their support is thrown away and wasted to no purpose whatsoever, except to make permanent paupers, who are a useless drag upon the country. . . . They simply seem to be rooted to the

66. "Report of a Vice President," in *The History of the Red Cross Society of Japan*, 306.
67. Lampe, *Report of the Foreign Committee*, 4.
68. "Dai 22 kai Teikoku Gikai Shūgiin."

ground, crying: "We can't work and we won't work and we won't go where there is work. Feed us and keep feeding us, or we starve."[69]

The merchant had written to a foreign missionary engaged in famine relief, offering work for one or two men. The unidentified missionary had apparently sent the following response:

> The famine is limited to about 500,000 farmers who seem to be unable to do any but farming work and those farmers, physically and intellectually, are an inferior class, even amongst their own surroundings. About 10,000 of the more active and intelligent have emigrated to the Hokkaido, and those who have remained are inferior people and certainly very much inferior to the people in the south. If they were sent to Yokohama to work as jinrikisha coolies they probably could not do the work, and certainly not any work requiring greater intelligence than that of jinrikisha coolies.... They would only be a source of trouble.[70]

Conclusion

By the early summer of 1906, the worst of the suffering in Japan's northeast had passed. On May 2, the *Christian Herald* declared that "the danger point has passed, and there is no longer apprehension that the sufferers will perish of starvation."[71] News media in Japan and elsewhere continued to cover famine-related stories: the establishment of orphanages to care for thousands of abandoned children, the effort of agricultural specialists to develop crops better suited to the Tōhoku climate, and the massive out-migration of people to other parts of Japan. Nonetheless, there was near-universal recognition that the relief efforts had been a success. Thanks to aid from within Japan and from overseas, many lives had been saved.

69. "Charity Thrown Away."
70. "Charity Thrown Away."
71. "Japan's Famine Siege Lifted," 194.

The Great Tōhoku Famine and the outpouring of transnational humanitarian aid is an important though often-overlooked episode in modern Japanese history. Like Japan's much-celebrated victory over Russia and the accompanying surge of nationalism, the victory over famine and the surge of worldwide sympathy tell us much about Japan and the world in the early twentieth century. In its conduct of the Russo-Japanese War, Japan demonstrated to the countries of Europe and America that it was a modern industrial state, able to conduct war in accordance with international norms and qualified to rank among the great powers of the world. On the very different Tōhoku battlefront, Japan's ability to succor its own people was also put to the test, and with the support of domestic and foreign aid, many lives were saved.

Both victories were ambiguous. As John Dower has shown, Japan's ability to bring Russia to its knees awakened fears of the "Yellow Peril."[72] For some observers, the image of Japan, as leader of the Asian masses, placed the superiority of Western civilization at risk. On the famine front, fundraising campaigns and sensational reports of starvation and distress highlighted, at home and abroad, images of needy, backward, and even shameful circumstances in Japan's northeast.[73]

And yet, the success of humanitarian aid efforts to release the three stricken prefectures from famine bequeathed a legacy of international goodwill, especially between Japan and its Pacific neighbor, the United States. On April 18, 1906, just as the disaster in Japan was easing, San Francisco was devastated by a massive earthquake. Newspapers in Japan issued special editions, reporting fears that "the whole town will be destroyed by fire."[74] The Japanese Red Cross immediately offered to send one of its state-of-the-art hospital ships. Although this offer was declined, President Roosevelt welcomed financial aid from Japan and other countries as representing "the growth of the spirit of brotherhood among nations."[75] On April 22, with donations for the Tōhoku famine still being solicited, the *Jiji shinpō* opened a

72. Dower, "Yellow Promise / Yellow Peril."
73. Kawanishi, *Tōhoku: Japan's Constructed Outland*"; Hopson, *Ennobling Japan's Savage Northeast*.
74. "The Earthquake in San Francisco."
75. "Earthquake and Fire at San Francisco," in *Papers Relating to the Foreign Relations of the United States*.

subscription for earthquake relief. Two days later, it reported that 5,805 yen in contributions had already been transferred to the Japanese Red Cross.[76] In all, Japan sent 244,960 dollars to San Francisco, by far the largest donation sent by any country.[77] In early May, the American chargé d'affaires in Japan, Huntingdon Wilson (1875–1946), toured the famine region to observe the distribution of food and other goods to needy families. When the mayor of Sendai expressed gratitude for the American relief aid received, Wilson responded by thanking the Japanese people for their "spirit of helpfulness" in donating generously to the victims of the San Francisco earthquake: "These two disasters, the famine here and the earthquake at San Francisco will have been the occasion for welding one more link in the long, strong chain of mutual goodwill which has been the relation between Japan and American from the days of Perry and Townsend Harris."[78]

Seventeen years later, when Tokyo was in flames, Japan's "spirit of helpfulness" had not been forgotten by Californians. On September 6, 1923, five days after the Great Kantō Earthquake, the mayor of Madera, a small city in central California, urged local citizens to respond generously to "the anguished call of suffering humanity." He reminded them that California was in debt to Japan: "It is up to California more than it is to any other state in the union to push relief work to the limit. It is up to this state to be there on the 'comeback,' for Japan was first of all the foreign nations to lend aid at the time our own San Francisco met with a like disaster back in 1906."[79] Another eighty-eight years later, the memory of Japan's initial humanitarian gesture remained strong. On April 18, 2011, a crowd gathered in downtown San Francisco to commemorate the 1906 disaster and share "a moment of silence for Japan, which gave $250,000 all those decades ago to help this city rebuild—and which is now trying to recover from its own devastating quake and tsunami." The Bay Area had already donated millions of dollars to relief efforts in Japan.[80]

76. "Sanfuranshisuko shinsai imonkin."
77. Museum of the City of San Francisco, "Foreign Assistance to San Francisco."
78. "Mr. and Mrs. Wilson in Sendai." See also "The San Francisco Earthquake."
79. "Madera County Will Respond."
80. Nelson, "S.F. Hopes to Return Favor."

Humanitarianism is a global phenomenon, having multiple sources and expressions. Challenging the notion of its foreign and Christian origins in Japan, Sho Konishi suggests a link between the Tokugawa-era ethic of "saving the people" through medical care and the early Meiji establishment of the Japanese Red Cross.[81] As part of Japan's national narrative, the Japanese Red Cross is known more for its service to fighting men on the battlefield than to the provision of relief and comfort to those stricken by famine and other disasters.[82] Indeed, the history of humanitarian responses to disaster in modern Japan has been little studied. Viewed from the famine fields of Tōhoku, an alternative narrative of Japan's modernity demands recognition, one more people-centered than state-centered, and one more committed to sharing wealth and ending inequalities.

81. Sho Konishi, "The Emergence of an International Humanitarian Organization," 1130.
82. Olive Checkland's *Humanitarianism and the Emperor's Japan* focuses on the role played by the Japanese Red Cross during the Russo-Japanese War. See also DePies, "Humanitarian Empire."

CHAPTER TWELVE

Postcards from Hell: Glimpses of the Great Kantō Earthquake

This chapter examines the ways in which picture postcards (ehagaki) were used to offer information and comment on the Great Kantō Earthquake of 1923.

Many people in Japan today can tell you exactly where they were when a major earthquake hit Japan at 2:25 p.m. on Friday, March 11, 2011. I was in a car in downtown Tokyo. Traffic stopped, and everyone on the street watched the swaying of the high-rise buildings with apprehension. What did people think at 11:58 a.m. on Saturday, September 1, 1923, when a 7.9-magnitude earthquake struck the Tokyo-Yokohama area directly? The earthquake and subsequent fires created an inferno that killed around 150,000 people, displaced many more, and destroyed much of the physical infrastructure of both cities. During the ensuing weeks of chaos and panic, picture postcards delivered information about the disasters to a public hungry for details. Collected as mementos or sent to worried family and friends, this new genre of social media offered insights into the tragedy and trauma of the moment, allowing the survivors of the earthquake to send pictures literally from hell.

This chapter describes the content, photographers, and printers of the earthquake postcards of 1923. It also finds links with the catfish prints and disaster broadsheets (kawaraban) that engulfed Edo after the Ansei earthquake had destroyed much of the city sixty-eight years earlier. Just as the catfish prints and other visual sources pointed to dislocations in late Tokugawa-era society and economy, the picture postcards sold after the 1923 earthquake suggest something of the ambiguities and fissures of modernity that had emerged in Japan since the 1850s.

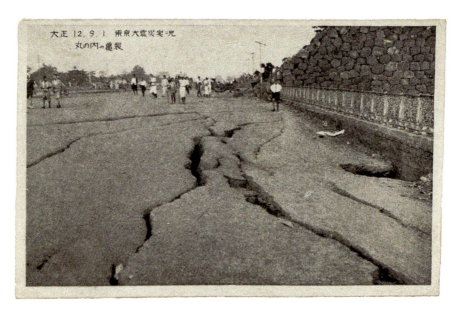

12.1. Fissures in front of the imperial palace, postcard, 1923. Author's collection.

In mid-November 1923, two and a half months after the Great Kantō Earthquake, a middle-aged man on a "one-sen steamer" that plied back and forth between Azumabashi and Shirohige on Tokyo's Sumida River shouted (figs. 12.1, 12.2):

> Picture postcards! I've got postcards! I'm sorry to bother you, ladies and gentlemen, especially while the ship is moving, and we are all crowded together. But I'm going to talk to you about something that we citizens can never ever forget. I've got photographs of what happened at 11:58, just before noon, on September 1 of this year, 1923. As a memorial to the souls of the dead, or as a memorial to what's eternal, I beg your generosity. This first one is of those dreadful fissures right in front of the imperial palace. Next is Yūrakuchō. The destruction is simply appalling! In both, the top shows what the area looked like before the quake and the bottom after, making it easy to grasp what's happened. These prints are all top-quality collotypes. You won't find anything with sharper detail. No one can say that these images are blurry. The next one shows

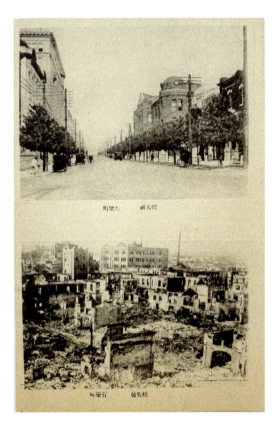

12.2. Yūrakuchō before and after the quake, postcard, 1923. Author's collection.

Shin-Yoshiwara and the mound of ashes of some six hundred souls. Next is Asakusa, the most famous entertainment district in Japan. Remember that row of motion picture theaters? Ah, so sad! It's now vanished like a dream, leaving no trace but the ruins of Shōchiku and Misonoza Theaters. And then there's the famous Asakusa Twelve Stories [Ryōunkaku], first knocked down by the earthquake and then, thanks to army engineers, completely gone. These prints are a unique memento of those events for all times, now and in the future, and for them I beg your generosity. Yes, thank you. Wait a minute...."[1]

1. "Sate goshōkai itashimasu wa." See also, for commentary and text, Kitahara, *Shashinshū Kantō daishinsai*, 292. The cost of the set was 20 sen for sixteen prints; the price included a second set of sixteen for free.

On September 1, 1923, a typhoon, followed by earthquake, tsunami, and fire, transformed Tokyo and Yokohama into a living hell. Known collectively as the Great Kantō Earthquake, the disasters had extreme social, political, and economic consequences. Around 150,000 people were killed, and the ensuing social and economic dislocations spread well beyond the immediate Kantō region.[2] The visage of Tokyo ablaze, the suffering, impoverishment, destruction, and general chaos forced people to radically rethink and refashion their lives and how to make sense of a sudden disruption in the course of history.

The imagining and memorializing of the 9.1 earthquake is the subject of several books published in the aftermath of the March 11, 2011 triple disaster.[3] All rely heavily on postcard images of the destruction caused by the earthquake. Gennifer Weisenfeld especially illustrates ways in which photography, film, and art help to "imagine disaster," showing how postcards and other visual media "played a critical mediating role in the production of the historical narrative of the quake and the solidification of its legacy."[4]

The extraordinary number of earthquake-related postcards, well over one thousand, often sold in sets, is well known, but has not been fully examined. Why were postcards of disaster and destruction so popular? Who published them and who bought them, and why? Were they simply souvenirs? This chapter aims to answer some of these questions by placing the picture postcards in a long tradition of disaster media, including broadsheets and woodblock prints, that went beyond the visual record to include information as well as political and social comment. In an age before digital social media, postcards functioned as a sort of social networking service, leaving a valuable record of what people saw and thought in happy times and sad, and in times of major social and political upheaval.

2. For an overview, see Schencking, "*Kantō daishinsai.*" On the short- and long-term economic impacts, see Hunter, "'Extreme Confusion and Disorder'?"
3. Kitahara, *Kantō daishinsai no shakaishi*; Schencking, *The Great Kantō Earthquake*; Weisenfeld, *Imaging Disaster*.
4. Weisenfeld, *Imaging Disaster*, 4.

Postcard History

Mailed cards came into general use in Europe and the United States in the 1860s and in Japan in the 1870s.[5] The world's first official correspondence postcard was issued in Austria in 1869, and postal services throughout the world quickly followed. In Japan, the first postcard was issued in 1873 as part of the establishment of a new Western-style postal system.[6] Picture postcards came later, to Europe in the 1880s and the United States in the 1890s. In Japan, they became popular after a change in postal regulations in 1900 allowed privately produced cards to be sent in the mail. At almost the same time, the United States government eased postal restrictions, allowing the address and message to be on one side of the card, and a photograph or illustration on the other.[7]

The early years of the twentieth century witnessed a worldwide boom in picture postcard production. In Japan, picture postcards were produced in great variety. Most were intended for domestic consumption and featured risqué photos of beautiful women, celebrated landscapes and local landmarks, and photos and illustrations of the unusual. Some were designed to meet the demand of foreign tourists for images of geisha, temples, shrines, and street scenes of Tokyo, Yokohama, and Kyoto (fig. 12.3).

In both the United States and Japan, war and natural disasters stimulated demand for picture postcards. Scenes from the 1898 Spanish-American War and photos of the damage caused by the 1906 San Francisco earthquake sparked a picture postcard boom in the United States; images of the Russo-Japanese War of 1904–1905 stimulated Japan's "golden age" of picture postcards.[8] For the first time, people formed long lines to buy picture postcard sets, impatient for inexpensive images from the war front. They included black-and-white or hand-tinted photos, imaginative artwork derived from photos, and

5. Willoughby, *A History of Postcards*.
6. Inoue and Hoshina, *Yūbin no rekishi*, 144–46. On Japan's first postal card, see Yūsei Hakubutsukan, "Nihon saisho no yūbin hagaki."
7. Smithsonian Institute, "Postcard History."
8. Bassett, "Wish You Were Here!"

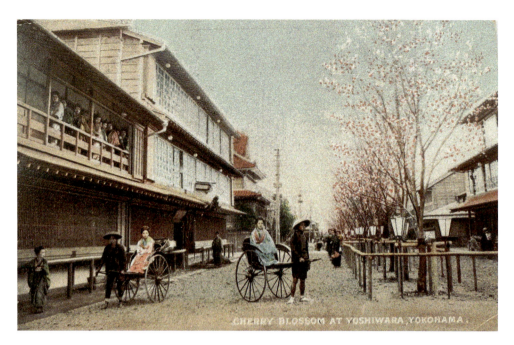

12.3. Yokohama street scene, postcard, 1905. Author's collection.

cartoons carrying patriotic messages (fig. 12.4). Postcards came to be valued more for their visual content than for the blank space reserved for communication. After the Great Tōhoku Famine of 1905–1906 and a flood that devastated downtown Tokyo and left some 270,000 people homeless in 1910, Japanese people became eager consumers of picture postcards showing disaster scenes (fig. 12.5). By this time, since woodblock prints of current events were too expensive and newspapers too ephemeral, picture postcards were sought after, as keepsakes of an event experienced or as a means of informing distant friends and relatives of a key personal experience. Deltiology, or postcard collecting, became a worldwide obsession. When picture postcards of the Great Kantō Earthquake became available around September 9, 1923, just over a week after the catastrophe, the lines of customers snaked up to three hundred meters.

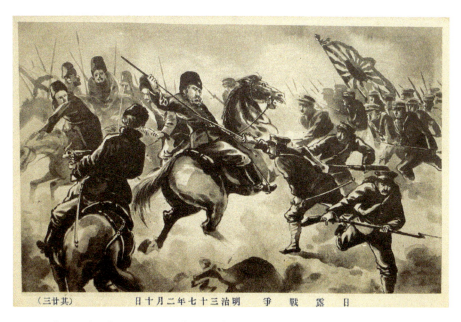

12.4. The Battle of 203 Meter Hill, one of the bloodiest episodes of the Russo-Japanese War, postcard, 1904 or 1905. Author's collection.

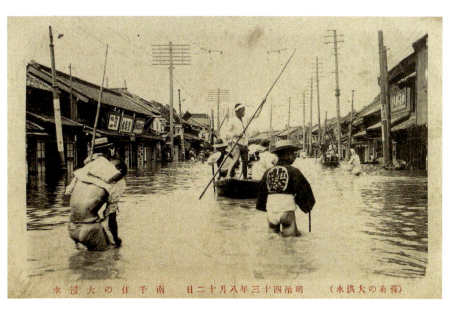

12.5. The Great Tokyo Flood of 1910, postcard, 1910. Author's collection.

Postcards and the Great Kantō Earthquake

After the earthquake stuck on September 1, fires raged for nearly two days, turning Tokyo into an inferno.[9] It took nearly a week for order to be restored and relief efforts to take effect—and several more weeks before the cleanup and rebuilding could begin. Of the more than three hundred printing companies in Tokyo, only around ten escaped the disaster relatively unscathed. Newspapers struggled to recover; most of their presses and typesetting equipment had been destroyed. The *Asahi shinbun* resumed its regular publishing schedule only on September 12, eleven days after the quake. During this period of chaos and panic, there was an unquenchable demand for images of the destruction and a few intrepid cameramen photographed scenes that they sold to the surviving printing establishments for the production of postcards. In the absence of radio (which did not begin broadcasting until 1925), postcards emerged as a sought-after commodity for an information-starved public (fig. 12.6).[10]

Mitsumura Printing, a small company with an established reputation in the picture postcard business, was able to take advantage of the calamity for profit. Mitsumura Toshimo (1877–1955), a cameraman himself, had originally set up a printing shop in Kobe in 1904, and his company became known for its picture postcards of events connected with the Russo-Japanese War. A popular get-rich book published in 1917 claimed that, with increasing numbers of tourists arriving in Tokyo from the countryside, fortunes could be made by selling picture postcards of the sights (and beauties) of Tokyo.[11] Inspired perhaps by the promise of riches, Mitsumura moved his business to the capital the following year. The earthquake destroyed his office in Jinbōchō, but the warehouse and factory in Tengenji escaped destruction, leaving the offset printing equipment in good working order. Mitsumura's earthquake memories were different from those of other more traumatized survivors. In the days after September 1, he searched frantically for paper, ink, and other printing supplies. By relying on his

9. Schencking, "*Kantō daishinsai*."
10. Tanabe, "Media to shite no ehagaki."
11. Fukuda, *Jōkyō shite seikō shiuru made*, 57–58.

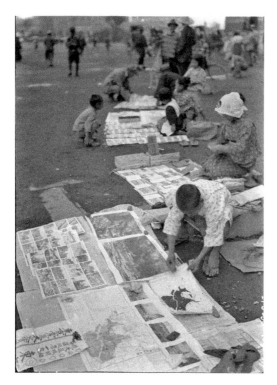

12.6. Open-air picture postcard sales in front of Tokyo Station, newspaper photograph, 1923. Used with permission from Kyodo News Agency/Amana Images.

A story by one woman recounts her survival from the sea of flames that engulfed her house in Yokohama. She walked barefoot to Tokyo, pawned her ring and watch, and managed to eke out a living by selling picture postcards in a make-shift stall. Her once affluent lifestyle was but a dream. The story of the Yokohama woman is related in Sadamura, *Taishō no daijishin daikasai sōnan hyakuwa*, 145–46.

Kansai contacts, he was able to meet the orders that came rushing in. Other publishing houses that specialized in postcards, including Ishikawa Shoten, Shobidō, and Aomidō, were forced to turn to Mitsumura for help. The earthquake was the making of his fortune.[12]

By the middle of September, larger companies, newspapers, and magazines had entered the postcard production market. Kikukadō, a Nagoya printing company that had been creating picture postcards since 1903, dispatched its own cameramen to Tokyo.[13] It billed its packets of postcards as "first reports" of "the disaster of unprecedented proportions" (fig. 12.7). Although the company continued to specialize in Nagoya themes, the postcards it sold of the Great Kantō

12. Masuo, *Mitsumura Toshimo-den*.

13. For a sampling of its postcards in the Meiji and Taishō periods, see "Kikukadō Museum."

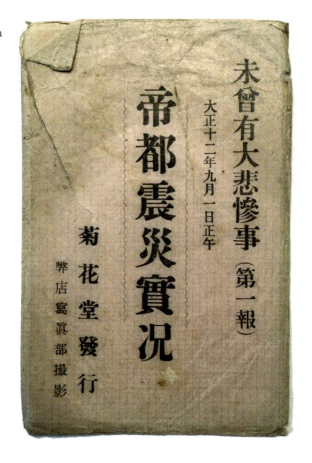

12.7. Packet cover of a set of earthquake postcards, 1923. "A record of the earthquake disaster in the imperial capital: A disaster of unprecedented proportions (first report) noon, September 2, 1923. Published by Kikukadō; pictures taken by our company's photography division." Author's collection.

Earthquake gave it access to a national market. Nonetheless, most of the printers are unknown. Often, the postcards were illegal publications, sold on the streets and at makeshift stands. Most were in packets of eight or ten, though some were offered for sale in uncut sheets. The journalist, satirist, and deltiologist Miyatake Gaikotsu (1867–1955) commented: "At first a set of cards worth 3 sen were sold at 20 sen; gradually the price came down, first to 15 sen, 10 sen, and then 6 sen; when cards were no longer sought after in the city, the vendors took the cards to the countryside."[14] A get-rich book published in 1925 described the post-earthquake boom: "The street between Hibiya and

14. Kimura and Ishii, eds., *Ehagaki ga kataru Kantō daishinsai*, 142.

the Marunouchi Building [in front of Tokyo Station] was lined with almost three hundred stalls selling picture postcards."[15] Even two years after the earthquake, the book could promote postcard production and sales as an avenue to get rich quickly.

Images were supplied by a variety of cameramen, including professionals who operated photography studios and pioneer photojournalists associated with newspapers and magazines such as the *Asahi gurafu* (Asahi graph). Among the professionals who risked their lives to take dramatic shots of the destruction was Kudō Tetsurō (1891–1971). As a cameraman attached to the army, he was able to use his military connections to gain access to devastated areas that had been declared off-limits.[16] Another photographer who gained a reputation for his earthquake shots was Okada Kōyō (1895–1972), later famous for his photo of Mt. Fuji that appeared on the five-thousand-yen note issued in 1984. In December 1923, Okada published his *Tōkyō shinsai shashinchō* (Photo album of the Tokyo disaster), a photographic record of damage caused by the earthquake in Tokyo.[17] For the most part, however, like the printers of picture postcards, the photographers remain unknown. The images used for postcards were largely the work of unnamed amateurs armed with imported Kodak brownies or the domestically produced Konica Sakura or Lily cameras that helped to make Japan into a nation of photographers.[18]

Miyatake Gaikotsu saw similarities between the 1923 postcard phenomenon and the outpouring of catfish prints and disaster broadsheets after the Ansei Earthquake of 1855 (see chapter 2).[19] All met the information demands of a traumatized public. In both eras, with priority placed on speed and cheapness, the quality of the printing and paper was poor. Images were used repeatedly in different formats, often with slightly different captions. Moreover, both the 1923 postcards and the 1855 disaster broadsheets featured maps of affected areas (fig. 12.8).

15. Jitsugyō no Nihonsha, *Kōsokudo kanemōke hō*, 182.
16. Kudō, *Kudō Shashinkan no Shōwa*.
17. Okada, *Tōkyō shinsai shashinchō*.
18. On the history of cameras in Japan, see Ross, *Photography for Everyone*.
19. Kimura and Ishii, *Ehagaki ga kataru Kantō daishinsai*, 142. On the catfish prints, see Smits, "Shaking Up Japan."

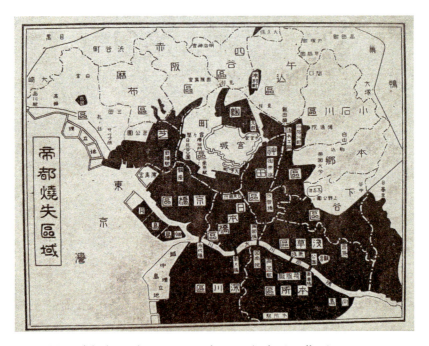

12.8. Map of the burned area, postcard, 1923. Author's collection.

Miyatake noted, however, that the postcards were more varied and realistic, focusing on scenes of ruined buildings and charred streets.

Like their 1855 antecedents, the earthquake postcards were largely unregulated: sales took advantage of a breakdown in normal regulatory practices. For example, attempts by the government to prevent the use of photos of dead bodies went unheeded. Weisenfeld describes a sort of voyeuristic "dark tourism" that made grisly picture postcards of death and destruction especially sought after.[20] And if the photos themselves were not sufficiently macabre, images were touched up with the addition of red flames and billows of gray smoke reminiscent of the Ansei-era prints (fig. 12.9).[21] However, despite rumors of well poisoning and other subversive activities by Korean residents of Japan, no more than a few postcards focused on the roundup

20. Weisenfeld, *Imaging Disaster*, 71.
21. Numata Kiyoshi, "Shiryō: Kantō daishinsai shashin."

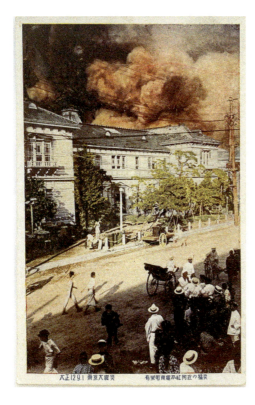

12.9. Yūrakuchō in flames, postcard, 1923. Author's collection.

and killing of these colonial citizens by vigilante groups, often aided by police and soldiers.[22]

A Picture Is Worth a Thousand Words

One further characteristic linked the disaster broadsheets of the late Tokugawa period with the picture postcards of the 1923 earthquake. Both used visual media to convey messages beyond the realistic depiction of people fleeing from flames, messages more moralistic and cautionary than the simple warning to prepare better for the next disaster. But while the late Tokugawa messages were often encased in witty and

22. For visual images of the massacre, see Yamada, *Kantō daishinsai-ji no Chōsenjin gyakusatsu*. See also Yamazaki, *Disasters, Rumors and Prejudice*.

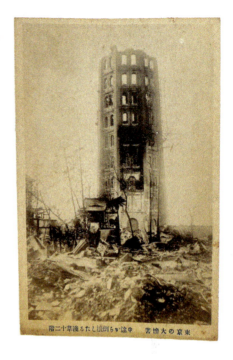

12.10. Ryōunkaku (Asakusa Twelve Stories) partially destroyed, postcard, 1923. Author's collection.

satirical texts, the 1923 postcards expressed meaning through their images. The photographs of collapsed buildings and fire-destroyed areas, famous monuments in ruins, piles of corpses and mounds of ashes, and fissures in the ground warned against the evils of excessive consumption, materialism, secularism, eroticism, and internationalism. Although the Taishō period (1912–1926) is often celebrated for its liberalism, resistance to modernity had deep roots. Like the 1855 Ansei prints, the 1923 disaster postcards carried a message of world renewal (*yonaoshi*)—a call to repudiate Western modernity and its values and to rebuild Japan anew.

Photographs of the Ryōunkaku, or Asakusa Twelve Stories, broken at the sixth-floor level, appeared in almost every set of earthquake postcards (fig. 12.10). Designed by the Scottish engineer William Burton (1856–1899), it was the second-tallest building in the world when opened in 1890 and a showcase of modern technology. As Weisenfeld explains, it was also the ultimate modern ruin: "Seeing such signature buildings in ruins suddenly made the unstoppable forward vector of

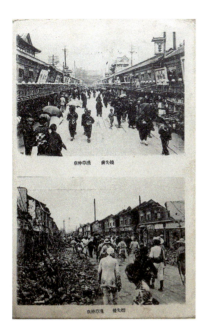

12.11. Asakusa before and after the earthquake, postcard, 1923. Author's collection.

the modern seem reversible."²³ Asakusa became the moral epicenter of the earthquake, shattering any confidence that tradition should be abandoned in favor of modernity.

Asakusa was epicenter in another regard: it was the heart of Tokyo's entertainment district, where money could buy hedonistic pleasures, traditional and modern. In addition to *rakugo* and *manzai* performance halls and high and low geisha establishments, Asakusa was known for its amusement park, game parlors, strip shows, motion picture theaters, and music halls where "modern boys and girls" danced to jazz. Images of the entertainment district burned to the ground sent a clear message: Japanese society had become degenerate and deserved divine punishment (fig. 12.11).²⁴ Shibusawa Eiichi (1840–1931), widely known as the father of Japanese capitalism, declared that the earthquake was heavensent retribution (*tenken*) for what he called the "tendencies in the economic world to pursue self-interest."²⁵

23. Weisenfeld, *Imaging Disaster*, 145.
24. Schencking, *The Great Kantō Earthquake*, 143.
25. "Tenkenron."

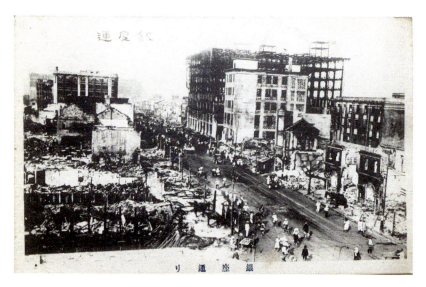

12.12. Ginza in ruins, postcard, 1923. Author's collection.

Another cause of the degeneracy was consumerism, especially of luxury and imported goods. Postcards showing fire-ruined department stores and luxury shops along the Ginza warned against crass materialism (fig. 12.12). Images of Nihonbashi, with Mitsukoshi department store in flames, were also in high demand.

Down the street from Mitsukoshi was Maruzen Bookstore (fig. 12.13), founded in 1869 by a disciple of Fukuzawa Yukichi. It was Japan's first Western-language bookstore and a symbol of Japan's Western-inspired civilization and enlightenment. Maruzen's fate could easily be interpreted as punishment for its role in spreading Western culture, the original sin that had brought on the *ero guro nansensu* (erotic grotesque nonsense) of the Taishō years.[26]

But the picture postcards could also send a positive message. The headless Great Buddha in Ueno Park conveyed perseverance in the face of adversity (fig. 12.14). The original Buddha was built in 1631 on the grounds of Kan'eiji, the Tokugawa family temple at Ueno. Damaged by recurrent earthquakes and fires, it was repeatedly rebuilt and repaired.

26. Silverberg, *Erotic Grotesque Nonsense*.

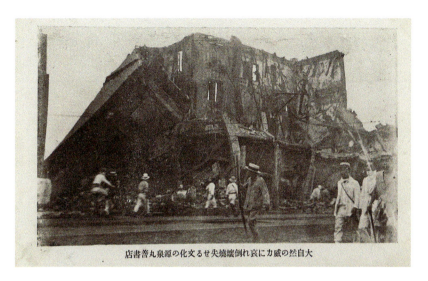

12.13. Maruzen Bookstore in ruins, postcard, 1923. Author's collection.

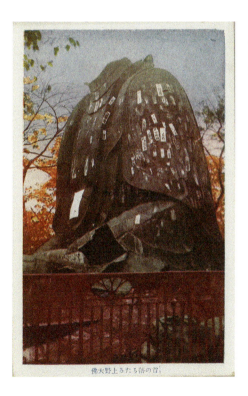

12.14. Headless Great Buddha in Ueno Park, postcard, 1923. Digital Collections, National Diet Library.

It was damaged by fire in 1841 and partially destroyed in the Ansei earthquake of 1855. In the 1923 earthquake, the Great Buddha lost its head, but still stood its ground. Notes pasted on its body asked for help in locating lost relatives and friends. In 1940, the body of the headless Buddha was melted down to support the war effort.

Conclusion

The picture postcards issued in the wake of the Great Kantō Earthquake offer unique insights into Japan's modern history. The gripping and realistic images were souvenirs of an existential experience and a means of communicating it to others. However, although appearing to depict simply what happened, the postcards also suggested interpretations. They can thus be situated not only in the moment that the earthquake struck or in the days that the fire raged but also in the political, social, economic, and cultural context of Japan in the early 1920s.

The Taishō period was one of unease and conflict in Japanese society. Tensions rose between the legacy of conservative authoritarian politics and growing demands for a more participatory democracy, between irrepressible desires for middle-class modernity and an equally irrepressible yearning to restore a disappearing past, and between the excitement of individualism and self-expression and criticisms of selfishness, hedonism, and greed.[27] In this context, the scenes of destruction shown in the earthquake postcards deepened anxieties about the trajectory of Japanese society. Like the catfish prints and disaster broadsheets that followed the Ansei earthquake of 1855, the postcards shook a society that was already under stress and urged a reconstruction and renewal that went beyond the rebuilding of roads, bridges, office buildings, and the places people called home.

The Great Kantō Earthquake was the last time picture postcards functioned as an important news channel in Japan, as other media diminished their importance.[28] The post-earthquake reconstruction of the printing and publishing industries provided an opportunity to

27. Silberman and Harootunian, *Japan in Crisis*.
28. Tanabe, "Media to shite no ehagaki," 81.

introduce the latest technologies, and the illustrated newspapers and magazines that resulted reached a mass audience. *Kingu* (King), a monthly general interest magazine founded in 1924, became the first magazine in Japan to sell over a million copies.[29] Radio broadcasting began in 1925, and the rebuilding of Tokyo stimulated the rapid spread of household telephone service. Picture postcards continued to be produced and sold, but as souvenirs of famous sights and commemorations of noteworthy events rather than as information channels. Postcards, created by leading artists and printed on quality paper, remained popular.[30]

Postcards were also collected as important visual records of times and places past. After witnessing the destruction of libraries, bookstores, and newspaper archives in the earthquake, Miyatake Gaikotsu recognized the need to collect and preserve paper media, including picture postcards. In 1927, he helped to establish Meiji Shinbun Zasshi Bunko at Tokyo Imperial University. Among its treasures is Miyatake's personal picture postcard collection of 340,000 cards arranged by theme, including scenes of disasters.

29. Marshall, *Magazines and the Making of Mass Culture*.
30. A. N. Morse, Rimer, and Brown, *Art of the Japanese Postcard*.

CHAPTER THIRTEEN

Looking Back on the Enlightenment: Kume Kunitake and World War I

This chapter offers a perspective on the course and consequences of Japan's pursuit of civilization and enlightenment through the reflections of Kume Kunitake, historian and observer of Japan's modern transformation from the early 1870s into the late 1920s. On the tenth anniversary of the Iwakura Mission Society in 2006, I spoke about Kume Kunitake's discovery of history during his travels to Europe and America as a member of the Iwakura Mission.[1] *Ten years later, as I was about to retire from teaching, I spoke at the society's twentieth-year event on Kume's reflections on those early foreign travels.*[2]

Kume is well known as the private secretary to Iwakura Tomomi and compiler of the Iwakura Mission's journey of observation, published in 1878. That record reflects Kume's excitement with what he had seen and for the possibilities that lay before Japan. This chapter draws on a series of articles Kume published during and after World War I and on his autobiography, written to commemorate his ninetieth birthday.[3] *In these later writings, the acknowledged elder statesman of Japanese history reflected that during his long life he had witnessed one of the most interesting acts in world history—the transition to industrial modernity. From the vantage point of World War I, however, Kume expressed his concern that the civilization he had helped to introduce to Japan contained the seeds of war and destruction. Looking back on the Meiji Restoration, Kume concluded that the desire for civilization and enlightenment and the promotion of wealth and power were the*

1. Steele, "Nihon no bunmei kaika no hikari to kage."
2. Steele, "*Bei-Ō kairan jikki*."
3. For a version of this chapter, see Steele, "Bunmei kaika o kaerimireba."

same thing. He doubted that the emerging post-World War I international order could preserve an enduring peace.

Kume Kunitake is probably best known as the author of the monumental five-volume account of the Iwakura Mission, a diplomatic voyage to the United States and Europe conducted by leading statesmen and scholars between December 23, 1871 and September 13, 1873.[4] With only one week's notice, Kume, a thirty-two-year-old Confucian scholar from the former Saga domain in northern Kyushu, had been assigned to accompany the mission as personal secretary to Iwakura Tomomi, court noble and leader of the mission.[5] For nearly two years, Kume traveled alongside Iwakura, taking notes on which to base his record of the remarkable journey (fig. 13.1). The experience challenged his Confucian world view, transforming him into a leading authority on all things Western, and led to a productive and sometimes controversial career as archivist and professional historian. When he died in 1931 at the age of ninety-three, Kume was known as "the elder statesman of Japanese history."[6]

The main goal of the Iwakura Mission was to open negotiations to revise the unequal treaties that had been imposed on Japan by Western nations since the late 1850s. A second, related goal was to obtain firsthand information about the West in order to implement the wide-ranging reforms necessary to elevate Japan's standing in the world as civilized and committed to progress. Itō Hirobumi, head of the newly established Ministry of Industry and future prime minister, expressed Japan's determination in a speech in San Francisco, the mission's first stop:

4. On the Iwakura Mission, see Tanaka Akira, *Meiji ishin to seiyō bunmei*; Mayo, "Rationality in the Meiji Restoration"; Soviak, "On the Nature of Western Progress"; Nish, *The Iwakura Mission*.
5. On Kume, see Ōkubo, *Kume Kunitake no kenkyū*; Takada, *Kume Kunitake*; Kondo, "Kume Kunitake as a Historiographer"; Mayo, "The Western Education."
6. "Kume Kunitake hakushi yuku," 11.

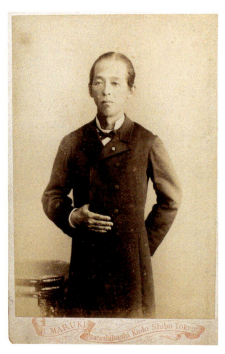

13.1. Kume Kunitake (c. 1872), at the time of the Iwakura Mission. Kume Museum of Art.

As Ambassadors and as men, our greatest hope is to return from this mission laden with results—valuable to our beloved country and calculated to advance permanently her material and intellectual condition.... Your modern inventions and result of accumulated knowledge enable you to do more in days than our fathers accomplished in years. Time, so condensed with precious opportunities, we can ill afford to waste. Japan is anxious to press forward. The red disc in the center of our national flag shall no longer appear like a wafer over a sealed empire, but henceforth be in fact what it is designed to be, the noble emblem of the rising sun, moving onward and upward amid the enlightened nations of the world.[7]

The leaders of new Japan investigated the institutions and values of the West systematically, touring government institutions, military facilities,

7. Lanman, *The Japanese in America*, 13–15. The speech is reproduced in Walthall and Steele, *Politics and Society*, 149–51. For the Japanese version, see Takii, *Itō Hirobumi enzetsu shū*, 13–15.

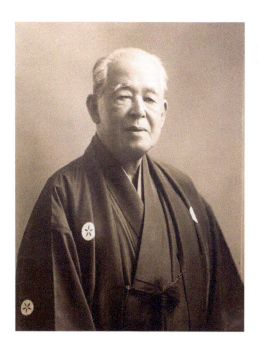

13.2. Kume Kunitake in 1927 at the age of eighty-eight. Kume Museum of Art.

factories, hospitals, mines, schools, libraries, and museums. Home-stay opportunities were arranged to allow glimpses into private as well as public aspects of Western culture and society. And for Kume Kunitake, this overseas experience constituted his "Western education," allowing him to explain the outside world to his fellow Japanese.[8]

Thanks to his remarkable record, we know much of what Kume saw and thought about the West during and immediately after the Iwakura Mission. Although he did not romanticize the West, he came to understand and respect its ideals, and he envisioned the possibility of a Japanese model of civilization and enlightenment based on careful planning, hard work, and intelligent decision-making. But fifty years later, after Japan had achieved great power status and had participated in World War I as an ally of the Entente Powers, how did Kume assess the results of this endeavor? How did his understanding of civilization change as Japan moved "onward and upward amid the enlightened nations of the world"? This chapter focuses on the older Kume (fig. 13.2)

8. Mayo, "The Western Education."

and how he looked back on his travels in America and Europe in the early 1870s. The conclusion shows Kume, disillusioned by the horrific results of the so-called Great War, looking to Japan's pre-1868 past, to the time before Japan opened to the West, as inspiration toward a more peaceful future.

Kume and the Discovery of History

Kume's experiences in the United States and Europe from January 1872 to July 1873 were instrumental in awakening him to the study of history.[9] Unsurprisingly, given its aim, members of the Iwakura Mission observed and marveled at the latest advances in Western industry, government, and society. But Kume was also fascinated by what was old: ancient buildings, historical sites and monuments, and history museums and exhibition halls. He realized that nothing in Japan compared with the Smithsonian Institution in Washington, DC, the British Museum and Crystal Palace in London, or the Conservatoire national des arts et métiers in Paris.

Museums, especially, were places where people learned about the past—and could see how the past informed the sweep of human progress toward civilization and enlightenment. Kume described his visit to the British Museum in September 1872 as an introduction to the stages of human history: from the Pyramids of Egypt, through the Greeks and Romans, the Enlightenment, to the Industrial Revolution:

> When one looks at the objects displayed in its museums, the sequence of stages of civilization through which a country has passed are immediately apparent to the eye and are apprehended directly by the mind. No country has ever sprung into existence fully formed. The weaving of the pattern in the nation's fabric is always done in a certain order. The knowledge acquired by those who precede is passed on to those who succeed; the understanding achieved by earlier generations is handed down to later generations; and so we move forward by degrees. This is what is called "progress."[10]

9. Steele, "Nihon no bunmei kaika no hikari to kage."
10. Kume, *The Iwakura Embassy*, 2:109–10.

Kume referred often to the importance Western people placed on history and tradition. After visiting a silk-weaving factory and a watch factory in Coventry, the county town of Warwickshire, the Japanese visitors were taken to see St. Michael's church, built five hundred years earlier, and to the town hall across the street, itself six hundred years old. They were greeted by the mayor, who wore civil state dress and was accompanied by mace-bearing attendants in long, sweeping robes. The events of the day led Kume to conclude: "Westerners daily strive after new things, but also constantly keep ancient things in mind and love what is old, preserving it and not discarding it. This is truly a civilized usage."[11]

When the Mission toured the Bibliothèque nationale in Paris in January 1873, Kume was again impressed with the importance placed on preserving the past. The contrast with Japan came to mind:

> Ever since news of the great progress made by the West arrived in Japan, impetuous individuals have tripped over themselves in a headlong rush to throw out the old and bring in the new. These so-called innovations, however, are not necessarily always beneficial and lead to the destruction and loss of many old ways which are actually worth preserving. How can this be called progress?[12]

Musing on the Roman-inspired Arc de triomphe from his accommodation in Paris, he wrote: "At the root of the march of progress in the West is a profound love of antiquity. . . . It is the accumulation of knowledge over hundreds and thousands of years which gives rise to the light of civilization."[13] In May, after a visit to the Venice city archives, Kume confirmed the connection between preservation of the past and progress toward civilization: "In the West, they have museums where they keep even the most insignificant objects and libraries where they store even discarded scraps of paper. This can be seen as the essence of civilized behaviour."[14]

11. Kume, *The Iwakura Embassy*, 2:363.
12. Kume, *The Iwakura Embassy*, 3:59.
13. Kume, *The Iwakura Embassy*, 3:60.
14. Kume, *The Iwakura Embassy*, 4:352–53.

Kume's encounter with the march of human progress necessarily raised the question: why is Japan different and to what extent should Japan change? Kume's response set an agenda for Japan:

> Perhaps it is because we are still insufficiently educated. We do not record the useful things which people have said and done and pass them on. We do not make a record of the advances made in the past and in the present and ensure that they are heard of. We do not stimulate the sense of sight through museums. We do not introduce new things through exhibitions. To excuse ourselves by saying that it is because we are of a different habit of mind is not an honest argument.[15]

And yet it was not too late. Kume came to realize that the flourishing condition of Europe was a recent achievement: "The vast difference between the appearance of Europe now and that of Europe of forty years ago can be imagined. No railway trains traversed the land; no steamship plied the oceans; no messages were sent by telegraph."[16] Kume learned that industry and commerce had been stimulated by the taste for luxury items in the court of Louis XIV. From Paris, once the center of civilization, new technologies and ways of thinking had spread through Europe, to America, and to Japan. Adopting the new ways, however, did not meaning casting off unique traditions:

> Britain was the first country to discover its own individual style in the industrial arts and to show that the crafts of countries other than France were worthwhile. This gradually brought about a dawning awareness in the peoples of other countries, and the industrial arts in Europe are now so to speak, an orchard in which many different trees from every country blossom in profusion, filling the air with fragrance.[17]

Kume, trained as a Confucian scholar, returned to Japan in September 1873, convinced of the need to develop a similar sort of love

15. Kume, *The Iwakura Embassy*, 2:111.
16. Kume, *The Iwakura Embassy*, 3:59–60.
17. Kume, *The Iwakura Embassy*, 2:60.

and respect for history. Movement along the path of progress pioneered in the West was imperative, but it was equally important to preserve the fragrance of Japanese traditional culture.

Kume as Historian

Kume spent several years compiling the official record of the Iwakura Mission while employed in the records section of Japan's Council of State, the Dajōkan. The five-volume *Tokumei zenken taishi Bei-Ō kairan jikki* (translated as *A True Account of the Ambassador Extraordinary & Plenipotentiary's Journey of Observation through the United States of America and Europe*), hereafter *Kairan jikki*, was published in 1878.[18] One year later, Kume was transferred to the Bureau of Historical Compilation, a forerunner of the present-day Historiographical Institute located in the University of Tokyo (chapter 7). His main assignment was to help prepare a definitive history of Japan that would bring to completion the *Dai Nihon shi* (History of great Japan), begun by scholars of Mito domain in the seventeenth century.[19] The projected work had been given the title *Dai Nihon hennenshi* (Chronological history of great Japan), and following the tradition of the Six National Histories, the earliest histories of Japan compiled at imperial order during the eighth and ninth centuries, the *Dai Nihon shi* was to be written in classical Chinese (*kanbun*). Writing began in 1882 under the direction of Shigeno Yasutsugu (1827–1910), a historian and scholar of Chinese learning.

Looking to established traditions of archival practice as well as on newer Western historiography, Shigeno's team aimed to compile a history based upon primary documents and verifiable facts.[20] From 1885, members conducted extensive field trips to survey and collect documents.

18. Kume, *Tokumei zenken taishi Bei-Ō kairan jikki*, in Tanaka Akira, ed., 5 vols. For the complete translation, see Kume, *The Iwakura Embassy*, 5 vols.
19. Matsuzawa, *Shigeno Yasutsugu to Kume Kunitake*; Mehl, "Scholarship and Ideology in Conflict," 339–40; Hyōdō, "Rekishi kenkyū ni okeru 'kindai.'"
20. Matsuzawa, *Shigeno Yasutsugu to Kume Kunitake*, 31–65; Mehl, "The European Model and the Archive," 115–17.

Shigeno collected more than 8,089 documents and 767 books in an eighty-one-day trip conducted through six Kantō prefectures that year; from July to December 1887, Kume traveled through all seven Kyushu prefectures in search of materials. By 1888, the Bureau had amassed some 67,000 documents and 7,800 books.

Through their scrutiny of documents, both Shigeno and Kume had come to doubt the accuracy and objectivity of the *Dai Nihon shi*, the very work their history was to complete. They pointed to its reliance on historical tales rather than on documents and especially on the selective use of legends and fictitious characters drawn from the *Taiheiki* (Chronicle of great peace). In a March 1885 report to his colleagues at the Bureau, Kume argued that the advance of historical scholarship demanded a break from the "vile practices" (*heifū*) of historical tales, especially the *Taiheiki*.[21] One year later, Shigeno attracted much criticism after a speech at the prestigious Tokyo Academy in which he declared the *Dai Nihon shi* to be simply "the personal and biased views of one family."[22]

In 1888, the Shūshikan was transferred to the Imperial University and, in addition to their compilation duties, Shigeno and Kume were appointed university professors. One year later, they were appointed to the newly established department of Japanese history. Along with Ludwig Reiss (1861–1928), a German historian who taught in the department of Western history between 1887 and 1902, they worked to establish a historiography based on empirical evidence, quantitative analysis, and textual criticism. In 1889, this group of three established the Historical Society of Japan (Shigakukai), and its journal, *Shigaku zasshi*.

The attempt to distinguish fact from fiction, however, proved controversial.[23] In a five-part article published in *Shigaku zasshi* in 1891, Kume declared that the *Taiheiki* was useless (*eki nashi*) for historical scholarship.[24] Another article published in the same year urged

21. For the text of the report, see Kume, "Rekishigaku no susumi."
22. Hyōdō, "Rekishi kenkyū ni okeru 'kindai,'" 258.
23. Mehl, "Scholarship and Ideology in Conflict," 341; Zhong, "Formation of History as a Modern Discipline."
24. Kume, "Taiheiki wa shigaku ni eki nashi."

students of history to present facts rather than moral teachings: "Let us see history purged of the old usages of exhortation."[25] These writings were a prelude to Kume's critique of Shinto mythology. In "Shintō wa saiten no kosoku" (Shinto is an ancient heaven-worshipping custom), an article published in three installments of *Shigaku zasshi* in late 1891, he asserted that Shinto was not a religion but the remains of an ancient heaven worship.[26] His argument, in effect, questioned the underpinnings of the Japanese imperial institution. In January 1892, Taguchi Ukichi (1855–1905), a leading proponent of the "history of civilization" school (chapter 7), republished Kume's article in his popular history journal *Shikai* (Sea of history). He expressed his support for Kume's argument and challenged Shinto supporters to respond. The torrent of negative comment that followed eventually led to Kume's dismissal from the Imperial University in March 1892.[27] In 1893, work on the *Dai Nihon hennenshi* was stopped on the grounds that it had wasted money and time and that a history written in classical Chinese was no longer appropriate.

Following his dismissal, Kume taught briefly at St. Paul's College (present-day Rikkyo University). In 1899, at the invitation of Ōkuma Shigenobu, a friend from his youth in Saga domain, he took up an appointment at the school that would become Waseda University teaching history and archival studies. He continued to publish monographs in ancient and medieval Japanese history with a focus on physical geography and the history of transportation and communications. He retired from teaching in 1918 but remained affiliated with Waseda until 1922, his eighty-fourth year. In his later years, Kume also wrote commentaries on current affairs that included reflections on his experiences in the West as recorded in the *Kairan jikki*. He began work on his autobiography in 1928, his ninetieth year, and completed it with the help of assistants; it was published in 1934, three years after his death.

25. Kume, "Kanzen chōaku no kyūshū."
26. Kume, "Shintō wa saiten no kosoku."
27. Mehl, "Scholarship and Ideology in Conflict," 348; Matsuzawa, *Shigeno Yasutsugu to Kume Kunitake*, 72–74; Zhong, "Formation of History as a Modern Discipline," 14–17. For a contemporary account, see "Monthly Summary of the Religious Press."

Looking Back

For some social and cultural critics, World War I was so widespread, so destructive, and so dependent on powerful new technologies that it marked a turning point—and a turn for the worse—in human history. Even in the opening days of the war, the American-born British novelist Henry James (1843–1916) expressed his horror at "the plunge of civilization into this abyss of blood and darkness."[28] And as the war drew to an end in the summer of 1918, the historian Oswald Spengler (1880–1936) published his influential *Decline of the West*. In China, the aged Yan Fu (1854–1921) renounced his earlier advocacy of Western liberal individualism: "As I have grown older . . . I have come to feel that Western progress during the last three hundred years has only led to selfishness, slaughter, corruption and shamelessness."[29] In Japan, too, opinion leaders of all persuasions, including the journalist Tokutomi Sohō (1963–1957), the politician Gotō Shinpei, and the cosmopolitan thinker Kayahara Kazan (1870–1952), expressed fears that civilization, especially Western material civilization, was heading in the wrong direction.[30] The bright civilization that was eagerly imported into Japan turned out to have a dark side characterized by militarism, materialism, and hedonism.

Looking back over the forty years since he had introduced the West to Japan in his *Kairan jikki*, Kume Kunitake was inclined to agree. A 1920 article he published in *Rekishi chiri* (Journal of history and geography) was ominously titled "Seiyō busshitsu kagaku no ikizumari" (Western material science at a dead end).[31] Instead of a creative force bringing people together, Kume claimed, Western technology was responsible for creating weapons of mass destruction and unprecedented carnage in war. He explained his dismay in an article written in 1919, in the war's aftermath:

28. Quoted in Hutchison, *Henry James's Europe*, 61.
29. Quoted in Mishra, *From the Ruins of Empire*, 212–13.
30. Tokutomi, *Sekai no henkyoku*; Gotō, "Daisensō go no shinbunmei"; Kayahara, "Shinbunmei no daitanjō." See also Baryshev, "Dai-ichiji sekai taisen-ki."
31. Kume, "Seiyō busshitsu kagaku no ikizumari."

In recent years, Western advances in technology have become increasingly destructive. Nature has been destroyed, and things must be made artificially. Moreover, vast amounts of money and labor have been used to produce weapons of war. The competition to invent cruel machines, in the end, brought on the Great War. Attacked from the skies and from the depths of the ocean, several million young men died before these machines. They became human bullets, and their corpses piled up. Hearing reports of this cruel war made people shudder in fear, and even though hostilities ceased at the end of last year after five long years, they have been made to doubt the existence of a god in heaven.[32]

In his autobiography, Kume reviewed the changes in his lifetime that had brought Japan and the world to this dead end. As a historian and an eyewitness to history, he had experienced one of the greatest transformations in Japanese history, and even world history. In his first thirty years, Japan had been closed to the West, a small and secluded speck on planet Earth; during his second thirty years, Japan had centralized its government and developed industrial and military prowess, becoming one of the great powers of the world. In his most recent thirty years, Japan had worked to maintain and secure world peace: "The period of my life has been the most interesting one in all of history. If history were a stage play, I have witnessed the most interesting act, and as there are many different seat levels in a theater, I was privileged to see the play from a first-class seat."[33]

Kume outlined events of the first thirty years of his life in the first volume of his autobiography. He described the emergence of global history in the transition from an age of nations focused on domestic issues to an age characterized by interactions among peoples of the world:

America was established sixty-two years before I was born. That was the time when Washington fought a war of independence, and the American Declaration of Independence was proclaimed. Afterward, change speeded up remarkably throughout the world, ushering in a new age in

32. Kume, "Rekishi yori mitaru sekai," 60.
33. Kume, *Kume hakushi kyūjūnen*, 1:3–4; Mayo, "The Western Education," 18.

world history. What was the cause? None other than the invention of new sources of power by the countries of the West. This resulted in extraordinary advances in communications and transportation. . . . In 1783, fifty-seven years before I was born, the world's first miniature steamship was made in France. This technology was gradually improved and made practical, and around the time I was born, steamship travel across the oceans of the world became possible. Japan and China; and Japan, China, and Europe; and the countries of Europe and America could no longer remain separate. Steam travel helped to bring about a great world transformation.[34]

Kume devoted the second volume of his autobiography to his experiences in Europe. In contrast with the narrative focus of the 1878 *Kairan jikki*, the reflections he dictated some fifty years later stressed Kume's personal encounter with civilization (*bunmei*). He recalled with satisfaction that the tour of the United States and Europe had allowed him to ride on trains and visit factories, hospitals, schools, government buildings, and museums. He had seen the West at its best, home to the most advanced technologies in the world. But Kume also recalled that he had seen real problems connected with this Western civilization. Progress had made some wealthy, but it had also created social and economic problems for the disadvantaged. Kume had seen industrial slums, poverty, open sewage flowing into rivers, and inhumane treatment of prisoners.[35] He had seen discrimination against Black people, who were once enslaved, and against Native Americans, whose lands had been taken from them.[36] He had seen the scars of the American Civil War, and at Arlington National Cemetery, he had solemnly mused over graves of fallen soldiers, stretching out as far as the eye could see.[37] He had been perplexed by the open displays of affection between men and women.[38]

Civilization, Kume noted in his autobiography, had two sides: "After the Restoration, I came to know civilization as a grand spectacle,

34. Kume, *Kume hakushi kyūjūnen*, 1:2–3.
35. Kume, *Kume hakushi kyūjūnen*, 2:284–86, 417–19.
36. Kume, *Kume hakushi kyūjūnen*, 2:213, 238–42.
37. Kume, *Kume hakushi kyūjūnen*, 2:265–66.
38. Kume, *Kume hakushi kyūjūnen*, 2:251–54.

but I also discovered that civilization and enlightenment contained within it many dangerous side effects."[39] Walking the streets of the poorer sections of London and other cities, Kume had been constantly surprised by the number of beggars and homeless people. He had expected people in the West to always wear shoes but was struck speechless at the sight of the destitute wandering the streets of London in bare feet: "What I saw in London was like the proverbial 'night parade of one hundred demons.'"[40] He had witnessed the "underside of civilization" (*bunmei no uramen*).

Even more dangerous than economic inequality was the Western emphasis on military strength and the endless competition to develop powerful killing machines. He described militarism (*gunkokushugi*) as the central feature of civilization as it had developed in the West, and most fully in Germany under Otto von Bismarck (1815–1898). In a 1914 article titled "Ōshū senran ni tsuki yo ga jissen rekishi no kaikan" (Reflections on the war in Europe based on my historical experience), he wrote that the war had been inevitable: "For the past ten years, while talking about peace and civilization, European countries have been preparing for war. Year after year, they devoted millions in tax revenues primarily to the manufacture of guns, battleships, and all manner of killing machines and to horrifying schemes to devise ways to project explosive shells through the skies and under the ocean. Instead of caring for the lives of their people, they have spent money on their militaries."[41]

Kume also claimed that, despite predictions by others of German victory, he had been certain of its defeat. In his 1920 article on the dead end of science in the West, he described Germany as the monster child of the scientific revolution, seeking mastery over the forces of nature.[42] Such hubris, Kume declared, had been its undoing. Like the ambitious and autocratic King Ling of Chu (r. 540–529 BCE) in the *Spring and Autumn Annals*, the German Kaiser had not only relied on military might but had also called upon heaven to support his cause; indeed,

39. Kume, *Kume hakushi kyūjūnen*, 2:421.
40. Kume, *Kume hakushi kyūjūnen*, 2:421–22.
41. Kume, "Ōshū senran ni tsuki," 29.
42. Kume, "Seiyō busshitsu kagaku no ikizumari," 6–7.

Kume wrote, he had identified himself as a god. Such arrogance had not gone unpunished.

As a professional historian, Kume sought, moreover, to provide a historical background to events such as the outbreak of the Great War. In his 1914 reflections on the war in Europe, Kume traced the development of militarism in Germany over sixty years. He recalled that his father, a Saga samurai official stationed in Nagasaki, had told him in 1854 that Prussia was reputed to be a country that loves war.[43] Twelve years later, Prussia had used a new weapon in its war against Austria: the Dreyse needle gun, a breech-loading rifle, had revolutionized warfare by allowing soldiers to fire five or more shots in the same time that an enemy could reload a muzzle-loading rifle. Following unification under Bismarck and victory against France in 1871, Germany gained a reputation as the strongest country in Europe. Finally, Kume related his experiences in Germany in 1873 as part of the Iwakura Mission, reproducing the summary of Bismarck's speech that had been included in the *Kairan jikki*.[44] Bismarck warned the Japanese delegation to be careful of the colonial ambitions of England and France. His advice to Japan was to build up its military strength quickly, following the example of Germany, a formerly small country that had become one of the great powers of the world. In 1878, Kume had reported that the Japanese envoys were impressed, feeling that "these were significant words indeed, and we relished our chance to learn from the prince's eloquent words."[45] By 1914, however, Kume concluded that this type of militaristic thinking had led only to the outbreak of war. He offered a warning to his Japanese readers: "Since Japan has a history of learning from Germany, we must be extremely careful not to earn the enmity of England, France, Russia and America."[46]

43. Kume, "Ōshū senran ni tsuki," 31.
44. Kume, "Ōshū senran ni tsuki," 32–35. For Bismarck's speech, see Kume, *The Iwakura Embassy* 3:323–25.
45. Kume, *The Iwakura Embassy* 3:324–25.
46. Kume, "Ōshū senran ni tsuki," 46.

Looking Forward (and Back at the Same Time)

Through the end of the war, Kume remained convinced that victory over Germany would ultimately lead to peace. When Prime Minister Ōkuma Shigenobu declared war on August 23, 1914, and sent a force of twenty-three thousand troops to seize the German leasehold in Shandong, Kume expressed approval—and not simply because of his close ties to Ōkuma. In a two-part history of Shandong, published in January and February 1915, Kume argued that Japanese control of the former German possession, as outlined in Group One of the Twenty-One Demands, would secure peace and security in China:

> We cannot overlook the strategic importance of Shandong.... Throughout history, this area has been key to peace in China. Now, however, the [Chinese] people are weakened and unable to sustain resistance. Indeed, they are beset by foreign intrusions, and the country is about to carved up like meat on a chopping block. In this situation, how can the foreign powers contribute, even slightly, to the preservation of China's integrity? Since we [Japanese] have recently completed our mission to liberate Qingdao from the Germans, we must now exert ourselves to occupy this area entirely for the sake of China's peace and security.[47]

When the armistice was signed on November 11, 1918, Kume looked forward to worldwide peace. His New Year's poem for 1919 expressed optimism for the future:

Blessed with happiness and good fortune
Standing before Fuji's majestic peak, I fear not the cold
 But yearn for the dawn of a world of peace and brotherhood.[48]

Moreover, in his essay "Rekishi yori mitaru sekai no heiwa" (World peace seen from history), published in September 1919, Kume affirmed

47. Kume "Heiwa hoshō no Santō rekishi," pt. 2, 151. See also Elleman, *Wilson and China*.
48. Kume, "Rekishi yori mitaru sekai," 61.

the righteousness of the Allied victory: "Those who follow heaven prosper; those who oppose heaven perish."[49]

In the same essay, however, Kume's discussion of the Paris Peace Conference reflected an emerging pessimism. Already, the rejection by the United States and Britain of the Japanese proposal to include a clause on racial equality had cast suspicion on the ideals of international cooperation and self-determination those countries professed.[50] Kume came to doubt that the victors would be able to secure a lasting peace.

> To ensure that there will never again be another such catastrophe, there was a proposal to create the League of Nations and to agree on the conditions for securing a lasting peace based on humanity and justice. By nature, I have a deep hatred of war, and I hold fervent hopes that it will be abolished. However, there are rats in every house, thieves in every country, and international aggression never ceases. I am therefore resigned, based on the record of history, to accept that abolishing war is an impossible proposition for humanity.[51]

Kume explained his pessimism by identifying spiritual and physical differences that separated the countries and regions of the world, and especially what he termed the "Far West" and the "Far East." Historically, he argued, rulers in the Far West derived their power from wealth, religion, and military might; the "absolute opposite" was true in the Far East, where cooperation, self-sufficiency, and following the will of heaven formed the basis of governance. Kume was also concerned by the anarchy he saw in the vast area that extended between West and East: Russia was in the throes of revolution, and China was struggling to create order out of chaos. Given these challenges and the predisposition of Western countries toward military solutions, Kume concluded that the fine ideals of the Covenant of the League of Nations were at odds with political and geographic realities.

Kume's disenchantment with Western civilization encouraged him to reevaluate the Japan that had existed before its opening to the world

49. Kume, "Rekishi yori mitaru sekai," 60.
50. Shimazu, *Japan, Race and Equality*.
51. Kume, "Rekishi yori mitaru sekai," 60.

in the mid-nineteenth century. He described this idealized past in a 1921 essay titled "Meiji no bunmei kaika" (Meiji civilization and enlightenment)."[52] The Tokugawa period, Kume maintained with obvious nostalgia, had been one of great peace, cultural richness, and happiness. He paraphrased a recent speech by American president Warren G. Harding (1865–1923): "Our country has developed over the past 130 years to be the leader of the world and the country with the highest level of civilization. America is now taking the lead to bring an end to warfare and establishment world peace."[53] Japan, too, wrote Kume, had developed its civilization over the past 130 years. In particular, the forty years from the beginning of the Kansei era (1789–1801) until the end of the Bunsei era (1818–1830) marked the epitome of peace and prosperity, in stark contrast to the constant warfare that characterized Europe at roughly the same time.

Kume argued that the bushido tradition on which Tokugawa society was founded could not be compared with the goals of military preparedness in the West:

> The character for the word "warrior," 武 (*bu*), is made up of two parts, one meaning "to stop" (止) and the other meaning "halberd" or "arms" (戈), making the intent of the word "to bring military strife to an end." In the West, the survival of the fittest is recognized as the true nature of society, and the principle stressed is that military preparedness is for the purpose of winning in that competition. Therefore, until now, it was felt that working to preserve international peace was extremely dangerous. Eventually, this way of thinking expanded into militarism, and the unprecedented, senseless Great War erupted with extreme levels of casualties and unprecedented physical destruction.[54]

In the *Kairan jikki*, the young Kume had written with muted approval of the displays of military preparations shown to the visiting Japanese: "It was as though each government saw it almost the whole

52. Kume, "Meiji no bunmei kaika."
53. Kume, "Meiji no bunmei kaika," 194–95. For the original speech, see "Address of President Harding at Lancaster, N.H., August 4, 1921."
54. Kume, "Meiji no bunmei kaika," 194.

of its duty to make a show of the nation's prestige and a display of its military strength. . . . Although they have reached such an advanced state of civilization, Europeans still compete in this way in military preparedness. . . . This is the reason civilized countries have standing armies."[55] With the outbreak of World War I, Kume's views darkened. Militarism defined Western civilization; instead of the law of nations, the guiding principle was force. Indeed, he recalled that during his travels with the Iwakura Mission, people in England spoke constantly about "enlightenment" and "civilization" but insisted on showing them factories that made guns, cannon, and warships alongside spinning mills and steam engines.[56] Kume came to believe that emphasis on military preparedness, for better or worse, constituted the essence of the civilization he had helped to introduce into Japan in the early Meiji era:

> Amid the confusion of the two words "civilization" (*bunmei*) and "culture" (*bunka*), the trend over the years was for Japan to compete in trade and industry and, by establishing the means for a wealthy country and strong army (*fukoku kyōhei*), to secure military preparedness in guns, cannon, and warships. We engaged in war with China and then with Russia, and finally joined the maelstrom of war in Europe. After destroying the root of militarism, Japan has become one of the five great powers, thus realizing our ambition of more than one hundred years. Now, as though after a typhoon has passed, there are calls to preserve peace and rid the world of war. We can hear voices of hope that the weather will recover.[57]

55. Kume, *The Iwakura Embassy* 2:88–89.
56. Kume, "Meiji no bunmei kaika," 203.
57. Kume, "Meiji no bunmei kaika," 204. Sun Yat-sen (1866–1925), visiting Japan in 1924, came to a similar conclusion. See Mishra, *From the Ruins of Empire*, 213–14.

Conclusion

During the 1920s, people in and out of government aspired to define Japan's place in the international order that had emerged after World War I. Shidehara Kijūrō, Japanese foreign minister for much of the 1920s, was committed to economic internationalism and a diplomacy based on cooperation with the United States and peaceful coexistence with China.[58] Within the military, however, many argued for a more unilateral approach that included strengthening Japan's military and securing control over Manchuria. Outside of the government, in 1919, Kita Ikki (1883–1937) issued his plan for a form of socialism from above; in that same year, Ōkawa Shūmei (1886–1957) joined Kita in founding the Yūzonsha, a political club promoting pan-Asianism. The Russian Revolution of 1917 inspired workers and intellectuals to dream of a communist revolution; Wilsonian democracy inspired others. Mushanokōji Saneatsu (1885–1976) tried to create a "new village" to restore a sense of community.[59]

Kume did not engage actively in these debates, though his position was closest to that of Shidehara. He had long looked forward to an era of justice and peace, and despite his expressed disenchantment with Western civilization, he continued to believe in international cooperation and the success of the League of Nations. His opposition to war and unilateralism, however, was not absolute, as had been shown in his earlier support for the Japanese occupation of Shandong. In some instances, Kume argued that war could contribute to peace (*heiwateki sensō*), reflecting the complexities and ambiguities of Japan's interactions with the outside world. His 1923 article on the long history of Sino-Japanese relations was written in response to growing tensions between the two countries. His solution, however, was no more than to urge both countries to reflect on their long history of peaceful trade and diplomacy before nineteenth-century Western intrusion.[60]

58. Iriye, *Japan and the Wider World*, 50–57.
59. Silberman and Harootunian, *Japan in Crisis*; Dickinson, *World War I*.
60. Kume, "Nisshi kankei mondai no gairon."

Kume, moreover, was mindful of the dangers of excessive economic competition and found a more appropriate inspiration for Japan's future in its past. He celebrated the spirit of harmony as reflected in the thought of Shōtoku Taishi (574–622) and praised what he saw as the great peace (*tenka taihei*) that had characterized Japan before its contact with the West. He stressed the importance of international economic regulation in an article written in 1922:

> In the recent Great War in Europe, the entire world was shaken with horror. Although fervent cries for peace emerged from its depths, they can be amply explained as the desire to promote foreign trade. In any case, commerce is simply the competition for profit and can be called "peacetime war." Since it is liable to lead to a rupture in international relations, it may unreservedly be seen as a cause of the recent war. However, can we not conclude that desiring peace but competing in foreign trade is like hating to be drunk but insisting on drinking wine? If we really seek peace, is there not rather a necessity to apply restrictions according to the Covenant of the League of Nations, setting up methods to control international transactions with the tariffs of each country?[61]

For Kume, the policies of the Tokugawa period offered an example to the contemporary world. He argued that *sakoku*, though literally "closed country," was in fact a positive policy that, by regulating foreign trade and restraining competition, had produced a period of peace that was unprecedented in world history.[62]

During the final years of his life, Kume saw nothing to quell the underlying anxiety he felt about the state of the world. His autobiography echoed his disquiet about the West's strong attachment to guns and the military: "Western civilization is, in essence, the civilization of guns. Seduced by these machines, Western nations have unreasonably forced their will upon other countries, occupied their lands, and used unequal treaties to secure unjust profit in trade. Such has been the

61. Kume, "Kokushijō ni yori mitaru," 26.
62. Kume, "Kokushijō ni yori mitaru," 22–27.

basis of European prosperity over the past century."[63] By idealizing the Japanese past and locating the problem of militarism in the West, was Kume simply ignoring the signs of Japanese military expansion in Asia? Coming just seven months before the Manchurian Incident of September 18, 1931, his death on February 24, 1931 spared him the necessity to rethink his world view yet again.

63. Kume, *Kume hakushi kyūjūnen*, 2: 490–91.

EPILOGUE

Ambiguous Pasts and Unknowable Futures

On January 1, 1931, *King*, a popular and best-selling monthly magazine, published *Meiji Taishō Shōwa dai-emaki* (The great picture scroll of the Meiji, Taishō, and Shōwa eras), a supplement to its New Year's issue.[1] The scroll was an illustrated chronology of modern Japanese history, covering the years 1868 to 1930, roughly the same time frame as the chapters in this book. Like the Kaei chronicle of the years 1853 to 1868 introduced in chapter 2, the *King* chronology includes illustrations and text for one or more major events each year as well as a list of lesser events, all presented in calendrical order. More ambitious than the earlier work, however, the *King* chronology was published as an accordion-style book of 152 pages that could be unfolded and displayed as a picture scroll. The artwork for each year was done by a leading artist or illustrator; a team of professionals, including historian Osatake Takeki (1880–1946) and architect Itō Chūta (1867–1945), served as advisers. The editors' stated aim was "to produce a great and interesting illustrated history of the Meiji, Taishō, and Shōwa eras from a great variety of viewpoints" in the hope that

1. For an online reproduction, see TSP, "Meiji Taishō Shōwa dai-emaki." See also Marshall, *Magazines and the Making of Mass Culture*, 156–60.

"our readers not only reflect on past events but at the same time become empowered to stride into the future."[2]

The *King* chronology is, in effect, a history of everything. The story begins with the negotiations between Saigō Takamori and Katsu Kaishū on the 14th day of the third month, 1868, which resulted in the surrender of Edo Castle and "opened the way for the peaceful completion of the great work of the restoration" (fig. E.1). More than 350 events follow, ranging from the first Japanese amputee to use a prothesis, also in 1868, to the "Flying Chop Suey King," Azuma Zensaku, who completed a solo round-the-world flight in his airplane, *The City of Tokyo*, in 1930. Out of the chaos, a recognizable narrative emerges, linking the Meiji Restoration (1868), the Iwakura Mission (1871), demands for a national assembly (1874), the Satsuma Rebellion (1877), the Meiji Constitution (1889), war with China (1894), the Anglo-Japanese Alliance (1902), war with Russia (1904), the annexation of Korea (1910), the outbreak of war in Europe (1914), the Treaty of Versailles (1919), the Great Kantō Earthquake (1923), universal suffrage (1925), and celebrations for the reconstruction of Tokyo (1930). This "war to peace" storyline, however, is encased in a complex array of perspectives on Japan's transition to modernity, including economic, social, and cultural change; advances in transportation and communications; achievements in science, technology, and medicine; together with artistic performances, sports and athletics events, imperial ceremonies, natural and not-so-natural disasters, crimes of all sorts; and an assortment of fads, fashions, and reports on the occult.

In its celebration of multiple perspectives, the *King* chronology makes it plain that history is not one story, but many. It also offers a reminder that the past is constantly changing. As historian Lawrence Levine has noted, we view the past through the prism of a changing present.[3] How did the editors of the *King* chronology view the unfolding of modern Japanese history from their 1930 vantage point? Unlike the Kaei chronicle published in the confusion of the 1868 civil war that pointed toward a dark, apocalyptic future, the *King* chronology was

2. *Meiji Taishō Shōwa dai-emaki*, end page.
3. Levine, "The Unpredictable Past," 4.

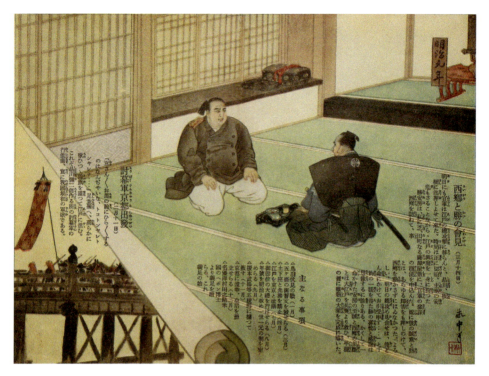

E.1. The meeting between Saigō Takamori and Katsu Kaishū, 14th day, third month (April 6), 1868, *Meiji Taishō Shōwa dai-emaki* (The great picture scroll: The Meiji, Taishō, and Shōwa eras). *King*, January 1, 1931. Author's collection.

The imperial army had advanced as far as Shinagawa and Itabashi and was posed for an all-out attack on Edo, even on that very next day. The situation was urgent. Aware that the fate of the Tokugawa family and the future of Edo was at stake, Katsu Awa [Kaishū] took it upon himself to meet secretly with the commanding officer of the imperial army, Saigō [Takamori], at the residence of Satsuma domain in Tamachi to seek a peaceful solution. In the end, Katsu's sincerity and passion overcame all obstacles and was able to move Saigō. "Agreed. I will order tomorrow's all-out attack postponed, even at the risk of my life." After Katsu heard such weighty words of understanding, his joy and gratitude knew no bounds. In this way, Katsu's sincerity and Saigō's decisiveness saved the great city of Edo from the ravages of war and opened the way for the peaceful completion of the great work of the Restoration.

optimistic. Lacking knowledge of the militarism and societal regimentation that would follow in the 1930s, it painted positive pictures of the opening of the country, the relatively peaceful transfer of power from shogun to emperor, increases in political participation, governance under a constitutional monarchy, wars fought and won, and

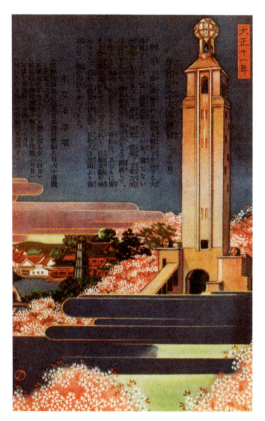

E.2. Great Peace Commemorative Exposition, March 10, 1922, *Meiji Taishō Shōwa dai-emaki* (The great picture scroll: The Meiji, Taishō, and Shōwa eras). *King*, January 1, 1931. Author's collection.

This spring, in March, an exposition to commemorate the end of the Great War was held in Ueno. The exposition was, in fact, larger in scale than all earlier exhibitions. In addition to the sections on livestock, forestry, agriculture, and industry, it also covered works of art, including paintings and sculpture. Exhibition halls of all designs and colors were constructed in every nook and cranny of the vast Ueno Park, making for an extraordinarily beautiful display. Given the good times that had followed the war, sightseers flooded in from all over the country, causing no end of hustle and bustle.

the advent of a new world order in the 1920s dominated by democracy, peace, and scientific advance.

The depiction of the 1920s is especially telling. Although some scholars have portrayed that decade as a pre-stage for militarism, Frederic Dickinson concludes that these years also saw the evolution of a "culture of peace."[4] The *King* chronology supports Dickinson's argument. Its defining event for the year 1922 is the Peace Commemorative

4. Dickinson, *World War I*, 144–66.

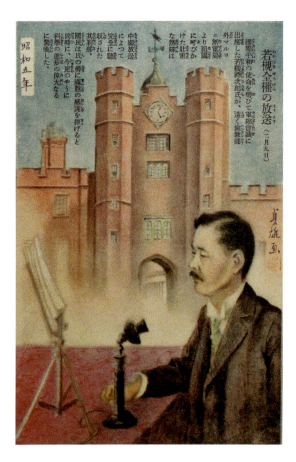

E.3. Ambassador Wakatsuki's broadcast speech, February 9, 1930, *Meiji Taishō Shōwa dai-emaki* (The great picture scroll: The Meiji, Taishō, and Shōwa eras). *King,* January 1, 1931. Author's collection.

Wakatsuki Reijirō, who attended the disarmament conference with a mission of international peace, spoke to the country by radio broadcast from the Marconi wireless station on the outskirts of London. When the people heard his solemn but passionate speech relayed from far-away London, they gave it their full attention and swelled with pride, extending to him their profound respect and gratitude. At the same time, they marveled at the extraordinary scientific progress that had been achieved.

Exposition held in Ueno Park between March and July to commemorate the end of World War I (fig. E.2).[5] The chronology goes on to depict the 1923 demonstrations for universal suffrage, the 1928 election held under the new universal manhood suffrage act, and the July 1929 report that the Japanese government had ratified the General Treaty for the Renunciation of War.

Two defining events for 1930 mark the end of the chronology's narrative of modern Japanese history. The first is the live radio broadcast

5. For full-color images of the exposition, see Sundberg, "Old Tokyo."

sent from London by Ambassador Wakatsuki Reijirō (1866–1949) following the London Naval Conference, which set limits on the naval capacity of the five signature nations, including Japan.[6] Wakatsuki's hopeful words regarding his "mission of international peace" were warmly received by the Japanese people (fig. E.3). The chronology's second defining event for 1930 is the weeklong festival held in March to celebrate the reconstruction of Tokyo after the 1923 earthquake: "This year, seven years after the Great Earthquake, sustained effort has finally led to the reconstruction of the imperial capital. The festivities were the occasion for the people of the city to celebrate and dance with joy."

In addition to the near-identical time frame, the *King* chronology resonates with the contents and purposes of this book. The chapters have examined various ways that contemporaries understood and reflected upon the whirlwind of events taking place around them. My attempt has been to add to the matrix of stories that both inform and challenge our understanding of modern Japan and the links between past, present, and future.

The *King* chronology reminds us that the course of modern Japanese history follows no inexorable trajectory. Few people in Japan in the late summer of 1868 foresaw that, out of the chaos surrounding them, a progressive regime committed to rapid and radical change would emerge. Similarly, although we can now identify in the late 1920s signs of bad times to come, few people in the spring of 1931, when the *King* chronology was published, could imagine that their country would soon be at war in Manchuria and ultimately under military control. And who can foresee what changes the multiyear engagement with COVID-19 will bring to Japan and the world? What history teaches us is to be skeptical, to consider alternative explanations, and to be prepared for any eventuality.

6. For the text of Wakatsuki's broadcast, "Documents on the London Conference," 521–22. See also Dickinson, *World War I*, 185–86.

Bibliography

Books and Journal Articles

Adachi, Yoshio 阿達義雄. *Bakumatsu Meiji bungaku to shomin keizai* 幕末明治文学と庶民経済 (Late Tokugawa, Meiji-period literature and the economy of common people). Tokyo: Tōyōkan Shuppan, 1983.

"Address of President Harding at Lancaster, N.H., August 4, 1921." Washington, DC: Government Printing Office, 1921.

Ajioka, Chiaki. "Aspects of Twentieth-Century Crafts: The New Craft and Mingei Movements." In J. Thomas Rimer, ed., *Since Meiji: Perspectives on the Japanese Visual Arts, 1868–2000*, 408–44. Honolulu: University of Hawai'i Press, 2011.

Alcock, Rutherford. *The Capital of the Tycoon: A Narrative of Three Years Residence in Japan*. 2 vols. New York: Harper, 1863.

Ambros, Barbara. "The Display of Hidden Treasures: Zenkōji's *Kaichō* at Ekōin in Edo." *Asian Cultural Studies* 30 (2004): 1–26.

"The Anglo-Japanese Alliance." *Kōki go-shōzō* 高貴御肖像 (The imperial portraits). *Taiyō* 8, no. 3, March 5, 1902, frontispiece.

Asano Akira 浅野晃 and Katō Mitsuo 加藤光男. *Genten de tanoshimu Edo no sekai* 原典で楽しむ江戸の世界 (Enjoying the world of Edo in original sources). Tokyo: Ribun Shuppan, 2009.

Asano Kenshin 浅野研眞. "Sada Kaiseki no daiyōhin undō ni tsuite" 佐田介石の代用品運動に就いて (On Sada Kaiseki's substitution campaign). *Shakai keizai shigaku* 9, no. 2 (1939): 205–22.

Baba Bun'ei 馬場文永. *"Genji yume monogatari": Bakumatsu dōjidai shi* 元治夢物語：幕末同時代史 (*Genji yume monogatari*: A contemporary history of the bakumatsu period). Tokyo: Iwanami Shoten, 2008.

Baba Bunyei. *Japan 1853–1864, or, Genji Yume Monogatari*. Translated by Ernest Mason Satow. Tokyo: 1905.

Barber, Daniel Lewis. "Tales of the Floating World: The Ukiyo Monogatari." MA diss., Ohio State University, 1984.

Barrow, Terence. "Introduction to the New Edition." In Edward S. Morse, *Japanese Homes and Their Surroundings*, xxi–xxvii. Reprint, Rutland, VT: Tuttle, 1972.

Baryshev, Eduard バールィシェフ・イドワード. "Dai ichiji sekai taisen-ki ni okeru Nichi-Ro sekkin no haikei: Bunmeiron o chūshin to shite" 第一次世界大戦期における日露接近の背景：文明論を中心として (The breakdown of relations between Japan and Russia following WWI: Focusing on theories of civilization). *Suravu kenkyū* 52 (2005): 205–40.

"The Basic Annals of Xiang Yu." In Sima Qian, *Records of the Grand Historian: Han Dynasty I*, 17–18, 43–48. Translated by Burton Watson. Rev. ed. New York: Columbia University Press, 1993.

Bassett, Fred. "Wish You Were Here!: The Story of the Golden Age of Picture Postcards in the United States." New York State Library. Updated December 23, 2021. https://www.nysl.nysed.gov/msscfa/qc16510ess.htm.

Baxter, Sylvester. *The Morse Collection of Japanese Pottery*. Salem, MA: Essex Institute, 1887.

Benfey, Christopher. *The Great Wave: Gilded Age Misfits, Japanese Eccentrics, and the Opening of Japan*. New York: Random House, 2003.

Bernard, Donald R. *The Life and Times of John Manjiro*. New York: McGraw-Hill, 1992.

Best, Anthony. "Race, Monarchy, and the Anglo-Japanese Alliance, 1902–1922." *Social Science Japan Journal* 9, no. 2 (2006): 171–86.

Botsman, Daniel. *Punishment and Power in the Making of Modern Japan*. Princeton, NJ: Princeton University Press, 2013.

Bowie, Theodore, ed. *Langdon Warner through His Letters*. Bloomington: Indiana University Press, 1966.

Brandt, Kim. *Kingdom of Beauty: Mingei and the Politics of Folk Art in Imperial Japan*. Durham, NC: Duke University Press, 2007.

Brownlee, John S. *Japanese Historians and the National Myth, 1600–1945*. Vancouver: University of British Columbia Press, 1997.

Burke, Peter. *Eyewitnessing: The Uses of Images as Historical Evidence*. Ithaca, NY: Cornell University Press, 2001.

Bytheway, Simon James, and Martha Chaiklin. "Reconsidering the Yokohama 'Gold Rush' of 1859." *Journal of World History* 27, no. 2 (2016): 281–301.

Candee, Richard. "E. Warren Clark (1849–1907): 'Noted Traveler and Lecturer on Oriental Topics.'" *The Magic Lantern Gazette* 24, no. 1 (Spring 2012): 3–20.

Carlyle, Thomas. "Signs of the Times." In *The Works of Thomas Carlyle*, vol. 2, 233–36. Reprint, Cambridge: Cambridge University Press, 2010.

Chamberlain, Basil Hall. *Things Japanese*. Reprint, Rutland, VT: Tuttle, 1970.
Checkland, Olive. *Humanitarianism and the Emperor's Japan, 1877–1977*. Basingstoke, UK: Palgrave Macmillan, 1993.
Chisolm, Lawrence. *Fenollosa: The Far East and American Culture*. New Haven, CT: Yale University Press, 1963.
Christy, Alan. *A Discipline on Foot: Inventing Japanese Native Ethnography, 1910–1945*. Lanham, MD: Rowman & Littlefield, 2012.
Clark, E. Warren. "Clark, writing from Nikko Japan to Griffis, Nov. 17, 1895." William Elliott Griffis Collection, Rutgers University.
———. *Katz Awa, The Bismarck of Japan*. New York: B. F. Buck, 1904.
Clark, John. "Okakura Tenshin and Aesthetic Nationalism." In J. Thomas Rimer, ed., *Since Meiji: Perspectives on the Japanese Visual Arts, 1868–2000*, 212–56. Honolulu: University of Hawai'i Press, 2011.
Clark, Timothy. *Demon of Painting: The Art of Kawanabe Kyōsai*. London: British Museum Press, 1993.
Cohen, Warren. *East Asian Art and American Culture*. New York: Columbia University Press, 1992.
The Craftsman (1910–1911). Website maintained by the University of Wisconsin-Madison Library. https://search.library.wisc.edu/digital/AQ5VII6GNL36H78T.
Craig, Albert. *Chōshū in the Meiji Restoration*. Cambridge, MA: Harvard University Press, 1961.
———. *Civilization and Enlightenment: The Early Thought of Fukuzawa Yukichi*. Cambridge, MA: Harvard University Press, 2009.
———. "Fukuzawa Yukichi: The Philosophical Foundations of Meiji Nationalism." In Robert E. Ward, ed. *Political Development in Modern Japan*, 99–148. Princeton, NJ: Princeton University Press, 1968.
Craig, Albert, ed. *Selected Essays by Fukuzawa Yukichi on Government*. Translated by Teruko Craig. London: Bloomsbury, 2019.
Craig, Teruko. *Musui's Story: The Autobiography of a Tokugawa Samurai*. Tucson: University of Arizona Press, 1991.

"Dai 22 kai Teikoku gikai shūgiin Tōhoku sanken kyōsakuchi kyūmin kyūjutsu ni kansuru dai 2 gō" 第二十二回帝国議会衆議院東北凶作地窮民救恤に関する第二号 (Second hearing in the 22nd Diet in the House of Representatives on the bill to provide relief to sufferers of famine in the three prefectures of the Tōhoku region). February 23, 1906. National Diet Library. https://teikokugikai-i.ndl.go.jp/#/detailPDF?minId=002212743X00219060223.
Daniels, Gordon. "The Anglo-Japanese Alliance and the British Press." In Gordon Daniels, Janet Hunter, David Steeds, and Ian Nish, *Studies in the*

Anglo-Japanese Alliance (1902–1923), 1–12. LSE STICERD Research Paper no. IS/03/443. London: Suntory Centre, 2003.

De Coningh, C. T. *A Pioneer in Yokohama: A Dutchman's Adventures in the New Treaty Port*. Edited and translated, with an introduction, by Martha Chaiklin. Indianapolis, IN: Hackett Publishing, 2012.

DePies, Gregory John. "Humanitarian Empire: The Red Cross in Japan, 1877–1945." PhD diss., University of California, San Diego, 2013.

Dickinson, Fredrick R. *World War I and the Triumph of a New Japan 1919–1930*. Cambridge: Cambridge University Press, 2013.

"Disaster Prints." Meiji at 150: Digital Resources. University of British Columbia. https://open.library.ubc.ca/collections/tokugawa/items/1.0222873.

Dispatch from Harry S. Parkes to the Foreign Office, Yokohama, June 13, 1868, no. 139. In *Historical Documents Relating to Japan in Foreign Countries: The United Kingdom*. Tokyo: Historiographical Institute, University of Tokyo, 1968. Microfilm, no. 6951-3-48-2.

"Documents on the London Conference." Digital Collection on the Documents for Japanese Foreign Policy. Ministry of Foreign Affairs of Japan. https://www.mofa.go.jp/mofaj/annai/honsho/shiryo/archives/pdfs/London_keika_25.pdf.

Dower, John. "Black Ships & Samurai: Commodore Perry and the Opening of Japan (1853–1854)." MIT Visualizing Cultures. https://visualizingcultures.mit.edu/black_ships_and_samurai/bss_essay01.html.

———. "Throwing Off Asia I: Woodblock Prints of Domestic 'Westernization' (1868–1912)." MIT Visualizing Cultures. https://visualizingcultures.mit.edu/throwing_off_asia_01/pdf/toa1_essay_03.pdf.

———. "Yellow Promise/Yellow Power." MIT Visualizing Cultures. https://visualizingcultures.mit.edu/yellow_promise_yellow_peril/yp_essay04.html.

Dyer, Anna H. "Japanese Wall Papers, Cheap and Beautiful." *The Craftsman* 11, no. 3 (December 1906): 398–402.

"Earthquake and Fire at San Francisco." In *Papers Relating to the Foreign Relations of the United States*, 1906, pt. 1, Message of the President. Washington, DC: Government Printing Office, 1909. https://history.state.gov/historicaldocuments/frus1906p1/san-Francisco-earthquake.

Edo-Tōkyō Hakubutsukan 江戸東京博物館, ed. *Akari no ima mukashi: Hikari to hito no Edo-Tōkyō shi* あかりの今昔：光と人の江戸東京史 (Lights past and present: A history of lights and people in Edo-Tokyo). Tokyo: Edo-Tōkyō Hakubutsukan, 1995.

Elleman, Bruce. *Wilson and China: A Revised History of the Shandong Question*. Oxford: Routledge, 2003.

Ericson, Mark. "The Bakufu Looks Abroad: The 1868 Mission to France." *Monumenta Nipponica* 34, no. 4 (1979): 383–407.
Ericson, Steven. *Financial Stabilization in Meiji Japan: The Impact of the Matsukata Reform*. Ithaca, NY: Cornell University Press, 2018.

"The Famine." *The Christian Movement in Japan*. Fourth annual issue. Published for the Standing Committee of Co-operating Christian Missions, Methodist Publishing House, 1906.
"Famine in Japan." *Foreign Papers of the United States, 1906*, vol. 2, 999–1005. Washington DC: United States Government Printing Office, 1909.
Fenollosa, Ernest. "Bijustu shinsetsu" 美術新説 ("Truth of Fine Arts" in Japanese translation). In Yoshino Sakuzō, ed., *Meiji bunka zenshū* 明治文化全集 (Collection of Works on Meiji Culture), vol. 12, 168–70. Tokyo: Nihon Kyōronsha, 1930.
Figal, Gerald. *Civilization and Monsters: Spirits of Modernity in Meiji Japan*. Durham, NC: Duke University Press, 1999.
Formanek, Susanne, and Sepp Linhart, eds. *Written Texts—Visual Texts: Woodblock-Printed Media in Early Modern Japan*. Amsterdam: Hotei Publishing, 2005.
Fox, Stephen. *Wolf of the Deep: Raphael Semmes and the Notorious Confederate Raider CSS* Alabama. New York: Alfred A. Knopf, 2007.
Frost, Peter. *The Bakumatsu Currency Crisis*. Cambridge, MA: East Asia Research Center, Harvard University. 1970.
Fukuchi Gen'ichirō, *Bakufu suibō ron* 幕府衰亡論 (On the downfall of the shogunate). Reprint, Tokyo: Heibonsha, 1967.
Fukuda Yaekichi 福田弥栄吉. *Jōkyō shite seikō shiuru made* 上京して成功し得るまで (How to succeed by going to the capital). Tokyo: Tōkyō Seikatsudō, 1917.
Fukushima-ken kyōsaku kyōsai gaiyō 福島県凶作暁斎概要 (Outline of relief measures during the famine in Fukushima Prefecture). Fukushima Prefecture, 1906.
Fukushima-ken Shōbō Bōsaika 福島県消防防災課, ed. *Fukushima-ken saigai shi* 福島県災害誌 (A history of disasters in Fukushima prefecture). Fukushima: Fukushima-ken Shōbō Bōsaika, 1972.
Fukuzawa Yukichi 福沢諭吉. *The Autobiography of Fukuzawa Yukichi*. Revised translation by Eiichi Kiyooka with foreword by Albert Craig. New York: Columbia University Press, 2007.
———. "Chōshū saisei ni kansuru kenpakusho" 長州再征に関する建白書 (A petition on the second subjugation of Chōshū). In Keiō Gijuku 慶応義塾, *Fukuzawa Yukichi zenshū* 福沢諭吉全集 (The collected works of Fukuzawa Yukichi), vol. 20, 6–11.

———. *An Encouragement of Learning.* Translated by David Dilworth and Umeyo Hirano. Tokyo: Sophia University Press, 1992.

———. *Gakumon no susume* 学問のすゝめ (An encouragement of learning). Edited and commentary by Koizumi Shinzō 小泉信三. Tokyo: Iwanami Bunko, 1978.

———. *Gendaigo yaku Gakumon no susume* 現代語訳学問のすすめ (An encouragement of learning translated into modern Japanese). Translated by Saitō Takashi 斎藤孝. Tokyo: Chikuma Shoten, 2009.

———. "Good-Bye Asia." In David Lu, ed., *Japan: A Documentary History, The Late Tokugawa Period to the Present,* 351–53. Armonk, NY: M. E. Sharpe, 1996.

———. *Jiji shōgen* 時事小論 (Commentary on current problems). Tokyo, 1881.

———. *Meiji jūnen teichū kōron; Yasegaman no setsu* 明治十年丁丑公論・瘦我慢の説 (A commentary on national issues in 1877; On fighting to the bitter end). Tokyo: Jiji Shinpōsha, 1901.

———. *Meiji jūnen teichū kōron; Yasegaman no setsu* 明治十年丁丑公論・瘦我慢の説 (A commentary on national issues in 1877; On fighting to the bitter end). Tokyo: Kōdansha Gakujitsu Bunko, 1999.

———. *Meiji jūnen teichū kōron; Yasegaman no setsu* 明治十年丁丑公論・瘦我慢の説 (A commentary on national issues in 1877; On fighting to the bitter end). Edited by Hirayama Yō 平山洋. Tokyo: Tokiwa Shobō, 2014.

———. *Meiji jūnen teichū kōron; Yasegaman no setsu* 明治十年丁丑公論・瘦我慢の説 (A commentary on national issues in 1877; On fighting to the bitter end). In Sakamoto Takao 坂本多加雄, ed., *Fukuzawa Yukichi chosakushū* 福沢諭吉著作集, vol. 9. Tokyo: Keiō Gijuku Daigaku Shuppankai, 2002.

———. *An Outline of a Theory of Civilization.* Translated by David Dilworth and G. Cameron Hurst. Tokyo: Sophia University Press, 1973.

———. *Seiyō jijō* 西洋事情 (Conditions in the West). Vol. 1. Edo: Shōkodo, 1866.

———. *Seiyō jijō* 西洋事情 (Conditions in the West). Edited by Marion Saucier and Nishikawa Shunsaku. Tokyo: Keiō Daigaku Shuppankai, 2009.

———. "Tadachi ni Pekin o tsuku beshi" 直ちに北京を衝くべし (Peking should be attacked immediately). In Keiō Gijiku, *Fukuzawa Yukichi zenshū,* vol. 14, 498–501.

———. "Yasegaman no setsu" 瘦我慢の説 (On fighting to the bitter end). In Keiō Gijiku, ed., *Fukuzawa Yukichi zenshū,* vol. 6, 555–84.

———. *Yasegaman no setsu* 瘦我慢の説 (On fighting to the bitter end). In Nagai Michio 永井道雄, ed., *Nihon no meicho: Fukuzawa Yukichi* 日本の

名著:福沢諭吉 (Famous works of Japan: Fukuzawa Yukichi), vol. 33, 469-83. Tokyo: Chūō Kōronsha, 1969.

———. "*Yasegaman no setsu*: On Fighting to the Bitter End." Translation and commentary by M. William Steele. *Asian Cultural Studies*, special issue 11 (2002): 139–52.

Fujitani, Takashi. *Japan's Modern Myths: Ideology in the Late Meiji Period*. Princeton, NJ: Princeton University Press, 1986.

———. *Splendid Monarchy, Power and Pageantry in Modern Japan*. Berkeley: University of California Press, 1996.

Gluck, Carol. *Japan's Modern Myths: Ideology in the Late Meiji Period*. Princeton, NJ: Princeton University Press, 1985.

Gordon, Andrew. "The Crowd and Politics in Imperial Japan: Tokyo 1905–1918." *Past and Present* 121, no. 1 (November 1988): 141–70.

Gotō Shinpei 後藤新平. "Daisensō go no shinbunmei" 大戦争後の新文明 (The new postwar civilization). *Shin Nihon* (April 1916): 23–29.

Gramlich-Oka, Bettina. "The Body Economic: Japan's Cholera Epidemic of 1858 in Popular Discourse." In "Society and Illness in Early Modern Japan." Special issue, *East Asian Science, Technology, and Medicine* 30 (2009): 32–73.

Griffis, William Elliot. *Townsend Harris: First American Envoy in Japan*. Boston: Houghton, Mifflin and Company, 1895.

Guth, Christine. *Art, Tea, and Industry*. Princeton, NJ: Princeton University Press, 1993.

Hanley, Keith, and Watanabe Aiko. "*Kokka*, Okakura Kakuzō, and the Aesthetic Construction of Late Meiji Cultural Nationalism." WIAS Discussion Paper 2019-003.

Hardacre, Helen. "Conflict between Shugendō and the New Religions of Bakumatsu Japan." *Japanese Journal of Religious Studies* 21, no. 2/3 (1994): 137–66.

Harris, Neil, "All the World a Melting Pot? Japan at American Fairs, 1876–1904." In Akira Iriye, ed., *Mutual Images: Essays in Japanese-American Relations*, 23–54. Cambridge, MA: Harvard University Press, 1975.

Hashikawa Bunzō 橋川文三, ed. *Okakura Tenshin: Hito to shisō* 岡倉天心:人と思想 (Okakura Tenshin: His life and thought). Tokyo: Heibonsha, 1982.

Hawks, Francis. *Narrative of the Expedition of an American Squadron to the China Seas and Japan, 1852–1854*. 3 vols. Washington, DC: B. Tucker, 1856.

Hayashi Hideo 林英夫, ed. *Banzuke de yomu Edo jidai* 番付で読む江戸時代 (Edo-period history from ranking sheets). Tokyo: Kashiwa Shobō, 2003.

Heco, Joseph. *The Narrative of a Japanese: What He Has Seen and the People He Has Met in the Course of the Last Forty Years*. Tokyo: Maruzen, 1895.

Helleiner, Eric. "The Return of National Self-Sufficiency? Excavating Autarkic Thought in a De-Globalizing Era." *International Studies Review* 23, no. 3 (September 2021): 933–57.

Higuchi Takehiko 樋口雄彦. *Hakodate sensō to Enomoto Takeaki* 函館戦争と榎本武揚 (The Battle of Hakodate and Enomoto Takeaki). Tokyo: Yoshikawa Kōbunkan, 2012.

Hildreth, Richard. *Japan as It Was and Is*. Boston: Phillips, Sampson and Co., 1855.

Hillsborough, Romulus. *Samurai Revolution: The Dawn of Modern Japan as Seen through the Eyes of the Shogun's Last Samurai*. Tokyo: Tuttle Books, 2014.

Hirayama Yō 平山洋. *Fukuzawa Yukichi* 福澤諭吉. Kyoto: Minerva, 2008.

Hiruma Hisashi 比留間尚. *Edo no kaichō* 江戸の開帳 (Special exhibitions of sacred treasures in Edo). Tokyo: Yoshikawa Kōbunkan, 1980.

Honjō Eijirō 本庄栄二郎. "Kaidai-hen" 解題編 (Introduction and commentary). In Sada Kaiseki 佐田介石, *Shakai keizai ron* 社会経済論 (Debates on social economics), 1–96. *Meiji bunka sōsho* 明治文化叢書 (Selected works on Meiji culture). Tokyo: Nihon Hyōronsha, 1941.

———. "Sada Kaiseki no hakuraihin haiseki no shisō to undō" 佐田介石の舶来品排斥の思想と運動 (Sada Kaiseki's opposition to the introduction of foreign things: His thought and activism). *Keizai ronsō* 27, no. 5. (1928): 767–82.

———, ed. *Sada Kaiseki: Saibai keizai ron* 佐田介石：栽培経済論 (Sada Kaiseki and his economic theory of cultivation). In *Meiji bunka sōsho*, 97–274. Tokyo: Nihon Hyōronsha, 1941.

Hopson, Nathan. *Ennobling Japan's Savage Northeast: Tōhoku as Japanese Postwar Thought, 1945–2011*. Cambridge, MA: Harvard East Asian Monographs, 2017.

Hori Ichiro. *Folk Religion in Japan*. Chicago: University of Chicago Press, 1994.

Horii Kenji 堀井健司. "Bakumatsu ishinki ni okeru hanken ni tsuite no ichikōsatsu" 幕末維新期における版権についての一考察 (A study of copyright at the end of the Edo era and the Restoration period). *Shuppan kenkyū* 40 (2009): 99–124.

Hosogoe Sachiko 細越幸子. "Meiji Sanriku ōtsunami to Nisseki kangofu yōsei to no kanren" 明治三陸大津波と日赤看護婦養成との関連 (Relation of the Meiji Sanriku massive tsunami and nurse training of the Japanese Red Cross). *Nisseki kankai shi* 14, no. 1 (2014): 41–49.

Hōya Tōru 保谷 徹. *Boshin sensō* 戊辰戦争 (The Boshin Civil War). Tokyo: Yoshikawa Kōbunkan, 2007.

———. "A Military History of the Boshin War." In Robert Hellyer and Harald Fuess, eds., *The Meiji Restoration: Japan as a Global Nation*, 153–70. Cambridge, MA: Cambridge University Press, 2020.

Huffman, James. *Down and Out in Late Meiji Japan*. Honolulu: University of Hawai'i Press, 2018.

———. *Politics of the Meiji Press: The Life of Fukuchi Genichirō*. Honolulu: University of Hawai'i Press, 1980.

Hughes, H. Stuart. *History as Art and as Science: Twin Vistas on the Past*. New York: Harper & Row, 1964.

Humeston, Helen. "Origins of America's Japan Policy." PhD diss., University of Minnesota, 1981.

Hunter, Janet. "'Extreme Confusion and Disorder'? The Japanese Economy in the Great Kantō Earthquake of 1923." *Journal of Asian Studies* 73, no. 3 (August 2014): 753–73.

Hur, Nam-lin. *Prayer and Play in Late Tokugawa Japan*. Cambridge, MA: Harvard University Press, 2000.

Hutchison, Hazel. *Henry James's Europe*. Cambridge, UK: Open Book Publishers, 2011.

Hyōdō Hiromi 兵藤裕己. "Rekishi kenkyū ni okeru 'kindai' no seiritsu: Bungaku to shigaku no aida" 歴史研究における「近代」の成立: 文学と史学のあいだ (The study of history and the formation of the "modern age": Between literature and history). *Seijō kokubungaku ronshū* 25 (March 1997): 255–80.

Ida Kanae 飯田鼎. "'Yasegaman no setsu' to 'Hikawa seiwa': Katsu Kaishū to Fukuzawa Yukichi no aida, sono ichi"「瘦我慢の説」と「氷川清和」: 勝海舟と福沢諭吉の間（その一）("Yasegaman no setsu" and "Hikawa seiwa": The gap between Katsu Kaishū and Fukuzawa Yukichi, pt. 1). *Mita gakkai zasshi* 90, no. 1 (1990): 1–18.

Imai Kingo 今井金吾, ed. *Teihon Bukō nenpyō* 定本武江年表 (Chronology of events in Edo, standard edition). 3 vols. Tokyo: Chikuma Gakugei Bunko, 2004.

Inoue Takurō 井上卓朗 and Hoshina Sadao 星名定雄. *Yūbin no rekishi* 郵便の歴史 (A history of postal services). Tokyo: Narumi, 2018.

Iriye, Akira. *Japan and the Wider World: From the Mid-Nineteenth Century to the Present*. London: Longman, 1997.

Irokawa Daisuke 色川大吉, ed. *Meiji kenpaku shūsei* 明治建白集成 (A collection of Meiji-era petitions). 9 vols. Tokyo: Chikuma Shobō, 2000.

Ishige Hiroko 市毛弘子. *Kogōsan seiken kōkoku zenji no rekishi* 巨鼇山清見興国禅寺の歴史 (A history of Kogōsan Seiken Kōkoku Zen Temple). Tokyo: Shinjinbutsu Ōraisha, 1974.
Ishii Takashi 石井孝. *Katsu Kaishū* 勝海舟.Tokyo: Yoshikawa Kōbunkan, 1974.
Ishikawa Eisuke 石川英輔. *Dai Edo banzuke jijō* 大江戸番付事情 (On Edo ranking sheets). Tokyo: Kōdansha, 2004.
Ishikawa Kanmei 石河幹明. *Fukuzawa Yukichi-den* 福沢諭吉伝 (A biography of Fukuzawa Yukichi). 4 vols. Tokyo: Iwanami Shoten, 1932.
Iwaki Noriko 岩城紀子. "Ishin to bunmei kaika" 維新と文明開花 (The Restoration and civilization and enlightenment). In Hayashi Hideo, ed., *Banzuke de yomu Edo jidai*, 108–17. Tokyo: Kashiwa Shobō, 2003.
Iwakura Tomomi 岩倉具視, Fukuba Bisei 福羽美静, and Nishi Amane 西周, eds. *Taisei kiyō* 大政紀要 (Chronicle of imperial rule). 10 vols. N.p., 1883.
Iwane Yasushige. "*Chikyū setsuryaku to Tsui chikyū setsuryaku*: Ishin zengo no shin tenmon chiri-setsu ni taisuru handō shisō no ichi rei" 地球説略と槌地球説略：維新前後の新天文地理説に対する反動思想の一例 (*Outline of the earth* and *Smashing the outline of the earth*: An example on reactionary thought opposing new explanations of astronomy and geography before and after the restoration). *Chikyū* 22, no. 2 (1934): 124–33.

Jannetta, Ann Bowman. *Epidemics and Mortality in Early Modern Japan*. Princeton, NJ: Princeton University Press, 2014.
Jansen, Marius. *Sakamoto Ryōma and the Meiji Restoration*. Princeton, NJ: Princeton University Press, 1961.
"Japanese Famine Fund." *American National Red Cross Bulletin* 1, no. 3 (July 1906): 3–11.
Jitsugyō no Nihonsha 実業の日本社, ed. *Kōsokudo kanemōke hō: Shōshi kaiten daishihonka* 高速度金儲法：小資廻転大資本家 (How to get rich quick: Great wealth from small investments). Tokyo: Jitsugyō no Nihonsha, 1925.
Jordan, Brenda G. "Potentially Disruptive: Censorship and the Painter Kawanabe Kyōsai." In Hiroshi Nara, ed., *Inexorable Modernity: Japan's Grappling with Modernity in the Arts*, 27–48. Lanham, MD: Lexington Books, 2007.

Kaei nenkan yori kome sōba nedan narabi ni nendaiki kakinuki daishinpan 嘉永年間より米相場値段并年代記書拔大新版 (A new publication of rice market prices and chronicle of selected events beginning with the Kaei era). Ishimoto Collection, General Library, University of Tokyo. https://iiif.dl.itc.u-tokyo.ac.jp/repo/s/ishimoto/document/13a002d9-ba2d-4d52-866e-a5dbdd5c9d25.

———. William Sturgis Bigelow Collection, Museum of Fine Arts, Boston. https://collections.mfa.org/objects/533656.

Kanagaki Robun 仮名垣魯文. *Ansei fūbun shū* 安政風聞集 (A collection of rumors during the Ansei period). 3 vols. N.p., 1856.

———. [Kinton Dōjin 金屯道人]. *Ansei korori ryūkōki* 安政箇労痢流行記 (An account of the spread of cholera during the Ansei period). Edo: Tenjudō, 1858.

Kanaya Masatake. "Reading Edo Urban Space in the *Tōkyō Gōshō Sugoroku* (Tokyo Rich Merchant's Board Game)." Meiji at 150: Visual Essays. University of British Columbia. https://meijiat150dtr.arts.ubc.ca/essays/kanaya/.

Kano Masanao 鹿野政直, ed. *Bakumatsu shisō shū* 幕末思想集 (A collection of works on thought in the late Tokugawa period). *Nihon no shisō* 日本の思想 (Japanese thought), vol. 20. Tokyo: Chikuma Shobō, 1969.

Karlin, Jason. "The Tricentennial Celebration of Tokyo: Inventing the Modern Memory of Edo." In Yamaji Hidetoshi and Jeffrey E. Hanes, eds., *Image and Identity: Rethinking Japanese Cultural History*, 215–27. Kobe: Kobe University, 2004.

Katsu Kaishū 勝海舟. *Bakufu shimatsu* 幕府始末 (The last days of the shogunate). Tokyo: Kokkōsha, 1895.

———. *Katsu Kaishū zenshū* 勝海舟全集 (The collected works of Katsu Kaishū). Edited by Katsube Mitake 勝部真長, Matsumoto Sannosuke 松本三之助, and Ōguchi Yujirō 大口勇次郎. 22 vols. Tokyo: Keisō Shobō, 1974–1983.

———. *Keizai zassan* 経済雑纂 (A miscellany of economic records). Unpublished manuscript, 1887. In *Katsu Kaishū kankei monjo* 勝海舟関係文書 (Katsu Kaishū papers). National Diet Library, Japan. https://dl.ndl.go.jp/info:ndljp/pid/11222491.

———. *Suijinroku* 吹塵録 (A record of dust blown away). 2 vols. Tokyo: Ōkurashō, 1890.

Kawamata Keiichi. *The History of the Red Cross Society of Japan*. Tokyo: Nippon Sekijūjisha Hattatsushi Hakkōjo, 1919.

Kawamoto Yumiko 河本由美子. "Yūnosuke no koto: Kaikokugo kikoku hyōryūmin dai 1 gō" 勇之助の事:開国後帰国流民第1号 (On Yūnosuke: The first castaway to return to Japan after the opening of the country, pt. 1). *Eigakushi kenkyū* 2007, no. 39 (2006): 81–95.

Kawanishi, Hidemichi. *Tōhoku: Japan's Constructed Outland*. Leiden: Brill, 2016.

Kayahara Kazan 茅原華山. "Shinbunmei no daitanjō" 新文明 (The great birth of a new civilization). *Dai san teikoku* 45 (July 5, 1915): 4–6.

Keene, Donald. "The Sino-Japanese War of 1894–95 and Its Cultural Effects in Japan." In Shively, *Tradition and Modernization*, 121–75.

Keiō Gijuku 慶応義塾, ed. *Fukuzawa Yukichi zenshū* 福沢諭吉全集 (The collected works of Fukuzawa Yukichi). 22 vols. Tokyo: Iwanami Shoten, 1969–1971.

Keirstead, Thomas. "史学 / Shigaku / History." In *Working Words: New Approaches to Japanese Studies*. University of California, Berkeley: Center for Japanese Studies. https://escholarship.org/uc/item/32t6g8nf.

Kemnitz, Thomas Milton. "The Cartoon as a Historical Source." *Journal of Interdisciplinary History* 4, no. 1 (Summer 1973): 81–93.

Kennan, George. "The Japanese Red Cross." *New Outlook* 78 (September 3, 1904): 27–36.

Kikuchi Akira 菊地明. *Bakumatsu shōgen 'Shidankai sokki-roku' o yomu* 幕末証言「史談会速記記録を読む」 (Bakumatsu testimonies: Reading the *Stenographic records of historical narratives*). Tokyo: Yōsensha, 2017.

Kikuchi Yoshiaki 菊池義昭. "Tōhoku sanken kyōsaku de Okayama kojiin ga shūyō shita chōki zaiinji e no yōgo jissen no rekishiteki yakuwari (4)" 東北三県凶作で岡山孤児院が収容した長期在院児への擁護実践の歴史的役割 (4) (The care experience of long-term residents in the Okayama Orphanage interned following the famine in the three Tōhoku prefectures, pt. 4). *Raifu dezaingaku kenkyū* (Alternate title *Journal of Human Life Design*) 10 (2014): 65–108.

Kikuchi, Yuko. "Hybridity and the Oriental Orientalism of Mingei Theory." *Journal of Design History* 10, no. 4 (1997): 343–54.

———. *Japanese Modernisation and Mingei Theory: Cultural Nationalism and Oriental Orientalism*. London: Routledge, 2004.

———. "The Myth of Yanagi's Originality: The Formation of Mingei Theory in its Social and Historical Context." *Journal of Design History* 7, no. 4 (1994): 247–66.

Kikuchi, Yuko, and Watanabe Toshio. "The British 'Discovery' of Japanese Art." In G. Daniels and C. Tsuzuki, eds., *The History of Anglo-Japanese Relations, 1600–2000*, vol. 5: *Social and Cultural Perspectives*, 146–70. London: Palgrave Macmillan, 2002.

"Kikukadō Museum" 菊花堂ミュージアム. Kikukadō. http://walklionbuil.com/museum.html.

Kimura Matsuo 木村松夫 and Ishii Toshio 石井敏夫, eds. *Ehagaki ga kataru Kantō daishinsai: Ishii Toshio korekushon* 絵はがきが語る関東大震災:石井敏夫コレクション (The Great Kantō Earthquake as seen through postcards: The Ishii Toshio Collection). Tokyo: Tsuge Shobō, 1990.

Kindai Shigaku Kenkyūkai 近代史学研究会 (Modern History Research Association), ed. *Meiji Taishō Shōwa sandai shōchokushū* 明治大正昭和三代詔勅集 (Collection of imperial rescripts over the Meiji, Taishō, and Shōwa periods). Ōita: Ōita-ken Shakai Fukushi Kyōgikai, 1968.

Kinoshita Nagahiro 木下長宏. *Okakura Tenshin: Mono ni kansureba tsune ni ware nashi* 岡倉天心　物二観ズレバ竟二吾無シ (Okakura Tenshin: When one contemplates the thing, the self is already lost). Kyoto: Minerva Shobō, 2005.

Kinoshita Naoyuki 木下直之 and Yoshimi Shun'ya 吉見俊哉, eds. *Nyūsu no tanjō: Kawaraban to shinbun nishiki-e no jōhō sekai* ニュースの誕生―かわら版と新聞錦絵の情報世界 (The birth of news: The information world of *kawaraban*, newspapers, and Meiji woodblock prints). Tokyo: Tōkyō Daigaku Sōgō Kenkyū Hakubutsukan, 1999.

Kitahara Itoko 北原糸子. *Jishin no shakaishi: Ansei daijishin to minshū* 地震の社会史:安政大地震と民衆 (The history of earthquakes: Commoners and the Ansei earthquake). Tokyo: Kōdansha, 2000.

———. *Kantō daishinsai no shakaishi* 関東大震災の社会史 (A social history of the Great Kantō Earthquake). Tokyo: Asahi Shinbunsha, 2011.

———. *Shashinshū Kantō daishinsai* 写真集関東大震災 (A collection of images of the Great Kantō Earthquake). Tokyo: Yoshikawa Kōbunkan, 2010.

Köhn, Stephan. "Between Fiction and Non-fiction: Documentary Literature in the Late Edo Period." In Formanek and Linhart, *Written Texts—Visual Texts*, 283–310.

Koike Makiko 小池満紀子 and Ōuchi Mizue 大内瑞恵, eds. *Tsukioka Yoshitoshi: Kaidai hyaku sensō* 月岡芳年:魁題百戦相 (Tsukioka Yoshitoshi: A selection of one hundred warriors). Machida: Machida Shiritsu Kokusai Hanga Bitjitsukan, 2011.

Koizumi Masahiro 小泉雅弘. "Bakumatsu fūshiga to sono juyōsō: Kindaiteki 'yoron' keisei no ichi zentei to shite" 幕末風刺画とその受要層:近代的「世論」形成の一前提として (Late Tokugawa political cartoons and their owners: A hypothesis regarding the formation of modern public opinion). *Journal of the Historical Association of Komazawa University* 53 (1993): 100–22.

Kojima Masataka 小島政孝. *Kojima shiryōkan mokuroku* 小島史料館目録 (Catalog of the Kojima Archives). Machida: Kojima Shiryōkan, 1978.

Kondo, Shigekazu. "Kume Kunitake as a Historiographer: Iwakura and After." In Ian Nish, ed., *The Iwakura Mission in American & Europe: A New Assessment*, 179–87. Richmond, Surrey: Japan Library (Curzon Press) 1998.

Konishi, Sho. "The Emergence of an International Humanitarian Organization in Japan: The Tokugawa Origins of the Japanese Red Cross." *American Historical Review* 119, no. 4 (October 2014): 1129–53.

Konnō Washichi 昆野和七. "Fukuzawa Yukichi no jōsho: Chōshū saisei ni kansuru kenpakusho shahon" 福沢諭吉の上書:長州再征に関する建白書写本 (Fukuzawa Yukichi's petition: On the manuscript copy of the petition to

engage in a second expedition against Chōshū). *Hōgaku kenkyū* 2, no. 8 (1950): 52–62.

Kornicki, Peter. *The Book in Japan: A Cultural History from the Beginnings to the Nineteenth Century*. Leiden: Brill, 1998.

Kudō Miyoko 工藤美代子. *Kudō shashinkan no Shōwa* 工藤写真館の昭和 (Kudō photography studio in the Shōwa era). Tokyo: Kōdansha, 1991.

Kumakura Isao 熊倉功夫. *Mingei no hakken* 民芸の発見 (The discovery of *mingei*). Tokyo: Kadokawa, 1978.

Kume Kunitake 久米邦武. "Heiwa hoshō no Santō rekishi" 平和保障の山東歴史 (Peacekeeping in the history of Shandong). 2 pts. *Shin-Nippon* 5, no. 1 (January 1, 1915): 53–60; *Shin-Nippon* no. 2 (February 1, 1915): 142–51.

———, comp. *The Iwakura Embassy, 1871–73: A True Account of the Ambassador Extraordinary & Plenipotentiary's Journey of Observation through the United States of America and Europe*. 5 vols. Edited by Graham Healey and Chushichi Tzuzuki. Princeton, NJ: Princeton University Press, 2002.

———. "Kokushijō yori mitaru kokusai mondai" 国史上より観たる国際問題 (The international problem as seen from our national history). *Chūō shidan* 4, no. 1 (January 1, 1922): 21–32.

———. *Kume hakushi kyūjūnen kaiko roku* 久米博士九十年回顧録 (Dr. Kume's recollections of a life of ninety years). 2 vols. Tokyo: Waseda Daigaku Shuppanbu, 1935.

———. "Meiji no bunmei kaika" 明治の文明開化 (Civilization and enlightenment in the Meiji period). *Kaihō* 3, no. 10 (October 1, 1921): 194–204.

———. "Nisshi kankei mondai no gairon" 日支関係問題の概論 (An introduction to problems in Japanese-Chinese relations). *Chūō shidan* 6, no. 4 (April 1, 1923): 423–45.

———. "Ōshū senran ni tsuki yo ga jikken rekishi no kaikan" 欧州戦乱につき余が実験歴史 (Reflections on the war in Europe based on my historical experience). *Rekishi chiri* 23, no. 11 (November 1, 1914): 29–47.

———. "Rekishigaku no susumi" 歴史学の進み (The advance of historical scholarship). In Tanaka Akira 田中彰 and Miyachi Masato 宮地正人, eds., *Rekishi ninshiki* 歴史認識 (Historical Consciousness), *Kindai Nihon shisō taikei* 近代日本思想体系 (Compendium of works on modern Japanese thought), vol. 13, 222–27. Tokyo: Iwanami Shoten, 1991.

———. "Rekishi yori mitaru sekai no heiwa" 歴史より観たる世界の平和 (World peace as seen from history). *Taikan* 2, no. 9 (September 1, 1919): 60–74.

———. "Seiyō busshitsu kagaku no ikizumari" 西洋物質科学の行詰り (Western material science at a dead end). *Rekishi chiri* 35, no. 1 (January 1, 1920): 1–8.

———. "Shintō wa saiten no kozoku" 神道は祭天の古俗 (Shinto: The outdated custom of worshiping the heavens). 3 pts. *Shigaku zasshi* 2, no. 23 (October): 63–670; Shigaku zasshi no. 24 (November): 728–42; *Shigaku zasshi* no. 25 (December): 799–811.

———. "Taiheiki wa shigaku ni eki nashi." 太平記は史学に益なし (*The Taiheiki* is useless as historical scholarship). *Shigaku zasshi* 2, nos. 17, 18, 20, 21, 22 (1891).

———, ed. *Tokumei zenken taishi Bei-Ō kairan jikki* 特命全権大使米欧回覧実記 (A true account of the ambassador extraordinary and plenipotentiary's journey of observation through the United States of America and Europe). 5 vols. Edited and commentary by Tanaka Akira. Tokyo: Iwanami Shoten, 1977–1982.

Kumoura Tōgan 雲浦兎眼. "Nichi-Ei dōmei o iwasu" 日英同盟を祝す (Celebrating the Anglo-Japanese Alliance). *Shōnen sekai* 8, no. 5 (April 2, 1902): 114–15.

Kuroki Takashi 黒木喬. *Edo no kaji* 江戸の火事 (The fires of Edo). Tokyo: Dōseisha, 1999.

Lampe, William. *Christians and Relief Work in Northern Japan*. Sendai: n.d. (1906?).

———. *The Famine in North Japan*. n.d. (1906?).

———. *Report of the Foreign Committee of Relief for the Famine in Northern Japan*. "Japan Mail" Office, Yokohama: 1906. 14 pages.

Lanman, Charles. *The Japanese in America*. New York: University Publishing Company, 1872.

Lears, Jackson. *No Place of Grace: Antimodernism and the Transformation of American Culture 1880–1920*. New York: Pantheon, 1982.

Legge, James. *Li Ki (Li Chi) The Book of Rites*. In *Sacred Books of the East*, vol. 27. Oxford: Oxford University Press, 1885.

Leutner, Robert W. *Shikitei Sanba and the Comic Tradition in Edo Fiction*. Cambridge, MA: Council on East Asian Studies, 1985.

Levine, Lawrence W. "The Unpredictable Past: Reflections on Recent American Historiography." *American Historical Review* 94, no. 3 (June 1989): 671–79.

Linhart, Sepp. "Kawaraban: Enjoying the News When News Was Forbidden." In Formanek and Linhart, *Written Texts—Visual Texts*, 231–50.

Lu, Roger. "Seismic Diplomacy: The American Aid Response to the Great Kanto Earthquake of 1923." BA thesis, Dartmouth College, 2016.

Lucie-Smith, Edward. *The Story of Craft: The Craftsman's Role in Society*. Oxford: Oxford University Press, 1981.

Manjiro, John. *Drifting toward the Southeast: The Story of Five Japanese Castaways*. Translated by Junya Nagakuni and Junji Kitadai. New Bedford, MA: Spinner, 2003.

Mantei Ōga 万亭応賀. *Katsuron gakumon suzume* 活論学問雀 (Sparrows at the gates of learning: A spirited debate). 6 fascicles. Tokyo: Murakami Jūzō, 1875.

———. *Mantei Ōga sakuhinshū* 万亭応賀作品集 (A collection of works by Mantei Ōga). Edited by Kokuritsu Kokugo Kenkyūjo. Tokyo: Heibonsha, 2017.

Markus, Andrew. "The Carnival of Edo: Misemono Spectacles from Contemporary Accounts." *Harvard Journal of Asiatic Studies* 45, no. 2 (December 1985): 499–541.

Marshall, Amy Bliss. *Magazines and the Making of Mass Culture in Japan*. Toronto: University of Toronto Press, 2019.

Mason, Anna. *William Morris*. London: Thames & Hudson, 2021.

Masuo Nobuyuki 増尾信之. *Mitsumura Toshimo-den* 光村利藻伝 (A biography of Mitsumra Toshimo). Tokyo: Mitsumura Toshiyuki, 1964.

Matsuura Rei 松浦玲. *Katsu Kaishū* 勝海舟. Tokyo: Chikuma Shobō, 2010.

———. *Meiji no Kaishū to Ajia* 明治の海舟とアジア (Katsu Kaishū and Asia in the Meiji period). Tokyo: Iwanami Shoten, 1987.

Matsuyama Iwao 松山巖. *Gunshū: Kikai no naka no nanmin* 群集: 機械の中の難民 (The crowd: Displaced people in a mechanized world). Tokyo: Yomiuri Press, 1996.

Matsuzaki Kinichi 松崎欣一. "Mita seidankai, Seidansha enzetsukai ni tsuite: Meiji jūnendai zenhan ni okeru Keiō Gijuku kakari enzetsukai no kenkyū" 三田政談会・社談社演説会について: 明治十年代前半における慶応義塾係演説会の研究 (On the Mita Seidankai and Seidan Enzetsukai: A study of Keiō Gijuku–related lecture associations in the early Meiji 10s). *Kindai Nihon kenkyū* 12 (1995): 1–60.

Matsuzawa Yūsaku 松沢裕作. *Shigeno Yasutsugu to Kume Kunitake: "Seishi" o yume mita rekishika* 重野安繹と久米邦武: 「正史」を夢みた歴史家 (Shigeno Yasutsugu and Kume Kunitake: Historians who dreamed of "definitive history"). Tokyo: Yamakawa Shuppansha, 2012.

Maus, Tanya S. "The Recollections of Tetsu: A Translation of Her Testimonial Narrative with Commentary." *U.S.-Japan Women's Journal* 46 (2014): 101–26.

Mayo, Marlene. "Rationality in the Meiji Restoration: The Iwakura Embassy." In Bernard Silberman and Harry Harootunian, eds., *Modern Japanese Leadership*, 323–62. Tucson: University of Arizona Press, 1966.

———. "The Western Education of Kume Kunitake, 1871–6." *Monumenta Nipponica* 28, no. 1 (Spring 1973): 3–67.

Mehl, Margaret. "The European Model and the Archive in Japan: Inspiration or Legitimation?" *History of the Human Sciences* 26, no. 3 (October 2013): 107–27.
———. *History and the State in Nineteenth-Century Japan*. New York: Palgrave Macmillan, 1998.
———. "Scholarship and Ideology in Conflict: The Kume Affair, 1892." *Monumenta Nipponica*, 48, no. 3 (1993): 337–57.
Meiji Taishō Shōwa dai-emaki 明治大正昭和大絵巻 (The great picture scroll of the Meiji, Taishō, and Shōwa eras). Tokyo: Kōdansha, 1931. Supplement to *Kingu* 7, no. 1 (January 1931).
Mertz, John. *Novel Japan: Spaces of Nationhood in Early Meiji Narrative, 1870–88*. Ann Arbor: Center for Japan Studies, University of Michigan, 2003.
Metzler, Mark. "Japan and the World Conjuncture of 1866." In Robert Hellyer and Harald Fuess, eds., *The Meiji Restoration: Japan as a Global Nation*, 15–39. Cambridge: Cambridge University Press, 2020.
Minami Kazuo 南和男. *Bakumatsu ishin no fūshiga* 幕末維新の風刺画 (Satirical cartoons at the time of the Restoration). Tokyo: Yoshikawa Kōbunkan, 1999.
———. *Edo no fūshiga* 江戸の風刺画 (Edo-period satirical cartoons). Tokyo: Yoshikawa Kōbunkan, 1997.
———. *Ishin zen'ya no Edo shomin* 維新前夜の江戸庶民 (Edo commoners on the eve of the Restoration). Tokyo: Kyōikusha, 1980.
Ministry of Foreign Affairs of Japan. "List of Relief Supplies and Donations from Overseas." Ministry of Foreign Affairs of Japan. https://www.mofa.go.jp/j_info/visit/incidents/pdfs/r_goods.pdf.
Mishra, Pankaj. *From the Ruins of Empire: The Intellectuals who Remade Asia*. New York: Farrar, Straus and Giroux, 2013.
Miyagi-ken, ed. 宮城県偏. *Meiji sanjūhachinen Miyagi-ken kyōkō shi* 明治三十八年宮城県凶荒誌 (An account of the famine in Miyagi prefecture in 1906). Miyagi Prefecture: 1916.
Miyanaga, Takashi. "Eikoku kōshikan tsūben Denkichi ansatsu ikken" 英国公使館通弁伝吉暗殺一件 (The assassination of Denkichi, interpreter to the British Legation). *Shakai rōdō kenkyū* 40, nos. 3, 4. (February 1994): 234–70.
Miyata Noboru 宮田登. *Miroku shinkō no kenkyū* ミロク信仰の研究 *(A study of Miroku beliefs)*. Tokyo: Miraisha, 1970.
———. *Shūmatsukan no minzokugaku* 終末観の民俗学 (Folk views on millenarian beliefs). Tokyo: Kōbundō, 1987.
Mochizuki Kōtarō, ed. *Japan Today: A Souvenir of the Anglo-Japanese Exhibition*. Tokyo: Liberal News Agency, 1910.

Moeran, Brian. *Lost Innocence: Folk Craft Potters of Onta, Japan.* Berkeley: University of California Press, 1984.

"Money which might be contributed to the famine relief-fund for the people of North Japan" 東北飢饉地に寄付したき金. *Tōkyō Puck* 2, no. 4 (February 1906): 52.

Morse, Anne Nishimura, Tomas J. Rimer, and Kendall H. Brown. *Art of the Japanese Postcard.* Boston: Museum of Fine Arts, 2004.

Morse, Edward S. *Japan Day by Day.* 2 vols. New York: Houghton Mifflin, 1917.

———. *Japanese Homes and Their Surroundings.* Reprint, Rutland, VT: 1972.

Motoyama Yukihiro 本山幸広彦, ed. *Miyake Setsurei shū* 三宅雪嶺集 (A collection of works by Miyake Setsurei). *Kindai Nihon shisō-taikei* 近代日本思想大系 (Compendium of works on modern Japanese thought), vol. 5. Tokyo: Chikuma Shobō, 1975.

Museum of the City of San Francisco. "Foreign Assistance to San Francisco During the 1906 Earthquake and Fire." Museum of the City of San Francisco. http://www.sfmuseum.org/hist11/foreignassistance.html.

Nagura Tetsuzō 奈倉哲三. *Boshin sensō no shinshiten* 戊辰戦争の新視点 (New views on the Boshin civil war). 2 vols. Tokyo: Yoshikawa Kōbunkan, 2018.

———. *Etoki bakumatsu fūshiga to tennō* 絵解き幕末風刺画と天皇 (Illustrated late Tokugawa satirical cartoons and the emperor). Tokyo: Kashiwa Shobō, 2007.

———. *Fūshiga ishin henkaku: Minshū wa tennō o dō miteitaka* 風刺画維新変革:民衆は天皇をどう見ていたか (The Restoration upheaval as seen through satirical cartoons: How did commoners view the emperor?). Tokyo: Azekura Shobō, 2004.

———. *Nishiki-e kaiseki: Tennō ga Tōkyō ni yatte kita!* 錦絵解析:天皇が東京にやって来た！ (Analyzing woodblock prints: The emperor comes to Edo!). Tokyo: Tōkyōdō Shuppan, 2019.

Nakajima Mineo 中島岑夫. *Bakushin Fukuzawa Yukichi* 幕臣福沢諭吉 (Fukuzawa Yukichi, an officer of the shogunate). Tokyo: TBS Britannica, 1991.

Nakamura Sunao, ed. *Okakura Kakuzō: Collected English Writings.* 3 vols. Tokyo: Heibonsha, 1984.

Nakayama Einosuke 中山榮之輔. *Edo-Meiji kawaraban senshū* 江戸明治かわらばん選集 (A collection of *kawaraban* from the Edo and Meiji periods). Tokyo: Jinbunsha, 1974.

Nara, Hiroshi, ed. *Inexorable Modernity: Japan's Grappling with Modernity in the Arts*. Lanham, MD: Lexington Books, 2007.

Nihon Gasu Kyōkai 日本ガス協会, ed. *Nihon toshi gasu sangyōshi* 日本都市ガス産業史 (An industrial history of Japan city gas). Tokyo: Nihon Gasu Kyōkai, 1997.

Nish, Ian. *Alliance in Decline: A Study in Anglo-Japanese Relations, 1908–23*. London: Athlone Press, 1972.

———. *The Anglo-Japanese Alliance: The Diplomacy of Two Island Empires, 1894–1907*. London: Athlone Press, 1966.

Nishibe Susumu 西部邁. *Fukuzawa Yukichi: Sono bushidō to aikokushin* 福沢諭吉：その武士道と愛国心 (Fukuzawa Yukichi: His bushidō and patriotism). Tokyo: Bungei Shunjū, 1999.

Notehelfer, F. G. *Japan through American Eyes: The Journal of Francis Hall, Kanagawa and Yokoyama, 1859–1866*. New York: Routledge, 2001.

Numata, Jirō. "Shigeno Yasutsugu and the Modern Tokyo Tradition of Historical Writing." In W. G. Beasley and E. G. Pulleyblank, eds., *Historians of Japan and China*, 264–87. London: Oxford University Press, 1961.

Numata Kiyoshi 沼田清. "Shiryō: Kantō daishinsai shashin no kaizan to netsuzō" 資料：関東大震災写真の改ざんと捏造 (Documents: Falsification and forgery of great Kantō earthquake photographs). *Reishi jishin* 34 (2019): 103–13.

Nute, Kevin. "Ernest Fenollosa and the Universal Implications of Japanese Art." *Japan Forum* 7 (March 1995): 25–42.

Ogawara Masamichi 小川原正道. "Meiji sanjūkyūnen Tōhoku kikin to Bukkyō: *Chūgai nippō* o megutte" 明治三十八―三十九年東北飢饉と仏教：『中外日報』をめぐって (The Tōhoku great famine of 1905–1906 and Buddhism, especially focusing on *Chūgai nippō*). *Hōsei kenkyū* 28, no. 6 (2016): 85–95.

Ohkura, Takehiko, and Hiroshi Shimbo. "The Tokugawa Monetary Policy in the Eighteenth and Nineteenth Centuries." In Michael Smika, ed., *The Japanese Economy in the Tokugawa Era, 1600–1868*, 241–64. London: Routledge, 2012.

Okada Kōyō 岡田紅陽. *Tōkyō shinsai shashinchō* 東京震災社帖 (A photo album of the Tokyo earthquake disaster). Tokyo: Bunsansha, 1923.

Okakura Kakuzō. *The Awakening of Japan*. New York: The Century Co., 1904.

———. *The Book of Tea*. London: G. P. Putnam's Sons, 1906.

———. *The Ideals of the East with Special Reference to the Art of Japan*. London: John Murry, 1903.

———. "Modern Art from a Japanese Point of View." Unpublished speech delivered in 1904. In *The Heart of Heaven, Being a Collection of Writings hitherto Unpublished in Book Form*, by Okakura Kakuzo, 177–203. Tokyo: Nippon Bitjutsuin: 1922.

———. "Reading 'Calligraphy Is Not Art.'" Translated by Timothy Unverzagt Goddard. *Review of Japanese Culture and Society* 24 (December 2012): 168–75.

Okakura Takashi 岡倉登志, Okamoto Yoshiko 岡本佳子, and Miyataki Kōji 宮瀧交二. *Okakura Tenshin: Shisō to kōdō* 岡倉天心思想と行動 (The thought and behavior of Okakura Tenshin). Tokyo: Yoshikawa Kōbunkan, 2013.

Okitsu Kaname 興津要, ed. *Meiji kaikaki bungakushū* 明治開花期文学集 (Collection of literary works on civilization and enlightenment), vol. 1. *Meiji bungaku zenshū* 明治文学全集 (Collected works on Meiji literature), vol. 1. Tokyo: Chikuma Shobō, 1966.

Oku Takenori 奥武則. *Bunmei kaika to minshū* 文明開化と民衆 (Commoners and Japan's civilization and enlightenment). Tokyo: Shinhyōron, 1993.

Ōkubo Toshiaki 大久保利謙. *Kume Kunitake no kenkyū* 久米国武の研究 (A study of Kume Kunitake). Tokyo: Yoshikawa Kōbunkan, 1991.

———. *Nihon kindai shigaku no seiritsu* 日本近代史学の成立 (The establishment of modern historiography in Japan). Tokyo: Yoshikawa Kōbunkan, 1988.

———. "Ōsei fukko shikan to kyūhan shikan, hanbatsu shikan" 王政復古史観と旧藩史観・藩閥史観 (History as seen by advocates of the restoration of imperial rule, the former domains and the domain factions). *Hōsei shigaku* 12 (1959): 4–24.

Ono Hideo 小野秀雄. *Kawaraban monogatari: Edo jidai no masukomi no rekishi* かわら版物語：江戸時代マスコミの歴史 (The *kawaraban* story: The history of mass communications in the Edo period). Tokyo: Yūzan Kaku Publishers, 1960.

Ono Hideo Collection. University of Tokyo. http://www.lib.iii.u-tokyo.ac.jp/collection/ono.html.

Osatake Takeshi 尾佐竹猛. "Mikaeshi-e kaidai" 見返し絵解題 (Comments on the frontispiece illustration). In *Shakaihen* 社会編 (Society), *Meiji bunka zenshū* (A compendium of works on Meiji culture), vol. 22, 40. Tokyo: Nihon Hyōronsha, 1929.

Osborne, Thomas J. *Pacific Eldorado: A History of Greater California*. 2nd ed. Hoboken, NJ: John Wiley & Sons, 2020.

Ouwehand, Corneillis. *Namazu-e and Their Themes*. Leiden: E. J. Brill, 1964.

Parker, F. Calvin. *Sentaro, Japan's Sam Patch: Cook, Castaway, Christian.* Bloomington, IN: iUniverse, 2010.
Partner, Simon. *The Merchant's Tale: Yokohama and the Transformation of Japan.* New York: Columbia University Press, 2018.
Penick, Monica, and Christopher Lang. *The Rise of Everyday Design: The Arts and Crafts Movement in Britain and America.* New Haven, CT: Yale University Press, 2019.
Pepper, Charles Melville. *Life Work of Louis Klopsch, Romance of a Modern Knight of Mercy.* New York: Christian Herald, 1910. Reprint, Whitefish, MT: Kessinger Publishing, 2005.
Platt, Brian. *Burning and Building: Schooling and State Formation in Japan, 1750–1890.* Cambridge, MA: Harvard University Press, 2004.
Plummer, Katherine. *The Shogun's Reluctant Ambassadors: Japanese Sea Drifters in the North Pacific.* Portland: Oregon Historical Society Press, 1991.

Rambelli, Fabio. "Buddhism and the Capitalist Transformation of Modern Japan." In Hanna Havnevik et al., eds., *Buddhist Modernities*, 33–50. New York: Routledge, 2017.
———. "Sada Kaiseki: An Alternative Discourse on Buddhism, Modernity, and Nationalism in the Early Meiji Period." In Roy Starrs, ed., *Politics and Religion in Japan*, 104–42. New York: Palgrave Macmillan 2011.
Ravina, Mark. *The Last Samurai: The Life and Battles of Saigō Takamori.* New York: John Wiley & Sons, 2004.
Rendai Dōshi 蓮台道子. *Matsudai banashi hakiyose zōshi* 末代噺話掃寄草紙 (Swept up stories of the latter days). Edo: 1858.
"Reply from the Japan Legation with telegraph instructions from Tokyo." *Foreign Papers of the United States, 1906,* vol. 2. Washington, DC: Government Printing Office, 1909.
"Report of a Vice President of our Red Cross Society who made a tour to those famine stricken regions to investigate conditions of the suffers." In Kawamata Keiichi, *The History of the Red Cross Society of Japan*, 304-214. Tokyo: Nippon Sekijūjisha Hattatsushi Hakkōjo, 1919.
Robertson Scott, J. W. *The Foundations of Japan.* London: John Murray, 1922.
Rosenberg, Daniel, and Anthony Grafton. *Cartographies of Time: A History of the Timeline.* Princeton, NJ: Princeton Architectural Press, 2012.
Rosenberg, John D., ed. *The Genius of John Ruskin: Selection from his Writings.* Richmond, VA: University of Virginia Press, 1997.
Ross, Kerry. *Photography for Everyone: The Cultural Lives of Cameras and Consumers in Early Twentieth-Century Japan.* Stanford, CA: Stanford University Press, 2015.

Rotermund, Hartmut O. "Illness Illustrated: Socio-Historical Dimensions of Late Edo Measles Pictures (*Hashika-e*). In Formanek and Linhart, *Written Texts—Visual Texts*, 251–77.

Rowland, Benjamin, Jr. "Langdon Warner, 1881–1955." *Harvard Journal of Asiatic Studies* 18, no. 3/4 (December 1955): 447–50.

Ruskin, John. *The Stones of Venice*, vol. 1. Boston: Estes and Lauriat, 1853.

Ruxton, Ian Ruxton. "Ernest Satow, British Policy and the Meiji Restoration." *Bulletin of the Kyushu Institute of Technology* 45 (1997): 33–41.

Sada Kaiseki 佐田介石. *Saibai keizai ron* 栽培経済論 (Economic theory of cultivation). 2 vols. Tokyo: 1878–1879.

———. *Saibai keizai ron* 栽培経済論 (Economic theory of cultivation). Reprinted in *Meiji bunka zenshū* 明治文化全集 (A compendium of works on Meiji culture), vol. 15: *Shisō-hen* 思想編 (Thought), 307–410. Tokyo: Nihon Hyōronsha, 1929.

———. *Yo naoshi iroha uta, yonaoshi hitotsutose bushi* 世なをしいろは歌・世なをし一ツとせぶし (Songs that change the world). Supplement to *Saibai keizai mondō shinshi* 栽培経済問答新誌 (Economic cultivation debate and news) 27 (1882).

Sadamura Seihyō 定村青萍, ed. *Taishō no daijishin daikasai sōnan hyakuwa* 大正の大地震大火災遭難百話 (One hundred tales of woe from the Taisho great earthquake and fire). Chiba: Tadaya Shoten, 1923.

Saitō Osamu. *The Economic History of the Restoration Period, 1853–1885*. Kunitachi: Institute of Economic Research, Hitotsubashi University, 2011.

Salter, Rebecca. *Japanese Popular Prints: From Votive Slips to Playing Cards*. Honolulu: University of Hawai'i Press, 2006.

Sang, Seung Yeon. "Japanese Folk Art in the United States: Yanagi Muneyoshi and Harvard." *Harvard Museums Newsletter*, August 27, 2018. https://harvardartmuseums.org/article/japanese-folk-art-in-the-united-states-yanagi-muneyoshi-and-harvard.

Sasaki Suguru 佐々木克. *Boshin sensō: Haisha no Meiji ishin* 戊辰戦争:敗者の明治維新 (The Boshin Civil War: Losers in the Meiji Restoration). Tokyo: Chūō Kōron, 1977.

Satō Daigo 佐藤大悟. "Meiji Dajōkan-ki no Shūshi bukyoku ni okeru kiroku kanri" 明治太政官期の修史部局における記録管理 (Record management in the Office of Historiography under the Dajōkan in the Meiji period). *Kokubungaku kenkyū shiryōkan kiyō ākaibuzu kenkyūhen* 50, no. 15 (2019): 53–70.

Schencking, J. Charles. *The Great Kantō Earthquake and the Chimera of National Reconstruction in Japan*. New York: Columbia University Press, 2013.

———. "*Kantō daishinsai:* The Great Kantō Earthquake." Great Kantō Earthquake. http://www.greatkantoearthquake.com/index.html.
Scidmore, Eliza R. "The Recent Earthquake Wave on the Coast of Japan." *National Geographic Magazine* 7, no. 9 (September 1896): 285–89.
"Secretary of State to Commodore Aulick, Department of State, Washington, June 10, 1851." In *Documents Relating to the Foreign Relations of the United States with Other Countries During the Years from 1800 to 1898*, vol. 36. Senate Executive Document 59 (32nd Congress, 1st Session), Existing Relations between the United States and Japan, April 15, 1852: 80–82.
Shidankai 史談会, ed. *Shidankai sokkiroku* 史談会速記録 (Stenographic records of historical narratives). 45 vols. Tokyo: Hara Shobō, 1971–1976.
Shigeno Yasutsugu 重野安繹. "Shigaku ni jūji suru mono wa sono kokoro shikō narazaru bekarazu" 史学に従事する者 は其心至公至平ならざるべからず (Historians must be impartial). *Shigakukai zasshi* 史学会雑誌 1 (1889): 1.
Shimazu, Naoko. *Japan, Race and Equality: The Racial Equality Proposal of 1919*. London: Routledge, 1988.
Shively, Donald. "The Japanization of Middle Meiji." In Shively, *Tradition and Modernization*, 77–119.
———, ed. *Tradition and Modernization in Japanese Culture*. Princeton, NJ: Princeton University Press, 1971
Silberman, Bernard S., and Harry Harootunian. *Japan in Crisis: Essays on Taisho Democracy*. Princeton, NJ: Princeton University Press, 1974.
Silverberg, Miriam. *Erotic Grotesque Nonsense: The Mass Culture of Japanese Modern Times*. Berkeley: University of California Press, 2006.
Sima Qian. *Records of the Grand Historian: Han Dynasty*. 2 vols. Translated by Burton Watson. New York: Columbia University Press, 1993.
Smith, Henry D., II. "The Edo-Tokyo Transition: In Search of Common Ground." In Marius Jansen and Gilbert Rozman, eds., *Japan in Transition: From Tokugawa to Meiji*, 347–74. Princeton, NJ: Princeton University Press, 1986.
———. *Taizansō and the One Mat Room*. Mitaka: ICU Yuasa Memorial Museum, 1993.
Smithsonian Institute. "Postcard History." Smithsonian Institute. https://siarchives.si.edu/history/featured-topics/postcard/postcard-history.
Smits, Gregory. "The Ansei Earthquake and Catfish Prints." Meiji at 150: Visual Essay. University of British Columbia. https://meijiat150dtr.arts.ubc.ca/essays/smits/.
———. *Seismic Japan: The Long History and Continuing Legacy of the Ansei Edo Earthquake*. Honolulu: University of Hawai'i Press, 2013.

———. "Shaking up Japan: Edo Society and the 1855 Catfish Picture Prints." *Journal of Social History* 39, no. 4 (Summer 2004): 1045–77.

———. "Warding off Calamity in Japan: A Comparison of the 1855 Measles Prints and the 1852 Measles Prints." *East Asia Science, Technology and Medicine* 30 (2009): 9–31.

Soviak, Eugene. "On the Nature of Western Progress: The Journal of the Iwakura Embassy." In Shively, *Tradition and Modernization*, 7–34.

Soyofuku kaze そよふく風. In Meiji Bunka Kenkyūkai 明治文化研究会, ed., *Bakumatsu Meiji shinbun zenshū* 幕末明治新聞全集 (A collection of late Tokugawa newspapers), vol. 3, no. 7, 407–8. Tokyo: Sekai Bunko, 1966.

Spielmann, M. H. *Cartoons from "Punch."* London: Bradbury, Agnew & Co., 1906.

Steele, M. William. "Against the Restoration: Katsu Kaishū's Attempt to Reinstate the Tokugawa Family," *Monumenta Nipponica* 34 (Autumn 1981): 299–316.

———. *Alternative Narratives in Modern Japan History*. London: RoutledgeCurzon, 2003.

———. "The Anglo-Japanese Alliance and Japanese Nationalism." *Asian Cultural Studies* 29 (March 2003): 15–25.

———. "Apocalypse Now: An Alternate View of the Bakumatsu Years." Meiji at 150: Visual Essay. University of British Columbia. https://meijiat150dtr.arts.ubc.ca/essays/steele/.

———. "*Bakumatsu mokushi roku: Mō hototsu no mikata*" 幕末黙示録:もう一つ味方 (A late Tokugawa chronicle of the apocalypse: An alternative view). In Steele, *Meiji ishin to kindai Nihon*, 63–122.

———. "*Bei-Ō kairan jikki* no henchōsha Kume Kunitake, bannen no kyōchi" 米欧回覧実記の編著者久米邦武、晩年の境地 (The compiler of *Bei-Ō kairan jikki* Kume Kunitake in his later years). In Izumi Saburō 泉三郎, ed., *Iwakura shisetsu-dan no gunzō: Nihon kindaika no paionia* 岩倉使節団の群像：日本近代化のパイオニア(A portrait of members of the Iwakura mission: Pioneers of Japan's modernization), 55–66. Kyoto: Minerva, 2019.

———. "*Bunmei kaika o kaerimireba: Kume Kunitake to sekai taisen*" 文明開化を顧みれば：久米邦武と政界大戦 (Looking back on Japan's enlightenment: Kume Kunitake and the Great War). In Steele, *Meiji ishin to kindai Nihon*, 305–32.

———. "California's Pacific Destiny." *The Journal of Social Science* 29, no. 3 (March 1991): 101–18.

———. "Casting Shadows on Japan's Enlightenment: Sada Kaiseki's Attack on Lamps." *Asian Cultural Studies*, special issue 16 (2007): 57–73.

———. "Edo in 1868: The View from Below," *Monumenta Nipponica* 45, no. 2 (Summer 1990): 127–55.

———. "Fukuzawa Yukichi and the Idea of a Shogunal Monarchy: Some Documents in Translation." *Asian Cultural Studies*, special issue 7 (1997): 17–27.

———. "Goemon's New World View." In M. William Steele, *Alternative Narratives in Modern Japanese History*, 4–18. London: RoutledgeCurzon, 2003.

———. "The Great Northern Famine of 1905–1906: Two Sides of International Aid." *Asian Cultural Studies* 39 (March 2013): 1–15.

———. "Integration and Participation in Meiji Politics." *Asian Cultural Studies* 14 (1984): 132.

———. "Katsu Kaishū and the Collapse of the Tokugawa Bakufu," PhD diss., Harvard University, 1976.

———. "Katsu Kaishū and the Historiography of the Meiji Restoration." In James C. Baxter and Joshua A. Fogel, eds., *Writing Histories in Japan: Texts and Their Transformations from Ancient Times through the Meiji Era*, 299–315. Kyoto: International Research Center for Japanese Studies, 2007.

———. "Katsu Kaishū and Yokoi Shōnan: Late Tokugawa Imaginings of a More Democratic Japan." In Gary R. Leupp and De-min Tao, eds., *The Tokugawa World*, 1125–48. London: Routledge, 2021.

———. "Kindai Nihon no honpō naru kigen: Mantei Ōga to Fukuzawa Yukichi" 近代日本の奔放なる起源:万亭応賀と福沢諭吉 (The unconventional origins of modern Japan: Mantei Ōga and Fukuzawa Yukichi). In Peter Nosco et al., eds., *Edo no naka no Nihon, Nihon no naka no Edo* 江戸のなかの日本、日本のなかの江戸 (Edo in Japan, Japan in Edo), 418–35. Tokyo: Kashiwa Shobō, 2016.

———. *Meiji ishin to kindai Nihon no atarashii mikata* 明治維新と近代日本の新しい見方 (New views of the Meiji Restoration and modern Japan). Tokyo: Tōkyōdō Shuppan, 2019.

———. "Meiji Twitterings: A Parody of Fukuzawa's *An Encouragement of Learning*." *Asian Cultural Studies*, special issue 18 (2010): 55–77.

———. "Nihon no bunmei kaika no hikari to kage: Kume Kunitake no rekishika" 日本の文明開化の光と影:久米邦武の歴史家 (Light and shadows in Japan's engagement with civilization and enlightenment: Kume Kunitake as historian). In Ō-Bei-A Kairan no Kai 欧米回覧の会, ed., *Sekai no naka no yakuwari to kangaeru* 世界の中の役割と考える (Thoughts on Japan's role in the world), 107–13. Tokyo: Keiō Gijuku Daigaku Shuppankai, 2009.

———. "Nosutarujia to kindai: Sada Kaiseki no hakuraihin haiseki undō" (Nostalgia and modernity: Sada Kaiseki and the movement against the import of foreign goods). In Steele, *Meiji ishin to kindai Nihon*, 181–201.

———. "Osoroshiki 1868 nen: Fūshiga kara miru Meiji ishin" 恐ろしき1868年: 風刺画からみる明治維新 (1868—What a terrible year: The Meiji Restoration as seen in satirical cartoons). In Steele, *Meiji ishin to kindai Nihon*, 63–121.

———, ed. *Poking Fun at the Restoration: Satirical Prints in Late 19th Century Japan*. Mitaka: ICU Hachiro Yuasa Memorial Museum, 2012.

———. "Public, Private, and National in Bakumatsu Political Thought: The Case of Katsu Kaishū." *Asian Cultural Studies*, special issue 2 (1990): 33–45.

———. "The Rise and Fall of the Shōgitai: A Social Drama." In Tetsuo Najita and J. Victor Koschmann, eds., *Conflict in Modern Japanese History*, 188–44. Princeton, NJ: Princeton University Press, 1982.

———. "The Unconventional Origins of Modern Japan: Mantei Ōga vs. Fukuzawa Yukichi." In Peter Nosco, James E. Ketelaar, and Yasunori Kojima, eds., *Values, Identity, and Equality in Eighteenth- and Nineteenth-Century Japan*, 243–61. Leiden: Brill, 2015.

Stevenson, John. *Beauty and Violence, Prints by Yoshitoshi, 1839–1892*. Bergeyk, The Netherlands: Society for Japanese Arts, 1992.

Sundberg, Steve. "Old Tokyo: Peace Commemorative Exposition, Ueno Park, 1922." Old Tokyo. http://www.oldtokyo.com/peace-commemorative-exposition-1922/.

Suzuki Hiroyuki. *Antiquarians of Nineteenth-Century Japan: The Archaeology of Things in the Late Tokugawa and Early Meiji Periods*. Translated by Maki Fukuoka. Los Angeles: Getty Research Institute, 2022.

Takada Seiji 高田誠二. *Kume Kunitake: Shigaku no megane de ukiyo no kei o* 久米邦武: 史学の眼鏡で浮世の景を (Kume Kunitake: The floating world through an historian's lens). Kyoto: Minerva, 2007.

Takagi, Hiroshi, and D. V. Botsman. "The 50th and 60th Anniversaries of the Meiji Restoration: Memory, Commemoration and Political Culture in the Pre-War Period." In D. V. Botsman and Adam Clulow, eds., *Commemorating Meiji: History, Politics and the Politics of History*, 329–41. Abingdon, Oxon: Routledge, 2022.

Takii Kazuhiro 瀧井一博, ed. *Itō Hirobumi enzetsu shū* 伊藤博文演説集 (A collection of speeches by Itō Hirobumi). Tokyo: Kōdansha, 2011.

Tanabe, Motoki 田邊幹. "Media to shite no ehagaki" メディアとしての絵葉書 (The meaning of postcards as media). *Niigata kenritsu rekishi hakubutsukan kenkyū kiyō* 3 (2002): 73–83.

Tanaka Akira 田中彰. *Hokkaidō to Meiji ishin* 北海道と明治維新 (Hokkaido and the Meiji Restoration). Sapporo: Hokkaidō Daigaku Tosho Kakōkai, 2000.

———. *Meiji ishin-kan no kenkyū* 明治維新観の研究 (A study of views of the Meiji Restoration). Sapporo: Hokkaidō Daigaku Shuppankai, 1987.

———. *Meiji ishin to seiyō bunmei: Iwakura shisetsudan wa nani o mita ka* 明治維新と西洋文明：岩倉使節団は何を見たか (The Meiji Restoration and western civilization: What did the Iwakura mission see?). Tokyo: Iwanami Shinsho, 2003.

Tanaka Satoshi 田中聡. *Kaibutsu kagakusha no jidai* 怪物科学者の時代 (The age of monster scientists). Tokyo: Sōbunsha, 1998.

Tanikawa Yutaka 谷川穣. "'Kijin' Sada Kaiseki no kindai" 「奇人」佐田介石の近代 (The modernity of that "eccentric," Sada Kaiseki). *Jinbungakuhō* (Kyoto University) 87 (2002): 57–101.

Tokutomi Sohō 徳富蘇峰. *Sekai no henkyoku* 世界の変局 (The world in a state of emergency). Tokyo: Min'yūsha, 1915.

Tōkyō Daigaku Shiryō Hensanjo 東京大学史料編纂所, ed. *Fukkoki* 復古紀 (A record of the restoration movement). 15 vols. Reprint, Tokyo: Tōkyō Daigaku Shuppankai, 1974–1975.

———, ed. *Meiji shiyō* 明治史要 (Key events in Meiji history), 2 vols. Reprint, Tokyo: Tōkyō Daigaku Shuppankai, 1966.

Tōkyō Kokuritsu Hakubutsukan 東京国立博物館, ed. *Tanjō 150 nen: Kuroda Seiki, Nihon kindai eiga no kyoshō* 誕生150年：黒田清輝、日本近代絵画の巨匠 (Born 150 years ago: Kuroda Seiki, giant of Japanese modern painting). Tokyo: Bijutsu Shuppansha, 2016.

"Tokugawa Literature." In Richard Bowring and Peter Kornicki, eds., *Cambridge Encyclopedia of Japan*, 134–40. New York: Cambridge University Press, 1993.

Totman, Conrad. *Early Modern Japan*. Berkeley: University of California Press, 1995.

Triggs, Oliver Lovell. *The Arts and Crafts Movement*. New York: Parkstone Press International, 2009.

TSP. "Meiji Taishō Shōwa dai-emaki." 明治大正昭和大絵巻 (The great picture scroll of the Meiji, Taishō, and Shōwa eras). Tsumura Special Engineering Co. http://www.tsp-giko.com/emaki/emaki.html.

Tsuchida Hironari 土田宏成. "1905 nen Tōhoku sanken kyōsaku o meguru kokunaigai no dōkō" 一九〇五年東北三年凶作をめぐる国内外の動向 (Domestic and international responses to events surround the 1905 famine in the three Tōhoku prefectures). *Nihon rekishi* 866 (July 2020): 55–71.

Tsunezuka Akira 常塚聴. "Sada Kaiseki no ningen-kan to shakai-kan" 佐田介石の人間観と社会観 (Sada Kaiseki's view of humanity and society). *Gendai to Shinran* 24 (June 2021): 2–33.

Tsūzoku kanso gundan 通俗漢楚軍談 (Military tales of the Han and the Chu, easy-to-read version). 20 vols. Kyoto: 1695.

Umebayashi Seiji 梅林 誠爾. "Sada Kaiseki ryaku nenpyō" 佐田介石略年表 (An abbreviated chronology of Sada Kaiseki). *Bunsai* 3 (March 2009): 1–11.

Vlastos, Stephen. "Opposition Movements in Early Meiji, 1868–1885." In Marius Jansen, ed., *The Cambridge History of Japan*, vol. 5: *The Nineteenth Century*, 367–431. Cambridge: Cambridge University Press, 1989.

Waley, Arthur, trans. *The Analects of Confucius*. New York: Vintage Books, 1989.

Walthall, Anne, and M. William Steele. *Politics and Society in Japan's Meiji Restoration: A Brief History with Documents*. Boston: Bedford/St. Martin's, 2017.

Warner, Langdon. "All Their Desire Is in the Work of Their Craft." Commencement address, Rhode Island School of Design, Providence, RI, 1942.

———, *The Craft of the Japanese Sculptor*. New York: McFarlane, Warde, McFarlane, 1936.

———. *Kobe to Luchu*. Unpublished travel diary. Houghton Library, Harvard University.

Wayman, Dorothy G. *Edward Sylvester Morse: A Biography*. Cambridge, MA: Harvard University Press, 1942.

Webster, Daniel. *The Writings and Speeches of Daniel Webster*. 18 vols. Boston: Little Brown and Co., 1903.

Weisenfeld, Gennifer. *Imaging Disaster: Tokyo and the Visual Culture of Japan's Great Earthquake of 1923*. Berkeley: University of California Press, 2012.

Wert, Michael. *Meiji Restoration Losers: Monarchy and Tokugawa Supporters in Modern Japan*. Cambridge, MA: Harvard University Asia Center, 2013.

Weston, Victoria. *Japanese Painting and National Identity: Okakura Tenshin and His Circle*. Ann Arbor: University of Michigan Press, 2004.

Willoughby, Martin. *A History of Postcards: A Pictorial Record from the Turn of the Century to the Present Day*. London: Bracken Books, 1994.

Wilson, George. *Patriots and Redeemers in Japan: Motives in the Meiji Restoration*. Chicago: University of Chicago Press, 1992.

Wilson, Richard L. "Modern Japanese Ceramics into Mingei: Industry, Art and Idea." In Michael L Conroy, ed., *Mingei Legacy: Continuity and Innovation through Three Generations of Modern Potters*, 13–24. Erie, CO: National Council on Education for the Ceramic Arts, 2003.

Yamada Shōji 山田昭次. *Kantō daishinsai-ji no Chōsenjin gyakusatsu to sono go: Gyakusatsu no kokka sekinin to minshū sekinin* 関東大震災時の朝鮮人虐殺とその後：虐殺の国家責任と民衆責任 (The massacre of Koreans during the Great Kantō Earthquake and its aftermath: The responsibility of the state and that of the people). Tokyo: Sōshinsha, 2011.

Yamaguchi Ken. *Kinsé Shiriaku: A History of Japan from the First Visit of Commodore Perry in 1853 to the Capture of Hakodate by the Mikado's Forces in 1869*. Translated by Ernest Mason Satow. Yokohama: Japan Mail Office, 1873.

Yamamoto Hirofumi 山本博文. *Gendaigo yaku: Fukuzawa Yukichi bakumatsu-ishin ronshū* 現代語訳福澤諭吉幕末・維新論集 (A collection of works by Fukuzawa Yukichi on the late Tokugawa and Restoration periods in modern Japanese translation). Tokyo: Chikuma Shobō, 2012.

Yamazaki, Jane. *Disasters, Rumors and Prejudice*. Charlottesville: University of Virginia Press, 1978.

Yanagi, Sōetsu [Muneyoshi], *The Unknown Craftsman*. Translation by Bernard Leach. Tokyo: Kodansha International, 1982.

Yokohama-shi Gasukyoku 横浜市ガス局, ed. *Yokohama gasushi* 横浜瓦斯史 (A history of gas in Yokohama). Tokyo: Tōkyō Gasu, 1971.

Yoshida Yutaka 吉田豊. *Edo no masukomi "kawaraban"* 江戸のマスコミ「かわら版」 (Edo mass media: *"Kawaraban"*). Tokyo: Kōbunsha, 2003.

Yūsei Hakubutsukan 郵政博物館 (Postal Museum Japan). "Nihon saisho no yūbin hagaki" 日本の最初の郵便はがき (Japan's first postal card). https://www.postalmuseum.jp/column/collection/post_8.html.

Zhong, Yijian. "Formation of History as a Modern Discipline in Meiji Japan." Asian Research Institute Working Paper Series, no. 191 (October 2012): 3–20. National University Singapore. https://ari.nus.edu.sg/wp-content/uploads/2018/10/wps12_191.pdf.

Newspaper References

"All Eager to Save Japan." *Christian Herald*. February 21, 1906, 159.
"The Alliance." *Japan Weekly Mail*. February 22, 1902.
"Alliance Honors." *Japan Times*. March 1, 1902, 2.

"American and Japanese Intercourse." *Sacramento Daily Union*. May 25, 1852.
"The Anglo-Japanese Agreement." *Manchester Courier and Lancashire General Advertiser*. February 12, 1902.
"An Anglo-Japanese Alliance." *Graphic*. February 22, 1902.
"The Anglo-Japanese Alliance." *Japan Times*. February 13, 1902.
"The Anglo-Japanese Alliance." *Japan Weekly Chronicle*. March 1, 1902.
"The Celebrations." *Daily Alta California*. October 31, 1850.
"Charity Thrown Away." *Eastern World*. March 24, 1906, 5.
"China and Japan." *Daily Alta California*. March 5, 1851.
"China Correspondence." *Daily Alta California*. August 9, 1852.
"Christian America's Gift to Japan." *Christian Herald*. March 28, 1906, 279.
"Commercial Intercourse with Japan." *Daily Alta California*. July 8, 1851.
"Commercial Supremacy of the Pacific Coast." *Daily Alta California*. March 13, 1851.
"Commodore Perry's Squadron." *Gleason's Pictorial*. February 12, 1853.
"Dōmei shukuga ni yōbekarazu" 同盟祝賀に酔べからず (Do not get drunk on the alliance celebrations). *Yorozu chōhō* 万朝報. February 23, 1902.
"The Earthquake in San Francisco." *Japan Weekly Mail*. April 21, 1906.
"To the Editor of the *Chronicle*." *Japan Weekly Chronicle*. January 11, 1906, 54.
"To the Editor of the *Chronicle*." *Japan Weekly Chronicle*. February 22, 1906, 245.
"Editorial." *Daily Alta California*. February 1, 1853.
"Editorial." *Daily Alta California*. May 9, 1853.
"Editorial." *Daily Alta California*. September 20, 1853.
"Editorial." *Daily Alta California*. October 18, 1853.
"Editorial." *Daily Alta California*. June 8, 1854.
"Editorial." *Japan Times*. March 4, 1902, 2.
"The Famine." *Japan Weekly Chronicle*. February 15, 1906, 190–91.
"Famine in Japan Feared." *New York Times*. October 28, 1905.
"The Famine in Japan: Selling the Children for Money." *Auckland Star*. December 30, 1905.
"The Famine in the North." *Japan Weekly Mail*. March 3, 1906, 225.
"The Famine-Stricken Districts." *Japan Weekly Mail*. February 3, 1906.
"Fighting Back Famine in Japan." *Christian Herald*. February 7, 1906.
"Final Statement of the Foreign Committee of Relief for the Famine in North Japan." *Japan Weekly Mail*. July 28, 1906.
"First $10,000 for Starving Japan." *Christian Herald*. May 30, 1906.
"From Japan Comes Reports of Famine and Starvation in Many Districts—Thousands are Dying." *Daily Press, Newport News*. February 4, 1906, 4.

"Fugō no gien" 富豪の義捐 (Donations of the wealthy). *Asahi shinbun* 朝日新聞. February 5, 1906.

"Gentō saishin eiga Tōhoku kikin" 幻灯最新映画東北飢饉 (Magic lantern new images Tōhoku famine). Advertisement. *Asahi shinbun*. February 25, March 17, March 27, April 20, April 26, 1906.

"Gikin" 義金 (Relief funds). *Asahi shinbun*. July 3, 1885.

"Government Famine Relief." *Japan Weekly Mail*. January 20, 1906.

"An Hour with the Japanese." *Daily Alta California*. March 17, 1851.

"Hundreds Now Dying of Famine." *Christian Herald*. March 7, 1906, 202.

"Intercourse with Japan." *Daily Alta California*. March 6, 1851.

"Intercourse with Japan." *Daily Alta California*. March 26, 1851.

"Intercourse with Japan." *Daily Alta California*. July 29, 1851.

"Interesting from Japan—Captain Burrows at Jeddo Bay." *San Joaquin Republican*. January 26, 1855.

"Interesting Political Occurrences in North Eastern Asia." *Daily Alta California*. March 5, 1853.

"The Island of Formosa." *Daily Alta California*. April 17, 1851.

"Japan." *Daily Alta California*. December 2, 1852.

"Japan." (From the *Polynesian*). *California Star*. February 19, 1848.

"The Japanese at the Ball." *Daily Alta California*. March 20, 1851.

"Japan: The Boy King." *New York Times*. December 15, 1868, 12.

"The Japanese Famine." *Poverty Bay Herald*. June 18, 1906, 3.

"The Japanese Press on the ALLIANCE." *Japan Weekly Mail*. February 15, 1902.

"The Japan Expedition." *Daily Alta California*. June 21, 1852.

"The Japan Expedition." *Daily Alta California*. December 3, 1852.

"The Japan Expedition." *Daily Alta California*. December 6, 1852.

"The Japan Expedition." *Daily Alta California*. January 11, 1853.

"Japan Famine Most Terrible of Late Years: One Million Estimated to be Starving." *Los Angeles Herald*. March 23, 1906, 2.

"Japan Famine Relief Fund: Subscription to be Opened in University toward Relief of Japanese Famine." *Harvard Crimson*. March 27, 1906.

"Japan in Famine's Grasp." *Christian Herald*. January 31, 1906, 87.

"Japan Needs Our Aid." Editorial. *Christian Herald*. January 31, 1906, 88.

"Japan's Famine Appeal Is Heard." *Christian Herald*. February 14, 1906, 137.

"Japan's Famine Siege Lifted." *Christian Herald*. May 2, 1906, 394.

"The Japan Squadron." *Daily Alta California*. May 1, 1852.

"Keiō Gijuku seito no kyoka gyōretsu" 慶応義塾生徒の炬火行列 (The torchlight parade of the Keiō Gijuku students). *Jiji shinpō* 時事新報. February 15, 1902.

Kinji gahō 近事画報 (The Japanese graphic). "Tōhoku kikin gō" 東北飢饉号 (Special issue on the Tōhoku famine). No. 80. February 1, 1906.

"Kume Kunitake hakushi yuku" 久米邦武博士逝く (Dr. Kume Kunitake passes away). *Asahi shinbun*. February 25, 1931, morning edition, 11.

"Kyōsakuchi gienkin" 凶作地義捐金 (Charity donations for the famine district). *Asahi shinbun*. July 9, 1906.

"Kyōsakuchi gokyūjutsu" 凶作地の御救恤 (Imperial relief donations for the famine district). *Asahi shinbun*. February 1, 1906.

"Kyōsaku kyūsai gienkin" 凶作救済義捐金 (Charity donations for famine relief). *Asahi shinbun*. January 23, 1906.

"The Lady Pierce's Visit to Japan." *Daily Alta California*. October 20, 1855.

"Late and Important from China." *Sacramento Daily Union*. July 11, 1853.

"Letter from China." *Daily Alta California*. October 30, 1854.

"Letter from China." *Daily Alta California*. November 4, 1854.

"Madera County Will Respond to Call of Distressed Nippon." *Madera Tribune*. September 6, 1923.

"Many Japanese Perishing." *New York Times*. February 21, 1906, 5.

"Miyagi-ken kikin kyūsai gien" 宮城県飢饉救済義捐 (Charity donations for famine relief in Miyagi prefecture). *Asahi shinbun*. December 7, 1905.

"Monthly Summary of the Religious Press." *Japan Weekly Mail*. April 2, 1892.

"More Aid for Japanese." *New York Times*. March 31, 1906.

"The Movement of the Age." *California Star*. November 27, 1847.

"Mr. Kato and Count Okuma." *Japan Weekly Mail*. February 15, 1902, 167.

"Mr. and Mrs. Wilson in Sendai." *Japan Weekly Mail*. May 19, 1906.

"Naval Expedition to Japan." *New York Times*. April 11, 1853.

Nelson, Katie. "S.F. Hopes to Return Favor to Japan over '06 Quake." *The Daily*. April 17, 2011. https://www.sfgate.com/bayarea/article/S-F-hopes-to-return-favor-to-Japan-over-06-quake-2375038.php.

"News from China." *Daily Alta California*. June 10, 1853.

"News from Japan." *Daily Alta California*. June 8, 1854.

"News from the *Polynesian*." *Californian*. November 14, 1846.

"Nichi-Ei dōmei" 日英同盟. *Niroku shinpō* 二六新報. February 14, 1902.

"Nichi-Ei dōmei oyobi sono shōrai" 日英同盟及其将来 (The Anglo-Japanese alliance and its future). *Kokumin shinbun* 国民新聞. February 14, 1902.

"Nichi-Ei kyōyaku shukuga kyoka gyōrestu" 日英協約祝賀炬火行列 (Torchlight procession to celebrate the Anglo-Japanese alliance). *Jiji shinpō*. February 14, 1902.

"Ōsaka no Nichi-Ei dōmei shukugakai" 大阪の日英同盟祝賀会 (Anglo-Japanese alliance celebrations in Osaka). *Jiji shinpō*. February 24, 1902.

"O te shaku" お手爵 (The count filling his own glass). *Maru maru chinbun* 団団珍聞. March 8, 1902, 5.

"Our Japanese Correspondence." *Daily Alta California*. October 10, 1859.

"President Aids Japanese: Issues an Appeal for Aid for the Famine Suffers." *New York Times*. February 14, 1906.

"The President and the Famine Fund." *Christian Herald*. April 6, 1906, 299.

"The Progress of Annexation—Our New Territory on the Pacific." *California Star*. June 12, 1847.

"Reconstruction of Tohoku Region to Test Commitment of 'Self-Help' Suga." *Asahi Shimbun*. September 21, 2020.

"The Red Cross in Japan." *Christian Herald*. March 7, 1906, 203.

Sada Kaiseki 佐田介石. "Ranpu bōkoku no imashime" ランプ亡国の戒め (Lamps and national collapse, an admonition). *Tōkyō nichi nichi shinbun* 東京日日新聞. 2 parts. July 16 and 18, 1880.

"The San Francisco Earthquake." *Japan Weekly Mail*. May 5, 1906.

"Sanfuranshisuko shinsai imonkin" 桑港震災慰問金 (Sympathy donations for the San Francisco earthquake disaster). *Jiji shinpō*. April 24, 1906.

"Sate goshōkai itashimasu wa . . ." さて御紹介いたしますは . . . (Now, let me introduce to you . . .). *Asahi gurafu* 朝日グラフ. November 21, 1923, 9.

"Scenes in the Land of Famine." *Christian Herald*. March 14, 1906, 223.

"Seidai ni gashisha" 聖代に餓死者 (People starving to death in the imperial reign). *Asahi shinbun*. February 14, 1906.

"Shakoku" 社告 (Company notice). *Asahi Shinbun*. April 11, 1906.

"Sheltering Japan's Famine Waifs." *Christian Herald*. May 30, 1906, 479.

"680,000 Japanese Are Now Starving." *New York Times*. January 20, 1906, 5.

"Something New." *Daily Alta California*. March 18, 1851.

"Song of Anglo-Japanese Alliance." *Japan Times*. February 15, 1902.

"The Spirit of Conquest." *Daily Alta California*. October 26, 1851.

"Survey of the Route between China and California." *Daily Alta California*. March 7, 1852.

"Tenkenron." 天譴論 (On heaven-sent retribution). *Hōchi shinbun*. September 10, 1923.

"$379.63 for Japan Relief Fund." *Harvard Crimson*. April 23, 1906.

"Tōhoku chihō kyūmin kyūjutsu gikin boshū" 東北地方窮民救恤義金募集 (Solicitation of contributions for the relief of distressed people in the Tōhoku region). *Jiji shinpō*. November 7, 1905.

"Tōhoku kikin kyūsaikin boshū shimekiri" 東北飢饉救済金募集締切 (Tōhoku famine relief subscription for funds closes). *Jiji shinpō*. April 28, 1906.

"Tōhoku kikin shisatsu" 東北飢饉視察 (Observations of the Tōhoku famine). *Jiji shinpō*. November 5, 1905.

"Tōhoku kikin to Shinpotō" 東北飢饉と進歩党 (The Tōhoku famine and the Progressive Party). *Asahi Shinbun*. October 26, 1905.

"Tōhoku kyōsaku no kekka" 東北凶作の結果 (The results of the Tōhoku famine). *Asahi shinbun*. December 30, 1905.

"Tōhoku kyūjutsukai heisa" 東北救恤会閉鎖 (Tōhoku charity fund closes). *Asahi shinbun*. May 9, 1906.

"Tōhoku sanken kyūjutsukin" 東北三県救恤金 (Money collected by the Association for Relief to the Three Tōhoku Prefectures). *Asahi shinbun*. May 10, 1906.

"Torch-light Procession of the Keio-Gijuku Students." *Japan Times*. February 16, 1902.

"Yamato-hime" やまとひめ (Princess Yamato). *Jiji shinpō*. February 18, 1902, 3.

"Yokohama Nichi-Ei dōmei shukuga tenka undō-kai" 横浜日英同盟祝賀点火運動会 (Anglo-Japanese alliance fireworks and procession in Yokohama). *Jiji shinpō*. February 26, 1902.

"West Moving West." *Daily Alta California*. July 10, 1851.

Index

Page numbers in *italics* indicate illustrations. Titles of works appear under the author's name after other subentries.

Abe Tokusaburō, 258
Adams, Will, 226
Aikokusha (Patriotic Society), 113
Akechi Mitsuhide, 72
Alcock, Rutherford, 202
alternative narratives, 3, 153–55, 236, 262, 309
Ambros, Barbara, 45
American Red Cross, 237, 244, 255
Amity and Friendship Treaty (1860), 35, 51
Anglo-Japanese Alliance (1902), 5, 219–34, *224–25*, 247, 305; Emperor Meiji and, *231*; flag of, *227*; Princess Yamato and, *233*
Ansei Edo earthquake (1855), 49, *49–50*, 53, 263, 273–76, 280
Ansei purge (1858), 34
Aosen (brass coin), 42
Arisugawa Taruhito, 95, 98
Arts and Crafts movement, 5, 200, 202–3, 217–18
Asakusa district, 252, 265, 277
Asakusa Sensōji (temple), 45
Asakusa Twelve Stories building, 265, 276, *276–77*
Ashio Copper Mine, 170
Atsuhime (aka Tenshō-in), 86, 87, 91, *93*, *96*
Aulick, John H., 11–12, 17, 21

Axling, William, *241*
Azuma Zensaku, 305

Baxter, Sylvester, 206
Bennett, Nathaniel, 10
Benzaiten (deity), 47
Biddle, James, 9
Bigelow, William Sturgis, 207
Bismarck, Otto von, 295–96
"blood tax" riots (1873), 106–7
bokumin (caring for the people), 160–61
Boshin Civil War (1868–1869), 53–54, 74, 75, 82–84, 91, 100
Boxer Rebellion (1900), 220
Buckle, Henry, 152
Bukō nenpyō, 45n33, 46, 47, 50–53
Bunkyū-sen (copper coin), 42
Bunsei era (1818–1830), 299
Bureau of Historical Compilation, 151
Buretsu, Japanese emperor, 132
Burke, Peter, 31
Burrows, Silas E., 24–26
Burton, William, 276
bushido values, 171–72, 175–76, 186–87, 190, 193, 299

calendars, xvii
California, 7–28, *12*; gold rush in, 9, 10, 26
calligraphy, 210

Carlyle, Thomas, 202
cartoons. See *fūshiga*
Carus, Paul, 198
"catfish prints" (*namazu-e*), 50, 263, 273, 280
Chamberlain, Basil Hall, 204–5
cholera, 34, 42, 51, 51–52, 158
Civil War (US), 68, 100, 164n52
civilization and enlightenment movement, 204, 278; Fukuzawa Yukichi on, 60, 104, 149, 152–53, 171; Kanagaki Robun on, 107; Kume Kunitake on, 6, 282–303; Mantei Ōga on, 4, 126; Sada Kaiseki on, 103, 106, 111–12, 124
Clark, E. Warren, 2, 162, 164n52
Confucianism, 127, 136, 145n18, 175; economic ideas of, 112; Kume on, 295–96
consumerism, 278
copyright laws, 138n13
Craig, Albert, 3, 57, 59
cultural hybridity, 5, 198–200, 216

Davison, C. S., 241
Dee-yee-no-skiee (aka Yūnosuke), 25–27
DeForest, John Hyde, 240, 241
deltiology (postcard collecting), 268, 272, 281
Denkichi (aka Iwakichi), 13–14, 25n54, 26–27
Dickinson, Frederic, 307
Ding Gu (aka Ding Gong), 188n28
disaster broadsheets. See *kawaraban*
disaster stories in Kaei chronicle, 29–30, 47–56, 49–52
Dower, John, 260
Dyer, Anna H., 204

Edo, 305, 306; coastal fortresses of, 42; earthquake of 1855, 49, 49–50; fire of 1859, 52, 53; Katsu on, 38; measles epidemic in, 52; police of, 37, 38
Edo Association, 154–55

Edward VII of United Kingdom, 223, 231, 232
ehagaki. See postcards
Ekōin temple, 45–46, 46
enlightenment. See civilization and enlightenment movement
Enomoto Takeaki, 5, 151; career of, 172–73; Fukuzawa on, 171–72, 175–79, 191–97; *Kanrin Maru* monument and, 177, 177–78; Katsu and, 192

Fenollosa, Ernest, 198, 199, 207, 209–12, 211
Fillmore, Millard, 11
Forbidden Gate Incident (1864), 35–36, 53
Foreign Committee of Relief for the Famine in North Japan, 240–42, 241, 247, 255–58
Forrest, G. R., 241
Freer, Charles Lang, 207
Fudō Myōō (deity), 107
Fukagawa storm (1856), 50, 50–51
Fukkoki, 151–52
Fukoku ayumi no hajime, 113–18, 114–15
Fukuchi Gen'ichirō, 155
Fukushima nuclear accident (2011), 236, 263, 266
Fukuzawa Einosuke, 60
Fukuzawa Ichitarō, 223
Fukuzawa Yukichi, 4–5, 57–74, 149, 234; on Anglo-Japanese Alliance, 221–22; autobiography of, 57, 60n8, 175n11; on civilization and enlightenment movement, 60, 104, 149, 152–53, 171; on Confucianism, 127; on enlightenment, 104, 152–153; on Enomoto, 171–72, 175–79, 191–97; on Japan's future, 58–61, 161, 208; on Katsu, 58, 64, 171–79, 189–91, 196–97; Mantei and, 107–8, 126–29; on Meiji Restoration, 169; on Perry's arrival, 152; portraits of, 60, 174; Sada and, 111–13; on Sino-Japanese

INDEX

War, 174, 177, 178, 221; *Bunmeiron no gairyaku*, 152; *Gakumon no susume*, 5, 126–27, 138n13; *On Fighting to the Bitter End*, 5, 169–97; *A Petition on the Subjugation of Chōshū*, 57–58, 61–74, 65; *Seiyō jijō*, 59, 63, 104
fūshiga (satirical cartoons), 76–102, 79, 81

Gaigokyō, 136
Gaozu, Han emperor, 188
"General (or Brother) Jonathan," 22n41
Genji yume monogatari, 36, 49, 51, 53, 55–56
Ginza district, 278
gokoku (protecting the nation), 109
Gokokusha (Protect the Country Society), 113
Gotō Shinpei, 292
Gotō Shōjirō, 153
Great Buddha in Ueno Park, 278–79, 279
Great Inflation (1864–1868), 40–44, 41
Great Kantō Earthquake (1923), 6, 261, 263–81, 305, 309; map of burned area, 274; postcards of, 264, 265, 268, 271, 272, 275–79
Great Peace Commemorative Exposition (1922), 307, 307–8
great picture scroll. *See Meiji Taishō Shōwa dai-emaki*
Great Tōhoku Famine (1905–1906), 5–6, 235–62, 241, 245, 250–52
Griffis, William, 162n48

Hamada Shōji, 198, 201–2, 217
Han Xin (d. 196 BCE), 177n14
Harding, Warren G., 299
Harootunian, Harry, 3
Harris, Townsend, 27, 261
Harvard Mission, 246–47
Hattori Ōga. *See* Mantei Ōga
Hawai'i, 9–10

Hayashi Tadasu, 220, 228
Heco, Joseph (aka Hamada Hikozō), 13–14, 16, 25n54, 26–27
Higuchi Takehiro, 176
Hioki Eki, 248
Hitotsubashi Yoshinobu. *See* Tokugawa Yoshinobu
Hōkokusha (National Service Society), 113
Honnōji Incident (1582), 72n29
Huangdi (Yellow Emperor), 159
Hughes, H. Stuart, 3–4
humanitarian aid, transnational, 235–62, 241, 245, 250–52

Ii Naosuke, 30, 34, 53
imported goods. *See* movement against imported goods
Inoue Kowashi, 112
International Christian University (ICU), 1–2, 74
International Committee of the Red Cross, 239
Ishii Jūji, 249
Isshu-gin (silver coin), 41–42
Itō Chūta, 304
Itō Hirobumi, 75, 100, 160, 161, 283–84
Itō Sōin, 142–43
Iwakura Mission (1871–1873), 6, 75, 305; Kume on, 282–86, 289–91, 296, 300
Iwakura Tomomi, 154, 282, 283
Iwasaki family, 255
Iwo Jima, Battle of (1945), 7

Jacquet, C., 241
James, Henry, 290
Japan Relief Fund, 242–44, 246
Japanese Red Cross, 235, 237, 244, 257–58, 262; membership of, 239; San Francisco earthquake and, 260–61
Jimmu Emperor, 151, 168
Jitsugokyō (Teachings of true words), 135–36
jōi movement (expel the barbarians), 66, 103, 109, 125, 173

Kaei chronicle, 29–56, 32–33, 49–52, 304
Kaei period (1848–1855), 142
kaichō events, 44–47, 46, 47, 55
Kamata Eikichi, 65
Kanagaki Robun, 107
Kanagawa Treaty (1854), 23–24, 48, 142n15
Kanda district, 43, 53
Kan'eiji temple, 39
Kangxi, Qing emperor, 188
kankōtō lamps, 123
Kanrin Maru (ship), 2, 59, 156, 173; attack on, 176–78, 177, 195
Kansei era (1789–1801), 299
Kantō Earthquake (1923). *See* Great Kantō Earthquake
Katō Tadaaki, 232
Katsu Kaishū (aka Katsu Awa), 2–3, 38, 91, 148–70, 185; autobiography of, 175n11; career of, 156, 172, 173; death of, 156; Fukuzawa on, 58, 64, 171–79, 189–91, 196–97; Oguri and, 62; portrait of, 157; Saigō and, 2, 87–90, 156, 305, 306; writings of, 5, 149, 157–58; on Yoshinobu, 148, 163–69; *Bakufu shimatsu*, 148, 161–63, 166–67, 168; *Kaikoku kigen*, 158; *Keizai zassan*, 158; *Suijin yoroku*, 157, 159; *Suijinroku*, 157–60
Katsu Kokichi, 2, 155
Katsura Tarō, 221, 228
Kawai Kanjirō, 201–2
Kawanabe Kyōsai, 107, 108, 128, 134, 143
Kayahara Kazan, 292
Kazunomiya (aka Seikan'in-no-miya), 80, 85–86, 93–94; cartoons of, 79, 81, 86, 87, 93, 96
Keichō era (1596–1611), 145–46
Keiō era (1865–1868), 76
Kennan, George, 239
Kikukadō company, 271–72, 272
Kimura Kaishū, 59, 62, 154; Fukuzawa and, 173, 178–79

Kinkazan island, 46–47, 47
Kinsei shiryaku, 56
Kishi Ka'ichirō (aka Shōji Ka'ichirō), 73
Kita Ikki, 301
Klopsch, Louis, 238–39, 242, 244, 245
Kōda Hikoemon (aka Kōda Tadayuki), 188n30
kōdō (public principles), 180
Kojima family, 77
Kōmei Emperor, 36
Komura Jutarō, 228, 247
Konishi, Sho, 262
Konkōkyō religion, 44
Korea, 220, 232, 305
Kōshin religion, 44
Koyama Shōtarō, 210
Kudō Tetsurō, 273
Kume Kunitake, 6, 168, 282–303; autobiography of, 282, 291–95, 302–3; on bushido tradition, 299; as historian, 283, 289–91; on Iwakura Mission, 282–86, 289, 291, 296, 300; on militarism, 295–96, 298–303; on museums, 286–87; on Paris Peace Conference, 298; portraits of, 284, 285; on Tokugawa shogunate, 299, 302; on United States, 293–94, 299; on Western technology, 287–88, 292–96, 298–302; on World War I, 286, 292–300, 302
Kumoura Tōgan, 232
Kurimoto Jōun, 112, 154
Kuroda Kiyotaka, 192n34
Kuroda Seiki, 199
Kurozumikyō religion, 44
Kuwada Hikoemon, 188
Kyoto: Chōshū radicals in, 61; Great Fire (1864) of, 36, 37, 55–56; Kaei chronicle on, 35–36

Lampe, William E., 239–40, 241, 243–44, 255–57
Lansdown, Lord (Henry Petty-Fitzmaurice), 220

INDEX

Leach, Bernard, 5, 198, 200–201, *201*, 217
League of Nations, 298, 301, 302
Lears, T. J. Jackson, 200
Levine, Lawrence, 305
Lincoln, Abraham, 164n52
literacy, 78
Longmen Grottoes, 215
lunisolar calendar, xvii

Macdonald, Claude, 223
Machiavelli, Nicolò, 64
Madden, M. B., 241
Manchurian Incident (1931), 303
Mansion House Famine Fund, 247
Mantei Ōga, 4–5, 126–27; *Kinsei akire gaeru*, 107, *108*; *Sparrows at the Gates of Learning*, 108, 126–47, *134*, *143*
Maruzen Bookstore, 278, 279
Mashiko pottery village, 198
Matsudai banashi hakiyose zōshi, 52
Matsudaira Yoshinaga, 110
Matsukata Masayoshi, 158, 159, 161, 244
Matsuura Rei, 2
Matsuura Takeshirō, 208–9, *209*
measles, 51–52, *52*
Meiji Constitution (1889), 305
Meiji Emperor, 36, 98, 150–51; Anglo-Japanese Alliance (1902) and, 231, 232
Meiji period (1868–1912), 103–4, 197, 208, 234
Meiji Restoration (1868–1869), 3, 8, 29, 76; alternative narratives of, 153–55; Fukuzawa on, 169; great picture scroll on, 304–5, *306*; histories of, 56; Kaei chronicle on, 31; Katsu on, 148–70; orthodox view of, 150–53
Meiji Shiyō, 151–52
Meiji Taishō Shōwa dai-emaki, 304–9, *306–8*
Meirokusha (organization), 112
Meng qui (*Mōgyū*), 127n2

Mertz, John, 107
Mexican-US War (1846–1848), 9
Mikawa warriors, 181, 182n22, 183–85, 197
militarism, 295–96, 298–303, 306
millennialism, 44, 47
mingei (folk craft) movement, 198–218. *See also* Arts and Crafts movement
Miroku, Buddha of the future, 44, 47
Mitsui family, 255
Mitsukoshi department store, 278
Mitsumura Toshimo, 270–71
Miyake Setsurei, 212
Miyatake Gaikotsu, 272–74
Moeran, Brian, 218
Mokujiki Shōnin, 201
Montesquieu, 125
Morris, William, 203, 217
Morse, Edward Sylvester, 198, 199, 202, 204–9, *206*
Mount Bandai eruption (1888), 239
Mount Fuji, 44, 273, 297
movement against imported goods, 4, 103–4, 109–18, *114–15*, 123–25
museums, 286–87
Mushanokōji Saneatsu, 301
Mutsuhito, Prince, 36

Nagasaki, 156
Nakahama Manjirō, 26–27
Nakamura Masanao, 112
Nakayama Naruchika, 182
namazu-e ("catfish prints"), 50, 263, 273, 280
nationalism, 5, 175, 219–34; Anglo-Japanese Alliance and, 222–34; bushido values and, 171, 172; modernization and, 199–200, 234
Niiro Chūnosuke, 214
Nitobe Inazō, 171
Nōbi earthquake (1891), 239
Norton, Charles Eliot, 203

Obata Tokujirō, 223–25
Oda Nobunaga, 72, 188

Oda Nobutada, 72n29
Oda Nobutaka, 188
Odaiba-gin (silver coin), 42
Odawara earthquake (1854), 48
Ōga. *See* Mantei Ōga
Ogata Kōan, 59
Oguri Tadamasa, 59, 62, 163
Okada Kōyō, 273
Okakura Kakuzō (aka Tenshin), 198, 199, 208–17, *211*
Ōkawa Shūmei, 301
Okayama Orphanage, 249
Ōkubo family, 48
Ōkubo Toshimichi, 94–95
Ōkuma Shingenobu, 222, 291, 297
Ōmura Masujirō, 91
oral histories, 154
Osaka: flood of 1868 at, 54; National Service Society of, 113; tidal wave of 1854 at, 48–49, *49*
Osatake Takeki, 304
Osborne, Thomas J., 26, 28
Oyamada Yoshikuni (aka Oyamada Nobushige), 188

Paris Peace Conference (1919–1920), 298
Parkes, Harry, 69
Patch, Sam (aka Sentarō), 13–14, 16, 26–27
Peace Commemorative Exposition (1922), 307, 307–8
Peng (deity), 134
Perry, Matthew C., xvii, 1–3, 7–8; Aulick and, 11–12; Fukuzawa on, 152; Japanese inflation and, 40–44; Kaei chronicle on, 31–34, *33*, *34*
Pierce, Franklin, 22
postcards (*ehagaki*), 6, 263–81; collections of, 268, 272, 281; examples of, *264*, *265*, *268–72*, *275–79*; history of, 267–68

Raleigh, Walter, 22
Rambelli, Fabio, 125

Reiss, Ludwig, 290
rice price inflation, 41, 42–44, 55
Rikkyo University, 291
Rinnōji-no-miya (aka Kitashirakawa Yoshihisa), 98n20
Robertson Scott, J. W., 200
Robun, Kanagaki, 107
Roches, Léon, 61, 62
ronin insurgents, 35, 36–37
Roosevelt, Theodore, 237, 244, 245, 260
Ross, Denman Waldo, 207–8
Ruskin, John, 202–3, 217
Russian Revolution (1917), 301
Russo-Japanese War (1904–1905), 5, 220, 230–31, 239, 260; picture scroll on, 305; postcards of, 267, 269; Tōhoku Famine after, 235, 237, 242, 248
Ryōunkaku building, 265, 276, 276–77
Ryūchikai (Dragon Pond Society), 210

Sada Kaiseki, 4, 103–25; on civilization and enlightenment movement, 103, 106, 111–12, 124; education of, 105; Fukuzawa and, 111–13; Mantei and, 126; on movement against imported goods, 109–18, *114–15*, 123–25; *Baka no banzuke*, 118–22, *119–21*; *Fukoku ayumi no hajime*, 113–18, *114–17*; *Fukokuron*, 110; *Saibai keizai ron*, 111–12; *Yo naoshi iroha uta*, 118
Saigō Takamori, 38, 165, 173; Katsu and, 2, 156, 166, 172, 305, 306
Sakamoto Ryōma, 61
Sakuma Shōzan, 2
Sakurada Gate, Battle at (1860), 34
San Francisco, 7–11, 12, 260–61, 267
Sanjō Sanetomi, 154
Sanriku earthquake and tsunami (1896), 239
satirical cartoons (*fūshiga*), 74–102, *79*, *81*
Satow, Ernest, 68

Satsuma Rebellion (1877), 153, 305
Shandong, 297, 301
Shibayama Niō temple, 46
Shibusawa Eiichi, 277
Shibusawa Keizō, 218
Shidehara Kijūrō, 301
Shigeno Yasutsugu, 112, 168, 289–90
shijō (private emotions), 180n20, 195
Shimazu Hisamitsu, 153
Shimazu Nariakira, 153
Shimonoseki, battles of, 67
Shimotsuke uprising (1861), *35*
Shin-Yoshiwara, 265
Shinagawa Yajirō, 96n18
Shinohara Chūemon, 27
Shintoism, 291
shipwreck survivors, 13–14, 25
Shizuoka Academy, 162
Shōgitai loyalists, 39, 55, 167
Shōmen Kongō (deity), 44
Shōtoku Taishi, 302
Shun, Chinese sage king, 132
Shuri Palace, 215
Sima Qian, 178n14, 194n36
Sino-Japanese War (1894-1895), 171, 220, 232, 239, 305; Fukuzawa on, 174, 177, 178, 221
smallpox, 51
Smiles, Samuel, 112
Smith, Adam, 175
Smith, Henry, 208
Society for the Narration of History, 154
Song dynasty (960–1279), 2, 183–84
Songō Incident, 182n21
Spanish-American War (1898), 267
Spengler, Oswald, 292
Stickley, Gustav, 203–4
Suga Yoshihide, 236
sugoroku board game, 30, 54
sumo wrestling, 45, 118
Suzuki Daisetsu, 198

Tagore, Rabindranath, 212
Taguchi Ukichi, 112, 152, 291

Taikun monarchy, 59, 60, 173
Taishō period (1912–1926), 276, 278, 280
Takamura Toyochika, 218
Takeda Katsuyori, 188
Takeda Shingen, 188n29
Takimoto Seiichi, 64–65
Tayasu Kamenosuke, 80, 167
tea ceremony, 198, 206, 213
Tenpō reforms (1841–1842), 77
Tenrikyō religion, 44
Toba-Fushimi, Battle of (1868), 80, 83, 84, 163, 164, 167, 184–85
Tōhoku Earthquake-Tsunami (2011), 236
Tōhoku Famine (1905–1906), 5–6, 235–62, 241, 245, 250–52
Tōhoku Sanken Kyūjutsukai (Association for Relief to the Three Tōhoku Prefectures), 255
Tokugawa Iemochi, 30, 35, 36, 62
Tokugawa Iesada, 34, 51–52, 86
Tokugawa Iesato, 167
Tokugawa Ieyasu, 146, 168, 182n22, 183
Tokugawa Ieyoshi, 48
Tokugawa Nariaki, 87, 154–55
Tokugawa shogunate, 29, 151–52, 186–87; families of, 86, 183–85; Fukuchi on, 155; Kaei chronicle of, 30–56, *32–33*; Katsu on, 148, 185–86; Kume on, 299, 302; Shōgitai of, 55; shrines of, 156, 165; US mission of, 35
Tokugawa Yoshinobu, 36–37, 62, 76–84, 90–93, 97, 110, 173; cartoons of, 79, 85–87, 90, 93, *95–97*, *101*, *110*; Katsu on, 148, 163–69
Tokutomi Sohō, 292
Tōkyō Puck, 253, 254
Tomimoto Kenkichi, 218
Tomita Tetsunosuke, 162, 255
Tōshōgū shrine, 156
Toyotomi Hideyoshi, 72, 188

transnational humanitarian aid, 235–62, 241, 245, 250–52
Troy, Thomas, 16
Tsukioka Yoshitoshi, 100

Ueki Emori, 153
Ueno Hill: Battle of 1868 on, 30, 39, 39–40, 54, 60n8, 76, 91; Tokugawa temple on, 80
Ueno Park: Great Buddha in, 278–79, 279; Peace Commemorative Exposition in, 307, 307–8
Umezu Kesagorō, 251
universal suffrage, 305, 308
Utagawa Hiroshige, 51
Utagawa Hiroshige III, 75, 79, 95, 97
Utagawa Kuniteru, 98
Utagawa Kuniyoshi, 77
Utagawa Yoshifuji, 104, 105
Utagawa Yoshimori, 82–83, 83

Wakatsuki Reijirō, 308, 308–9
Warner, Langdon, 214, 214–16
Webster, Daniel, 11, 16
Weisenfeld, Gennifer, 274, 276–77
Weld, Charles, 207
Western technology: Kume Kunitake on, 287–88, 292–96, 298–302; Sada Kaiseki on, 4, 109–18, 114–15, 123–25. *See also* civilization and enlightenment movement
Whitman, Walt, 26
Wilson, Huntingdon, 261
Wilson, Richard, 218
world renewal (*yonaoshi*), 44
World War I, 6, 285, 292, 305; Great Peace Commemoration Exposition after, 307, 307–8; Kume Kunitake on, 286, 292–300, 302; Paris Peace Conference of, 298
World War II, 306
Wright, Frank Lloyd, 199

Xiang Yu, Chinese king, 176, 193–95
Xie Fangde, 2

Yamaguchi Ryōzō, 64, 73n31
Yamato, Princess, 232–34, 233
Yan Fu, 292
Yanagi Sōetsu (aka Muneyoshi), 5, 198, 200–204, 201, 208, 210, 216–18
Yanaka Tennōji temple, 43
yasegaman (fighting to bitter end), 181
Yasuda Zenjirō, 255
Yellow Emperor (Huangdi), 159
"Yellow Peril," 260
Yerba Buena. *See* San Francisco
Yijing (Book of Changes), 123–24
Yodo River flood (1868), 54
Yokohama earthquake (1923), 263–81
"Yokohama Gold Rush," 40
Yokoi Shōnan, 58
Yokoyama Taikan, 212
Yoshida Shōin, 58–59
Yoshino Taizō, 3
Yoshinobu. *See* Tokugawa Yoshinobu
Yuko Kikuchi, 217
Yūkokusha (Country First Society), 113
Yūrakuchō, 264, 265, 274, 275

Zhou (Di Xin), Shang king, 132
Zhuang Zhou, 143

Harvard East Asian Monographs
(most recent titles)

432. Kenneth J. Ruoff, *Japan's Imperial House in the Postwar Era, 1945–2019*
433. Erin L. Brightwell, *Reflecting the Past: Place, Language, and Principle in Japan's Medieval Mirror Genre*
434. Janet Borland, *Earthquake Children: Building Resilience from the Ruins of Tokyo*
435. Susan Blakely Klein, *Dancing the Dharma: Religious and Political Allegory in Japanese Noh Theater*
436. Yukyung Yeo, *Varieties of State Regulation: How China Regulates Its Socialist Market Economy*
437. Robert Goree, *Printing Landmarks: Popular Geography and* Meisho zue *in Late Tokugawa Japan*
438. Lawrence C. Reardon, *A Third Way: The Origins of China's Current Economic Development Strategy*
439. Eyck Freymann, *One Belt One Road: Chinese Power Meets the World*
440. Yung Chul Park, Joon Kyung Kim, and Hail Park, *Financial Liberalization and Economic Development in Korea, 1980–2020*
441. Steven B. Miles, *Opportunity in Crisis: Cantonese Migrants and the State in Late Qing China*
442. Grace C. Huang, *Chiang Kai-shek's Politics of Shame: Leadership, Legacy, and National Identity in China*
443. Adam J. Lyons, *Karma and Punishment: Prison Chaplaincy in Japan*
444. Craig A. Smith, *Chinese Asianism, 1894–1945*
445. Sachiko Kawai, *Uncertain Powers: Sen'yōmon-in and Landownership by Royal Women in Early Medieval Japan*
446. Juliane Noth, *Transmedial Landscapes and Modern Chinese Painting*
447. Susan Westhafer Furukawa, *The Afterlife of Toyotomi Hideyoshi: Historical Fiction and Popular Culture in Japan*
448. Nongji Zhang, *Legal Scholars and Scholarship in the People's Republic of China: The First Generation (1949–1992)*
449. Han Sang Kim, *Cine-Mobility: Twentieth-Century Transformations in Korea's Film and Transportation*
450. Brian Hurley, *Confluence and Conflict: Reading Transwar Japanese Literature and Thought*

451. Simon Avenell, *Asia and Postwar Japan: Deimperialization, Civic Activism, and National Identity*
452. Maura Dykstra, *Uncertainty in the Empire of Routine: The Administrative Revolution of the Eighteenth-Century Qing State*
453. Marnie S. Anderson, *In Close Association: Local Activist Networks in the Making of Japanese Modernity, 1868–1920*
454. John D. Wong, *Hong Kong Takes Flight: Commercial Aviation and the Making of a Global Hub, 1930s–1998*
455. Martin K. Whyte and Mary C. Brinton, compilers, *Remembering Ezra Vogel*
456. Lawrence Zhang, *Power for a Price: The Purchase of Appointments in Qing China*
457. J. Megan Greene, *Building a Nation at War: Transnational Knowledge Networks and the Development of China during and after World War II*
458. Miya Qiong Xie, *Territorializing Manchuria: The Transnational Frontier and Literatures of East Asia*
459. Dal Yong Jin, *Understanding Korean Webtoon Culture: Transmedia Storytelling, Digital Platforms, and Genres*
460. Takahiro Yamamoto, *Demarcating Japan: Imperialism, Islanders, and Mobility, 1855–1884*
461. Elad Alyagon, *Inked: Tattooed Soldiers and the Song Empire's Penal-Military Complex*
462. Börje Ljunggren and Dwight H. Perkins, eds., *Vietnam: Navigating a Rapidly Changing Economy, Society, and Political Order*
463. En Li, *Betting on the Civil Service Examinations: The Lottery in Late Qing China*
464. Matthieu Felt, *Meanings of Antiquity: Myth Interpretation in Premodern Japan*
465. William D. Fleming, *Strange Tales from Edo: Rewriting Chinese Fiction in Early Modern China*
466. Mark Baker, *Pivot of China: Spatial Politics and Inequality in Modern Zhengzhou*
467. Peter Banseok Kwon, *Cornerstone of the Nation: The Defense Industry and the Building of Modern Korea under Park Chung Hee*
468. Weipin Tsai, *The Making of China's Post Office: Sovereignty, Modernization, and the Connection of a Nation*
469. Michael A. Fuller, *An Introduction to Literary Chinese (Second Edition)*
470. Gustav Heldt, *Navigating Narratives: Tsurayuki's* Tosa Diary *as History and Fiction*
471. Xiaolu Ma, *Transpatial Modernity: Chinese Cultural Encounters with Russia via Japan (1880–1930)*
472. Yueduan Wang, *Experimentalist Constitutions: Subnational Policy Innovations in China, India, and the United States*
473. M. William Steele, *Rethinking Japan's Modernity: Stories and Translations*